African Reflections

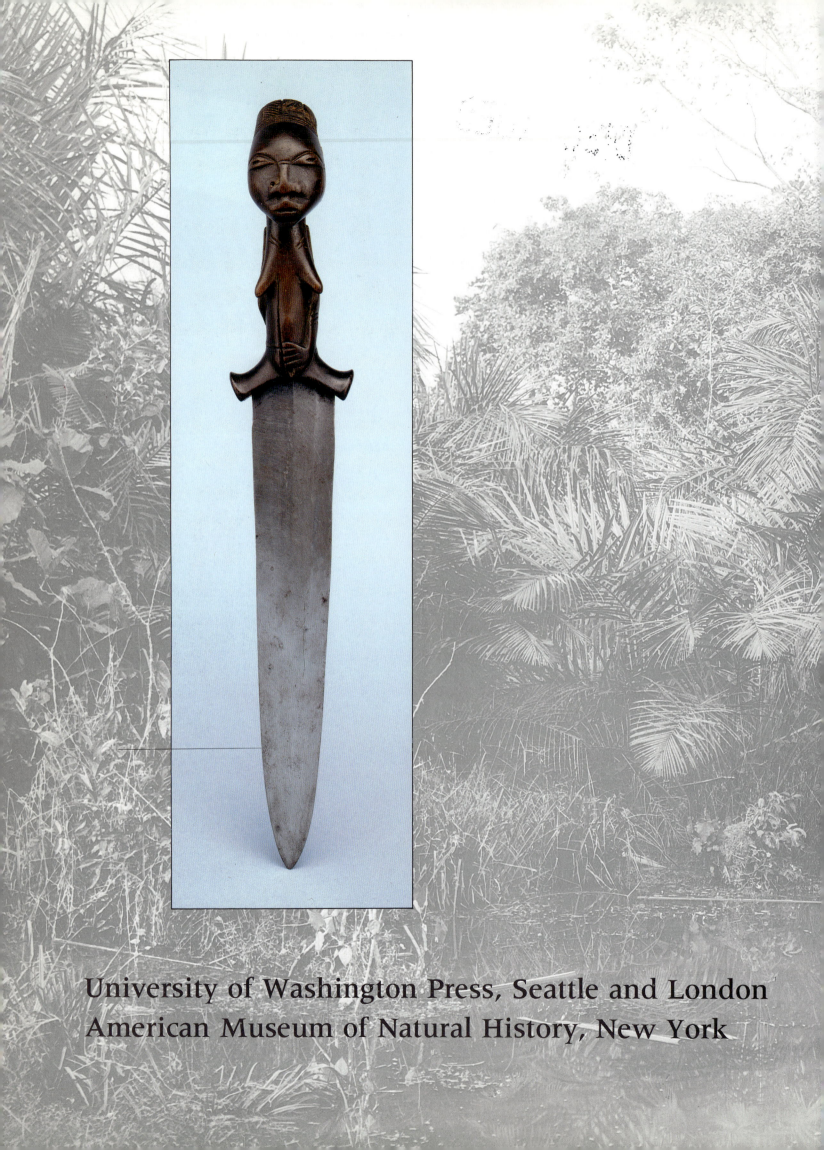

University of Washington Press, Seattle and London
American Museum of Natural History, New York

African Reflections

ART FROM NORTHEASTERN ZAIRE

by Enid Schildkrout and Curtis A. Keim

with contributions by Didier Demolin
John Mack
Thomas Ross Miller
Jan Vansina

List of Lenders

British Museum, London
The Brooklyn Museum
Frobenius-Institut, Frankfurt
Marc and Denyse Ginzberg
Jerome L. Joss
Dr. and Mrs. Robert Kuhn
Musée royal de l'Afrique centrale, Tervuren
Museo archaeologico nazionale di Perugia
Museo preistorico ed etnografico "Luigi Pigorini," Rome
Museum of Cultural History, University of California, Los Angeles
Museum Rietberg, Zurich
Museum für Völkerkunde, Berlin
Museum für Völkerkunde, Vienna
The Powell-Cotton Museum, Kent
Private collection, Los Angeles

Front and back cover and page 2

Knife, Mangbetu. *Iron, wood.*
L: 11.7 in. (30 cm). Lang, coll.
Medje, 1910. AMNH, 90.1/2082.

This dagger represents the earliest style of anthropomorphic carving found among the Mangbetu. The carving illustrates the fashionable Mangbetu style at the turn of the century, including the elongated head and the back apron, or *negbe*, worn by women. Similar daggers, carried in a sheath and worn tucked under a man's belt, were made throughout northeastern Zaire. Their wooden or ivory handles were often carved in simple geometric forms, but around 1900, carvers increasingly embellished everyday objects (including knives, boxes and other containers, and musical instruments) with human figures. This fine example shows a typical Mangbetu pose, one arm in front and the other in back resting on the apron. Herbert Lang collected it from Chief Zebuandra in 1910, during the American Museum of Natural History Congo Expedition.

Copyright © 1990 by the American Museum of Natural History
Printed and bound in Japan

Color photographs by Lynton Gardiner
Designed by Alex Castro

Library of Congress Cataloging-in-Publication Data

Schildkrout, Enid.
 African reflections: art from northeastern Zaire/by Enid Schildkrout and Curtis A. Keim with contributions by Didier Demolin . . . [et al.]: color photographs by Lynton Gardiner.
 p. cm.
 Includes bibliographical references.
 ISBN 0-295-96961-X (alk. paper).—ISBN 0-295-96962-8 (pbk. : alk, paper)
 1. Art. Mangbetu (African people) 2. Art. Black—Zaire. 3. Mangbetu (African people)—Social life and customs. 4. Ethnology—Zaire. 5. Art, Zande (African people) 6. Zande (African people)—Social life and customs. I. Keim, Curtis A. II. Gardiner, Lynton. III. American Museum of Natural History. IV. Title.
N7399.C6S35 1990
730'.089'965—dc20 90-11990
 CIP

ISBN 295-96961-X (cloth)
ISBN 295-96962-8 (paper)

The paper used in this publication meets the minimum requirements of American National Standard for Information Sciences—Permanence of Paper for Printed Library Materials, ANSI Z39.48-1984.

∞

CONTENTS

For Alicia, Ben, and Nathan

Foreword

The integration of research and exhibition is the most important mission of a great museum. This book and the exhibition it accompanies are based on research that began at the American Museum in the early years of this century. Although the Trustees who sponsored the Congo Expedition of 1909–15 could hardly have imagined that material collected there would be shown at the museum and documented in a book almost a century later, they certainly knew that they were collecting for posterity. The early expeditions have endowed generations of curators with the evidence they need to reinterpret the wonders of our planet.

Among the many expeditions to all corners of the globe sponsored by the American Museum of Natural History, the Congo Expedition is unique in its extraordinary breadth. Herbert Lang and James Chapin collected for every scientific department in the museum. Many of the zoological collections have been studied and published, but most of the ethnographic collection has waited almost a century for analysis and exhibition. Only a few of the objects and photographs have ever been published or exhibited, despite the wealth of documentation accompanying them.

Museum collections are never static, for their meaning changes in light of new developments in science, in the humanities, and in our own cultural outlook. The American Museum Congo Expedition took place in the early years of the colonial period, a time when African societies were poorly understood. Since this book is an account of an early twentieth-century expedition, it illuminates an epoch in Western history and in the history of Africa as well. It gives us, as few accounts of African art do, an intimate view of the encounter that took place between Africans and outsiders at that time. When the objects in the Congo collection were brought back to New York, in 1915, they created great excitement for those who first saw them. Coming from a continent shrouded in mystery and obscured by prejudice, the collection provided new insight and information about a culture then little known. The beautifully carved ivories and fine iron implements that Lang and Chapin collected were seen as evidence that Africa indeed contained great art and complex technology.

Today, African art is universally recognized as one of humankind's great heritages. With a new appreciation of the sophistication and beauty of African art objects and of the artists and cultures that produced them, we can take a fresh look at our earliest collections. In addition to appreciating their beauty, their technical complexity, and the wry humor and social commentary that the artists incorporated into their work, we can now understand the social and cultural context in which they were created.

Herbert Lang, who collected most of the objects included in this book, would never have imagined that eighty years later part of our fascination with his collection is in seeing how he himself, as collector and observer, influenced the history of Mangbetu art. The theme of reflections running through this book refers to the way in which these African artists commented in their work on European collectors and on the colonial experience.

I am delighted to present this book as a superb example of the continuing commitment of the American Museum to excellence in research, to fine exhibition and education, and to our mission of enhancing the mutual understanding of peoples throughout the world. In addition to the objects from the American Museum collection, the book includes photographs of great works of art from a number of other collections. I want to thank in particular the lenders to the exhibition, the National Endowment for the Humanities, the New York State Council on the Arts, the Institute of Museum Services, and those institutions and individuals who have assisted with this project in so many ways. I would also like to thank Enid Schildkrout and her co-curator Curtis A. Keim for initiating and carrying through this project that has allowed us to learn so much more about these magnificent African treasures. Most important, I want to thank those people in Zaire whose forebears created these wonderful works of art.

George D. Langdon, Jr.
President, American Museum of Natural History

Preface

For many years I have known that the heart of the American Museum of Natural History African ethnology collection was the material collected by a mammalogist, Herbert Lang, and an ornithologist, James P. Chapin. The Congo Expedition, as it was called in 1909 when it began, was organized to study the natural history, primarily the zoology, of northeastern Zaire, then known as the Belgian Congo. The unexplored region had come to world attention in 1902 with reports that the okapi, the only living relative of the giraffe, inhabited the northern fringes of the Ituri forest. Since the expedition was asked to collect for all departments of the museum, this included anthropology. The artifacts that were brought back to New York in 1915 were stored in the Department of Anthropology, but few were studied or exhibited and many had deteriorated in the nearly eighty years since the expedition. Studying this collection seemed an impossible task until I met Curtis A. Keim, who had written his doctoral thesis on the history of the Mangbetu kingdoms.

The project turned out to be much larger and much more fascinating than I had expected when we began our collaboration over four years ago. A tremendous amount of detailed historical information emerged, which enabled us to study the art history of northeastern Zaire in a unique way. It is rare with collections of African art (or artifacts) to be able to document the past almost as if one was doing contemporary fieldwork. Once we matched Lang's fieldnotes with the Congo Expedition's 10,000 photographs, 4,000 ethnological objects, and volumes of letters and reports, we could begin to unravel threads in the story of the art history of northeastern Zaire. These data grew even richer when examined in the light of modern fieldwork.

This catalog traces the art history of northeastern Zaire, focusing mainly on the last 120 years. History, as we define it in this catalog and exhibition, is not a static look at times past but rather a look at processes of change. Our baseline is the mid-nineteenth century, the time when Westerners first started collecting the ob-jects shown in this exhibition. The book deals with the concept of "reflections" in two ways. In chapter 2, the myths that Europeans constructed about the Congo are considered in the context of the early explorations of the region. These myths projected aspects of the European worldview onto an African canvas. Not long after, artists in northeastern Zaire reflected images of themselves, and of Europeans, in their art. This is discussed primarily in chapter 12, where we trace the development of anthropomorphic art. The rest of the book elucidates the material culture of northeastern Zaire, showing that the most important esthetic principles in northeastern Zaire are in fact not those incorporated into the anthropomorphic art for which the region is famous but the principles of geometric design reflected in objects made for daily use. This esthetic concern is considered throughout the book, in sections on household organization, politics, trade and tribute, music, and religion.

Field research on the Mangbetu goes back to the middle of the last century, to Georg Schweinfurth's first encounter with King Mbunza in 1870. Expeditions in the early colonial period, including the American Museum Congo Expedition led by Herbert Lang and James P. Chapin, provide the basis for this exhibition and catalog. The major part of this book and exhibition is based on historically documented museum collections, which we have used as a way of establishing historical benchmarks to the many fine objects that grace other collections, both private and public.

Notes on the Organization of the Catalog

We have referred often in this work to Herbert Lang's unpublished fieldnotes, which are found in the archives of the Department of Anthropology of the American Museum of Natural History. In the text after references and quotes from the fieldnotes we have indicated the field-note number in parentheses. Where there is possible confusion with a publication, we have

specified that the reference is to a fieldnote. Lang's ethnographic notes were written over a four-year period (1910–14) in chronological order. The ethnographic collection was accessioned by the American Museum in 1915 and bears the accession number 1915–29. Lang gave an African name to virtually every object, and we have included these names in the text. Although their spelling is not always accurate, they can still be used for cross-reference with other published works. In some sections of the catalog authors have used more modern spellings.

Unless otherwise noted, the photographs are of American Museum of Natural History objects, and the archive photographs were taken by Herbert Lang and first printed in the Congo (Zaire) during the expedition. Photograph negative numbers refer to the catalog numbers in the American Museum of Natural History Photographic Archives, and stereoscopic images are noted by a parenthetical *s*.

With a few exceptions, we have adopted modern orthographies for the names of ethnic groups. For the Azande, we follow the precedent set by Evans-Pritchard in using *Zande* as the adjectival and singular noun form.

The translations of material quoted from foreign-language sources are those of the authors of this book except where a published translation is cited in the Bibliography.

Acknowledgments

The encouragement and support of the American Museum of Natural History made this project possible. The American Museum's commitment to research in Africa began with the Congo Expedition and continues in the present project. Although focused only on a small part of the collection, the exhibition and catalog are based on research over many decades in many departments of the museum. If mammals, birds, and other creatures had not kept Lang and Chapin in the heart of Africa for such a long time—only a few years after Henry M. Stanley first traced the course of the Congo River—the Mangbetu of the early colonial period would never have been so thoroughly documented.

We had a number of fascinating problems, conceptual as well as practical, in interpreting the wealth of material we discovered in the course of our research. So many people helped us solve them that it is impossible to acknowledge them all. This project took us to many countries in Europe, to museums and private collections, and finally to Zaire. In addition to this catalog, we produced an exhibition and two films directed by Jeremy Marre of Harcourt Films. One film is part of the exhibition, and the other is a television documentary produced in association with the British Broadcasting Corporation and Arts and Entertainment. Twenty hours of unedited footage provide a new resource with which to continue the study of the Mangbetu people.

Our research in European museums extended our knowledge of the art history of northeastern Zaire back to the mid–nineteenth century. In tracing these sources Ezio Bassani offered many helpful suggestions regarding objects in Italian museums. Enrico Castelli wrote a background paper on the explorations of the Upper Nile region, part of which has been incorporated into chapter 2. A. E. Feruglio of the Ministero per i beni culturali e ambientali in Perugia and Giovanni Scichilone, Egidio Cossa, and Alessandra Antinori at the Museo nazionale di antropologia e di etnologia (L. Pigorini) in Rome helped us in our study of Italian collections. The largest collection of objects from the Belgian Congo is in the Musée royal de l'Afrique centrale at Tervuren. We are most grateful to Huguette Van Geluwe for assisting us in studying the Tervuren collections. We are also grateful to Albert Maessen, Louis de Stryker, and Marc Felix for their suggestions.

Explorers from Britain, Germany, and France followed the Italians into the heart of Africa, and museums in those countries generously allowed us to study their collections. Our debt to John Mack is obvious in this catalog and in the exhibition. He facilitated our study of the British Museum (Museum of Mankind) collection, read drafts of many chapters, and had countless discussions with us about our sometimes controversial interpretations. We also thank Derek Howlett of the Powell-Cotton Museum, Yvonne Schumann of the Liverpool Museum, Elizabeth Edwards of the Pitt-Rivers Museum, Malcolm McLeod of the Museum of Mankind, and Paul Sant-Cassia of the University Museum in Cambridge. People in many other European museums have given generously of their time, including Francine N'Diaye at the Musée de l'homme; Colette Noll, Musée national des arts africains et oceaniens; Charlotte von Graffenreid, Bernisches historisches Museum; Claude Savary, Musée d'ethnographie, Geneva; Francoise Keller, Musée Barbier-Mueller; Johanna Agthe, Museum für Völkerkunde, Frankfurt; Armand Duchateau, Museum für Völkerkunde, Vienna; Hermann Forkl, Linden-Museum Stuttgart; Eike Haberland, Frobenius-Institut, Frankfurt; Jean-Loup Rousselot, Museum für Völkerkunde, Munich; Hans-Joachim Koloss, Museum für Völkerkunde, Berlin; Wulf Lohse, Hamburgisches Museum für Völkerkunde; and Hans Manndorff, Museum für Völkerkunde, Vienna.

Many individuals and museums in the United States have given us information and access to the collections under their care, including Kate Ezra of the Metropolitan Museum of Art, William Seigman of the Brooklyn Museum, and Doran Ross of the Museum of Cultural History, University of California at Los Angeles. Owen Moore of the Museum of Cultural History graciously escorted me around Los Angeles to visit many wonderful private collections, some of which have lent objects to this exhibition. Curt

Keim and I had the honor to visit many fine collections in New York and Belgium and we hope that our historical treatment of the art of northeastern Zaire will be of interest to those who treasure this art.

At the American Museum of Natural History, more people contributed to this project than we can possibly acknowledge. Donna Ghelerter worked with the American Museum collection, kept everything organized, and simultaneously wrote the legends to the figures in this catalog. Peggy Cooper and Tom Miller carefully edited the manuscript. Jill Hellman contributed to the early planning and research; her contribution is most evident in chapters 6 and 7. Paul Beelitz, Joan Buttner, Carol Gelber, Belinda Kaye, Mary LeCroy, Melanie LeMaistre, Scarlett Lovell, Donald McGranaghan, Lauriston Marshall, Juliana Perry, Gary Sawyer, Linda Stone, Francie Train, Catherine Walter, and Bill Weinstein all put special effort into this project. The American Museum library staff, under the direction of Nina Root, especially the people in the Administrative Archives and the Photographic Archives, deserve special thanks for helping us sort through images and archives. We are also very grateful to those people in the American Museum photography studio who spent many hours printing Lang's photographs.

Judith Levinson, Marian Kaminitz, Sasha Stollman, and other conservators worked painstakingly to conserve objects in the American Museum collection. Their research on techniques and materials also informed sections of this catalog, particularly chapters 6 and 7. Lynton Gardiner's fine color photography for this catalog would not have been possible without their work.

Very special thanks are due to Clifford La-Fontaine, who designed the exhibition and continually helped us focus our attention on its essential elements. Marlene Adlerblum made an outstanding contribution to the graphic design of the exhibition. Alex Castro, a pleasure to work with, designed this extraordinary catalog and also helped us with visual editing. Pam Bruton's insightful questions in the final stages of editing forced us to resolve the inconsistencies that inevitably turn up in a long and complex manuscript.

We are very grateful to the administration of Moravian College. They generously gave Curt Keim time away from his normal academic duties to devote to this project. We wish to thank in particular the staff of the library and the media center. Mary Lou Bross, Greg Crawford, Bonnie Falla, Debbie Gaspar, Joann Grandi, Hwa Yol Jung, Tom Minor, and Robert Stinson deserve special mention for their assistance.

Fieldwork by Curt Keim and Didier Demolin have informed many of the chapters. Keim's research in Zaire was generously assisted by Dr. Lema Gwete, Director of the National Museum of Zaire, and by Nestor Seeuws, Derrill Sturgeon, Sharon Sturgeon, Rob McKee, Carol McKee, the Danga family, and many others who shared their knowledge and hospitality. We are grateful to Benoit Quersin, of the National Museum of Zaire; Miro Morville, Cultural Attaché of the United States Embassy in Kinshasa; and Karen Aquilar, of the United States Information Agency, for facilitating the film component of this project.

Many people read parts of this manuscript, offered helpful advice, discussed ideas with us, and gave encouragement. We thank Jessie Allen, Robert Bailey, Ruth Chapin, Michael Hager, Aldona Jonaitis, Jay Levinson, Mary McMaster, Diana Marre, Phyllis Martin, Armin Prinz, Alan Roberts, Francoise Van Vliet, Jean-Luc Velut, Susan Vogel, and Herbert Weiss. We have a very special debt to Jan Vansina, who read most of our chapters and whose extensive work on northeastern Zaire informs and inspires much of this book.

This project has been supported in part by a grant from the National Endowment for the Humanities. We especially thank Tom Wilson at the Endowment for his encouragement and guidance. A planning grant from the Endowment allowed us to develop ideas and follow leads in unanticipated directions. Valued support has also been received from the Institute of Museum Services for the conservation of objects. This catalog has also benefited from public funds from the New York State Council on the Arts.

Our families deserve very special acknowledgment. Karen and Nathan put up with Curt Keim's many trips to New York and Zaire; and John, Alicia, and Ben Van Couvering kept things going while I was distracted by thoughts of the Mangbetu, the Azande, and their neighbors. John Van Couvering resolved many of our zoological and geographical quandaries and read parts of the manuscript. Karen Keim also commented on many drafts with the wisdom of her own experience in Zaire.

Enid Schildkrout
Curator, American Museum of Natural History
October 1989

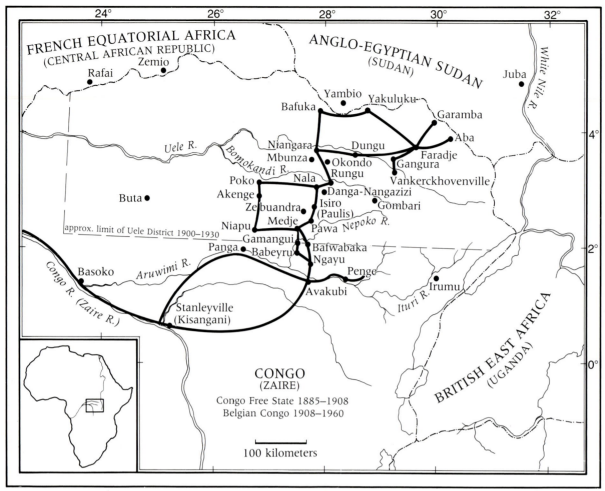

The American Museum of Natural History Congo Expedition, 1909–15

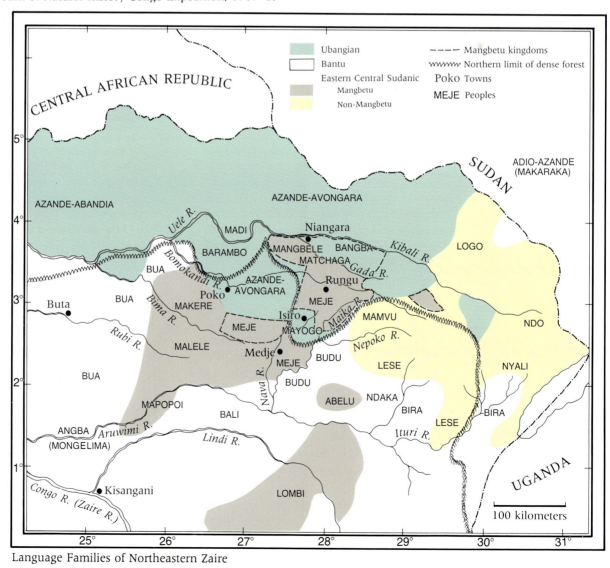

Language Families of Northeastern Zaire

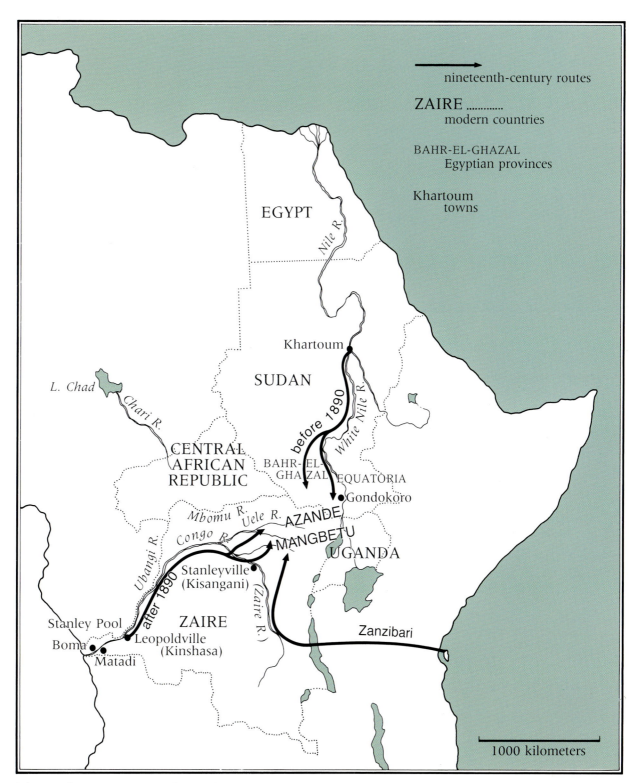

Nineteenth-Century Approaches to the Uele Region

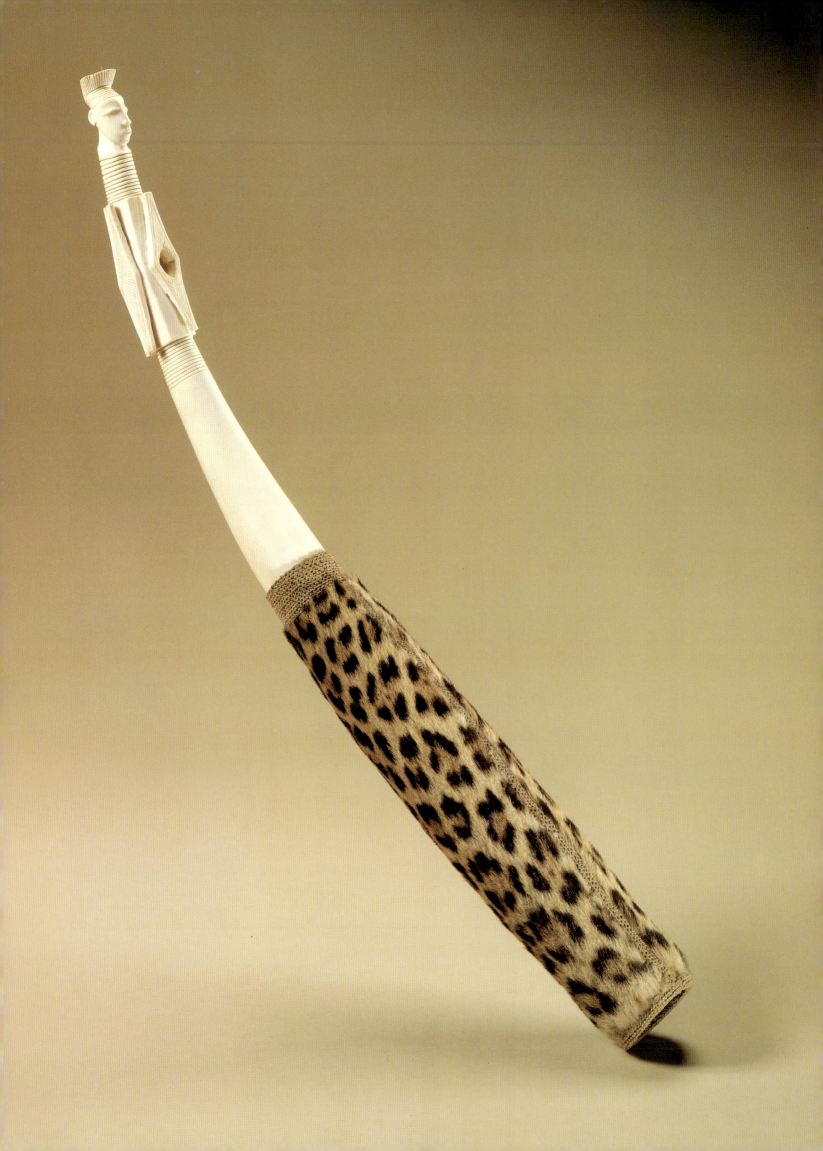

1

Art, Ethnography, and History in Northeastern Zaire

Mangbetu woman arranging her husband's hair, drawn on an ivory horn by the Zande artist Saza.

←

1.1
Horn, Mangbetu. *Ivory, leopard hide with fur, wood, plant fiber. L: 33.3 in. (85.4 cm). Lang, coll. Niangara, 1913. AMNH, 90.1/ 4619.*

Ivory horns symbolized power and prestige for Mangbetu chiefs. The horns, along with drums, rattles, and bells, were played in chiefs' orchestras for court dances and ceremonies.

The great ethnographic collections in American and European museums dating from the turn of the century can be viewed as a material footnote to European colonial expansion. Taken from Africa as souvenirs of military, economic, political, and missionary penetration, these collections have been stored as trophies and souvenirs in curiosity cabinets and ethnographic exhibits for three-quarters of a century. Their resurrection in exhibitions and accompanying catalogs stems from their appropriation into Western consciousness as art. Conforming to popular European tastes of the late nineteenth century, the earliest collectors praised the naturalism and symmetry of sub-Saharan African art and compared it with classical Egyptian and Greco-Roman sculpture. Egyptian art was sometimes credited for inspiring that of northeastern Zaire. Such biases certainly influenced what objects were collected and may also have been communicated to African artists, thereby affecting the production of the art itself.

This exhibition and catalog focus on the art of northeastern Zaire in the first part of this century. Many exhibitions of African art draw their finest objects from this same period, although few deal directly with the fact that these works were produced in the context of an intense confrontation between early European colonizers and African societies. In this exhibition we are fortunate to have an incredibly rich trove of historical information that we can use to shed light on the context in which the art

was produced. With this documentation we are able to answer many questions about the artists and about the audiences for whom the objects were made. Without it, we could still enjoy these objects as art—a valid enough approach in its way—but we could not presume to understand the meaning they had for their makers.

The desire for context, particularly with non-Western art, often leads to poorly conceived anthropological attempts to explain the meaning of the art. Non-Western art is almost invariably presumed to be associated with ritual, and often Westerners have difficulty accepting the idea that Africans traditionally produced art just for its esthetic value. In northeastern Zaire, there is considerable historical evidence to show that art—even the idea of art—was present well before the advent of the modern tourist trade but that once outsiders discovered this art, their tastes left a strong mark on it.

Generic anthropological explanations of African art often fail to take history into account. For those who would rectify this state of affairs, the necessary information is often lacking or hard to find; this reflects the circumstances in which most of the art was first removed from its context. By assuming that non-Western art emerged in cultures that lacked a concept of art for art's sake, Westerners have attributed meanings to these objects that they never had. The famous carved human figures of the Mangbetu have been described as ancestral effigies and as

memorial figures for deceased rulers, and their bark boxes surmounted by carved heads have been assumed to hold sacred relics. There is virtually no documentation for such interpretations, but they fit the Western stereotypes that legitimate non-Western art. The corollary, that African art that was made *as* art had to be tourist art, has been damaging and demeaning to African artists, who may have taken pride in making beautiful objects simply for pleasure.

The American Museum of Natural History's Congo Expedition collection, made by Herbert Lang (1.3) and James Chapin (1.4) between 1909 and 1915, offers an extraordinary opportunity to study the art history of northeastern Zaire in the early colonial period (see chap. 3). These two zoologists went to northeastern Zaire specifically to study the flora and fauna of this little-known region, but they also had instructions to collect for all the departments of the American Museum. Being scientists, they conducted their anthropological investigations with attention to the same fastidious detail that they applied to collecting plants, birds, and beetles: recording observations, measurements, and informants' accounts on a daily basis for five years. Lang, although not formally trained in anthropology, wrote the field catalog for the ethnographic collection and collected material ranging from grain samples to head measurements, household items, and finally, at the end of his stay, works of commissioned art (1.2). Because these two men were the only outsiders on a very long expedition, they depended on local people to serve as porters, cooks, field guides, hunters, translators, specimen prepara-

1.2
Left:
Pipe, Azande. *Wood. L: 3.1 in. (8 cm); W: 2.8 in. (7.2 cm). Lang, coll. Dungu, 1913. AMNH, 90.1/ 4117.*

Right:
Pipe, Azande. *Wood. L: 3.0 in. (7.7 cm); W: 1.7 in. (4.4 cm). Lang, coll. Dungu, 1913. AMNH, 90.1/4646.*

These two European-style pipes are portraits representing Herbert Lang (*left*), leader of the American Museum's Congo Expedition, and his assistant, James Chapin.

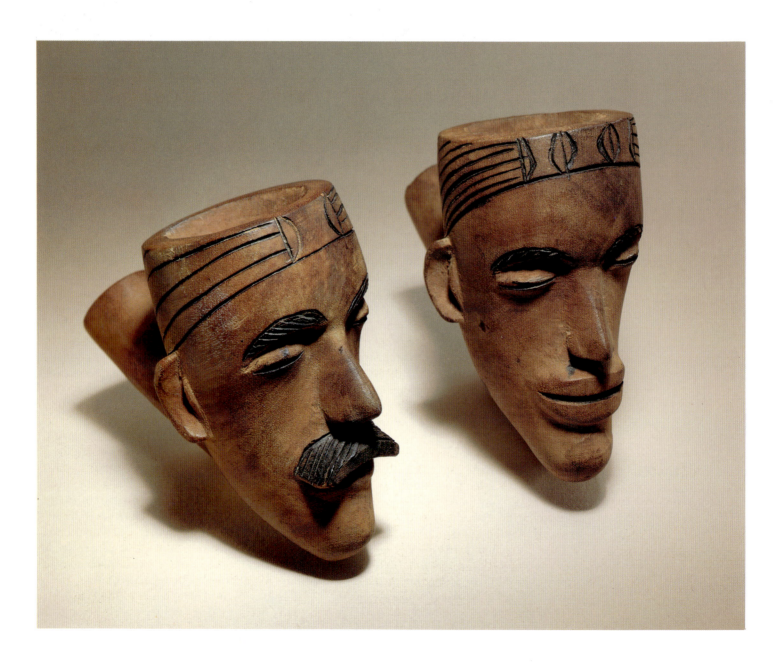

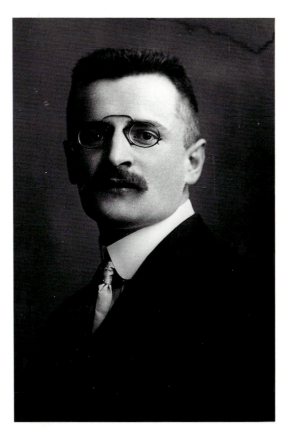

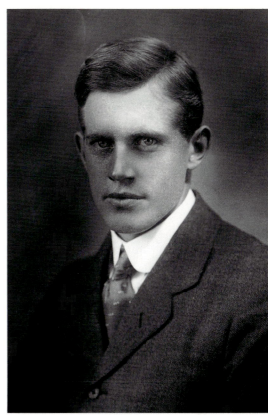

1.3

Herbert Lang, 1909. *AMNH Archives, 32297.*

Herbert Lang was a mammalogist at the American Museum of Natural History when he was chosen to lead the museum's Congo Expedition, which lasted from 1909 to 1915. After Lang returned from Africa, he continued working at the museum as a curator in the Department of Mammalogy.

1.4

James P. Chapin, 1915. *AMNH Archives, 34604.*

James P. Chapin, an ornithologist, was assistant to Herbert Lang on the American Museum's Congo Expedition. Chapin was only eighteen years old when he sailed with Lang for Africa in 1909. After returning from the expedition, Chapin wrote *Birds of the Belgian Congo.* He went on to become a curator and chair of the Department of Ornithology at the American Museum of Natural History.

tors, and informants. Neither man was immune to the typical colonial stereotypes and prejudices of the day. Nevertheless, Lang's commitment to empirical observation led him to collect masses of information about material culture and the people who produced it.

The American Museum Congo Expedition was one of several to northeastern Zaire at the dawn of the Belgian colonial period. Taking the collections made by German, Belgian, and American expeditions together with the miscellaneous collections amassed by military men, missionaries, and colonial officials between 1898 and 1915, we can estimate that at least 20,000 objects, representing every facet of material culture, were carried away from the region at that time, despite the fact that there were very few European settlers in the area.[1] The American Museum of Natural History has about 800 objects from the Uele region given in 1907 by the Congo Free State and about 4,000 objects collected by Lang and Chapin. The Musée royal de l'Afrique centrale has many more from the region collected by the Congo Free State government and an estimated 10,000 to 12,000 collected on the Belgian Ethnographic Mission by Armand Hutereau. Adding miscellaneous, other early colonial collections, the number of objects totals well over 20,000. In chapter 12 we summarize the historical evi-

dence concerning the rise and decline of the anthropomorphic genre. Clearly, this discussion must consider the European presence and its effect on art production. Innovations occurred (as they always had) within established traditions, and new art forms developed in response to the economic and political changes of the twentieth century (**1.4**).

Mid-nineteenth-century Italian, British, and German explorers in search of the headwaters of the Nile, as well as subsequent military expeditions into the troubled Anglo-Egyptian Sudan, had brought back to Europe fantastic stories of a people known as the Niam-niam—supposedly cannibals with tails. The stories were modified as Europeans encountered actual Zande and Mangbetu people, but exaggeration, distortion, and the elaboration of these fantasies continued well into the twentieth century, if not to this day. Beginning with the first European encounter with the Mangbetu—the meeting between the German botanist Georg Schweinfurth and King Mbunza in 1870—the Mangbetu were stereotyped in myth (see chap. 2). Schweinfurth's florid account of the Mangbetu court (1874) provided a model for subsequent descriptions, most of which exaggerated the power of the rulers and the prevalence of cannibalism.

1.5
Harp, Mangbetu(?). *Hide, plant fiber, wood, brass. L: 19.5 in. (50 cm). Lang, coll. Niangara, 1910. AMNH, 90.1/3971.*

The art of northeastern Zaire intermingles styles and forms of the various peoples living in the region. Niangara, where this harp was collected, was a cosmopolitan center that attracted artists from several groups. The harp is carved in the classic Mangbetu style with sleek lines and an elongated head.

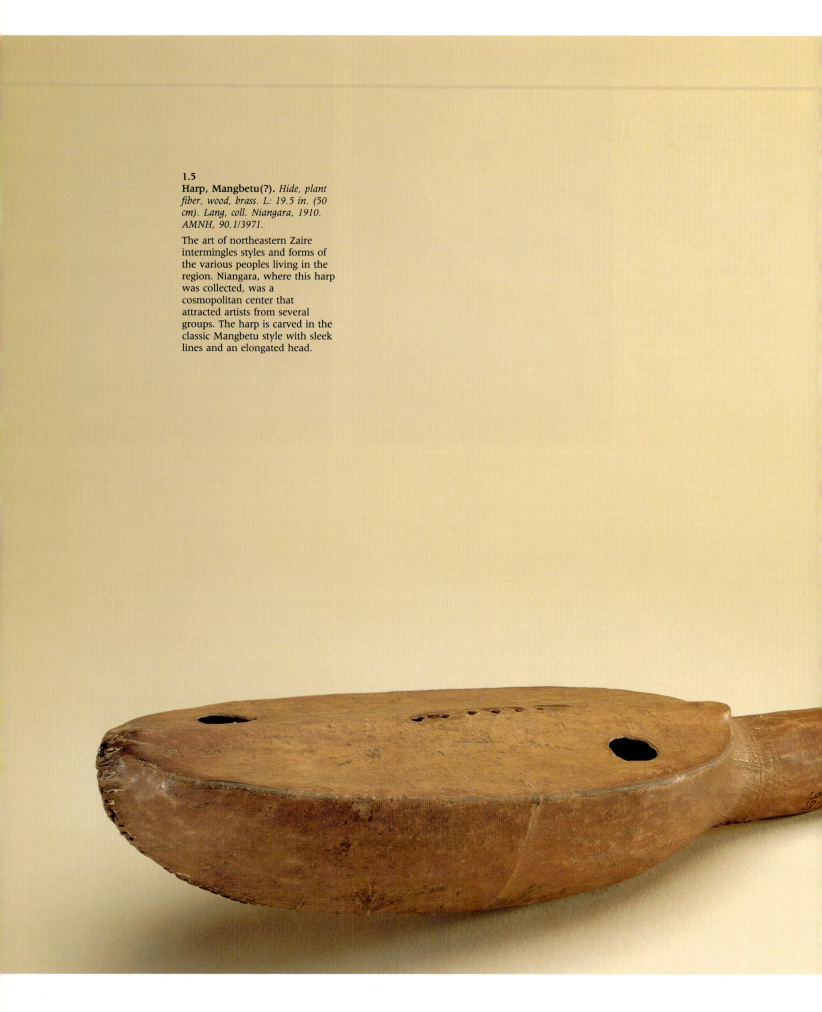

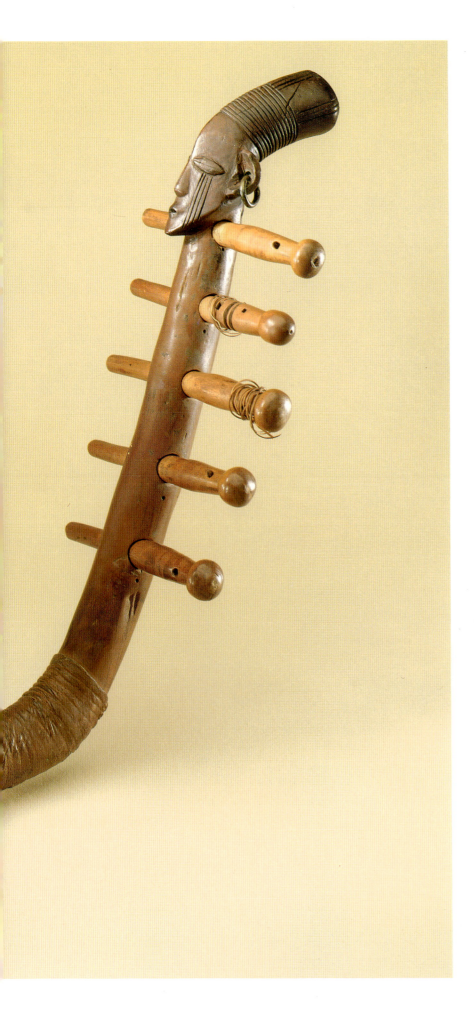

At the same time, these stories contributed to the elaboration of a stereotype of the art of the region, which soon was reflected in the art being produced by carvers, potters, and smiths in the area. Mangbetu art began to be produced—not always by Mangbetu artists—in conformity with this caricature of the culture. ''Mangbetu art'' in Western collections usually refers to a particular style of sculpture found on knives, pots (1.6), standing figures, horns (1.1), and five-stringed harps (1.5) that depicts a distinctive turn-of-the-century fashion of upperclass Mangbetu women: the elongated wrapped head and the halolike coiffure (1.7).[2] Archival photographs show that the anthropomorphic carvings were naturalistic renderings of the Mangbetu ''look,'' even if they were more problematic as examples of the work of Mangbetu artists.

Production of the anthropomorphic art so widely collected in the colonial period has virtually ceased in northeastern Zaire. The simplest explanation for this is that local culture was radically transformed, or even destroyed. In fact, the cultures of northeastern Zaire have remained remarkably intact, particularly in their adherence to a coherent worldview (see chap. 9). The reason for the disappearance of the anthropomorphic genre known as Mangbetu art is far more complex and has to do with the fact that this kind of art was never really an intrinsic part of the regional material culture in the first place. While the peoples of northeastern Zaire clearly appreciated sculpture as art, it never functioned within their culture in the way that Westerners often expect of ''primitive'' art. Nor was it simply a tourist genre, produced solely for outside demand. In fact, many types of objects that were formerly decorated with sculpted human images are still made, but without the figurative embellishment. In order to understand the place of anthropomorphic art in the cultures of northeastern Zaire, we need to inquire about how material objects, including representational art, were imbued with meaning within the entire repertoire of material culture. What, for example, was the difference between a whistle with a head carved on it and one without? These are important and difficult issues that we address in the following pages, and particularly in the last chapter.

The question of the rise and decline of the anthropomorphic genre should be posed not simply as, What happened to Mangbetu art? but also as, Who made Mangbetu art? At least part of the answer, discussed in the pages that follow, is that northeastern Zaire should be seen as an art-producing region in which artists, media, forms, and individual styles were

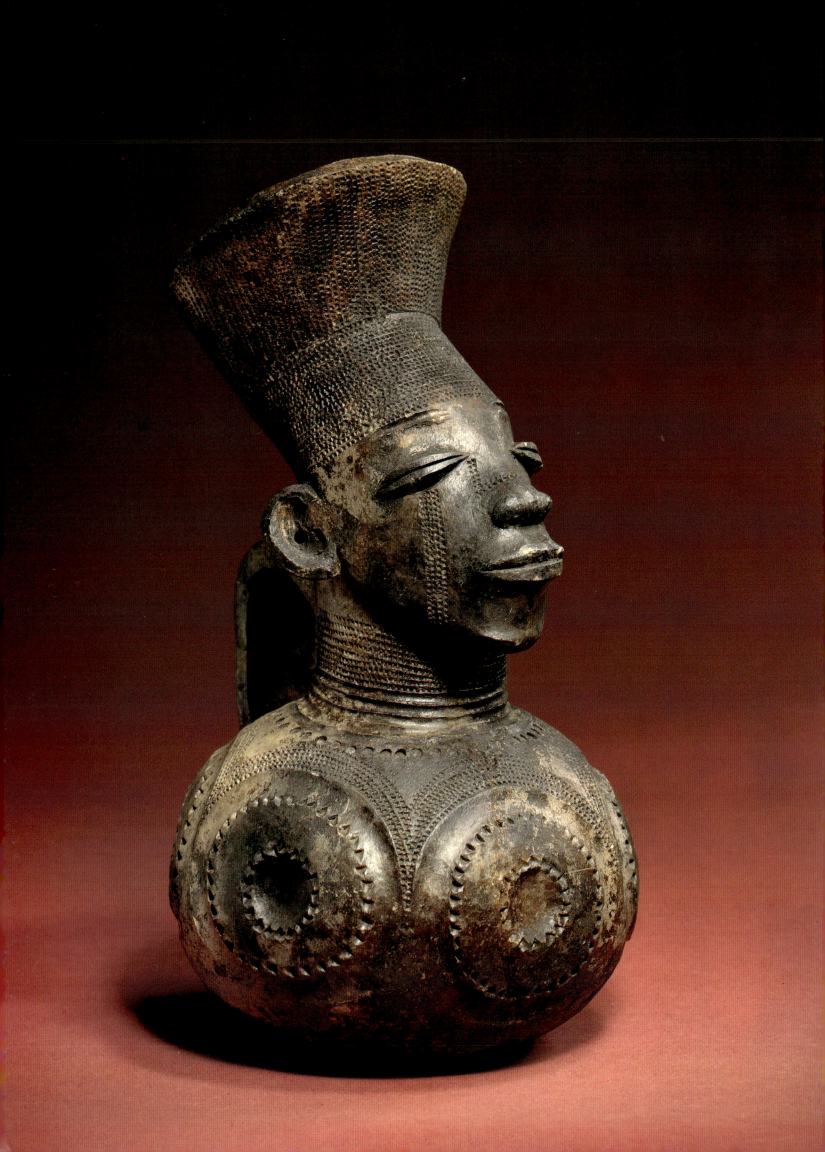

1.7
Mangbetu woman, Okondo's village, 1910. *AMNH Archives, 224507.*

The Mangbetu ideal of feminine beauty, exemplified by wives of important men, featured an elongated, bound head with an elaborate fanlike coiffure. The Mangbetu, as well as some neighboring groups, often based their figurative art on this style. The Mangbetu head was depicted in wood, ivory, and ceramic on various objects, including pots, knives, and musical instruments.

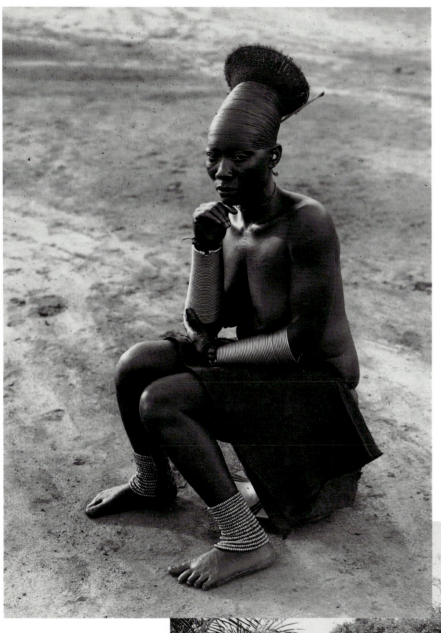

1.8
Mangbetu women standing at a stream, Okondo's village, 1910. *AMNH Archives, 111932.*

Mangbetu women drew water and took baths at this stream near Chief Okondo's village. The landscape of northeastern Zaire, featuring both dense forest and open grasslands, attracted peoples from the three main language families of eastern and central Africa.

←

1.6
Pot, Mangbetu. *Ceramic. H: 10.3 in. (26.5 cm); D: 6.2 in. (15.9 cm). Lang, coll. Niangara, 1913. AMNH, 90.1/4671.*

This pot, with its elongated head, coiffure, and facial decorations, is in the classic Mangbetu anthropomorphic style. Found on knives, figures, harps, pipes, boxes, and other objects, this form is a stylized representation of the way fashionable Mangbetu women adorned themselves in the early years of this century.

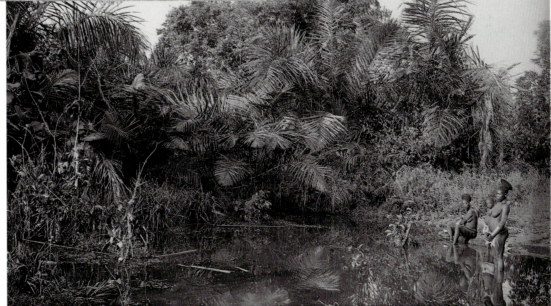

exchanged and communicated over space and time. In the exhibition we have avoided the concept of "ethnic art"; the heterogeneity of the region and the historical interaction among the peoples who lived there make it necessary to go beyond ethnic typologies. In tracing the history of particular objects, there are many instances in which we can document that works regarded by collectors and museums as most typically Mangbetu were in fact made by Barambo, Bangba, or Zande artists.

In working with the Lang collection, as well as with other early museum collections such as those at the British Museum (Museum of Mankind) and the Musée royal de l'Afrique centrale, we have been able to piece together a good deal of the ethnography and art history of northeastern Zaire. The discussion of regional art history is approached in three broad categories. First, there were the long-term interactions of peoples in northeastern Zaire, the development of ethnicity, and the merging of traditions in the region over at least two millennia. Second, there was the development of kingdoms, particularly among the Azande and the Mangbetu, which by the mid–nineteenth century had made certain groups predominant and led to the prominence of certain art styles. Concurrently, continuing social and cultural interchanges occurred

as people of diverse origins were incorporated into growing kingdoms or moved across their very permeable borders or were brought into contact through religious associations that overrode local social and political allegiances. Third, there was the influence of foreigners: Arabs, who came as slavers and ivory traders in the mid–nineteenth century, and then European soldiers, scientists, missionaries, and colonizers.

Northeastern Zaire is an ecologically rich area that includes the northern edge of the Ituri forest and the savanna grasslands extending northward into the Sudan (**1.8**). This geographical and biological diversity, with fauna and flora from several different microenvironments, explains its attraction for early twentieth-century naturalists like Lang and Chapin. Following Schweinfurth's explorations in the 1870s, several unique species of animals were known to inhabit this region, most notably the okapi (first described in the scientific literature in 1902), a rare prize for museum dioramas.

This ecological diversity has also attracted immigrants from a wide geographical area as far back as history takes us. Very little archeological work has been done in this region, but historical linguistics suggests that for at least two millennia people from three major linguistic families have been entering the area and

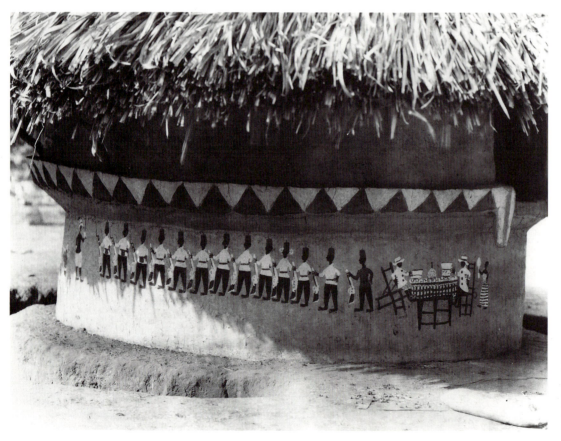

1.9
Zande mural painting, Faradje, 1913. *AMNH Archives, 223945.*

With the advent of colonialism, art in the Belgian Congo often featured images of soldiers and administrators. The mural on this Zande building shows a white man and woman eating at a table covered with a checked tablecloth; numerous soldiers are in attendance.

→
1.10
Cup, Azande. *Gourd, plant fiber. H: 6.7 in. (10.5 cm). Lang, coll. Akenge's village, 1913. AMNH, 90.1/2625.*

Lang collected several engraved gourds made by Zande artists during the colonial period. Scenes on the gourds portray the Azande, neighboring groups, and Europeans. A soldier taking prisoners appears on the side of this gourd cup.

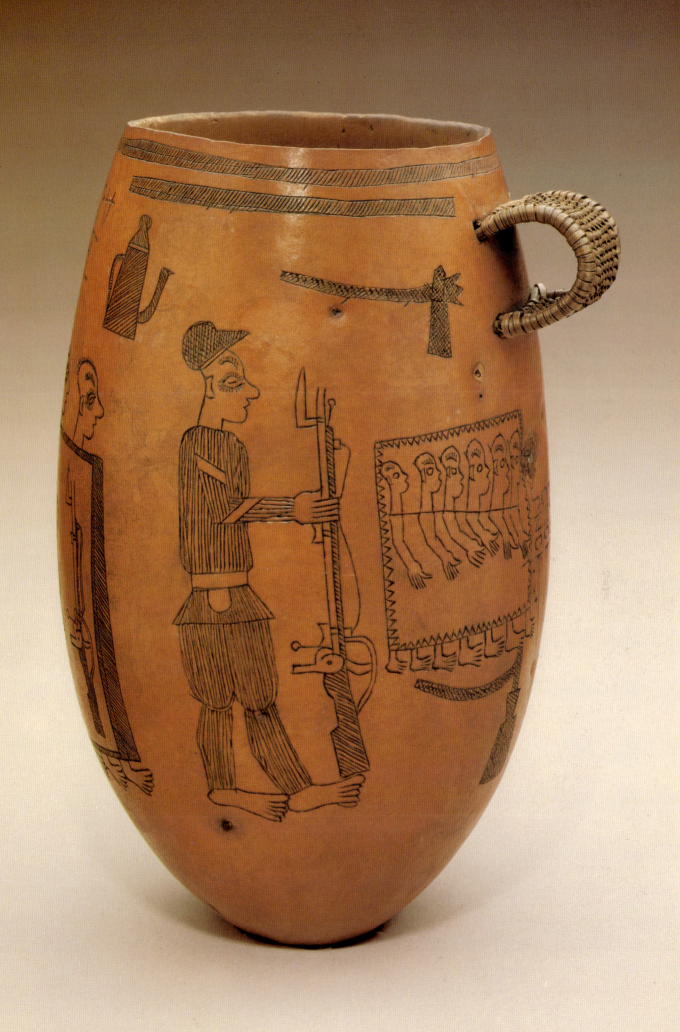

sharing their languages and cultures (see chap. 4). Today the region includes people speaking Bantu, Central Sudanic, and Ubangian languages. In a recent study of the languages of Africa (Dalby 1977), this region is referred to as part of a fragmentation zone, because of the interpenetration of many language groups. The Bantu-speaking peoples include the Bua in the west, the Budu and Bali in the south, the Angba (Mongelima) in the southwest, and the Lese in the southeast. The (Eastern) Central Sudanic speakers include the Mamvu, the Madi, and the Mangbetu. Mangbetu speakers include the Meje, Makere, Malele, Mapopoi, and the Mangbele (former Bantu speakers). The Ubangian-speaking peoples include the Azande, the Bangba, and the Barambo.[3]

The concept of region, unlike the simpler concept of tribe, does not inherently imply clear geographical or cultural boundaries. The problem is compounded in northeastern Zaire by the fact that linguistic, cultural, and political boundaries, let alone the later boundaries imposed by colonial authorities,[4] are not congruent. The Azande and Mangbetu, for example, speak quite unrelated languages but share some features of culture and political organization. The Asua (called Akka by the Mangbetu), Mbuti, Efe, and other Pygmies, still culturally distinct in some respects, now largely share the languages of their Bantu and Central Sudanic neighbors. The Mangbele have for the most part adopted the Mangbetu language and political culture while retaining some features of their original culture. Some groups, such as the Meje, Madi, and Mangbele, have subgroups both inside and outside the Mangbetu kingdoms.

We have chosen to focus on the Mangbetu-speaking peoples and deal with other groups in the region as "neighbors." This decision is not based on a judgment that the Mangbetu are the most typical culture of the region. However, in more than one hundred years of European contact with northeastern Zaire, the Mangbetu have been the object of much more research and comment than other regional peoples. Moreover, the collection we are dealing with is primarily Mangbetu, or from groups in close contact with the Mangbetu. Our central premise, however, is that in order to under-

1.11
Porters of the Congo Expedition, c. 1909–15. *AMNH Archives, 1404(s).*

The Congo Expedition was originally planned to last for two years. Instead, Lang and Chapin stayed for six, sometimes working in different locations for periods of time. They returned to New York in 1915 with fifty-four tons of materials, including mammals, birds, reptiles, fish, and invertebrates, as well as ethnographic materials.

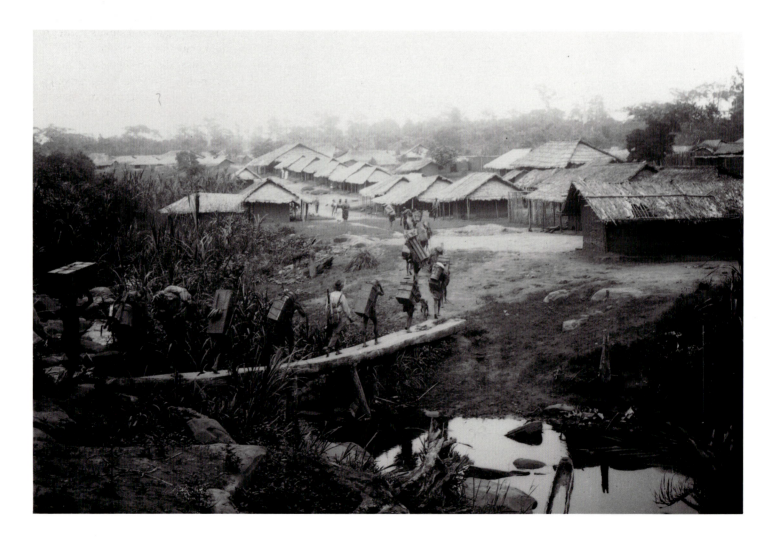

stand Mangbetu-style art and culture—or those of any people in this region—we must view the art producers in a regional context, in dynamic interaction with their neighbors, both allies and enemies.

Our focus on Mangbetu-style art has necessarily led us to give more attention within the region to immediate neighbors of the Mangbetu (such as some of the Azande, the Mamvu, the Budu, the Makere, and the Barambo) than to distant neighbors (such as the Adio Azande [Makaraka], Ngbaka, Logo, Bongo, and Mongelima). Subject peoples of the Mangbetu, like the Meje, Mabisanga, Mangbele, and Bangba, are also given greater attention than others and in some parts of our discussion are treated simply as Mangbetu.

Returning to the question posed earlier of who made Mangbetu art, we suggest that although the term *Mangbetu* can be used to describe one style of African art, it is not an appropriate description of the artists, who may or may not have considered themselves Mangbetu. Within the Mangbetu kingdoms there were many different groups, some of whom maintained many non-Mangbetu traditions. One of these groups, the Matchaga (a Barambo group), even ascended to Mangbetu kingship. Furthermore, some Mangbetu speakers, such as the Makere, were never incorporated into the Mangbetu kingdoms, and others, such as the Meje, were divided between the kingdoms and independent chiefdoms.

The ethnic and political complexity of the region has often made the interpretation of material culture difficult. This problem is addressed in chapter 11, where John Mack discusses how the Azande attribute much of their art to the Mangbetu and the Mangbetu say the same of the Azande. Speaking unrelated languages, having competed and fought over territory and allegiances for a century before colonial penetration, the Azande and Mangbetu nevertheless continually exchanged objects and technology and, by the early colonial period, frequently intermarried. Cultural exchange among the peoples of northeastern Zaire was encouraged by the rise and fall of kingdoms; captives were taken from one kingdom to the next, tribute was sometimes paid in the form of art, and artists moved from the patronage of one ruler to another. Music and dance, as well as styles in carving and design, were exchanged throughout the region. These exchanges occurred not only among the major powers—kingdom to kingdom—but also among the non-centralized peoples in the area, including even the Asua, Mbuti, and Efe, all of whom traded, created art for one another, and intermarried.

The rise of ruling lineages—the Avongara among the Azande and the Mabiti among the Mangbetu—promoted the exchange of ideas and specific art forms, but these two peoples had different policies in regard to cultural integration and diversity. The Azande deliberately spread the culture of the ruling lineage, insisting, for example, that all subjects adopt their language. Mangbetu royal styles also spread, but mainly through their prestige, and were adopted even by some peoples never incorporated into the kingdoms. Moreover, Mangbetu rulers were more likely than the Azande to adopt the practices of their subjects.

By the era of colonial penetration, the prestige of Mangbetu style had become so great that Westerners assumed that political hegemony—a kind of Mangbetu cultural imperialism—was behind the perceived cultural homogeneity of the area. Mangbetu art was described as strictly a court art, thereby overemphasizing the role of the rulers, who, by the early colonial period, were able to partially control access to art by outsiders. In reality, the flow of artistic currents was much more complex, as styles spread independently of political control. For example, the practice of binding infants' heads to create an elongated skull and the halolike hairstyle favored by adult women became popular among the Mangbetu ruling group and spread throughout the region, but there is no evidence that these fashions originated with the Mangbetu rulers. Mural painting, in a style found among the Bangba, was adopted by Mangbetu rulers and then by subject peoples. Carving the necks of harps into likenesses of Mangbetu men and women was common among surrounding peoples but never among the Mangbetu. These carvings were assumed by Europeans to be the acme of Mangbetu art, although the court orchestra of the Mangbetu kings never included harps.

Lang and the other collectors of the early colonial period[5] all collected widely throughout the region but also often gathered material from members of several cultural groups in cosmopolitan centers like Niangara or Poko, towns created originally as colonial government posts. By 1908, the year that Leopold, King of the Belgians, turned over the administration of the Congo to the Belgian government, several administrative and military stations had been established in the area, employing African soldiers from very far afield and attracting workers and traders from the wider region. There was therefore a growing cosmopolitanism in the African community during the colonial period. Although cultural interaction long antedated colonial penetration, the growth of urban

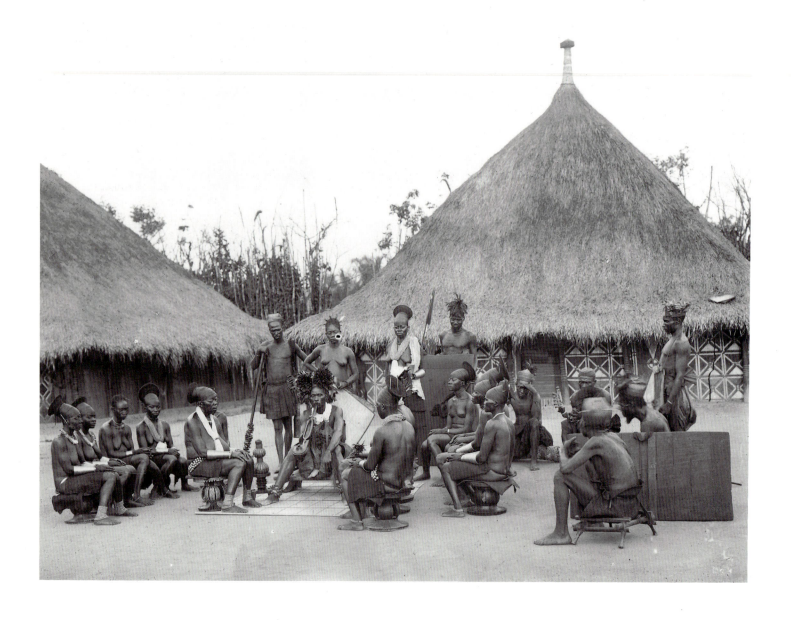

centers and new markets changed the nature of interethnic contact and altered the pace and character of cultural exchange.

The new cosmopolitanism that developed in the early colonial period led to a growing ethnic consciousness in northeastern Zaire (as elsewhere in Africa). Ethnicity expressed itself in material culture, and especially in the representational art that flourished at this time. Art became more than ever before an expression of ethnicity, and even of a self-consciousness of being African. This trend is most evident in the art that self-consciously illustrated the African-European encounter: sculptures by Africans depicting Europeans, drawings of Europeans on objects like ivory horns and calabashes (**1.10**), and murals painted on the exterior walls of houses (**1.9**). These images portrayed the authoritarianism of the colonial encounter, showing Africans in stockades and gun-bearing

Europeans astride horses. Other representational art of the same period dealt with interethnic encounters among Africans, as in the example of an ivory horn with pictograms showing a battle between the Azande and the Mangbetu, the Azande bearing their typical oval shields and the Mangbetu their rectangular ones. Much of this representational art (pottery and wood sculpture as well as graphic art) expresses a new ethnic awareness that can be understood only in the context of the new economic and political structures of the colonial period.

The role of Europeans as new patrons at the turn of the century was significant, but its effect was not simply the creation of a new market for "tourist art." Much of the art collected before 1915 was commissioned by specific individuals, both African and European, and not made to conform to an anonymous foreign

1.12
Chief Okondo, Okondo's village, 1913. *AMNH Archives, 111792.*

The Mangbetu court was noted in the nineteenth century for its splendor, and in the early twentieth century Mangbetu rulers such as Okondo continued court traditions. Here, Okondo sits surrounded by his principal wives, with Nenzima on his right and Matubani on his left. Royal objects, including the chief's bench, pipe, and pot, are placed on a mat because they are not allowed to touch the ground.

taste. At least until World War I, most art from northeastern Zaire was created in the context of traditional (though changing) political structures, by artists mostly working under the patronage of chiefs and a few working directly for Europeans in newly created colonial towns (1.11).[6] The flowering of representational Mangbetu-style art occurred in the midst of this changing political landscape. The Mangbetu kings, whose power had been unstable for the preceding five decades, remained patrons of the arts and they used this patronage as a way of defining themselves to the colonial authorities, to their subjects, and to their neighbors. Mangbetu rulers like Okondo (see chap. 8) used art as a currency of exchange with Europeans and also as a means of redefining royal power (1.12). Ivory, for example, assumed new importance as a symbol of kingship after the Arab and European trade redefined the economic and political significance of this material.

The overall thesis of this catalog and the exhibition it accompanies is that the art of the Mangbetu—the nonrepresentational art embodied in household furnishings, personal adornment, and the art of the court, as well as the genre of anthropomorphic art—should be interpreted in the larger ethnographic and historical context of the region. The development and disappearance of Mangbetu style have to be studied in light of the complex relationships between the Mangbetu and their neighbors—relationships that involved warfare, trade, intermarriage, and consequent linguistic and cultural borrowing. The rise and role of kingdoms in the region are crucial to interpreting the art, since so much of it was made under royal patronage. The impact of colonialism is also important and can be documented with unusual precision. However, colonialism did not confront static societies. The art traditions of northeastern Zaire were being continually redefined as peoples migrated, extended trading networks, conquered each other, and resisted conquest. The art of the early colonial period was just one phase in the continual transformation of these traditions; it just happens to be in the one period most accessible to us.

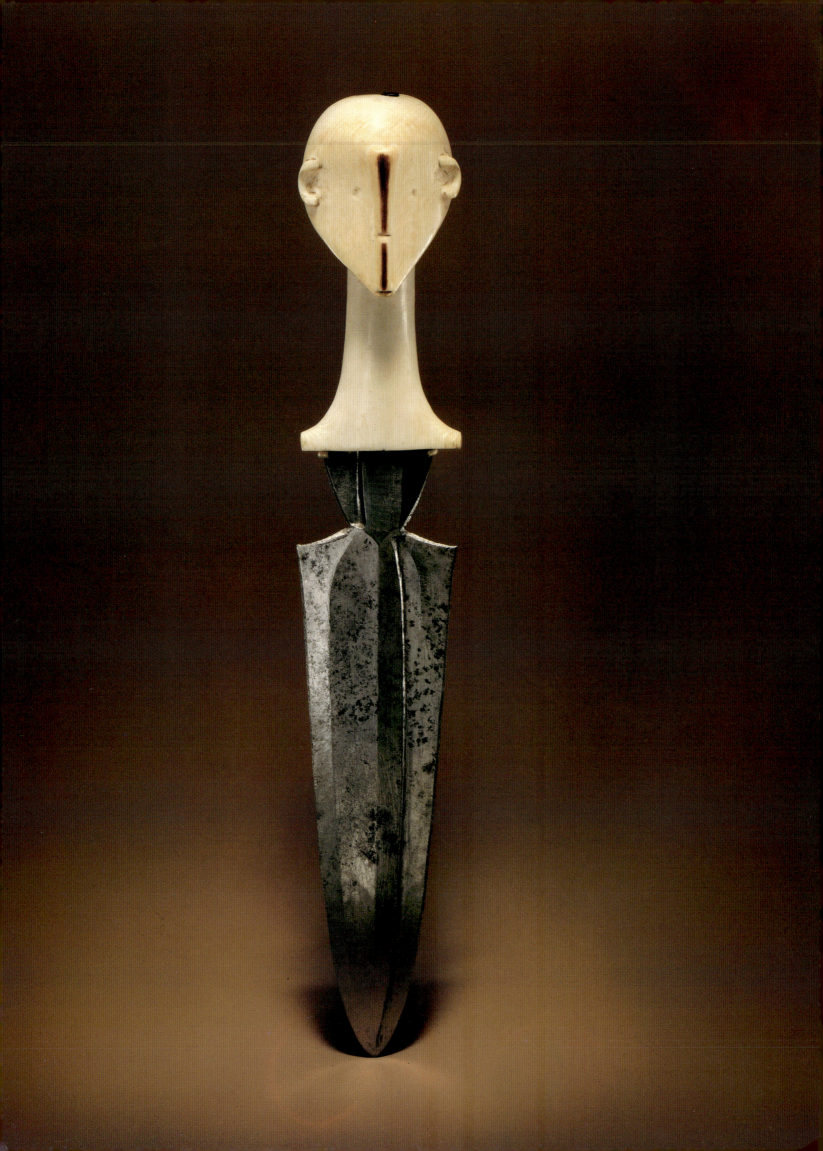

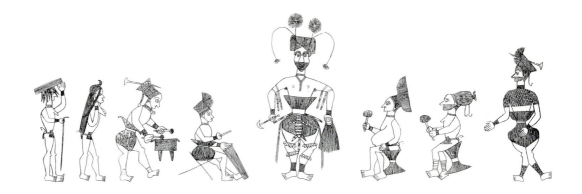

2

Through Western Eyes: The Making of the Mangbetu Myth*

Incised drawing taken from an ivory horn, representing a healer performing a curing ceremony for a sick child. Two drummers accompany the healer's dance, while women at the left bring special kinds of wood for the healer to use in preparing medicine.

←

2.1
Knife, upper Uele. *Ivory, iron. L: 10.1 in. (25.9 cm). Belgian government,* access. 1907. AMNH, 90.0/2810.

Iron and ivory, both prestigious materials, were combined in display knives around the turn of the century. This dagger, collected during the period of the Congo Free State, is a typical shape for northeastern Zaire although the abstract form of the head is unusual.

*We are grateful to Enrico Castelli, whose background paper on the Nile explorers before Georg Schweinfurth has contributed to this chapter.

Just over a hundred years ago the Uele region was invaded by long-distance slave and ivory traders and "discovered" by European explorers. Within a few decades the Azande, Mangbetu, and neighboring peoples experienced their first contacts with Europeans, the slave trade, and colonization. These encounters could be described as a straightforward series of events; however, much more interesting is the subtext of myth-making that went on from even before the first meeting between Europeans and the peoples of northeastern Zaire.[1] This chapter focuses on European perceptions of the Azande and the Mangbetu, with some attention also to Mangbetu perceptions of Europeans (**2.2**). The latter are expressed most obviously (at least to outsiders) in one genre of Mangbetu art that incorporates images of Europeans and that, for a brief period, made some accommodation to a European esthetic.

The dominant tone of European literature on Africa—and indeed on the whole world—in the period of European expansion and colonization was one of self-congratulatory comparison. By the middle of the nineteenth century, with the exploration and colonization of the African interior, Europeans began to justify colonialism with "scientific" as well as moral comparisons. Theological and moral justifications of Caucasian superiority were buttressed by a smattering of empirical observations, and comparisons between races and cultures were made according to a notion of evolutionary progress. By the

turn of the century these notions were translated into justifications for conquest and colonial rule.

The peoples whose homelands lay near the watershed between the Nile and Congo rivers were the subject of myth long before they were actually encountered by Europeans. The ancient Greek historian Herodotus heard of a race of dwarfs somewhere south of the Sahara and recounted tales of an African interior occupied by humanlike beasts with the faces of dogs or with eyes in their chests and no head (Herodotus, 1952 ed., 56, 131, 156). By the middle of the nineteenth century, slave raiders and explorers in search of the source of the Nile began to bring back fabulous stories of the Niam-niam, as the Azande were known in the last century. After Georg Schweinfurth described his encounter with the Mangbetu in the 1870s, these myths and stories became amalgamated and embellished to such an extent that a virtual "Mangbetu myth" was created, encompassing some elements of the Niam-niam myth that preceded it (**2.3**).

The Mangbetu myth is just one variation of generalized European stereotypes of Africa.[2] They inevitably were built upon fragmentary bits of information that were incorporated into exotic tales through exaggeration and romanticization. The resulting stereotypes were characterized by ambivalence and Eurocentrism. In the case of the Mangbetu, the myth consisted of exaggerated descriptions of court life and of

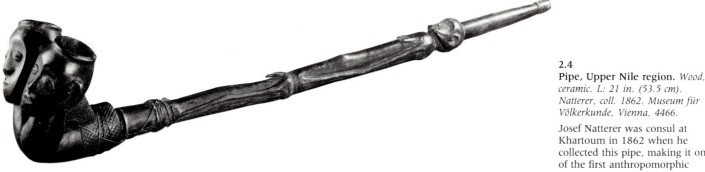

2.4
Pipe, Upper Nile region. *Wood, ceramic. L: 21 in. (53.5 cm). Natterer, coll. 1862. Museum für Völkerkunde, Vienna, 4466.*

Josef Natterer was consul at Khartoum in 1862 when he collected this pipe, making it one of the first anthropomorphic carvings acquired by Europeans from the Upper Nile region. Two heads serve as bowls, and a full figure embellishes the stem.

The Italian Carlo Piaggia (1827–81), a miller and avid hunter, arrived in the Upper Nile region in 1856.[5] He spent several years as a traveler, professional ivory hunter, taxidermist, and armorer. In 1860 he joined an expedition to the Bahr-el-Ghazal led by the Marquis Orazio Antinori (1811–82), an ornithologist and naturalist who cofounded the Italian Geographical Society (**2.6**, **2.7**). He later joined a Coptic ivory merchant's caravan that took him to the village of the Zande ruler Tombu. Piaggia remained among the Azande for a year and a half, learning the language and traveling far into Zande territory to the border of the forest Azande, western neighbors of the Mangbetu.

Piaggia was unusual among precolonial European travelers and explorers for the length of time he stayed in one area and for his sympathetic view of Africans. In his diaries, which remained unpublished in his lifetime (Piaggia 1978), this poorly educated man from Lucca rejected the common view of the Azande. "The savage," he wrote, "is no different from any other human being; he lives in forests like the domestic man lives in houses" (Bassani 1979, 40). Piaggia looked askance at the potential benefits of colonialism and believed that Africans would be better off if agriculture rather than industrialization were encouraged. He seems to have regarded cannibalism as a custom that developed as a response to hunger (Bassani 1979, 52). Divorced as he was from both the scientific and the incipient colonial community (the official explorers and military men), Piaggia did not exert a great influence on the course of European contact with Africa.

Europeans lost their preeminent place in the ivory trade in the 1860s to Copts, Syrians, and Arabs, who continued the rapid expansion of the zeriba-razzia system toward the south. By 1865 the vanguard had pushed trading expeditions along three major routes through the Zande lands to the Uele River and the Mangbetu.[6] This opened the way for Georg Schweinfurth to accompany the caravan of a Coptic

company to the Mangbetu in 1870–71. Schweinfurth, a learned man and a passionate lover of nature, traveled with the support of the German Royal Academy of Science and the Humboldt Institution. He was also a good storyteller, and in *The Heart of Africa* (1874) he enthralled readers with his Mangbetu discoveries. He described how the "fascinating dreams of my early youth" were fulfilled by seeing the land with "beauty as might be worthy of Paradise," the "idyllic homes," and King Mbunza, whom he compared to Mwata Yamvo, the ruler of the great Lunda empire of central Africa. To Schweinfurth, Mbunza governed through divine kingship, had a bureaucracy, required regular tribute, and imposed commercial monopolies. The reality was somewhat different. The Mangbetu were certainly more centralized than their neighbors, but the kingdom was neither as powerful nor as stable as Schweinfurth implied (see chap. 6).

Although Schweinfurth's account is probably the most valuable source on nineteenth-century Mangbetu life, he was undoubtedly the most important perpetrator of the "Mangbetu myth." Schweinfurth painted a portrait of a people at once civilized and savage. He presented two images of King Mbunza: a wealthy absolute monarch who governed an artistically advanced people and vast territories in central Africa, and "a truly savage monarch" in whose eyes "gleamed the wild light of animal sensuality" (1874, 2:46). Schweinfurth's ambivalent description is repeated again and again in subsequent accounts of the Mangbetu.

Much of the information that Schweinfurth collected by direct observation is accurate, and his splendid illustrations bear witness to an eye for detail and an appreciation for indigenous productions. He, along with Piaggia, deserves credit for being among the first Europeans to label African objects as art rather than as mere curiosities (**2.8**). Nevertheless, the way in which Schweinfurth reached his conclusions about the Mangbetu must be considered. He was at

2.5
Ring, Adio Azande. *Copper. H: 2.5 in. (6.4 cm). Petherick, coll. 1850s. British Museum, 4457.*

John Petherick, a Welshman, was a British administrator in Khartoum during the 1850s and also an ivory trader who hunted among the Bongo, Dinka, and Azande. He collected this copper ring and a zoomorphic harp (**11.12**) among the northeastern Azande.

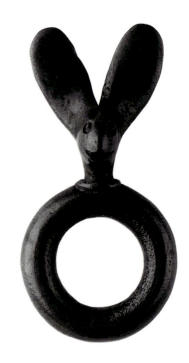

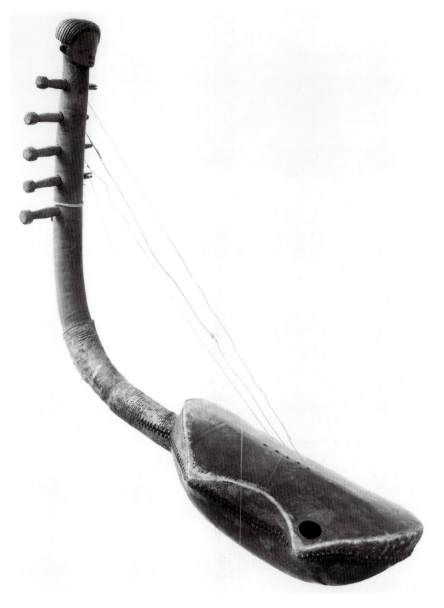

2.6
Harp, Azande. *Wood, hide. H: 23.5 in. (60 cm). Antinori or Piaggia, coll. c. 1860s. Museo archaeologico nazionale di Perugia, 49687.*

Early Italian explorers to the Nile basin included Carlo Piaggia, Giovanni Miani, Orazio Antinori, and Romolo Gessi. This Zande harp was collected during an Italian exploration of the Upper Nile region in the 1860s.

2.7
Pipe, Mittu, Bongo, Zande(?). *Ceramic. H: 3.5 in. (9 cm). Antinori or Piaggia, coll. c. 1860s. Museo archaeologico nazionale di Perugia, 49532.*

Collected on the northeastern edge of Zande territory in the 1860s, this pipe illustrates the earliest known use in the region of human forms on ceramic objects.

Mbunza's capital for less than three weeks and among the Mangbetu for just over four weeks. During most of this period he remained in his camp because curious crowds pressed in on him. When he ventured out, he was followed by up to a hundred people, mostly women. However, more than the curiosity of crowds may have insulated Schweinfurth from the Mangbetu. The explorer wrote to Giovanni Miani[7] that he felt "persecuted by horrible privations" since even while surrounded by the comforts provided by his trader host and drinking his mountain port and favorite sherry, he could not get "tea, coffee, tobacco, wine, soap—in a word everything that a European needs for his well being," having lost his provisions in a fire (Bassani 1979, 48).

Schweinfurth's published account relies mostly on direct observations rather than on conversations with Mangbetu, with whom he could not communicate except through serial translations (from Arabic, which Schweinfurth spoke, to Azande to Mangbetu). He communicated through the traders with whom he traveled, and the traders' rumors were probably responsible for many of Schweinfurth's opinions about the savage nature of the Mangbetu. In his account of his travels, he made up for what he lacked in concrete information with effusive literary flourishes, most evident on the subject of cannibalism. Schweinfurth claimed that on two occasions he happened upon people who "were actually engaged in preparing human flesh for consumption" (1874, 2:92).

> The cannibalism of the Monbuttoo is the most pronounced of all the known nations of Africa. . . . The carcasses of all who fall in battle are distributed upon the battle-field, and are prepared by drying for transport to the homes of the conquerors. They drive their prisoners before them without remorse, as butchers would drive sheep to the shambles, and these are only reserved to fall victims on a later day to their horrible and sickening greediness. During our residence at the court of Munza the general rumour was quite current that nearly every day some little child was sacrificed to supply his meal. (1874, 2:92–93)

If the explorer saw little actual evidence of cannibalism there were obvious reasons:

> Incontrovertible tokens and indirect evidences of the prevalence of cannibalism were constantly turning up at every step we took. On one occasion Mohammed and myself were in Munza's company, and Mohammed designedly turned the conversation to the topic of human flesh, and put the direct question to the king how it happened that just at this precise time

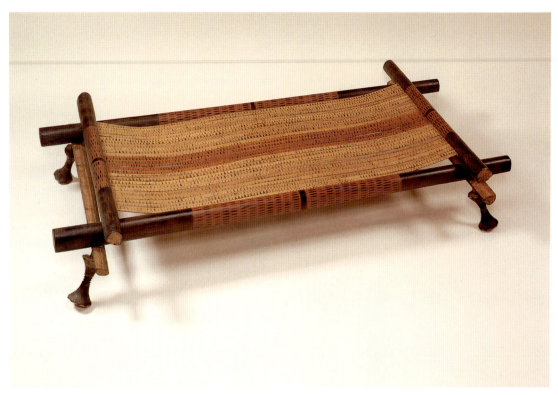

2.8
Bench, Meje. *Wood, raffia palm fiber. L: 66.5 in. (170.6 cm); H: 13.3 in. (34.2 cm). Lang, coll. Medje, 1909–15. AMNH, 90.1/ 1744.*

Benches (*neckalackba*) were used by Mbunza when Schweinfurth visited his court and continue to be used among Mangbetu men today. Schweinfurth described their production in *Artes Africanae* (1875). Lang later noted of them, "If the men go on visits or [to] social gatherings they are usually accompanied by several of their women. One is usually carrying the *neckalackba*" (398).

→
2.9
Harp, White Nile region. *Wood, hide. H: 17.7 in. (45 cm). Gessi, coll. 1883. Museo preistorico ed etnografico ''Luigi Pigorini,'' Rome, 29518.*

Gessi Pasha (Romolo Gessi) collected this harp while working for the Egyptian government as military commander of Bahr-el-Ghazal, a region that included the Azande and their northern neighbors.

→
2.10
Harp, Azande. *Wood, hide. L: 27.5 in. (70 cm). Junker, coll. 1879. Museum für Völkerkunde, Berlin, IIIA842.*

This elegant harp was collected by Wilhelm Junker during his travels through the Zande and Mangbetu regions in the 1870s. It features a stylized, conical Mangbetu head and a hatched diamond pattern on the neck.

while we were in the country there was no consumption of human food. Munza expressly said that being aware that such a practice was held in aversion by us, he had taken care that it should only be carried on in secret.

As I have said, there was no opportunity for strangers to observe the habits of the Monbuttoo at their meals. Nevertheless the instances that I have mentioned are in themselves sufficient to show that the Monbuttoo are far more addicted to cannibalism than their hunting neighbours, the Niam-niam. (1874, 2:93–94)

More recent discussions with Mangbetu informants show that they did not eat human flesh regularly. Mangbetu claim that human sacrifice occurred in the context of iron smelting and at the funerals of kings and that the consumption of human flesh was involved in one ritual: the consecration of the double bell.[8] Mangbetu also probably engaged in occasional cannibalism as a by-product of warfare. However, although stories of cannibalism are still used by the Mangbetu as a metaphor for power and in the past were used to frighten people into submission, there is no evidence that the great feasts described by Europeans ever occurred. Today Mangbetu informants mockingly tell tales of their cannibal past and at the same time cite evidence of European cannibalism (some Mangbetu considered canned corned beef to be concrete evidence of European packaging of human flesh). Schweinfurth himself indicated

that the Mangbetu wondered about his own savagery as he collected Africans' skulls to take back to European phrenologists (1874, 2:55).

Along with his view of the Mangbetu as savages, Schweinfurth also presented them as generally more advanced than their neighbors:

> But with it all, the Monbuttoo are a noble race of men; men who display a certain national pride, and are endowed with an intellect and judgment such as few natives of the African wilderness can boast; men to whom one may put a reasonable question, and who will return a reasonable answer. (1874, 2:94)

Schweinfurth was particularly impressed by Mangbetu political organization and represented the Mangbetu kingdoms as larger, more centralized, and more powerful than they actually were (see chap. 8). These views were spread widely in Europe and America since Schweinfurth, unlike Piaggia, had no trouble getting his work published in several editions and languages. Nearly every subsequent Western visitor to the Mangbetu and Azande read and accepted his view of the Mangbetu.

A thirty-year struggle between the traders and the Egyptian government began in the late 1860s. The traders desired to do business as usual, to acquire and export slaves and ivory without restraint. The Egyptians, however, planned colonial control of the upper part of the Nile basin as well as the Zande and Mang-

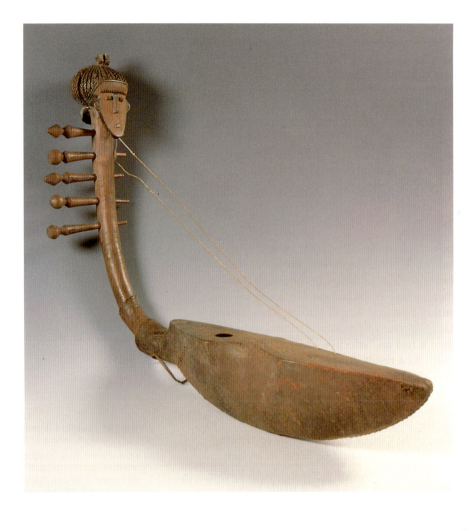

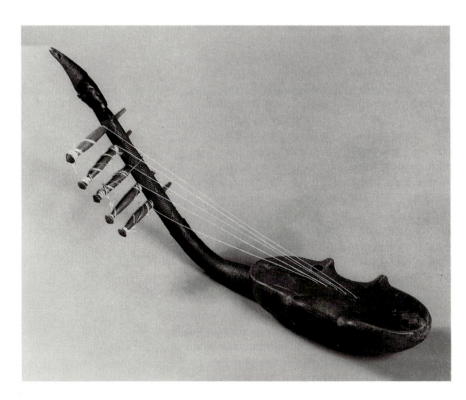

betu lands. Moreover, under British pressure the Egyptians felt obliged to outlaw the slave trade. By the late 1870s Egypt had installed pashas (military commanders) in the southern provinces of Bahr-el-Ghazal and Equatoria, and its armies had won several major victories over the private traders, with a major one achieved by the Italian Gessi Pasha (Romolo Gessi) (**2.9**). Emin Pasha (Eduard Schnitzer), a German physician and pasha of Equatoria, extended Egyptian rule into "Monbuttu"[9] during the relative peace from 1880 to 1885. He established government posts among the Mangbetu and Azande, punished the crimes of the traders, and in 1882 made a month-long tour of inspection to the region. He was accompanied by the Italian Gaetano Casati, who went to Africa in 1879 to make maps of the Uele for Gessi Pasha (Gessi had fought in the campaign led by Major-General C. G. Gordon against the slave traders). In this same period Wilhelm Junker, a wealthy physician born in Moscow (1840–92) and educated in Russia, Germany, and Austria, also traveled through the Zande and Mangbetu regions (**2.10**).

The accounts written by Emin, Junker, and Casati provide valuable details on the Azande and Mangbetu during this period. In particular, they relate how Mangbetu and Zande rulers coped with the rapacious traders and the new authority of the Egyptian government. Junker and Casati lived for months with regional rulers and either spoke local languages or engaged interpreters. On the whole, these three explorers of the early 1880s provided a more sober picture of the Mangbetu than did Schweinfurth. They did little, however, to destroy Schweinfurth's hyperbolic image of the Mangbetu, because each largely accepted Schweinfurth's premises. They assumed that if the Mangbetu were not as powerful as at the time of Schweinfurth's visit, it was because of the destructive impact of the slave and ivory traders. Casati described an attack on a ruler as "the last blow struck at the liberty of the Mambettu tribe, the last stone thrown at the work of destruction inaugurated by the slave traders" (1891, 1:236). Emin Pasha commented that "now anyone wishing to study the people and their customs must leave the beaten paths" (Schweinfurth et al. 1889, 442).

Junker assumed a decline not only in Mangbetu political organization but also in their arts:

> The union of small states under one ruler endured longest in Mangbattu, and this gave them a good start in the protection of their arts. In general, industry declines with the breaking up of large states into smaller ones, and in this respect Mangbattu has now also

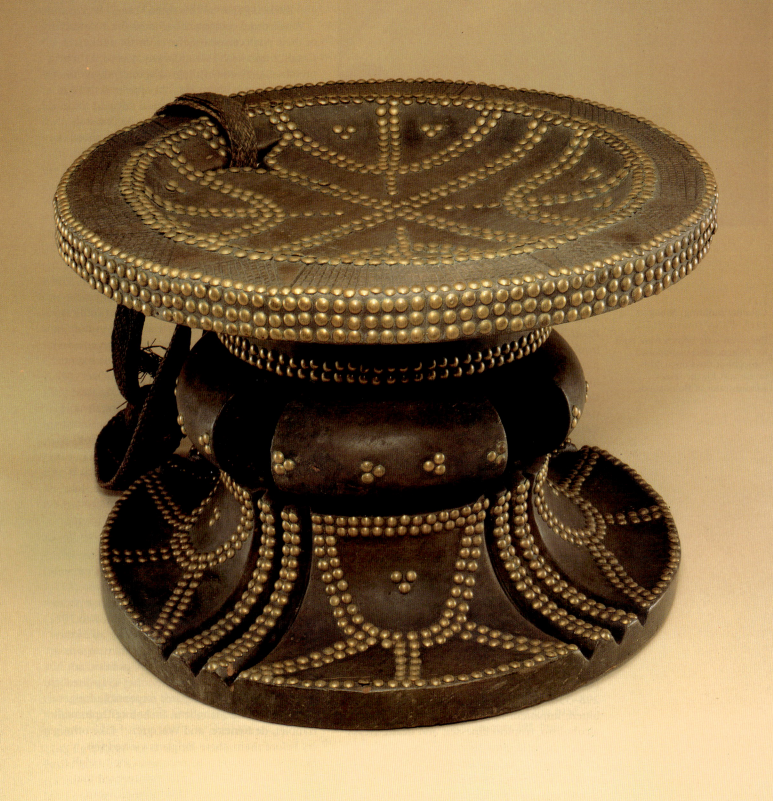

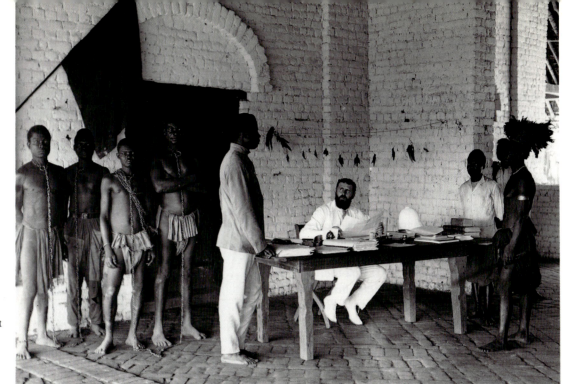

2.13
Trial, Avakubi, 1909. *AMNH Archives, 112197.*

In this startling photograph, members of the *aniota* secret society are accused of having killed several people. They are brought before Judge Altdorfer, the chief colonial administrator of the village, and interpreters. At the time of Lang's visit, the Belgians were trying to suppress these secret associations, which they regarded as a threat to colonial authority.

2.12
Stool, Azande. *Wood, brass studs. H: 9.2 in. (23.5 cm); D: 14.1 in. (36 cm). Lang, coll. Panga, 1914. AMNH, 90.1/3334.*

This studded stool belonged to a wife of Chief Akenge of the Azande. Because of its decoration, Lang considered it the best example he had seen.

view of warrior, he is inferior to the Azande; but from all other points of view, he is superior" and "of all the peoples of the Uele the Mangbetu, the Mangbelle, and the Mobadi [considered to be closely related] are by far the most cultivated, the most advanced, and the most industrious." Hanolet said "all the objects that they make are infinitely more graceful than analogous objects of other blacks of the Uele" and "it is one of the best looking tribes that I know, and if not the best looking, the most interesting. The character of the Mangbetu is gay, expansive. He is serious although loving to laugh" (Van Overbergh and De Jonghe 1909, 125, 124, 125, 425, 120).

Clearly the Mangbetu were considered superior to others in the region insofar as they had traits that Europeans valued in themselves. But the early Belgian rulers also took pains to make sure that racial distinctions were not blurred. De Renette stated it plainly: "Their civilization naturally has nothing in common with ours." Others revealed their assumptions in comments about how the Mangbetu were expected to make progress under colonial rule. For example, Hanolet explained that the Mangbetu was "ambitious, industrious, a good soldier, an avid hunter, very independent, artistic, full of the superiority of his race, endowed with great personal dignity, [the Mangbetu] is, according to me, susceptible of all sorts of progress." Jules Laplume, who served in the Uele from 1893 to 1911, noted that "the Mangbetu who are in direct contact with whites assimilate quickly enough our habits and keep them well enough, after a momentary eclipse" (Van Overbergh and De Jonghe 1909, 125, 124, 561).

Some observers thought that Mangbetu art could be improved with European instruction. In 1896 Captain-Commander Christiaens published a brief paper, quoted in Van Overbergh and De Jonghe, in which he discussed the Mangbetu and their land as potential sources of labor and natural resources. In regard to their art, he wrote:

As for the inhabitants of the country, without sharing completely the enthusiasm with which Junker speaks of their superiority, I cannot but place them at a level slightly above that of most of their race. They are certainly endowed with a developed artistic sense considering the state of their civilization; the form of the objects that they produce is often original and elegant, and except for the copper nails with which they ruin their stools, their ornamentation is ordinarily full of taste. But it is also necessary to acknowledge the somewhat numerous defects and imperfections in the details of their work; and it could not be otherwise with the primitive tools which they have and which they use surprisingly well. When civilization provides them with better tools and especially when it teaches them to use the tools—in a word, when their natural dispositions will have the advanced means at their disposal that we have—it is certain that they will make great strides and will not delay in producing great works of art. (1909, 560)

The colonizers assumed that the progress the Mangbetu and other Africans could make would be maintained only by constant European oversight (**2.12, 2.13**). These observers thought the Mangbetu had already made rapid progress in ten or fifteen years of colonialism. A persistent theme among the military men inter-

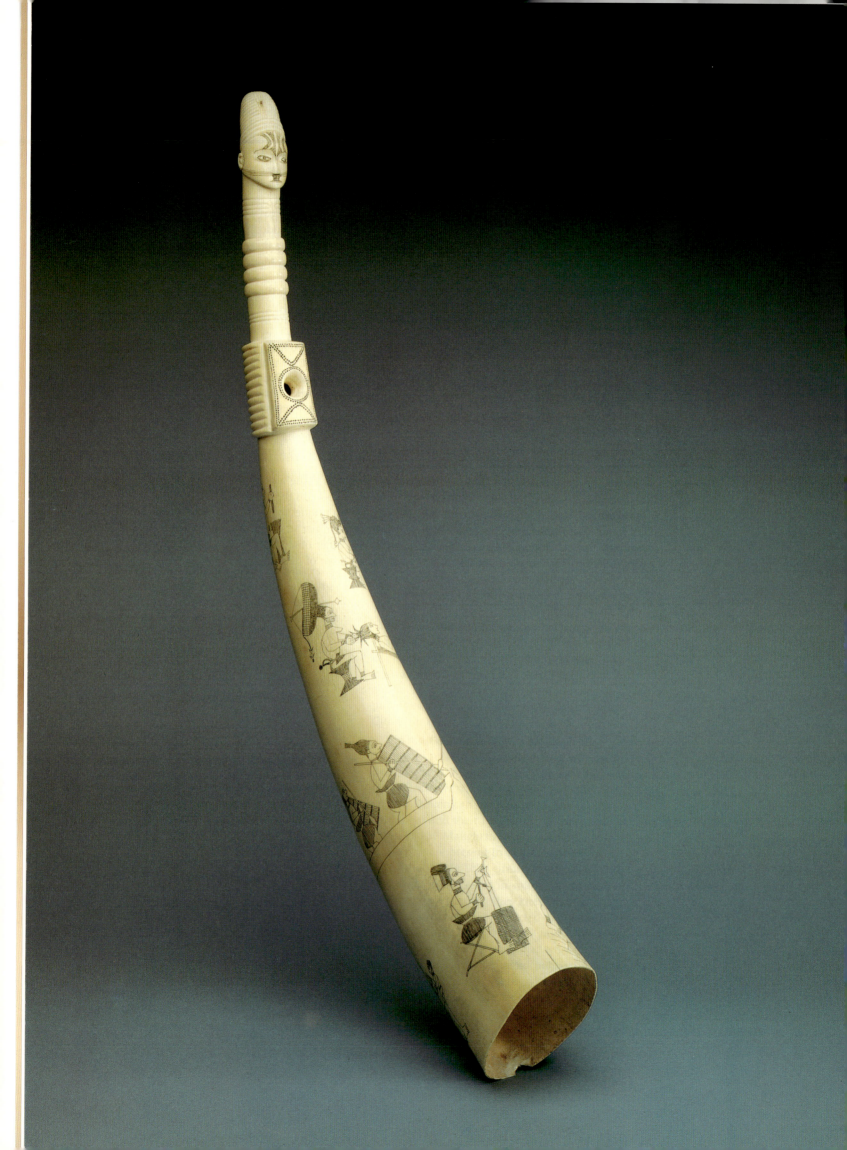

3

Collecting in the Congo:
The American Museum
of Natural History
Congo Expedition, 1909–1915

3.1
Horn, Azande. *Ivory. L: 25.0 in. (64 cm). Lang, coll. Akenge's village, 1913. AMNH, 90.1/1805.*

The engravings on this ivory horn were made by a Zande artist and depict images of daily life in the Uele region. Seen here are pictographs of an artist cutting an ivory horn, Barambo fighting in boats, and a woman dressing her husband's hair as he stretches out on a bench.

Between the abolition of the slave trade in the early 1800s and the formal colonization of Africa by European powers at the end of that century, Americans looked toward the "dark continent" with varying motives and intentions. Businessmen and investors, part of a rapidly industrializing economy, sought new sources of raw materials and new markets; missionaries looked for opportunities to proselytize; Southern politicians, with a mixed bag of motives, looked for a place to send the slaves freed after the Civil War; and the most adventurous sportsmen eyed the fabulous bounty of the African continent, its hordes of elephants, lions, and other walking trophies.

Scientists followed the missionaries, merchants, and sportsmen to Africa, relying on them for financial backing. The American Museum of Natural History, founded in 1869, received its earliest African collections as a result of missionary and commercial interest in Africa, and its earliest expeditions were financed by the amateur explorers and sportsmen who sometimes took museum scientists with them as guides. One of the most important early African ethnology accessions, consisting of more than 3,000 objects (**3.2**, **3.4**), was a 1907 gift from Leopold II, king of the Belgians from 1865 to 1908. The negotiations that led to this gift and the opening of a major exhibition featuring the Congo solidified relations between the American Museum and the Belgian king. After the administration of King Leopold's African terri-

tory—known as the Congo Free State—was turned over to the Belgian government in 1908, negotiations with the American Museum continued and plans were made for a major expedition into the heart of Africa. This chapter explores the American Museum Congo Expedition of 1909–15, its background, and the ethnographic and photographic collections from northeastern Zaire that resulted from it.

King Leopold's interest in the Congo basin was sparked by the news of the exploration of the Congo River by Henry Morton Stanley. A Welsh-born reporter working for the *New York Herald*, Stanley first went to Africa in 1871 to find the famous lost missionary David Livingstone. On his second African trip, as leader of the Anglo-American Expedition of 1874–77, Stanley became the first white man to traverse Africa by following the course of the Congo River from east to west. King Leopold recognized the immense commercial potential of the watershed between the Nile and Congo. In 1898 his deputies intercepted Stanley on the explorer's return from Africa, invited him to Brussels, and asked him to head an international committee set up by Leopold in 1876 to guide the exploration of the Congo basin. Stanley, in the employ of King Leopold, also led the mission that established the first camps along the Congo River on behalf of the Congo Free State.

In the decade preceding the actual partition of Africa by the European powers, King Leo-

pold carved out a private domain in the Congo, promising investors from Europe and the United States commercial concessions in exchange for their political and moral support. Within a few years of Stanley's journey across Africa, all the major European powers found themselves embroiled in disputes over partition. The Berlin Conference of 1884–85 was convened to settle these questions and to define the nature of European involvement on the African continent. King Leopold's organization, by then known as the International Association for the Exploration and Civilization of the Congo, gained formal recognition in the treaty ratified at this conference (known as the General Act or the Berlin Act), although the United States had in fact recognized the flag of the association several months before the Berlin Conference opened.[1]

Throughout his life King Leopold professed humanitarian goals and an interest in scientific exploration. Historians today, like many people at the time, associate his regime with horrific atrocities and unbridled greed. Nevertheless, the king's public posture was as a patron of the arts and sciences and as an advocate of moral causes, including the abolition of slavery, the suppression of cannibalism, and the "civilizing" mission of the Europeans.

Leopold's promotion of scientific research was expressed most lavishly in the creation in 1898 of the Musée royal du Congo (now called the Musée royal de l'Afrique centrale) in Tervuren, near Brussels, a monumental research institution and museum devoted to the natural history and ethnography of Zaire. Following the Exposition of 1897 in Belgium, the king began plans for the construction of the museum. His agents collected thousands of specimens for the new museum, and the museum sponsored many ethnological expeditions, including the one to northeastern Zaire led by Armand Hutereau (see chap. 2, Early Colonial Scientific Expeditions, 1902–15). Leopold found many other opportunities to invest in highly visible projects outside Belgium. He employed agents throughout western Europe and the United States to tap potential sources of favorable publicity in the press, in expositions and exhibitions, and in research and collecting expeditions.

Advance Planning and the Congo Reform Movement

According to the account of Henry Fairfield Osborn, president of the American Museum of Natural History from 1908 to 1933, his predecessor Morris K. Jesup had first entertained the idea of sending an expedition from the American Museum to the Congo. Herman C. Bum-

pus, the museum's director from 1902 to 1911, became interested in the area after viewing the live exhibits of "exotic" peoples at the 1904 St. Louis Exposition.[2] Alongside the American Indian Geronimo was the African exhibit. Nine Africans from the Congo, four of whom were Pygmies, excited the curiosity of the public. Some people, particularly those interested in the theory of evolution, thought that the Pygmies were a distinct species and even possibly the "missing link" between humans and other primates.

In 1906, after eight of the Africans returned to the Congo, the man who had brought them to St. Louis, Samuel P. Verner, arrived in New York with the remaining man, a Pygmy named Ota Benga. Ota Benga stayed about a month at the American Museum, helping out with the installation of some of the African mammal exhibits before being taken to the New York Zoological Society (Bronx Zoo), where he was put on exhibit with some chimpanzees. Public outrage led to his eventual relocation to South Carolina, but the travesty continued and Ota Benga committed suicide in 1916.[3]

Verner himself never worked for the American Museum, but he did work for King Leopold. He made at least one ethnographic collection, which he tried unsuccessfully to sell to the American Museum in 1904.[4] He obtained trading concessions from King Leopold and joined forces with some of the museum's major patrons who were interested in investing in the Congo. He became the first president of a consortium known as the American Congo Company, whose members included J. P. Morgan (a trustee of the American Museum of Natural History)[5] and other patrons of New York's major cultural institutions. The American Congo Company was formed mainly to import rubber from the Congo; a mining company with many of the same investors prospected for minerals.

Between 1906 and 1908, the museum made plans to mount a full-scale African exhibition focusing on the Congo. The secretary general of the Congo Free State, Charles Liebrechts, discussed the idea with Jesup in 1907 and formal negotiations were carried out between the Congo Free State's consul general, James Gustavus Whiteley, based in Baltimore, and, on behalf of the museum, the Belgian consul general in New York, Pierre Mali (a friend of Jesup's) (Osborn 1919, xvii).

Early museum correspondence on the matter refers to the construction of a Congo exhibition consisting of several rooms devoted to the ethnography, fauna, and flora of the Congo. The idea of mounting an exhibition in New York devoted to the Congo interested King Leopold,

3.2
Bark box, Uele region. *Wood, bark, plant fiber, brass. H: 14.25 in. (36.2 cm). Belgian government, access. 1907. AMNH, 90.0/5101.*

Bark boxes, typically cylindrical, were used to store trinkets, clothing, charms, and other personal treasures. This one was a gift from King Leopold to the American Museum of Natural History in 1907. The metal studs were prestigious decorative additions to the basic form.

who qu
ethnogr
seum.[6]
the kin
uments
publica
ples of
African
in 1910

King
for the
Bumpu
in the
gift beg
months
been ca
gional
cials, m
for Nev
du Con
tions w
change
from "
harp (3
current
this gif
region

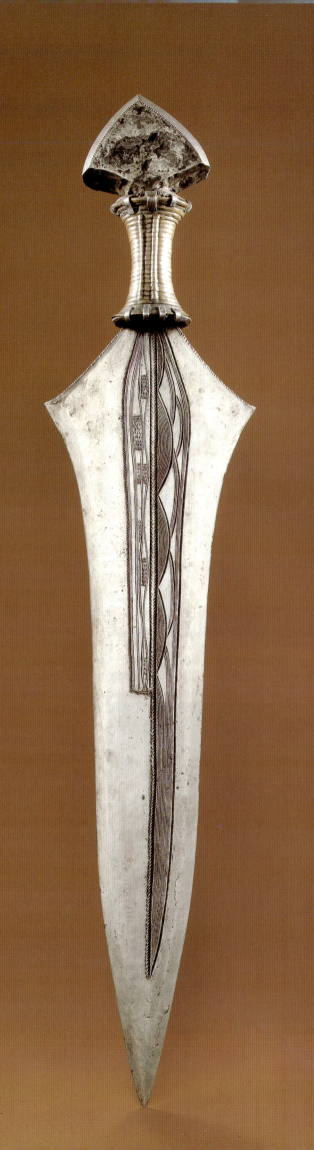

50

of Zande chiefs, including Akenge. He visited, lived with, and collected among the Barambo, the Mongelima, the Logo, the Meje, and the Makere (3.21).

Although there were quite a number of Europeans in Niangara and other small towns of the region by 1914, most of them had very different kinds of relationships with local people. Traders, military men, and government administrators for the most part had formal and sporadic contact, characterized always by intense hierarchy. Most scientific expeditions made quick forays into ''native villages'' and included many more Europeans. In contrast, Lang and Chapin's isolation and their scientific mission led them into close and cordial relationships with local people. These were not necessarily egalitarian, but more than most Europeans they recognized their dependence on Africans. Moreover, their study lasted longer than the term of duty of any European colonial officer at the time.

Because the American Museum collection is so well documented, it can be used to study some of the changes in material culture that occurred in the early years of Belgian colonial rule. These changes are complex and cannot be described as a simple transformation from ''traditional'' to ''tourist'' arts. During this time, new objects and materials like beads and brass wire were introduced into the area, but these new materials were seldom incorporated into the objects made at the time. It is interesting in this regard that beadwork never became important for the Mangbetu or the Azande, even though beads were certainly traded into the region from before the turn of the century. The most important changes in material culture in this period include the flowering of anthropomorphic art among the Mangbetu (see chap. 12); the shift from women to men in the manufacture of pottery, particularly anthropomorphic pottery; the introduction of anthropomorphic pottery to southern Mangbetu areas, in particular, Medje; and the manufacture of ivory objects made as models of European objects or of Mangbetu ones. (In addition to the ivory forks, knives, and spoons in the exhibition [12.21], the ivory collection includes model boats and an eight-inch-long model slit drum.)

The close relationship that Lang established with many people, particularly Okondo, Senze, and the artists working in their courts, affected the material culture of the region in a complex way. Lang was among the Mangbetu and Azande long enough for them to understand that like Hutereau, who was in the region at the same time, he was making a large collection to take to a white man's museum (whether or

not they understood the idea of a museum). Lang made it clear that he admired the art, especially metalwork and ivory carving, and he became a patron of the arts. After a while he established direct relationships with particular artists, some of whom created objects for him in which they depicted scenes of daily life. The Zande artist Saza and others engraved scenes on ivory trumpets and gourds, and Lang carefully recorded the artists' long explanations of the pictures. These scenes show the daily life of the Mangbetu and Azande, distinguished by their different types of implements; objects, like shields and knives, were used in these images as markers of ethnic identity. They show hunting, farming, palm wine tapping, craft production, divination, music and dance, body adornment, warfare, and trade. They also depict social organization, with scenes documenting the settlement of disputes and the relationships between men and women (including bridewealth payments and sexual activities), mothers and children, chiefs and subjects; and encounters between Africans and Europeans (3.1). In these works, as in the rebuilding of Mbunza's court, local artists were describing and sometimes re-creating their traditions. They incorporated into their art their image of themselves, of neighboring Africans, and of Europeans and the image that they perceived their new audience had of them.

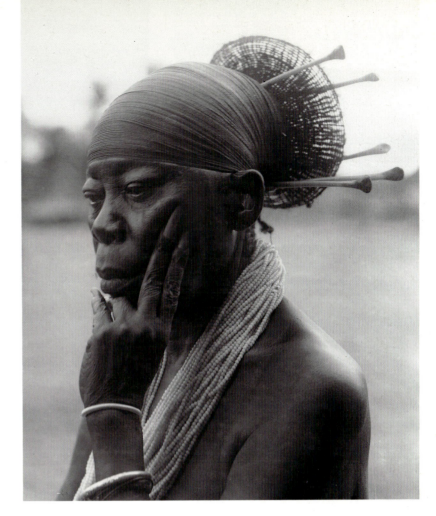

3.22
Nenzima, Okondo's village, 1910. *AMNH Archives, 111806.*

Nenzima's long fingernails were an indication of her elite position as a principal wife of Chief Okondo. Lang received a gift from Nenzima of her fingernails and toenails strung on a cord to be worn as a necklace. In Mangbetu belief this gift was a sign of trust, for possession of part of another's body gave the owner power over that person. Lang reciprocated with a gift of his thumbnail so that Nenzima would have equivalent power over him.

←
3.21
Knife, Mongelima. *Iron, copper, wood. L: 18.3 in. (47 cm). Lang, coll. Medje, 1914. AMNH, 90.1/ 3348.*

Lang collected among the Mangbetu, Azande, Meje, Makere, Logo, Mongelima, and Barambo. Knives, pottery, and baskets were acquired from the Mongelima.

hold that the whole Uele Neolithic began only with the Iron Age, which started about two millennia ago (see below) (F. Van Noten and E. Van Noten 1974, 58–59; F. Van Noten et al. 1982). The hematite has such a high iron content that the Neolithic people simply polished the ore, rather than smelting it, to make strong tools. However, other archeologists believe the practice of making hematite axes started many centuries before the Iron Age and merely continued during that period. Only new excavations will settle this debate.[1]

In the absence of systematic archeology, the general settlement of northeastern Zaire by farmers is known only through comparative linguistics. Language families can be reconstructed, loanwords and internal innovations can be ordered in succession, and approximate dates can be provided for the main developments in the history of languages.[2] The more than twenty languages of the area fall into three main families, the first two belonging to the Niger-Congo language phylum. The first family, usually labeled Ubangian or Adamawa-Eastern, comprises four groups of languages found in the region. Azande, the most important language during the last two centuries, is now dominant throughout the area north of the Uele. Mayogo, one of the main languages in the Uele region, belongs to another Ubangian group. The second language family, Bantu, covers most of Africa south of a line from Mount Cameroon to southern Somalia. Two of its myriad subdivisions are found in northeastern Zaire. The first is the Buan group,[3] spoken by people who once occupied the lands of the middle Bomokandi–Nepoko region. By 1800 only a few fragmentary groups of these people still lived there. The second subdivision includes the Budu language, spoken by people living south of the Mangbetu. The third language family is Eastern Central Sudanic, a member of the Nilo-Saharan phylum. This family consists of three main divisions: the Mangbetu language proper, now dominant south of the Uele; Mamvu-Lese; and Logo-Madi (Greenberg 1963; Bryan 1959; Tucker and Hackett 1959; Larochette 1958; Vorbichler 1969).

This linguistic complexity resulted from sociolinguistic conditions that occur wherever people define their ethnic affiliation according to the extended household they belong to—the usual situation among the Ubangian and Central Sudanic speakers of the area (Costermans 1953). In these cases, language is perceived as a part of household identity. This often leads to bilingualism or multilingualism as households became part of wider social groups. Dominant languages spread and are themselves replaced,

but people cling tenaciously to the language of the home. In this way a particularly rich body of historical data about successive linguistic conditions is preserved and can be "read" rather like the way that geologists "read" stratigraphic deposits. Among Bantu speakers, however, the district rather than the household is the main marker of ethnic identity. Consequently, many Bantu speakers abandoned their household language when they came under foreign domination, leaving few linguistic traces.

Farmers came to the area in three separate waves of immigration: one of Ubangians, one of Bantu, and one of Eastern Central Sudanese. Each of these groups brought with them their own cultural and social heritage. Yet all were farmers, and before their arrival, there were none in the region. The earliest arrivals may have been the Ubangians, who began to settle in the wooded savanna north of the Uele by about 3000 B.P.[4] They may well have been the first makers of the hematite axes mentioned earlier. By 2500 B.P. perhaps, Bantu speakers arrived from the dense rain forest of the southwest, among them the ancestors of the Budu. The proto-Budu first settled on the forest-savanna boundary zone near 30° east longitude and beyond. Meanwhile the area south of the middle Bomokandi valley became the cradle of the Buan group, which began to diversify by 2300 B.P. (McMaster 1988, figs. 1:4, 2:1; Bastin

4.2
Smelting iron, Akenge's village, 1913. *AMNH Archives, 224070.*

These Zande men are in the process of smelting iron, to be used for making weapons, hairpins, tools, and musical instruments.

4.3
Smelting iron, Nangazizi, 1989.
Iron smelting continues to be practiced among the Mangbetu. Ritual songs and dances are performed to protect the smiths and ensure success.

et al. 1983). At that time ancestors of the Mamvu had entered the area from the east and maintained contact with the Buan speakers, indicating that the whole Eastern Central Sudanic family had already differentiated in the region just west of the upper White Nile and Lake Mobutu (Ehret et al. 1975).[5]

Knowledge of iron smelting reached the area around 2300 B.P. (**4.2, 4.3**), from the west and from the east (McMaster 1988, chap. 3). The cultivation of the banana (plantain), an ideal crop for rain forest environments, spread from the Upper Nile area in the first few centuries A.D. and triggered population growth (Vansina 1984). Its adoption allowed farmers to settle everywhere in the forests, not just along the banks of rivers, and to produce an abundance of food with less work than before. They could now spend more time on other activities as well as form long-lasting relationships with hunters based on the exchange of fruits, vegetables, and iron for meat. The fowl may have been introduced as early as the banana and eventually became a significant source of meat for some populations.[6] Other Asiatic plants such as taro (Lacomblez 1918, 105) and sugarcane, a supplementary food crop in the area, came later.

The technological upheavals caused by the use of iron and by banana cultivation may have played a significant role in the expansions that occurred at that time: the expansion of Buan speakers to the southeast and northward between the Uele and Mbomu rivers; the deep expansion of Mamvu-related speakers southward into the Ituri forests east of 28° east longitude; and the strong influence of Mamvu lan-

guages on Bantu speakers as far south as 1°30′ south latitude. The speakers of Ubangian languages began to spread toward the upper and lower Ubangi River as well as toward the Zaire (Congo) bend.

Interaction of People and Environments

Most of the region south of the Uele River today receives 1,700 to 1,900 mm of rainfall per year, although in the western portion of the Nepoko River rainfall reaches 2,000 mm. Rains are spread throughout most of the year at this latitude, a situation that favors the growth of various types of rain forest: evergreen forest in the south and semideciduous forest near the Uele. North of the Uele conditions are less favorable. West of 26° east longitude, rainfall of 1,600 mm and longer dry seasons still allow semideciduous forests to dominate portions of the landscape. Farther east, annual rainfall rapidly decreases to less than 1,600 mm and there is a rise in elevation. Consequently savanna woodlands dominated there. Since rainfall patterns in the area appear to have been relatively stable for several millennia, we conclude that the early Sudanese speakers found open savanna, the Bantu speakers found familiar evergreen forests, and the Ubangians coming from the north found themselves in fragile deciduous forest, probably interspersed with patches of savanna.

The farming practices of all three groups involved slash (and later, slash-and-burn) cultivation, which meant that each year farmers cut new fields. The consequent migration soon affected the landscape. The first areas to be affected were along the rivers, because two of the main crops of both the Bantu and the Ubangian speakers, yams and oil palms (*Elaeis*), do not grow in dense forests. Instead, they do very well on forest margins such as along the breaks in forest cover provided by rivers in this area and the small savannas north of the Uele. These farming practices caused the forest cover north of the middle and lower Uele to give way to wooded savanna covered by a tree, *Lophira alata*, that grows in deforested areas. Its presence indicates that population density was once high enough to achieve such a change in the landscape (a density greater than those found in this century).

Over the last century or two a significant number of farmers also moved south of the Uele, downstream from the mouth of the Bomokandi, where they began to clear a form of evergreen forest dominated by a single species, *Gilbertiodendron dewevrii*. This kind of forest testifies to a relatively undisturbed condition for many centuries (Hart 1985); thus the modern

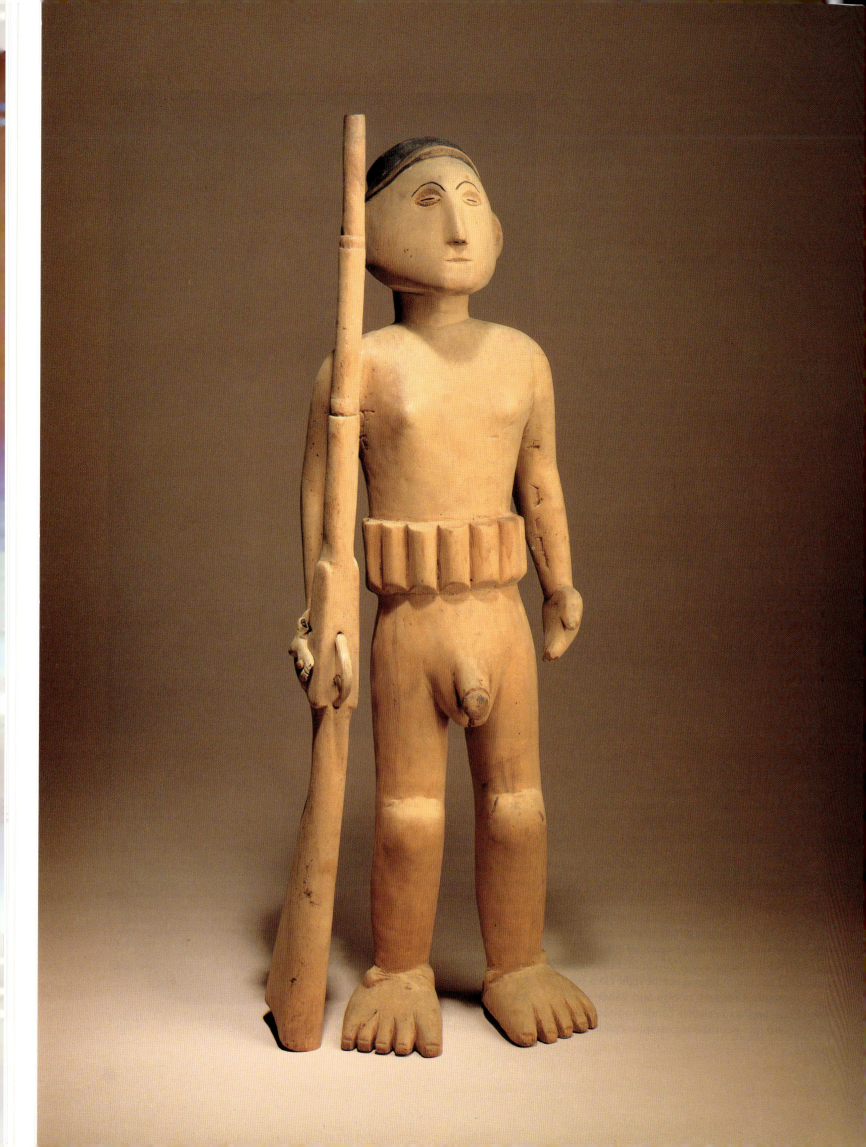

The result was a slowly solidifying political system that was becoming more homogeneous from court to court as the century drew to a close. From the courts the new model of society and the new culture radiated over the areas around them (**4.17**).

In the realm of political ideology, descent from Ngura remained the only criterion for legitimacy. During the rapid expansion there was no time to develop a common body of beliefs, values, and rituals that could have given hallowed underpinnings to Zande rule. Zande rulers stand out in central Africa as secular rulers whose claims were based only on force and descent. Not even a minimally sacralized ideology such as the Mangbetu theory of luck took root among them. Zande princes remained purely warlords.

Twilight of the Kingdom

Sudanese ivory traders and slave raiders from the Nile played a role in the final battle of 1873 during which Mbunza was killed. They had first encountered Mangbetu forces north of the Uele in 1865, when one of their expeditions met defeat at the hands of the Mangbetu troops led by Nelengbe, one of Tuba's daughters. Spears and bows prevailed over guns (Keim 1979, 232; Schweinfurth 1874, 2:58, 95). Later one of these merchants became friendly with Mbunza while another befriended Dakpala. Trade itself and the access to guns it provided soon became important in local power struggles, but Mbunza could still reject the demands of traders and oust them (Keim 1983). But when the merchants assisted his enemies in 1873, their intervention was decisive. And for seven years afterward they were the dominant force in the land (Keim 1979, 240–45). The traders established fortifications near the courts of rulers. They helped these rulers in war but also raided on their own for ivory and slaves. On balance, this favored some Zande chiefs, who began to make deeper inroads south of the Uele and to acquire significant armaments in the north. By 1880 the Egyptian government began to intervene. The region became in effect part of Equatoria Province, governed for the Egyptians by Emin Pasha (Keim 1979, 245–71). He established authority through a network of alliances with local princes, mostly Zande, while attempting to slowly curtail their autonomy. But by 1885 he had to evacuate the area as a result of the 1881 uprising, led by the Mahdi, against Egyptian rule in the Sudan.

Zande and Mangbetu rulers found themselves free again for two years. Then groups of new slave and ivory traders (**4.18**) attacked from the deep forests in the south. These men were Zanzibari agents of the notorious Tippu Tip, who had established a trading empire in eastern Zaire. Eventually Tippu Tip kept a force of some 1,400 armed men in the Uele region (Mohun 1893, 41). These men found enthusiastic allies among some Zande princes, who gained more territory with Tippu Tip's help. But this situation was also ephemeral. In 1891 a column from the Congo Free State defeated the Zanzibari on the Uele (Mohun 1893, 36; Ceulemans 1959, 326–31) and ushered in colonial rule (**4.19**). In its first decade or two the Congo Free State ruled (like the Nile traders, Egyptians, and Zanzibaris) on the basis of alliances with the strongest local rulers. Gradually, though, it gained the upper hand and put an end to the struggles for hegemony between the Azande and the Mangbetu. By the time Lang and Chapin visited the area, much of the fighting had died down, although peace came only with the defeat of the last Avongara prince in 1916 (Keim 1979, 283–310; Salmon 1963, 1969).

4.19
Figure, Azande. *Wood, plant fiber. H: 24.3 in. (62.3 cm). Lang, coll. Panga, 1914. AMNH, 90.1/ 3321.*

Images of soldiers appear often in art made during the colonial period. These figures were made for secular use; the Mangbetu found them amusing.

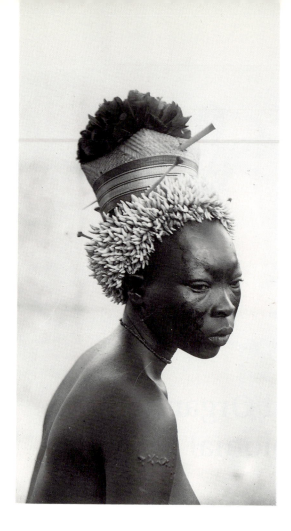

Meje leadership principles. Generally a younger man directed the day-to-day affairs of each Mangbetu-Meje House while the elders stood by to counsel and support him. This man, called *nombi kpokpo* (literally, "Big Man") in the north and *nekumu* in the south, attained power through his personal ability. Although the Big Man was almost always a member of the dominant lineage and a son of the previous Big Man, if that lineage lacked impressive candidates, almost any capable member of the House could demonstrate some sort of kinship link to the dominant lineage that would qualify him as a legitimate choice. The elders could choose a younger man to lead because he represented the virtues they considered important for the House, or a younger man could claim power and then seek the support of the elders. When the elders chose the leader, they usually took into account virtues such as generosity, fairness, and sound judgment, qualities that could override military prowess or parentage. Either chosen by the elders or self-selected, legitimacy of leaders rested ultimately on ability. When the elders were choosing, the firstborn had a right to be considered before other candidates, but, elders explain, firstborn sons are often not as generous or fair-minded as younger sons. It was not uncommon for a younger brother to head a

lineage while older brothers became his advisers (or adversaries).

These principles of succession are illustrated in one story of how Manziga, the founder of the Mangbetu-Mabiti House, came to power. Manziga was a Mabiti war refugee who became the slave of the Big Man of the Mapaha House. A man of great ability, Manziga attracted his master's daughter, fathered a child by her, and persuaded the Mapaha leader to accept him as a son-in-law. On the death of the master, Manziga became the Big Man of the Mapaha. This takeover seems to have occurred because Manziga was much better qualified to lead the Mapaha than were any Mapaha. The result was the subordination of the Mapaha to the Mabiti. Manziga's son Nabiembali, the first Mangbetu king, relied on his Mapaha populations to support the extension of his power.

Vansina was the first scholar to recognize the House organization of forest peoples, illustrated here by the Meje. He has pointed out that the two sets of principles described above are contrasting ideologies that gave the House organization both stability and flexibility. The first set posited unequal categories of House membership such as elder-younger, patron-client, master-slave, male-female, and controlling lineage–junior lineage. It thereby provided for a "tight coherent internal organization." The second set assumed equality between the members of the dominant lineage and allowed the lineage to choose the most capable leader (1982, 175).

By the late nineteenth century there were at least thirty major Meje lineages, each with several sublineages. North of the Nepoko River, where evolution of the House organization was more advanced, a House tended to include all the members of one lineage. South of the Nepoko, Houses were smaller and often included only members of one sublineage. Mangbetu-Meje Houses could have fewer than 100 members or as many as 2,000. Very small Houses had to join with others to form a village because in the forest-savanna region small villages were vulnerable to raids and unable to provide the labor necessary for efficient use of resources. Very large Houses had to divide into several villages because large villages overexploited the environment and were ungovernable under the Mangbetu-Meje House organization. Judging from turn-of-the-century reports and from modern oral histories and census figures, the optimum population for a Meje village was about 300 inhabitants. Populations varied considerably, however, depending on specific factors of environment and leadership.

←
5.2
Mayogo woman, Medje, 1914. *AMNH Archives, 112165.*

This woman was a principal wife of the Mayogo chief Abiembali; her elaborate headdress denotes her rank. She wears an undercap made from hundreds of dogs' teeth, a basketry hat topped with red tail feathers of the gray parrot, an ivory hairpin, and a hairpin made from a monkey bone.

5.3
Water jar, Mangbetu. *Ceramic. H: 10.3 in. (26.5 cm); D: 6.5 in. (16.6 cm). Lang, coll. Niangara, 1910. AMNH, 90.1/4675.*

Mangbetu pottery illustrates the sense of beauty and design incorporated into objects of everyday use. This water jar was given to Lang by Nenzima, a principal wife of Okondo. Lang noted that Mangbetu women possessed and sold objects on their own, without consulting their husbands.

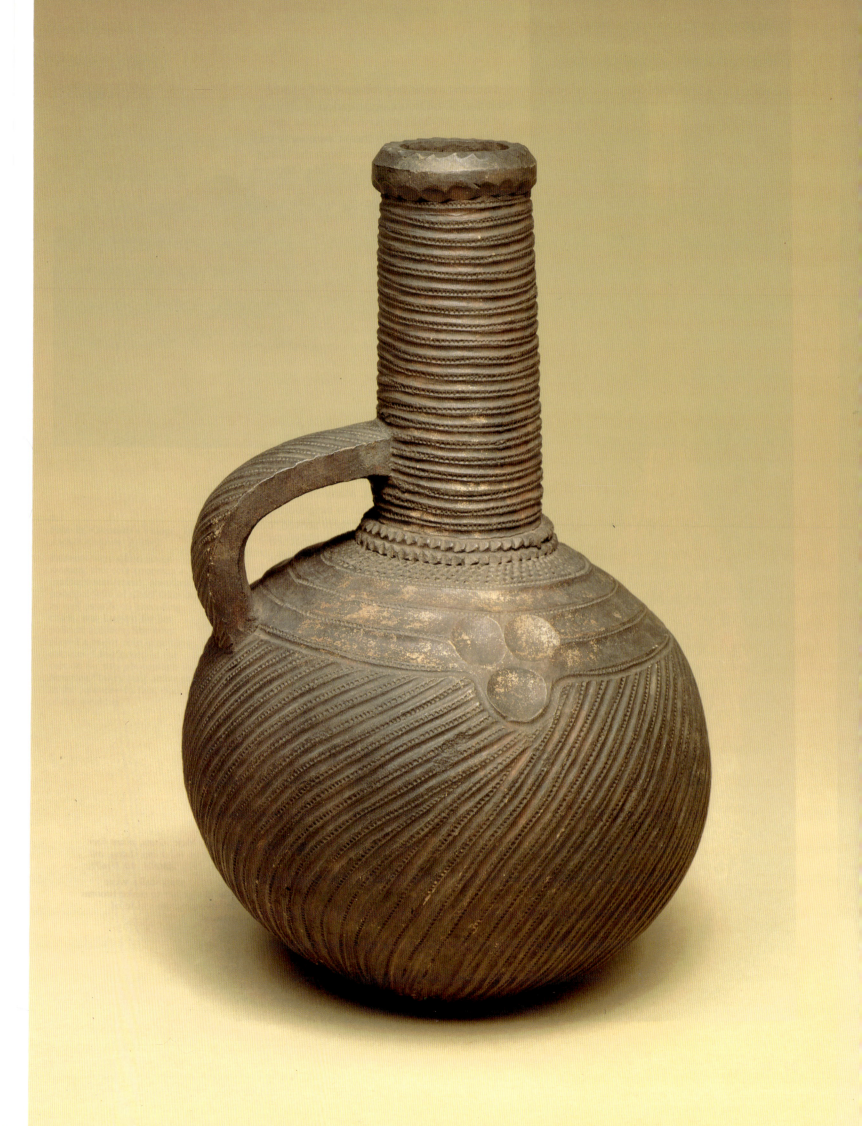

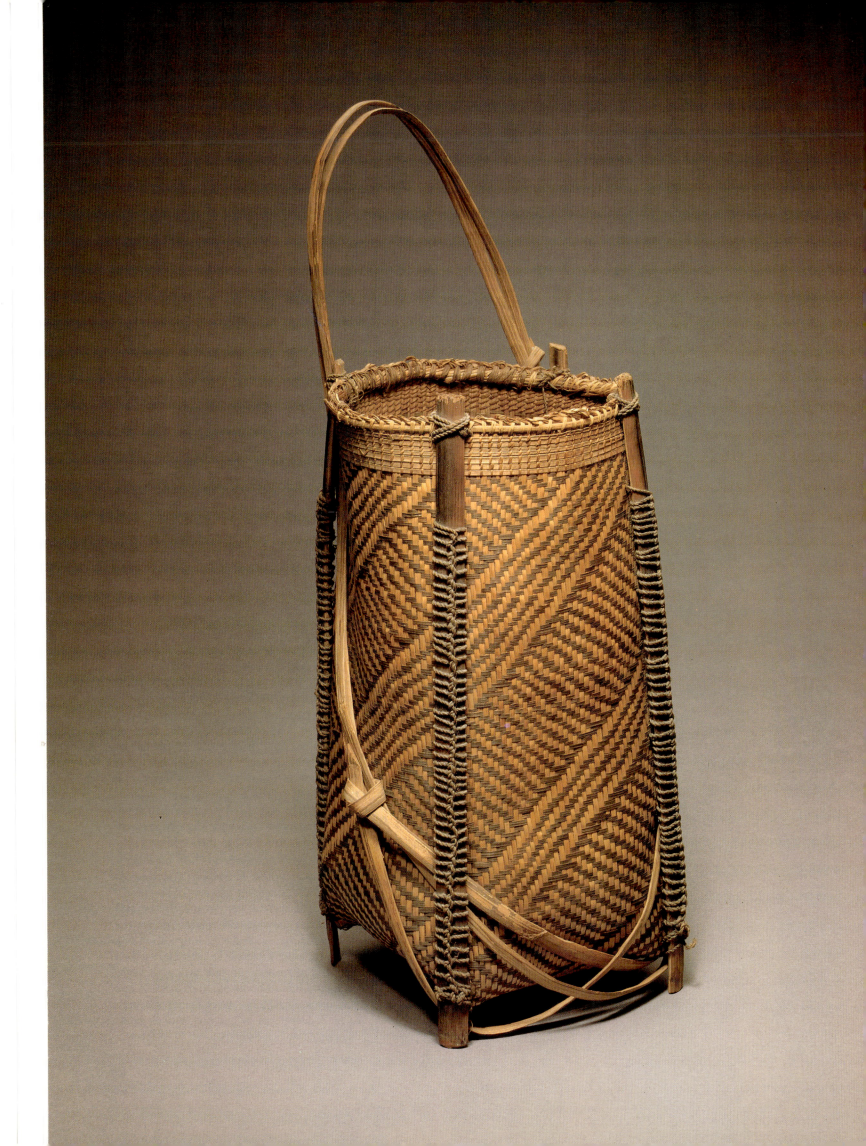

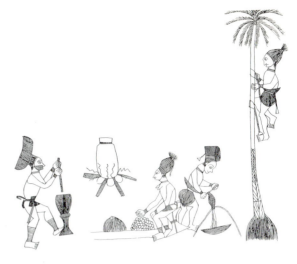

6

The Art and Technology of Daily Life

Scenes from an ivory horn showing the gathering of palm nuts and the manufacture of palm oil. In explaining this series of drawings the artist told Herbert Lang: "All the people are happy; only the animals are fighting now" (2761).

6.1
Basket, Meje. *Plant fiber, wood. H: 11.9 in. (30.5 cm). Lang, coll. Medje, 1910. AMNH, 90.1/1571.*
Mangbetu women could own property, including baskets like this one and the objects kept inside. Lang described such baskets as "made by women, used generally only for objects of women, such as adornments, strings, necklaces, armlets, leglets, objects of medicine or real remedies, also the smaller knives, the bandages used to bind their own and the heads of children" (627).

The peoples of northeast Zaire manufactured even the most ordinary tools and utensils with skill and with an eye for beauty. Fine craftsmanship was valued in the construction of virtually all household objects, and modern informants tell us that the care given to the appearance of an object was to make it beautiful and to show the intelligence of the creator. Many useful objects served as ornaments when first made and as implements when they were older. The best brooms, for example, were used first in dances, where they were held in the air as wands, and later for sweeping (**5.4**). People demonstrated their wealth and position by the fine decoration on their utilitarian possessions. Spears, knives, and even shields were worn or held as ornaments. Toothbrushes and drinking straws were sometimes wrapped with ornamental copper wire. Fly whisks had carved wooden or ivory handles and, for high-status people, were wrapped with copper, brass, or iron wire.

Architecture and House Design

Precolonial Mangbetu villages tended to be located on the sides of hills. Crops that thrive on drier land, such as yams, were planted uphill, and those that require more moisture, such as plantains, were planted downhill near a stream. Each village consisted of a line of small settlements up to one or even two miles long. Schweinfurth wrote, "The huts are arranged in sets following the lines of the brooks along the valleys, the space between each group being

occupied by plantations of oil-palms" (1874, 2:119). A number of early travelers commented on how the Mangbetu took care to site their houses and villages not only to use environmental conditions to best advantage but also to provide pleasing views. Each village had a large *negbamu*, or open-sided sitting area, sheltered for protection from sun and rain, where people gathered for discussions, disputes, drinking, smoking, and dancing. The shelter usually stood near the houses of the Big Man and the principal elders.

Each family group lived in its own settlement area. A family from a lineage with able leadership would have had many well-built houses, a sheltered sitting area, a cooking shelter, granaries, chicken houses, and a shelter for a signal drum. Fathers, brothers, and sons lived with their wives toward the center of the settlement, while clients and slaves had their houses a few yards off. Smaller families—those that had recently broken away from a larger unit or that had suffered some misfortune—lived in modest settlements with perhaps only one or two houses.

The Mangbetu built their villages several miles apart. Population density in the Mangbetu area was higher than anywhere else in the region except among the Budu to the south. However, there was sufficient land for each village to have large hunting and fishing grounds. Villages and individual settlements also required considerable land for agriculture, because old fields had to lie fallow for a number of years

6.12

Left:

Pot, Mangbetu. *Ceramic. H: 8.8 in. (22.5 cm); D: 5.3 in. (13.5 cm). Lang, coll. Niangara, 1910. AMNH, 90.1/4692.*

Right:

Jar, Mangbetu. *Ceramic. H: 8.2 in. (21 cm); D: 5.4 in. (13.9 cm). Lang, coll. Niangara, 1910. AMNH, 90.1/4683.*

The anthropomorphic pot and the water jar, both Mangbetu, have the same patterns on their bases. This similarity suggests that the anthropomorphic styles were seen as an embellishment on the traditional household pottery.

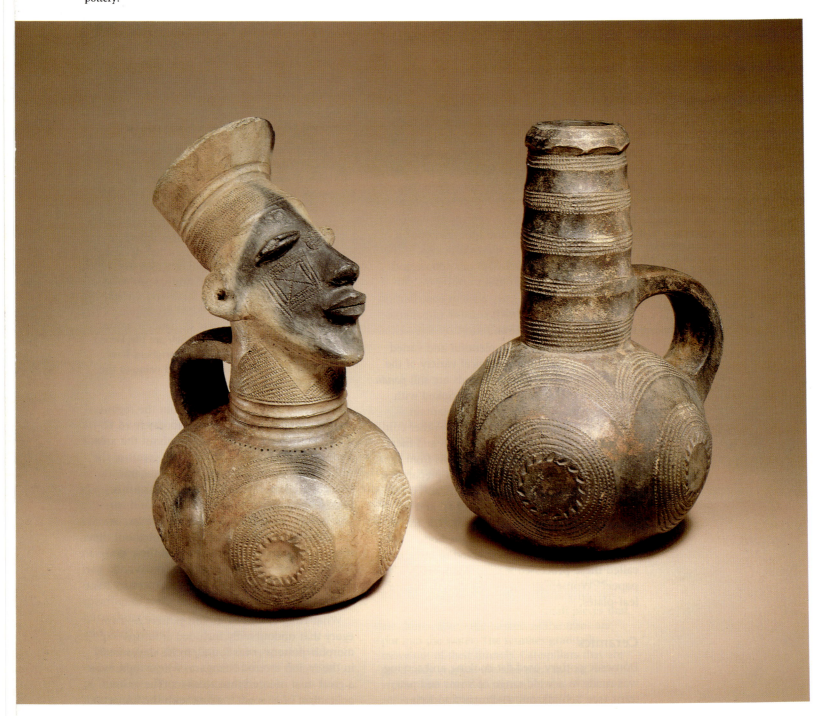

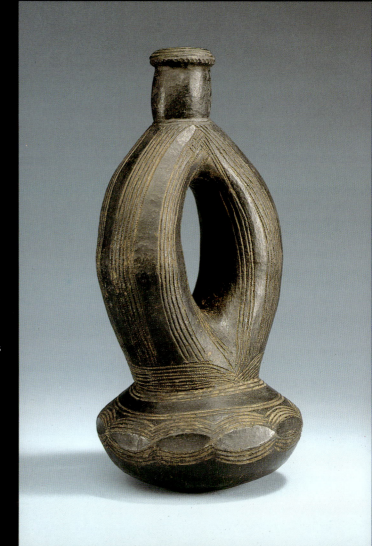

6.13
Pot, Azande. *Ceramic. H: 12.7 in. (32.5 cm); D: 6.6 in. (16.8 cm). Lang, coll. Akenge's village, 1913. AMNH, 90.1/2723.*

Household pots and drinking jars took many forms. Pots for rulers were more ornate than those used by their subjects. This double-necked pot belonged to Chief Akenge of the Azande and held water and wine.

6.14
Jar, Mangbetu. *Ceramic. H: 9.9 in. (25.5 cm); D: 8.8 in. (22.5 cm). Lang, coll. Niangara, 1910. AMNH, 90.1/4676.*

Mangbetu household pottery was sometimes made in unusual shapes, like this jar with three balls forming the base. The jars were used to store water, wine, beer, and oil.

of the new patrons, contributed to the efflorescence of anthropomorphic pottery that occurred in this period (see Schildkrout, Hellman, and Keim 1989). Schweinfurth found a great elaboration of pottery shapes among the Mangbetu in the last quarter of the nineteenth century, but it was not until Lang's time that Mangbetu anthropomorphic pottery was described or collected. The anthropomorphic pots that Lang collected, first in Niangara (1910) and later in Medje (1914), included examples that were virtually identical in shape and surface design to the long-necked water jars made at the same time, and probably earlier, suggesting that the head was added as an embellishment to an already accepted form (6.12).

The similarity in the sculptured heads on the many pots collected by Lang and others in this period suggests that there were very few artists making these pots. Although we do not know exactly who they were, Lang reported and photographed Mangbetu men making these pots. This is significant because among the Mangbetu, Makere, Meje, and Barambo, pottery was, and still is, normally made by women. Zande potters were usually men. Lang's comment raises two fascinating possibilities: either there was a shift in the gender of the Mangbetu potters in the early colonial period or Zande potters were making the many pots depicting the Mangbetu head style. Some of the pots may even have been the joint work of male and female artists. A series of photographs taken thirty years later, now in the Archives d'ethnographie of the Musée royal de l'Afrique centrale in Tervuren, shows a woman making a pot and a man adding the head.

In the early colonial period, interethnic marriage occurred in places like Niangara with increasing frequency. This trend almost certainly affected craft production. Lang noted that five jars he collected[6] were made by Zande women who were married to Mangbetu or to "Abangba [Bangba], as indeed Okondo is Abangba and no pure Mangbetu" (1283). It was in discussing pottery that Lang wrote about intermarriage:

> At the present time the Mangbetu and Azande intermarry readily. Formerly the Mangbetu would rather kill a woman than give [her] to an Azande (who were the worst enemies) and vice versa; but all these differences have gradually disappeared under the pacifying influence of white men. (1283)

Fiber and Gourd Objects

The Mangbetu widely exploited their environment to obtain an array of fabrication materials that when subjected to their inventive technical expertise yielded items of utility and beauty.

The types of plants collected for basketry objects included grasses from swamp areas, fibers from food crops such as sorghum, millet, and bananas, the fibers from oil and raffia palm plants, rattan, papyrus, and vines. All parts of the plants were used. For example, the bark of the fig tree was used to make barkcloth; split leaf sections, particularly of the raffia and oil palms, were used to make baskets and cordage; midribs of oil palm leaves were used as instrument strings; palm stalks, whole or in sections, were used to make furniture; split stem materials of all kinds had wide use as binding, tying, and wrapping materials, as well as serving as foundation elements for basketry of all types. The Mangbetu used these plant parts in their natural color and also dyed them red or black.

Woven basketry techniques were used to create baskets, mats, hats, shields, rattles, and cordage. The primary techniques used were plaiting and twining. An incredible variety of patterns was possible using these two basic weaves. With twill plaiting (a weaving technique in which all fibers are active elements) diamond, checkerboard, cross, striped, lozenge, and zigzag designs were achieved. Twining (a technique employing stationary warp and active weft elements) was commonly used to make basket and hat rims, rattles, and, by the Azande, sturdy shields. Floated fibers were utilized within a plaited ground to add further design variation, particularly in creating motifs that stand out from the overall field. Combinations of dyed and undyed fibers further enhanced pattern variations. Placement of the fiber's glossy cuticle layer facing up or facing down was another artistic choice for augmenting an object's visual effect. Both regular and asymmetric designs were achieved using all of the above techniques.[7]

Supplementary fibers were used to elaborate the designs of woven structures. Wrapped loops on hats and edgings on hat rims were constructed of elements that were not essential to the integrity of the woven structure. The sides of baskets often had nonstructural fibers inserted through the plaited foundation. These additions, as well as being decorative, may provide extra strength to a basket, allowing it to hold heavier items without sagging. Supplemental overlays of fibers—on quivers, for example—may also have served as reinforcement, but they were clearly applied in such a way as to also create a decorative effect.

Straps for baskets, stools, shields, musical instruments, and pots were made using a single-element looping technique. Plaited overlays were added to wooden or ceramic objects, such as the plain weave bands used on the borders

6.15
Basket, Mangbetu. *Wood, plant fiber, hide with fur. H: 14.0 in. (36 cm). Lang, coll. Niangara, 1913. AMNH, 90.1/4492.*

Made for women to store their personal belongings, baskets of this type could be hung up in the house on a pole.

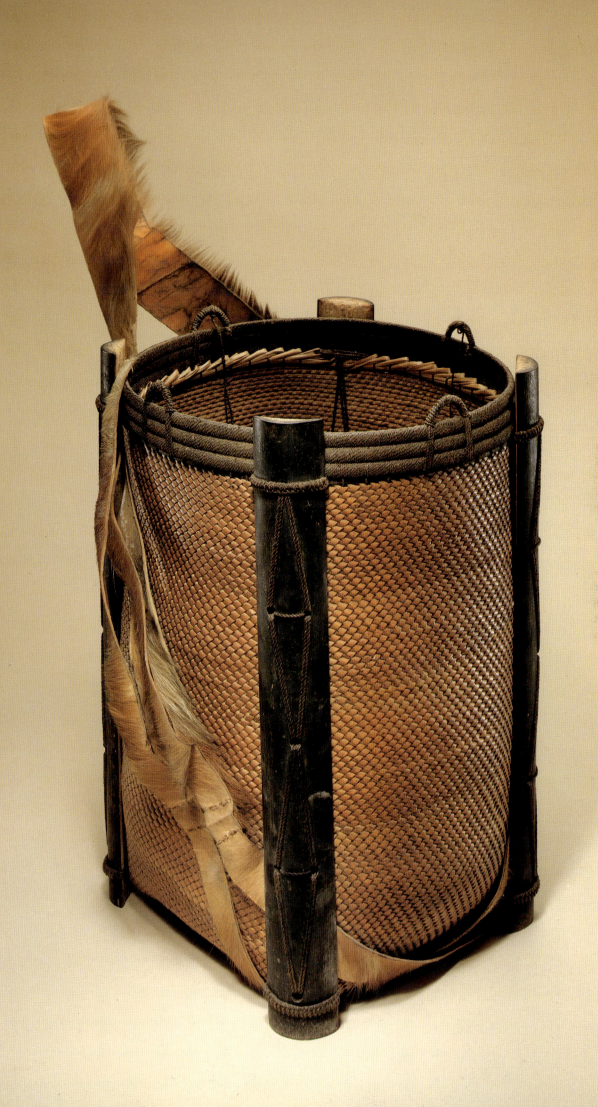

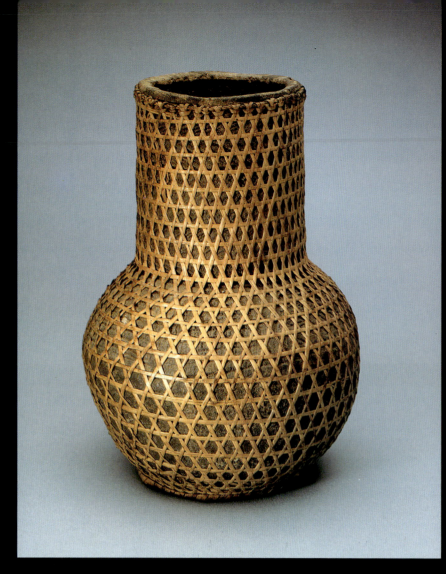

6.16
Pot, Meje. *Ceramic, plant fiber. H: 7.2 in. (18.5 cm); D: 5.1 in. (13.2 cm). Lang, coll. Medje, 1910. AMNH, 90.1/2390a.*

This pot, beautifully covered in basketry, was used for storing the black oil with which the Mangbetu adorned their bodies. "They say they weave these pots over because it looks pretty," Lang commented (1290). The woven surface also helped prevent the pot from slipping.

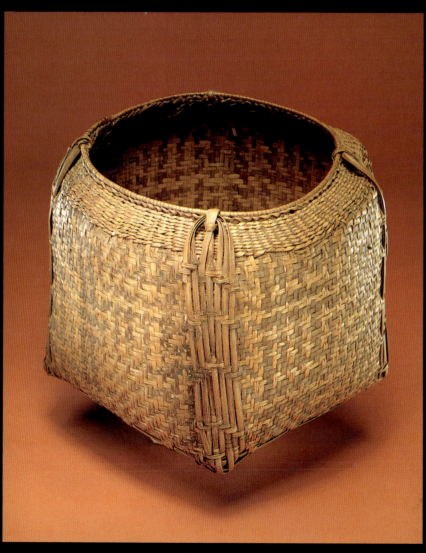

6.17
Basket, Mangbetu. *Plant fiber. H: 7.2 in. (18.5 cm). Lang, coll. Niangara, 1910. AMNH, 90.1/4505.*

Plaited baskets were made by both men and women and served many purposes. This one could have been used for storing personal articles, holding food, and also as a cover for large pots.

of rectangular wooden shields and the open-latticework basketry constructed over jars (**6.16**). Such plaiting was used for reinforcement, to provide a grip, as a repair, or for decoration. Further embellishment of plaited objects was common. Various decorations, often signifying status, were attached to hats. Animal hides were used not only for straps but were also attached to shields as talismans.

Many baskets had specific uses, but some served as general containers for food, tools, medicines, and jewelry (**6.1**). Mangbetu women made winnowing baskets and sieves from un-dyed split stem material using simple plaiting with coiled rims. Sieves and winnowing baskets were made in a variety of sizes that could be nested together. They were used in the preparation of cereal foods like porridge and beer. Winnowing baskets were also used to take the wings off termites, for their bodies were regarded as a delicacy. Very elegant storage baskets were used as containers in women's rooms, and those for wealthy women had antelope hide straps. The edges of some of these baskets were fortified by lashing sections of dyed palm stalks to them to keep them rigid (**6.15**). They were often woven in dark and light patterns similar to the designs on hats. Large carrying baskets were made with straps to be placed over the shoulder or used as a tumpline over the forehead. Special carrying baskets were used by blacksmiths for carrying tools and by ritual specialists for carrying divination equipment and medicines. The *mapingo* oracle operator, for example, today uses a basket to carry the oracle apparatus to a clearing in the forest where he sets up his oracle and questions it (see chap. 9, Oracles). Square-based baskets, woven in a great variety of patterns, were used for food containers (**6.17**); similar forms, when inverted, were transformed into hats.

Among the Mangbetu, both men and women made baskets, but only women made mats and men made most of the hats (403). Mangbetu hats and baskets made by men generally had more complex patterns than did the mats and baskets made by women. Judging from the American Museum collection, Mangbetu mats had simpler designs than did those of neighboring peoples.[8] The Mangbetu mats tended to have all-over monochromatic weaves, and the mats of the Barambo, Makere, and Azande incorporated subtle, colored patterns (**6.18**). In

6.18
Mat, Makere. *Plant fiber. L: 27.7 in. (71 cm); W: 19.7 in. (50.5 cm). Lang, coll. Niapu, 1914. AMNH, 90.1/2468.*

Makere mats have complex, abstract patterns. Twill plaiting is used here to create diamonds combined in an asymmetrical pattern.

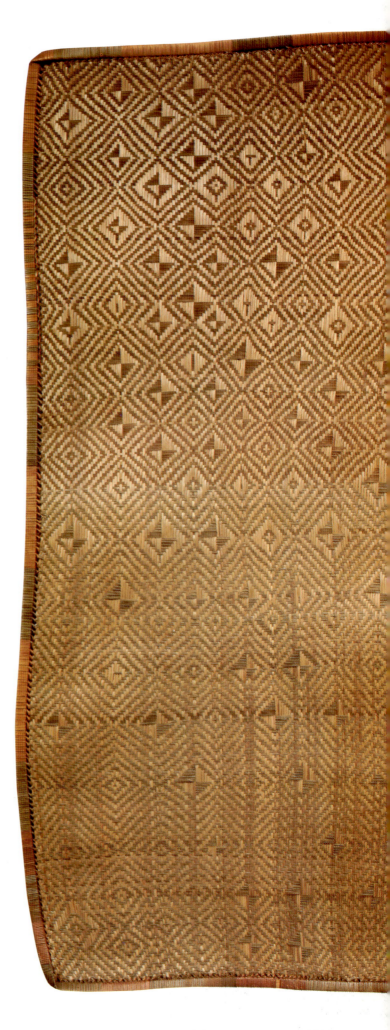

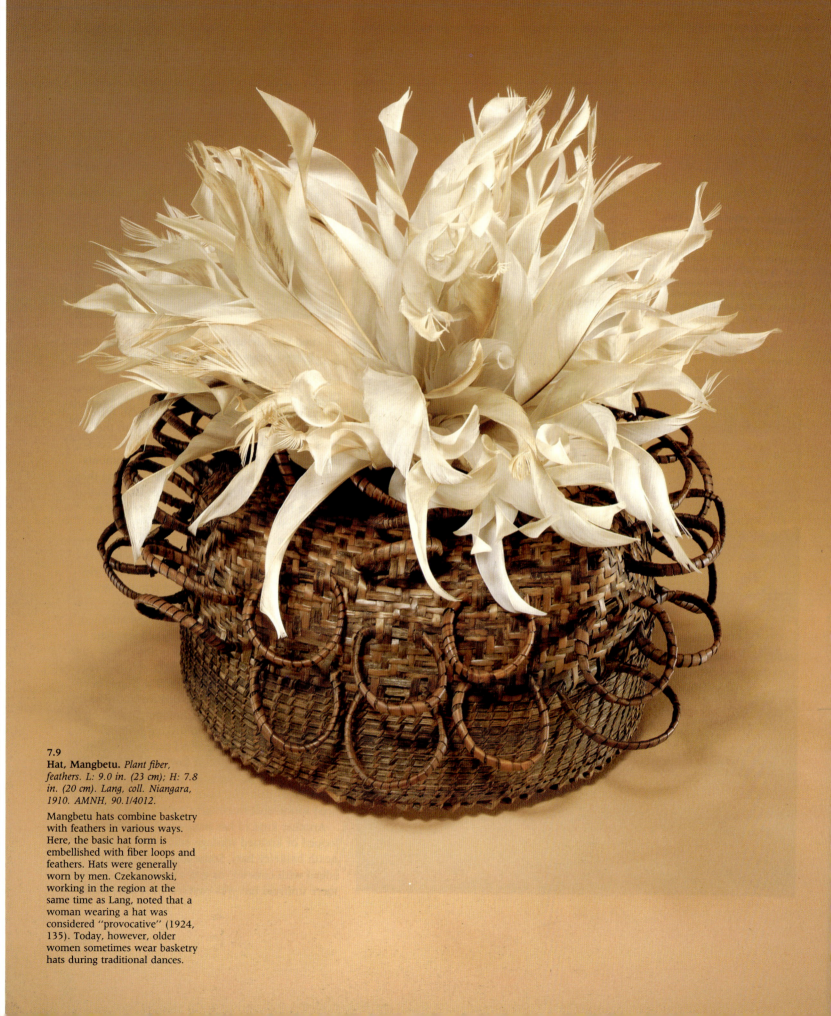

7.9
Hat, Mangbetu. *Plant fiber,*
feathers. L: 9.0 in. (23 cm); H: 7.8
in. (20 cm). Lang, coll. Niangara,
1910. AMNH, 90.1/4012.

Mangbetu hats combine basketry
with feathers in various ways.
Here, the basic hat form is
embellished with fiber loops and
feathers. Hats were generally
worn by men. Czekanowski,
working in the region at the
same time as Lang, noted that a
woman wearing a hat was
considered "provocative" (1924,
135). Today, however, older
women sometimes wear basketry
hats during traditional dances.

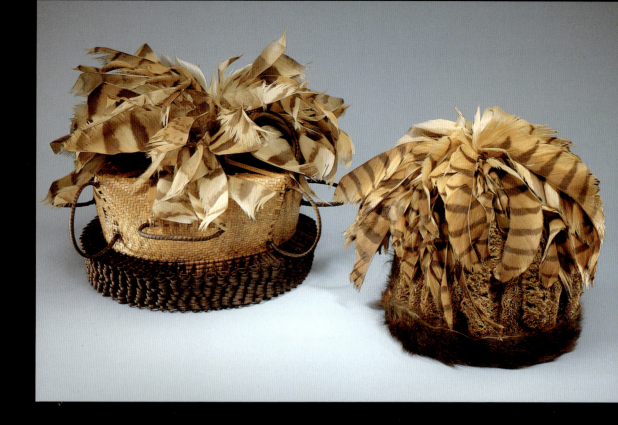

7.10
Left:
Hat, Azande. *Plant fiber, owl and eagle feathers. W: 10.9 in. (28 cm); H: 8.2 in. (21.1 cm). Lang, coll. Niangara, 1913. AMNH, 90.1/4712.*

Right:
Hat, Meje. *Loofah, hide with fur, hide, owl feathers. H: 8.0 in. (20.6 cm); D: 9.8 in. (25.2 cm). Lang, coll. Medje, 1910. AMNH, 90.1/1442.*

Hats from the Uele region incorporate a variety of techniques and materials. The hat at left features intricate basketry work, including loops and a ribbonlike border. The other one is made from the loofah plant.

7.11
Logo man, Faradje, 1911. *AMNH Archives, 225687.*

A Logo man, photographed at a dance, wears an extraordinary feather headdress on top of a basketry hat.

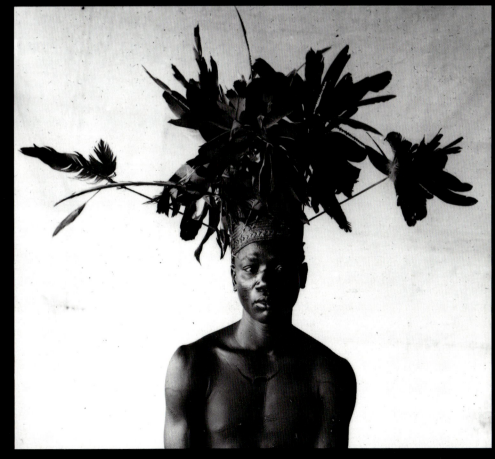

(7.7). Some hats were made from the loofah plant, often in combination with ornamental shells and feathers (7.10). Animal skins, including leopard, okapi, colobus monkey, genet, and chimpanzee, were commonly used. The skins were untanned or tanned lightly by being manipulated with oil. Skin hats sometimes had basketry edgings and interiors and they were often elaborately decorated with brightly colored feathers.

Most hats were made to be purely ornamental, but some had special meanings. For example, hunters who lived near the forest south of Medje wore special hats as a sign of mourning after they killed an okapi. These hats (9.1) were worn long after the hunters returned to their village to ensure that they would not become sick and die (675). There were also hats for mourning specific relatives; Lang collected some made for mourning the death of a child, others for mourning the death of a sibling. Like the hat for mourning the dead okapi, these hats lacked the usual binding and were finished with a fringe. The way the fringe was made had meaning: it was completely loose on the okapi hat, long and wild, but it was tightly twisted on the hat for the child. A net underhat (*nado*) was also worn as a sign of mourning. Several examples of the *nado* could only be worn by men although they were made by women.

Pins were made in a great variety of materials. Examples include two wooden ones carved into coils collected in the 1890s by Burrows (2.14) and iron (7.13), copper (4.10, 4.11), brass, silver, and ivory pins (7.14) collected about a decade later by Lang, Hutereau, and others. Long ivory hatpins were prestige items and indicators of wealth. The entire end of a tusk was required to make a fine pin with a disklike top. Lang wrote about the process:

> Only an experienced artist can hope to carve from the solid tip of an elephant tusk so slender a pin, topped with three large disks. No more wasteful design could be devised, for most of the ivory drops off in useless chips. All Mangbetu men of importance covet pins, most of which, however, terminate in a single concave disk, usually turned toward the front when worn, and supposed to represent the radiance of the sun. (Lang 1918a, 540)

Pins were worn by men and women, by men mostly in hats and by women in their hair. Women rarely wore hats in Lang's time, except as a sign of mourning. Like most objects, the pins had multiple uses. Lang referred to them as the Mangbetu woman's "pocketknife." Of an iron hairpin, he wrote: "used for surgical purposes, such as cleaning wounds, taking out jig-

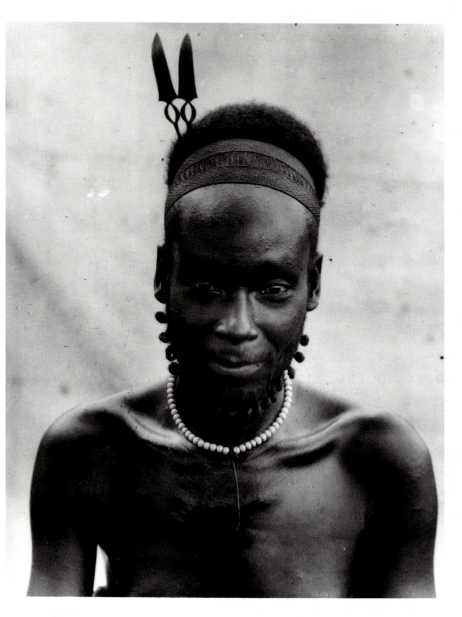

7.12
Zande man, Akenge's village, c. 1909–15. *AMNH Archives, 227671.*

This Zande man wears a headband, an iron hairpin, and a necklace of beads. His beard is twisted into a row of small coils along his jawline from ear to ear.

7.13

Left to right:

Pin, Barambo. *Iron. L: 13.1 in. (33.7 cm). Lang, coll. Poko, 1913. AMNH, 90.1/3724.*

Pin, Mangbetu. *Iron. L: 13.8 in. (35.4 cm). Lang, coll. Medje, 1910. AMNH, 90.1/1989.*

Pin, Mangbetu(?). *Iron. L: 11.2 in. (28.7 cm). Lang, coll. Niangara, 1910. AMNH, 90.1/ 4242.*

Pin, Barambo. *Iron. L: 14.2 in. (36.3 cm). Lang, coll. Poko, 1913. AMNH, 90.1/3725.*

Pin, Azande. *Iron. L: 8.7 in. (22.2 cm). Lang, coll. Niangara, 1913. AMNH, 90.1/4240.*

Pin, Azande. *Iron. L: 10.9 in. (28 cm). Lang, coll. Akenge's village, 1913. AMNH, 90.1/2656.*

These iron pins, for the hair or hat, display a variety of designs, from the classic disk often seen on ivory hairpins to irregularly shaped circles, stars, points, and cutouts.

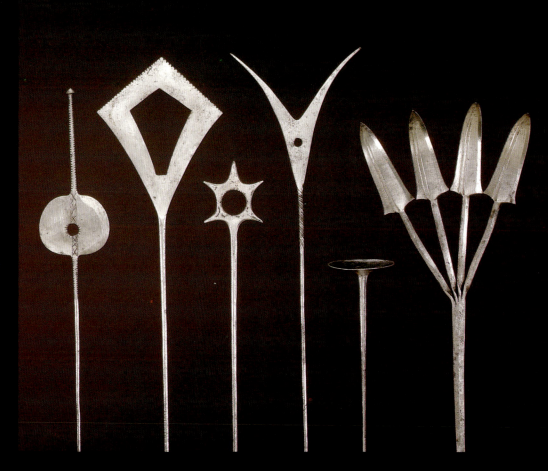

7.14

Top to bottom:

Pin, Meje. *Ivory. L: 12.4 in. (31.7 cm). Lang, coll. Medje, 1910. AMNH, 90.1/1865.*

Pin, Mangbetu. *Ivory. L: 22.2 in. (56.8 cm). Lang, coll. Medje, 1914. AMNH, 90.1/1867.*

Pin, Mangbetu. *Ivory. L: 14.0 in. (36 cm). Lang, coll. Pawa, 1910. AMNH, 90.1/2550.*

Ivory pins, worn in hats by men and in the hair by women, were prized possessions of high-ranking people and even played a part in their flirtations. Czekanowski commented, "Getting a hair pin as a gift from a woman equals an invitation to intimacy" (1924, 138). The disks on these elegantly carved ivory pins were said by Lang to represent the radiance of the sun.

gers, scraping the finger and toe nails and cutting them. A razor to arrange the fibers that maintain their elaborate hair dress and various other purposes" (1986). Hairpins were often exchanged as gifts among friends, as were small finger rings (1091).

Adorning the Body

Body-Painting

Mangbetu women took great care in ornamenting their bodies with painting as well as scarification. Lang noted that the Mangbetu liked to rub their bodies with scented and colored oils, which were stored in pots (4701) (7.17). For dances and special events women painted geometric designs on their bodies with a black pigment made from the gardenia plant (7.15, 7.16). Some designs were painted freehand and some were applied with stamps or small carved cylinders of wood similar to those used on pottery (1479). According to Schweinfurth, the variety of patterns was "unlimited" and included stars, Maltese crosses, bees, flowers, stripes, and irregular spots. He wrote that he saw "women streaked with veins like marble, and even covered with squares like a chess-board" (1874, 2:105). The designs lasted for about two days and then were rubbed off and replaced by new designs. According to Casati, Bangba women sometimes adorned their bodies with redwood powder "as a token of affection . . . [by which] an affianced woman seeks to attract her lover" (1891, 1:149). Mangbetu men and women rubbed their bodies with a mixture of pulverized redwood and oil from palm kernels to give the skin a coppery gloss (209).

Jewelry

Both men and women wore ornaments for adornment, though the vast majority of the belts (7.18), bracelets, necklaces, and anklets also had protective or magical properties (see chap. 9). Wooden ornaments derived their power from the species of wood from which they were made. Metal and ivory, however, were associated with wealth and political power but had no associated magical properties (see chap. 12). Metal could be fashioned into ornaments in the form of teeth and claws, but there is no evidence to suggest that they took on the power inherent in the animals they represented (7.19). Women commonly wore multiple strands of brass-bead anklets made by Mangbetu smiths. Probably the oldest anklets were the spiral bands found throughout central and

eastern Africa that both men and women wore from the ankle up to the calf. Armbands of hide with twisted copper or brass wire were also common from the last century.

Teeth and tusks from a great variety of animals served as adornments and charms. Ornaments made from parts of forest animals were imbued with magical properties and could also serve as status symbols, particularly in the case of the leopard and the okapi. Canine teeth and claws were worn on belts or necklaces (8.15) in great agglomerations or as single charms, sometimes encased in fiber covers made by men. Lang collected one bracelet with links said to be made from human bone. He claimed that in the past hats had been decorated with human teeth, but that all these had been buried with their owners in the previous generation and had been replaced by hats embellished with hundreds of dog teeth.

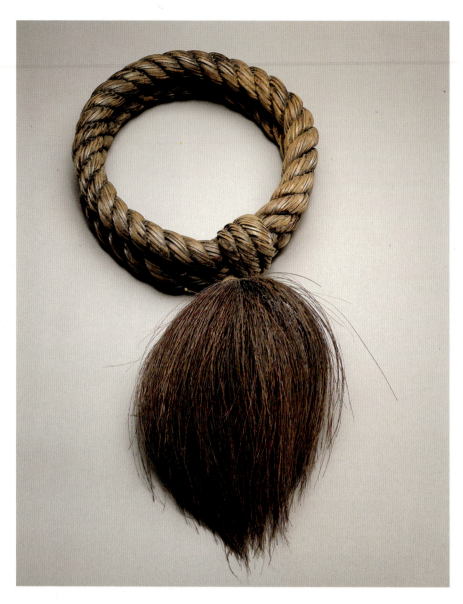

7.18
Belt, Mangbetu. *Plant fiber, warthog hair. L: 25.7 in. (66 cm); W: 12.1 in. (31 cm). Lang, coll. Rungu, 1913. AMNH, 90.1/2742.*

Mangbetu men wore a belt to hold their barkcloth in place, but some also served as charms. Lang wrote of this object, "A belt to be fastened above the ordinary belt for protection. A fine sample with a bunch of wart hog bristles in front" (2226).

7.19
Necklace, Makere or Malele. *Iron, copper, fiber cord. L: 9.8 in. (25 cm). Lang, coll. south of Poko, 1914. AMNH, 90.1/1981.*

Men and women wore necklaces for adornment and also as protective charms. In this example, the copper has been fashioned into representations of leopard teeth. The necklace was worn with the convex side of the pendant against the skin.

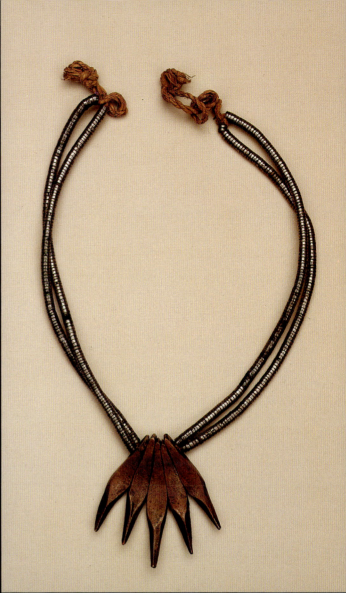

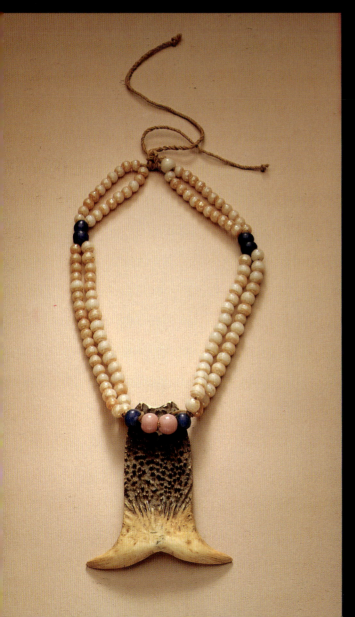

7.20
Necklace, Mangbetu. *Horn, glass beads, plant fiber. L: 9.2 in. (23.5 cm); W: 2.6 in. (6.7 cm). Lang, coll. Medje, 1910. AMNH, 90.1/ 4821.*

Glass beads, obtained from Europeans in trade, were sometimes incorporated into necklaces and other jewelry for chiefs and their wives, but the use of European beads was not widespread in the region.

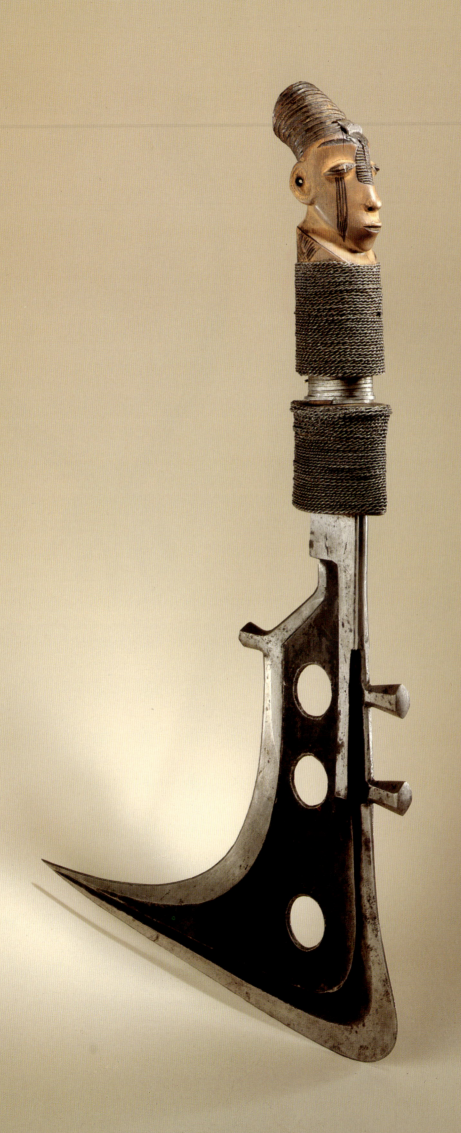

Important people like Okondo and his wives wore great masses of glass beads, introduced by Europeans, especially when they posed for formal photographs (**8.4**). The beads were accepted for a brief period as gifts and in exchange for locally made artifacts; Lang wrote of importing glass beads and purchasing them in the government store. Brass wire, however, was much preferred to glass beads. On the rare occasions when glass beads were incorporated into ornaments (**7.20**), they were used in simple, single strings on which were suspended objects, like animal claws and teeth, that had far more symbolic meaning than the beads themselves. Glass beads were never arranged in elaborate patterns as was done elsewhere in Africa. They never became an intrinsic part of Mangbetu material culture because they never meshed into the Mangbetu system of thought (see chaps. 9 and 12). They neither had the power associated with organic materials like plants or animal parts nor were scarce enough to be adopted as symbols of wealth and status, as were items made of iron, brass, copper, and ivory.

Knives

New knives and daggers were worn as ornaments before they were put to general use. Lang wrote of a knife similar to that held by Mbunza in Schweinfurth's drawing (**2.3**) that

> the *nagata/nagala* [a curved sickle-shaped knife] was worn by men during visits, palavers and ceremonious social gatherings. According to its fancy details and finish, it gives the bearer a certain distinction and enhances his reputation of wealth. Generally carried in the right hand, the knife is sometimes hooked over the left shoulder or carried under the arm, but it is not worn in the belt. It is for show-purposes only, but it is occasionally used to cut a branch in the road, etc. Old men use these knives for plantation work. (59)

The most famous kind of show knife was the *emambele*, the sharp-angled, sickle-shaped knife with two or three holes. Its hilt was made in a great variety of materials, including brass, wood, ivory, and iron. By Lang's time some of these knives featured carved heads (**7.21**):

> Emambele: [One of] two sickle shaped knives with carved heads of females made by Okondo's blacksmith. The carved handle is made by another man. They are also considered as a mark of distinction and conspicuously worn. (1144)

The dagger (*sape*) was worn in the belt, usually in a sheath, and served as both ornament and implement (cover photograph and **4.1**). The earliest documented examples of anthropomorphic carving definitively associated with the Mangbetu are found on this type of knife (see chap. 12, Anthropomorphic Art in the Early Colonial Period). The *sape* is also found among the Azande, although theirs rarely have figurative carving on the handle. One fine example with a carved ivory handle in the shape of a head was collected by the emissaries of King Leopold and given to the American Museum. Like most of the objects in the Congo Free State accession, it is documented only as coming from the upper Uele region (**2.1**).

Barkcloth

The main item of men's clothing was the *nogi*, a piece of barkcloth wrapped between and around the legs and held in place at the waist with a belt (**7.22**). Chiefs and other important men displayed their status by wearing a large *nogi* that was new and stiff so that it would stand upright above the belt and over the chest. Ordinary people wore older barkcloth, with the softened material drooping over the belt. Each man made his own cloth by removing a large piece of bark from either of two species of fig tree (*Ficus roko* and *Urostigma kotschyana*) and pounding it with a beater of ivory, wood, or elephant bone (208). According to Junker, shades of barkcloth in the 1880s ranged from the favored light brown to a deep red-brown to gray, with a coarser consistency for the more common types (1891, 249). Lang reported that the cloth was often colored red by rubbing it with a mixture of redwood powder and palm kernel oil and that it could also be made black by burying it in "black mud" (208, 209, 708). Three pieces sewn together side by side, the central one a natural color flanked by side panels of black, was a popular design. Today alternate light and dark stripes, each about four inches wide, are fashionable. In some cases the chief's barkcloth was made from bark of a special species of fig tree that produced lighter-colored and finer-quality material.

Women wore a rectangular barkcloth garment called *nogetwe*. Worn like a short skirt or sometimes like an apron, it was left open in the rear to reveal the *negbe*, or back apron. Men's and women's barkcloth were never exchanged (212). Women generally wore barkcloth when they were not at work—for visiting and receiving guests—and when strangers were present. (At work, the common garb was a bunch of banana leaves draped over a cord belt.) The *nogetwe* of upper-class women was larger and of

7.21
Knife, Mangbetu. *Iron, wood. L: 16.0 in. (41 cm). Lang, coll. Niangara, 1910. AMNH, 90.1/ 4140.*

Mangbetu artists often combined their skills to produce objects such as this prestigious show knife. From Lang's fieldnotes we know that Chief Okondo's blacksmith made the blade and another man carved the anthropomorphic handle.

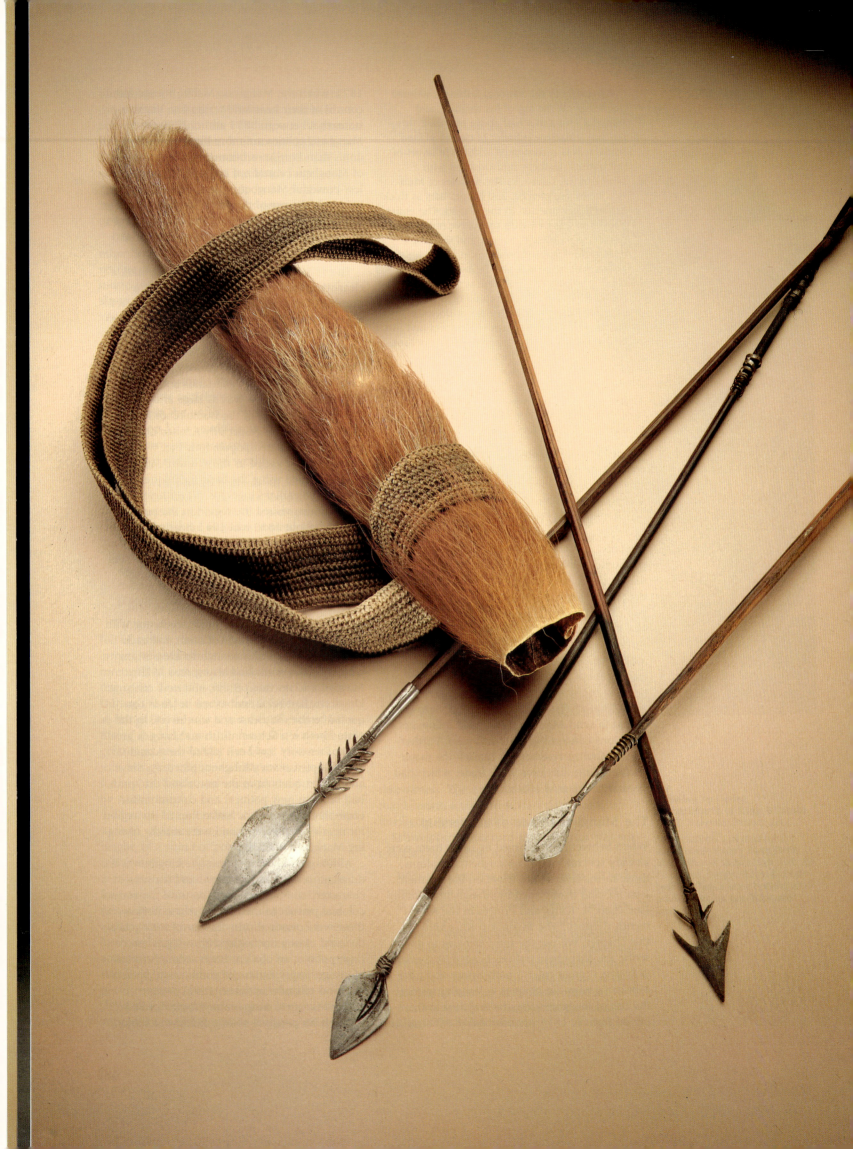

←

8.3
Quiver, Meje. *Hide with fur,
plant fiber. L: 13.3 in. (34 cm); W:
1.2 in. (3.1 cm). Lang, coll. Medje,
1910. AMNH, 90.1/2029.*

Arrows, Meje. *Iron, copper alloy,
plant fiber, leaf fragments. L: avg.
18.4 in. (47 cm). Lang, coll. Medje,
1910. AMNH, 90.1/2031a–d.*

This quiver, made from the hide
of the sitatunga antelope, held
arrows like the ones pictured
with their variously patterned
points.

8.4
**Chief Okondo in dancing
costume, Okondo's village,
1910.** *AMNH Archives, 111884.*

Music and dance were important
aspects of Mangbetu political
beliefs. A chief's reputation
rested, in part, on his ability to
dance well. Chief Okondo stands
to dance, wearing a costume for
the occasion, while his principal
wives sit on stools behind him.

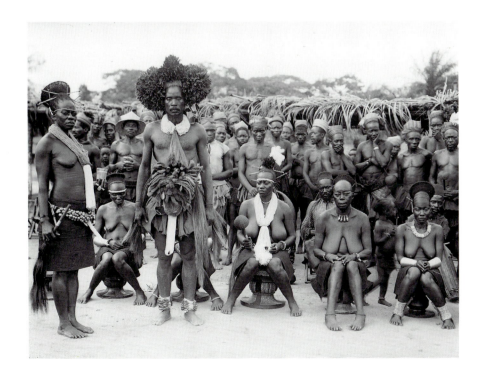

understood that without a great personality to
lead them there would be no kingdom. The
most important qualities of a good king (or of
any leader) were personal qualities: *nataate* (the
ability to be someone) and *nakira* (skill and
intelligence). In order to achieve and maintain
his authority, a Mangbetu king had to demon-
strate that he possessed both of these attributes.
Mbunza's public dancing, described by
Schweinfurth (and in chap. 10, pt. 1), can be
interpreted as the king's demonstration of these
two qualities. Most early Western travelers
commented on Mangbetu kings dancing before
their wives and followers. Lang wrote that the
dance of King Okondo "meant the heroic effort
of a star performer, and his endurance, agility,
and display of splendor were famed abroad by
hundreds of admiring subjects" (1918a, 530).
To the Mangbetu, possession of skills necessary
to coordinate body movements with music and
a personal style that held the attention of an
audience signified the ability to rule (**8.4**).

On another occasion Schweinfurth witnessed
King Mbunza speaking as a finale to a public
gathering:

> Munza endeavored to be choice and emphatic
> in his language, as not only did he often cor-
> rect himself, but he made pauses after the sen-
> tences that he intended to be impressive, to
> allow for the applause of his auditors. Then the
> shout of "*Ee, ee, tchuppy, tchuppy, ee, Munza,
> ee,*" resounded from every throat, and the
> musical instruments caught up the strain, until

the uproar was truly demonical. Several times
after this chorus, and as if to stimulate the
tumult, Munza uttered a stentorian "*brr*—"
with a voice so sonorous that the very roof
vibrated, and the swallows fled in terror from
their nests in the eaves. (1874, 2:51)

By speaking eloquently, Mbunza was demon-
strating the essence of his ability—his *nataate*
and *nakira*. The diverse ethnic and kinship loy-
alties of subject peoples and the constant mili-
tary threats from foreigners meant that the
Mangbetu king had also to be a military leader.
At least three of the greatest Mangbetu kings—
Tuba, Mbunza, and Dakpala—died defending
their lands. Moreover, booty was an important
source of wealth for Mangbetu kings and their
peoples. Manziga and Nabiembali were con-
querors who relied on soldiers of the Mabiti
House, as well as on a dependent lineage of
soldiers (the Mando). Schweinfurth clearly indi-
cates that Mbunza defended his rule with force.
At every gathering the explorer attended, armed
soldiers stood at the periphery of the royal
party. When he visited the king's armory,
Schweinfurth saw bundles of 200–300 lances
and piles of knives ready to be distributed in
case of war.

The Mangbetu believed warfare was a critical
component of their power, one which they rou-
tinely demonstrated to each other as well as to
foreigners. A typical way for Mangbetu kings to
honor and impress foreign visitors was with a
display of military maneuvers—in other words,
to stage a mock battle. Casati witnessed such a
presentation at the court of Yangala:

> The spectacle is a sham fight. Single warriors
> open the action by jumping forward and par-
> rying with their shields, kneeling, and hurling
> spears; thus giving evidence of their skill. Their
> rivals approach with arrows, leaping behind
> obstacles, stretching themselves on the ground,
> running in a stooping position, and waving the
> bow as a defiance to the enemy. . . . The first
> fighters have already increased in number, and
> war cries prove the excitement of the struggle.
> . . . Here comes the king—handsome, nimble,
> elegant, and distinguished by the richness of
> his ornaments. . . . His clever handling of the
> spear and shield, the rapidity and animation of
> his movements, as well as the regularity and
> precision of his performance, attract special at-
> tention. . . . The great trumpet sounds the war
> cry; there is general silence, the troops move
> forward with the king at their head, the *nug-
> gare* [horns] resound—halts, movements to
> and fro, and the fight is resumed; lances are
> thrown, whilst cries and war songs are heard.
> Suddenly the king throws his spear, and the
> rest follow suit, waving the *trombask* [war
> knife] and storming the enemy. There is a
> hand-to-hand fight, with a simultaneous burst

of applause. Then the king retires to his apartments, possibly to wipe his royal brow. (1891, 1:151)

The principal Mangbetu weapons were the spear or lance, shield, curved knife, and bow and arrow (8.3). The most favored war tactic at the end of the nineteenth century was to first shower arrows on the enemy and then to advance from several flanks with columns of spearmen. The spearmen carried large wooden shields, five or six extra spears each, and curved knives to hook their opponents' shields or dispatch a wounded enemy. Lang observed that in war games the spears were thrown "rather high up into the air about a distance of fifteen to thirty yards, [and] they land in nearly perpendicular position" (173). The most disciplined Mangbetu troops also used a heavier spear for stabbing or for throwing at closer range. Lang collected heavier spears and noted that they were used for hunting, show, and warfare (165). In some cases these tactics and weapons were new to enemies and very effective. The Mangbetu military advantage over subject peoples may even have originated in their discipline and their use of the spear and shield. Early Western observers noted that the Meje and Mangbele used only bows and arrows, but their Mangbetu-Mabiti masters carried spears and shields.[2] When the Mangbetu fought well-armed and warlike neighbors such as the Azande, however, weapons and tactics were more evenly matched.

Mangbetu shields and knives were distinctive and effective, both as weapons and as symbols of ethnicity and political organization. The Mangbetu rectangular shield made of wooden planks with woven reinforcements was distinctive in the region. Azande shields, in contrast, were elegant oblong structures, constructed of twined fibers that were painted with intricate geometric designs on one or both sides. Mangbetu chiefs' shields were decorated with skins and feathers specifically denoting royalty. One that Lang collected (AMNH, 90.1/2019) was decorated with twenty-four bundles of warthog bristles and red tail feathers of the gray parrot:

[This shield is] a most highly valued piece and [it is the] privilege of only the chiefs to carry such decorations. Usually their women or men bear it after them, but when they arrive in a village after having beaten their drums and gongs, these shields are held high and swayed to and fro in a very peculiar manner. The lower end of the shield rests . . . on the left forearm. . . . They take hold of the strap about at halfway [along] its length and moving the left arm in a semicircle, they jerk at the band so the wart hog bristles and feathers will sway

up and down and sideways. They always call the name of their chiefs and some wishes for his health. The shields of the chiefs are usually cleaned so the whitish natural color will at once denote the position any chief has taken, in battle, where he usually takes . . . a slightly elevated position, or meetings, where his shields are held high or hung up conspicuously. There are always about two or three bundles of spears with them (each bundle has about ten). (3080)

According to Lang spears also served as symbolic emblems. He likened them to national flags: a "show spear is often given to the chief's messenger [when he] . . . is sent to one of the smaller chiefs. The spear represents in this way the flag of the larger powers and is respected as much as the small flag given to messengers of the government" (869).

Mangbetu blacksmiths made a great variety of knives, each with a particular name and some with a distinctive use. Men wore new knives fastened in their belts as decorations and symbols of status. The most typical and famous Mangbetu knife was the curved bladed *emambele*, which served as a scepter, as portrayed in Schweinfurth's drawing of Mbunza (2.3). By the early colonial period these knives were being made with anthropomorphic handles (7.21). Often the carved head was made by someone other than the blacksmith (1144). Knives of this shape collected before the turn of the century had blades made of iron or brass and handles made of brass or iron wire, ivory, or wood (8.1).

The Mangbetu could field sizable armies. In addition to a small standing force at the capital, every subject lineage sent soldiers at the request of the king. Failure to do so was met by swift and harsh retaliation. The Mangbetu generally fought in homogeneous ethnic and linguistic units, with overall command exercised by the king or a deputy. On large campaigns slaves, youths, and wives accompanied the soldiers, carrying food and weapons. On raids, which required the approval of the king or a subchief, men traveled in small groups and ate preserved food or lived off the land.

Although the Azande remained militaristic, the Mangbetu relied less heavily on force after Mbunza's reign. The ruling Zande lineage, the Avongara, made a conscious effort to keep themselves distinct from the lineages of commoners and to preserve themselves as a ruling military elite. One indication of this effort is that Avongara kings always dressed as warriors, thus presenting themselves as constantly ready to defend their conquests. The Mangbetu-Mabiti, by contrast, mixed more freely with

their subjects and enjoyed pomp and ceremony, relying far less on military might.

One reason the Mangbetu did not turn to rigid separation and austerity to maintain power may have been that because their conquests were less wide-ranging than those of the Azande, a large proportion of their subjects had languages and cultures intelligible to their own. In addition, their relative integration with their subjects was more in keeping with the lineage model from which the Mangbetu kingdoms had evolved. Mbunza's father, Tuba, finding it necessary to preserve a mild separation between rulers and subjects, decreed in about 1860 that subjects could not call the Mangbetu-Mabiti *aja* ("uncles," men of the mother's lineage) even when the subjects' mothers were Mangbetu-Mabiti women. During the same period, however, the members of the ruling lineage themselves began calling all of their subjects "uncles," thus extending the lineage model to take in the entire kingdom. As uncles, subjects were responsible for helping their royal nephews whenever requested (see chap. 5). In the late 1860s, Azanga, Mbunza's brother, installed himself as a king south of the Bomokandi River. He further expanded the lineage model of the kingdom by asking all of his "uncles"— the elders of his Meje subjects—to give him the *naando* blessing given by father to son and uncle to nephew.

Another example of the relatively easy interaction between ruler and ruled is the way that each Mangbetu king joined with one or several non-Mangbetu-Mabiti lineages in order to rule. The most important people in the kingdom after the king's own sons and other close male relatives were members of the non-Mangbetu-Mabiti lineages that had most helped the king gain and keep power. Usually this meant a key role for the king's mother's lineage, his real *aja*, customarily expected to support and profit from their nephew's position (see the discussion of *aja* in chap. 5). The benefits of having a nephew in power were so great that court intrigue often centered on the rivalry between the uncles of different princes, each pushing their own nephew toward supreme power. From the Mangbetu-Mabiti point of view this relationship was essential to the maintenance and spread of power. Every Mangbetu king needed strong uncles to survive, and every Mangbetu king sent his sons to their own mothers' people and expected those people to obey and help extend Mangbetu power.

Such favored lineages received more power, did less physical work, and garnered more wealth from the king than did other lineages. Guy Burrows, an officer of the early colonial occupation force, commented that he was unable to recruit porters from a Mangbetu king because even though there were as many as sixty or seventy men around the king, they could not be expected to carry loads. " 'They do not work,' [the king] says, implying that as free-born they would not thus demean themselves" (1903, 80). In more recent times the daughter of a king, an older woman, related that her father had not wanted her to learn to make salt because she was of a royal lineage and should not have to do that kind of work. She was expected to work in her garden, dance for visiting Europeans, and accompany her father to meetings.[3] Some upper-class women let their fingernails grow long to show that they did not have to work. Junker noted this custom among the Barambo under Mangbetu leadership (1891, 421), and Lang received a gift of a fingernail necklace from Nenzima, Okondo's chief wife. Members of the upper class also dressed more elegantly than others. Interestingly, *nakirombi*, the Mangbetu word for a person who has good taste, comes from the same root as *nakira*, one of the qualities of a leader discussed above.

Although such wealth and power are evidence of a much greater inequality in the kingdoms than in the Houses, the upper class was not, as some early observers believed, a caste. One incident illustrates this point well. When Nabiembali was challenged by his sons, he was willing to destroy the Mangbetu lineage and make his former slave the king rather than lose his personal honor. Even in the mind of the king, personal qualities came before kinship or birth order in determining access to wealth and power.

Other facts confirm that the Mangbetu ruling classes were generally not segregated from their subjects. Rulers married into lineages of commoners. Many of those who were present at court were neither Mangbetu nor the king's *aja* but members of other families serving as village heads, advisers, aides, and soldiers. The cultures of royal and commoner lineages grew closer because the Mangbetu freely adopted the customs of their subjects and allowed them to adopt royal lineage customs (except for those practices reserved exclusively for the king). As a result, even head binding—the most visible sign of the Mangbetu elite—was adopted throughout the land.

With so many wars and power struggles continuing in the region, political relationships and the fortunes of lineages and individuals changed constantly. Proper birth was hardly enough to ensure power in this fluid sociopolitical context. Everyone, especially the king, depended on

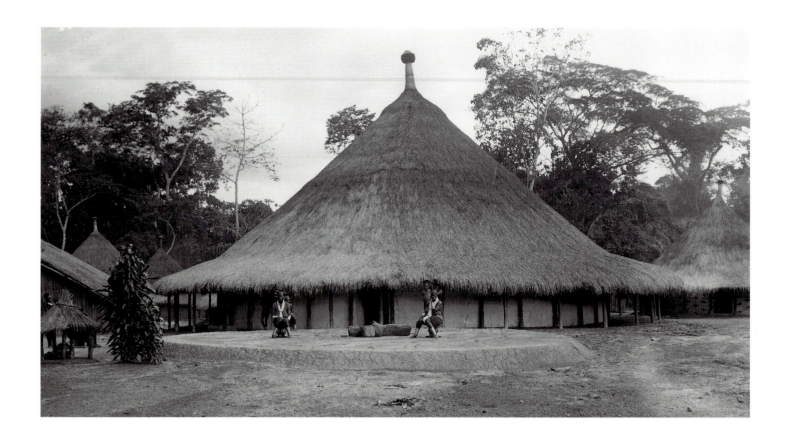

luck, ability, and effort, as well as birth, to maintain their social position.

The king made an effort to harmonize his policies with the feelings of his subjects, even though he had the final word in any discussion. He often consulted subchiefs, uncles, great warriors, and elders for advice. These advisers, the *ebaiki*, gave the king a chance to explore his subjects' views, functioned as a check on his impulses, and helped to legitimize decisions.

Another adviser, the *natangbombie*, was unique to Mangbetu courts. He was called by Schweinfurth a "court fool" and by Junker a "merry councillor," but his role appears to have been different from that of his supposed European counterparts. Like other counselors, the *natangbombie* put limits on the actions of the king. A modern *natangbombie*, Adiazi Appe, explained his function:

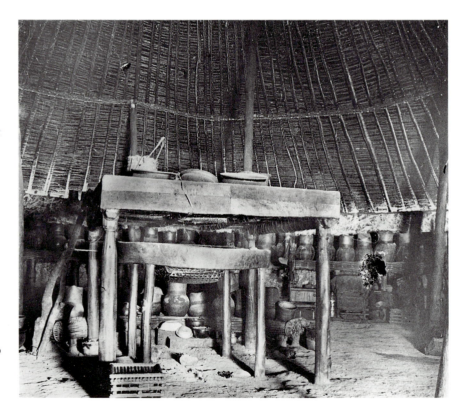

> The work of the *natangbombie* is hereditary. I learned the work from my father. My work is to make people hear what I say and to provoke acclamation. I announce the arrival of the king and make known his movements so that everyone will welcome him. The cries of the *natangbombie* implore the spirits of the ancestors to guard the king. . . . A special cane, *maduani*, accompanies the *natangbombie* to help bring good luck to the king. . . . The *natangbombie* was always with the king during his travels. He woke the king, announced his

←

8.5

Matubani's house, Okondo's village, 1910. *AMNH Archives, 111843.*

Mangbetu men, particularly chiefs and those of high rank, were polygamous, with numerous marriages providing alliances and descendants. Okondo was reported to have 180 wives. Houses for his wives were grouped together in the royal compound seen here. The largest building belonged to Okondo's wife Matubani, with whom Okondo stayed most of the time.

←

8.6

Interior of Chief Okondo's house, 1913. *AMNH Archives, 227014.*

Lang made detailed notes regarding the construction and organization of Chief Okondo's house. This photograph shows the hearth inside. The wall is lined with more than forty pots, each covered with a basketry lid.

→

8.7

Ornamented board, Mangbetu. *Wood. L: 33.3 in. (85.5 cm); W: 6.6 in. (17 cm). Lang, coll. Niangara, 1910. AMNH, 90.1/ 4534.*

Geometrically patterned boards were placed on the top and sides of the chief's bed. The boards were blackened before carving and rubbed with redwood powder when used by the chief.

movements, and reminded him of the time to go to bed. . . . The *natangbombie* is the intermediary between the ancestors and the king. If the ancestors want to say something to the king they say it to me in my dreams. I have some prayers which I say in my room or in bed and I go to sleep immediately and dream of the ancestors who speak to me. There are no medicines to help me. Criticism [of the king] by the *natangbombie* is given in the evening before about six elders. I remind the king, standing up, in a sort of poetry, about the ancestors' actions and how they were different from his own. Whenever the *natangbombie* speaks to the king he must speak openly. He reminds him to act correctly. He can criticize or praise the king.[4]

The King's Wives

Every Mangbetu king had many wives, and some had more than a hundred. Although he gave various figures in different accounts, Lang once reported that King Okondo had 180 wives, and Mbunza reputedly had so many wives that he divided them into five groups. Each group resided in a compound several hundred meters from the others and surrounded by fences of trees, ostensibly planted there to make adultery difficult (**8.5**). In such a compound, a head wife directed affairs and often male slaves or eunuchs served to keep out interlopers.

The king's wives played important political and economic roles. Having a hundred or more wives ensured that the king's descendants would be numerous and important. In addition, large harems and a continual new supply of young wives and children were taken as evidence of the personal power of the king. Every Mangbetu king wove a web of alliances through wife-giving and wife-taking. Families wanted their daughters to marry the king in order to gain influence at court, and the king could eventually extend Mangbetu influence by sending his adult sons to rule their mothers' lineages.

The king's wives also added to the wealth of the capital. The first wife, the *nejombine*, allocated the work to be done in the fields, compounds, and kitchens. Tens of favorite wives (*omoandra*) did little physical work and usually stayed near the ruler, but they were still responsible for production because they directed slaves or family members to perform work for them. The great majority of wives, the *mava*, worked in the fields and generally enjoyed little favor from the king, presenting themselves only on special occasions. Lang wrote that Okondo "must have at least a hundred wives and counting the servants, slaves and young girls,

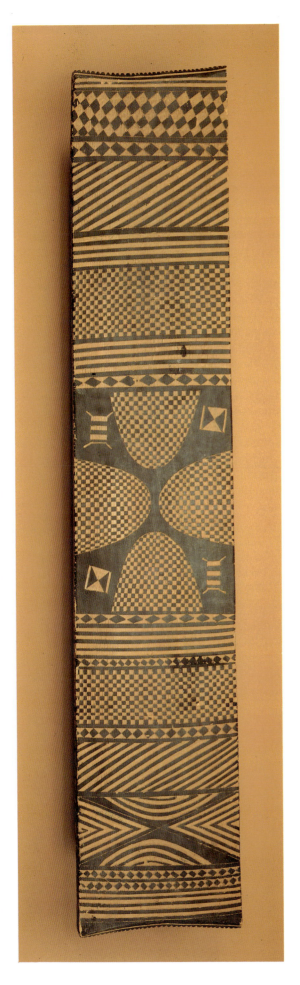

there are certainly more than 200 women attached to his court'' (1313).

The best known and most remarkable of Mangbetu wives was a woman named Nenzima, who was one of Mbunza's sisters. The common Mangbetu practice was for a king to require one of his sisters to remain unmarried and help supervise his affairs, so Nenzima may have first gained recognition as an aide to Mbunza. When Mbunza died in 1873 Nenzima became the chief wife of his successor, Yangala, and provided crucial support to his kingdom. The explorer Casati described Nenzima in the early 1880s as the ''queen of the Court . . . the prime ruler of politics and originator of the whims of the Government'' (1891, 1:146), and Emin Pasha noted that her residence was larger than Yangala's. Nenzima's importance in Yangala's kingdom was probably based on several factors: the general respect accorded to women, her own intelligence and decisiveness, and the fact that she was a true Mangbetu while her husband was an outsider. A reason given by Hutereau is that Nenzima's presence protected King Yangala from Mangbetu sorcery (1909, 71–72).

When Yangala died in 1895, Nenzima became the wife of his successors Mambanga and Okondo. At Okondo's court, Lang had several conversations with Nenzima:

> Endowed with great wisdom, she is renowned as a debater in court; the righteousness of her motives lends her sufficient daring to oppose rudeness and cruelty, and her charming simplicity places her beyond reproach. When it is announced that she will speak, great numbers flock to court. (1918a, 533)

Nenzima must have been between sixty and seventy years of age when she died in 1926.

Mangbetu Courtiers

The courts of the Mangbetu kings also included musicians, singers, dancers, interpreters, messengers, spies, healers, sorcerers, oracle workers, smiths, craftsmen, and craftswomen. There were generally no ''positions'' to be filled or wages to be paid. Each king simply gathered about him the people he found most loyal and useful, feeding and caring for them while they were at court. A few courtiers, such as oracle workers and smiths, might have been busy working for the king every day and have received food and gifts from the king. The others lived in the vicinity of the capital and came only when called, or lived at a distance and occasionally visited the capital to render their services.

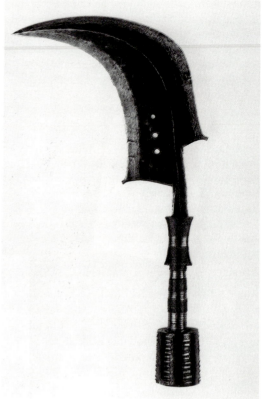

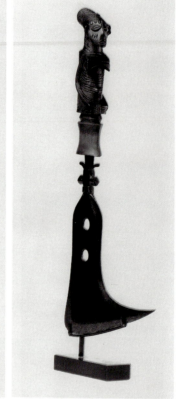

The ability of the king to gather skilled and creative subjects at his court was an important feature of Mangbetu kingdoms. Many of these people voluntarily left their villages in order to live at the capital. A drummer, describing to Keim the benefits of being connected to a king, cited the drink, food, and occasional money he received for doing something he enjoyed; the opportunity for excellence when he played with other good musicians; the recognition and protection that came as a king's performer; and the opportunity to speak to the king. Thus the capital became a center of excellence and innovation.

Symbols of Power

Most objects used by Mangbetu kings could be described with superlatives: the biggest, most beautiful, or most powerful. The kings built capitals that were far larger than the villages of subject Houses. With hundreds of wives and followers, these capitals could be described as towns. Likewise, the kings' clothing was more costly and finer than others could hope to wear: new barkcloth that was clean and stiff so that it would extend up under the arms, belts of rare animal skins, ceremonial knives made of brass, copper, and ivory (**8.6–8.9**), fly whisks

8.8
Knife, Mangbetu. *Iron, wood, copper. L: 20.9 in. (53.3 cm). Coll. 1882. British Museum, +8348.*

The wooden handle of this Mangbetu war knife is decorated with copper, the preferred metal in the nineteenth century for embellishing symbols of power.

8.9
Knife, Mangbetu. *Wood, iron. H: 17.3 in. (44 cm). Private collection, Los Angeles.*

The exchange of gifts among Mangbetu and Avongara rulers influenced art styles in the region. This highly embellished knife may have been presented by a chief to one of his courtiers or to another chief.

held as scepters (**8.10**), colorful feather head-dresses, and carefully crafted jewelry. Similarly, the kings' orchestras employed larger instruments and more musicians than village orchestras could afford.

Other symbols of power were fabricated by Mbunza's smiths, who used precious copper earned in the ivory trade to make showpiece weapons for the king. Schweinfurth wrote of

> hundreds of ornamental lances and spears, all of pure copper, and of every variety of form and shape. The gleam of the red metal caught the rays of the tropical noontide sun, and in the symmetry of their arrangement the rows of dazzling lance-heads shone with the glow of flaming torches, making a background to the royal throne that was really magnificent. (1874, 2:43)

The spears represented Mbunza's military might, and the material they were made of showed his ability to deal profitably with foreigners.

Certain natural products considered symbolic of the king's power always went to him, although he could give them to favored subjects. For example, if hunters killed a leopard—the most feared and respected of animals—they were obliged to send the skin, claws, and teeth to the king or face terrible punishment (**8.13**). Likewise, certain parts of other rare or powerful animals always went to kings: the red tail feathers from the gray parrot (**8.11**), eagle feathers, and the skins of the civet, the okapi (**8.12, 8.14**), the genet, and the lion. The materials were often incorporated into the king's clothing and accessories or used to decorate his shields. Lang collected a magnificent leopard-skin belt ornamented with a large number of lion and leopard teeth with brass beads used as separators (**8.15**). As the authority of kings has declined, so have these royal prerogatives. Today, the dance costumes of many people include hats with parrot and eagle feathers, although leopard is still the prerogative of chiefs.

Several other objects were reserved for the king. Some musical instruments could be used only in the court orchestra (see chap. 10) and, among the Mangbetu, were specifically associated with chieftaincy. The *nengbongbo* (double iron bell) (**8.16**) symbolized the king's authority, and its sound accompanied him wherever he went. Certain war horns were also specifically associated with chiefs, sometimes with particular rulers. One of these objects was an enormous horn called *emboussa*, made of ivory, wood, and elephant and okapi skin that Lang obtained in 1915 in Niangara. From the detailed description he gave of its manufacture, it may have been made for him. Lang recorded

8.10
Whisk, Mangbetu. *Ivory, elephant hair. L: 31.2 in. (80 cm). Lang, coll. Panga, 1914. AMNH, 90.1/5006.*

Fly whisks formed part of court regalia. Lang wrote that the whisk was "a sort of scepter of the chiefs in common use with the Mangbetu and all the neighboring tribes, generally worn in the right hand [and] used as a flywhip. The wearer enjoys evidently a certain distinction as it is the privilege of chiefs and other important men to carry one of these fiber bundles" (375). This fly whisk was carved by a Mangbetu but used by the Zande chief Akenge.

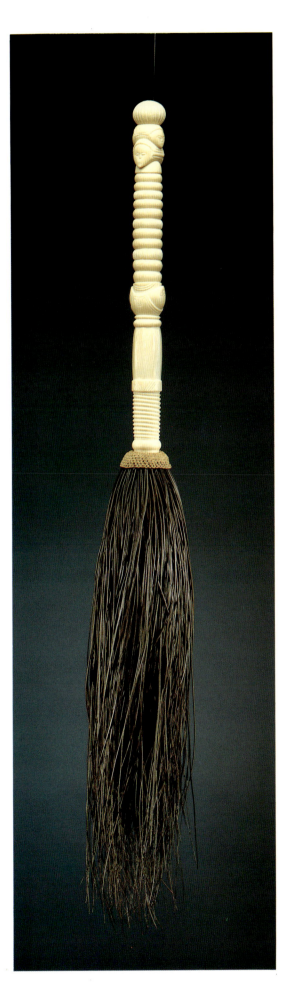

8.11

Whistle, Meje. *Wood, hide with fur, gray parrot feathers, fiber cord. L: 14.0 in. (36 cm). Lang, coll. Medje, 1914. AMNH, 90.1/2126.*

Peoples of northeastern Zaire used whistles to communicate with spirits; whistles allowed their owners to perform various magical acts. This whistle, which belonged to a chief, is embellished with a tuft of red tail feathers from the gray parrot.

8.12
Hat, Azande. *Okapi hide with fur; plant fiber; gray parrot, touraco, and eagle feathers. L: 17.2 in. (44 cm); H: 11.7 in. (30 cm). Lang, coll. Akenge's village, 1913. AMNH, 90.1/2858.*

Upon killing an okapi hunters were required to offer its hide to the chief. The hide was then incorporated into royal objects such as hats, belts, and instruments. In the past, red tail feathers from the gray parrot were also reserved for chiefs.

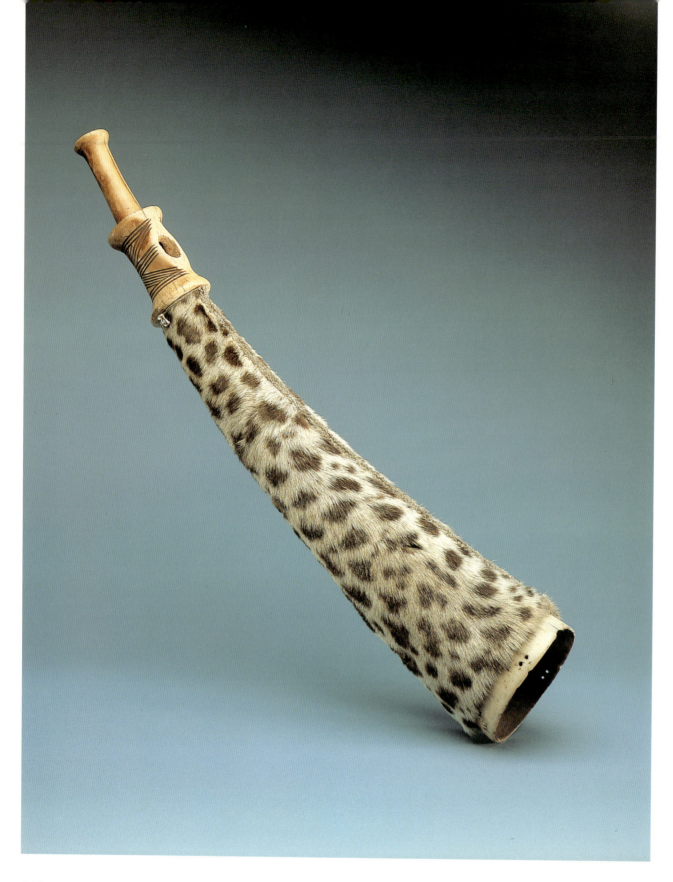

8.13
Horn, Mangbetu. *Ivory, leopard hide with fur, fiber cordage. L: 20.7 in. (53 cm); D: 3.6 in. (9.3 cm). Lang, coll. Niangara, 1913. AMNH, 90.1/3975.*

Horns crafted for the chief's orchestra were elegantly carved in ivory and sometimes covered with animal hide. The use of leopard hide was reserved for chiefs.

8.14
Harp, Mangbetu. *Ivory, okapi hide with fur. L: 26.5 in. (68 cm). Lang, coll. Medje, 1914. AMNH, 90.1/2230.*

Harps did not come into vogue among the Mangbetu until the early colonial period. Chief Okondo commissioned this ivory harp featuring carved Mangbetu-style heads on the ivory pegs and a human figure on the bow. The resonator is covered with okapi hide.

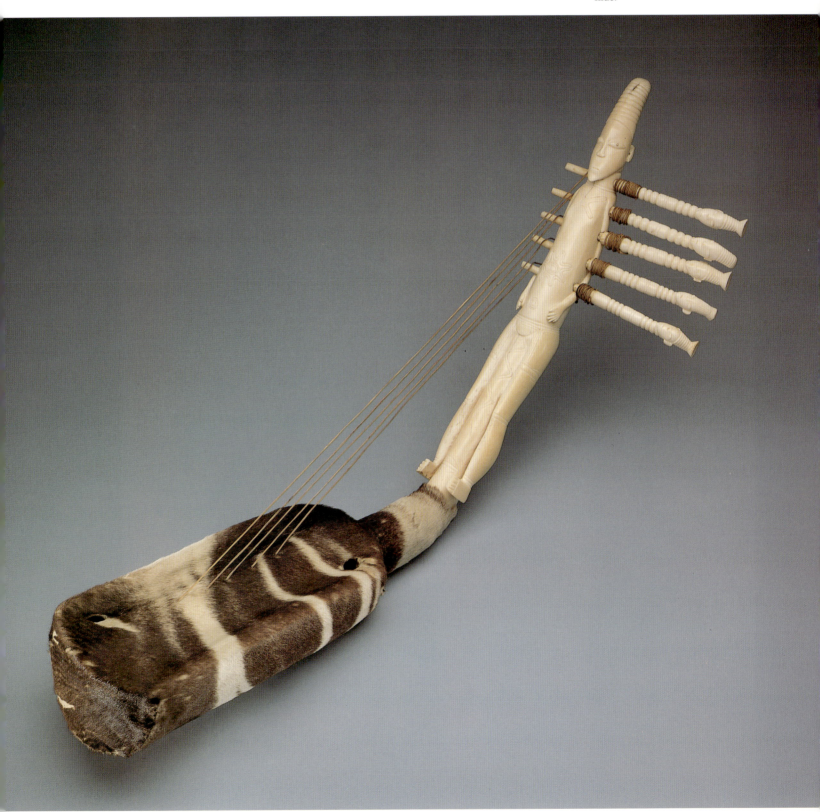

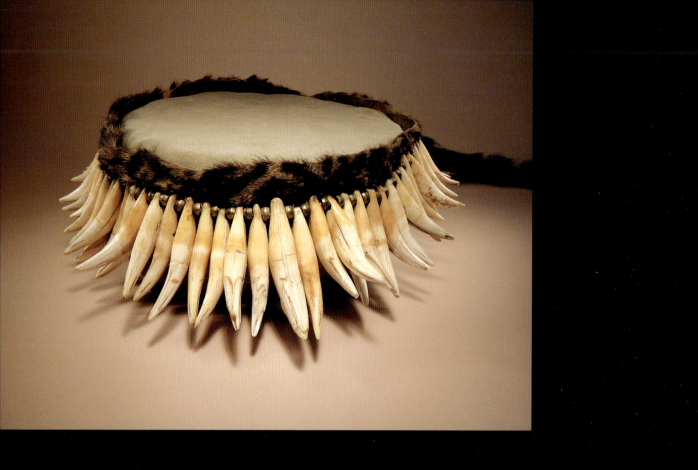

that "the present specimen" (9.18) was made by a Mangbetu from Niangara who spent three months working on it. Lang regarded it as "the very highest achievement of Mangbetu art." He noted, however, that he had only seen one other example:

> [These horns] are practically the only heirlooms that one sees in these regions, as all other objects are destroyed after the death of a chief. The surrender of such a horn means with them absolute submission to their enemies. These horns are extremely rare. I have only seen one of chief Zebuandra, near Medje, and it is very seldom that they make . . . use of it [now], in fact they hide it. But the natives tell a great many stories about it, for instance, they state that there is a piece of skin of a white man sewn below the other hides, that all sorts of amulets of other powerful charms are fastened in its interior. That if Zebuandra would go to war the very sounds would confound the enemies, etc. They use it of course in great dances, sometimes still to announce the arrival of chiefs when visiting the [Belgian] Post. These horns make the reputation of a chief. (3677)

The Mangbetu-Mabiti lineage also owned a backrest, *negbangba*, pictured in Schweinfurth's classic drawing of Mbunza (2.3). Schweinfurth described it as "a large support of singular construction, resting as it seemed upon three legs, and furnished with projections that served as props for the back and arms of the sitter; this support was thickly studded with copper rings and nails" (1874, 2:41). The backrest rightfully belonged to the Mangbetu king who was in most direct succession from Nabiembali: Tuba, Mbunza, Azanga, Zebuandra, Niapu, Nganzi, and Adruandra. It was reportedly destroyed by white ants during the violence following the independence of Zaire (then Congo) in 1960. During the colonial period, some local administrators feared that possession of the *negbangba* might give rise to a Mangbetu "king of kings" who could organize region-wide resistance. Other officials speculated that they might use this paramount king to influence other kings to cooperate with the state. The *negbangba* was not a sacred object, however, and did not give its owner any specific authority. It was a cherished family relic representing an ideal of unity within the Mangbetu-Mabiti House, but it meant little in political terms.

Two magnificent backrests similar to the one owned by the titular head of the Mangbetu-Mabiti were collected around the turn of the century, one by Burrows (2.15) and one by Hutereau (8.17). Both of these examples were covered with brass wire and studs and could be used only by chiefs and important men,

whereas simpler versions might be used by any man. Women did not use backrests.

A king's behavior, as well as the material possessions surrounding him, was special and circumscribed, even though he was not a sacred king as were some other African rulers of the nineteenth century. Schweinfurth wrote that the king's fire could not be used by subjects (1874, 2:98). Casati and Emin Pasha noted that the king did not eat in public and that any extra food from his table was buried, presumably to prevent sorcerers from making medicine with it (Casati 1891, 1:177; Schweinfurth et al. 1889, 206). Lang noticed that "objects destined for the king or persons of his close family never touch the ground. They are always put upon a mat" (1446). They were often larger than the objects used by ordinary people. Serving bowls for the court, used to serve many people, were enormous. Lang also collected a very long wooden tube (37.3 in.) with a carved bowl at the end that Okondo used to drink beer. The bowl is covered by a lid with a carved head (AMNH, 90.1/3997).

The burial of a king differed from those of his subjects. Most written and oral sources agree that when the king was buried, several of his wives, but not all, were killed and buried with him. There is disagreement, however, on the disposition of the king's possessions. Lang wrote that at the death of a Mangbetu king his people

> have great ceremonies and according to traditions certain [of the king's] objects are thrown in the forest, certain are burned in the fire, others thrown in the river. Nothing is preserved except objects of sorcery which are inherited from generation to generation. (1060)

Some writers and informants have reported that a king's most personal possessions were buried with him but that other objects were distributed to family or passed to his successor. It is probable that burial customs varied across the region and over time. Several descriptions indicate that in Azanga's kingdom south of the Bomokandi it was the practice to burn the king's body and place his ashes in a carrying box and bury them in a house guarded by *adimbo*, specially appointed soldiers whose descendants guarded the grave after the *adimbo* died.

The symbolism of grandeur associated with Mangbetu kings is closely related to magic, another tool of Mangbetu power (discussed in chap. 9). Mangbetu kings owned powerful charms and medicines such as a war whistle (*odikire*), a war belt (*nekporo*), and a rain staff to

8.15
Belt, Mangbetu. *Leopard hide with fur, leopard and lion canines, brass, fiber cord. W: 16.4 in. (42 cm); H: 4.3 in. (11 cm). Lang, coll. Panga, 1914. AMNH, 90.1/3304.*

For the Mangbetu, leopards symbolized power, and only rulers could wear teeth, claws, or hide taken from these animals. Made of leopard hide and encircled with leopard and lion canines, this belt was a particularly important part of a chief's regalia.

8.16
Double bell, Mangbetu. *Iron, plant fiber, wood. L: 23.5 in. (60.2 cm); W: 17.7 in. (45.3 cm). Lang, coll. Rungu, 1913. AMNH, 90.1/5130a.*

The double iron bell, used in the court orchestra, is one of the most important symbols of chieftaincy. Its fabrication and use were meshed with ritual, and blacksmiths prepared the bell in the forest under strict secrecy. Oral tradition tells that before the time of Belgian rule, a person was sacrificed, the completed bell was filled with human blood, and parts of the victim were eaten by the blacksmiths. Looking into the bells was prohibited; doing so was thought to cause death. This double bell was collected from Chief Senze.

mass is rubbed upon the breast, shoulders and forehead. This process is then accompanied with loud exclamations for good luck in hunting. The dances in the forest are monotonous affairs repeated every morning and evening. (301)

Magic for hunting and general good luck was just one attribute of *naando* usage. The substance also had at least three other important qualities: it permitted users to bless someone, to divine, and to heal. In most Mangbetu areas, specialists in the use of *naando* called *andoi* (sing., *naandombie*) belonged to a society that used the root along with dancing, songs, and other rituals to discover hidden things (such as witches), to foretell the future, and to bring a general blessing to people. Initiates had to master *naando* music and rituals, endure physical hardship, and understand the moral precepts of society, such as respect for elders. The *andoi* could be called on by village leaders or others to perform, divine, heal, bless, and instruct.

The Mangbetu sometimes prepared the root in food or drink and invited their friends to join them to perform *naando*. People came bearing arms to these celebrations, sometimes becoming quite aggressive and fighting under the influence of the root. *Naando* affects people in different ways and can produce sleepiness, sexual arousal (which the Mangbetu describe as the

desire to commit adultery), hunger, thirst, fear, industriousness, and other states. Most informants indicate, however, that the usual reaction was a wakeful tranquility and a desire to dance, which they contrast with the boisterous danger of alcohol. In describing a double *naando* pot, Lang noted that the beverage made from the scrapings of the root

> has first an exciting effect (produces the desire to dance exuberantly) but afterwards causes a long sleep during which dreams and hallucinations are the rule; under the inspirations of these, all sorts of crimes are committed because it is a common belief among these tribes (Abarambo, Medje, Makere—also some Azande of the forest) that thus they can foretell the future and often divinatory powers are ascribed to it. (They detect thieves, see their enemies, but also find out if these are successful in their prospects.) (2851)

These gatherings could go on for days and weeks. Generally at the end of a *naando* fete, the *naando* blessing was performed by and for the group.

Before the rise of Mangbetu kingdoms, when regional Houses were still quite small, the use of *naando* for a blessing and for hunting luck may have been practiced by the lineage organization, whereas specialist *naando* users, *andoi*,

←
9.2
Mangbetu woman eating *naando* root, Nangazizi, 1989.

The root from the *naando* plant is an essential element in the *naando* ritual. Participants can drink a liquid made from the root or chew it as seen here. The substance acts as a stimulant to provide energy for the prolonged dancing that occurs during *naando*.

9.3
***Mu* dancers, Poko, 1913.** *AMNH Archives, 225160.*

Barambo dancers are arrayed in leaves as they perform the *mu* dance, a part of the *naando* ritual. Their costume incorporates materials from many forest animals and plants, and their songs and dances bestow the blessing of the forest on the community.

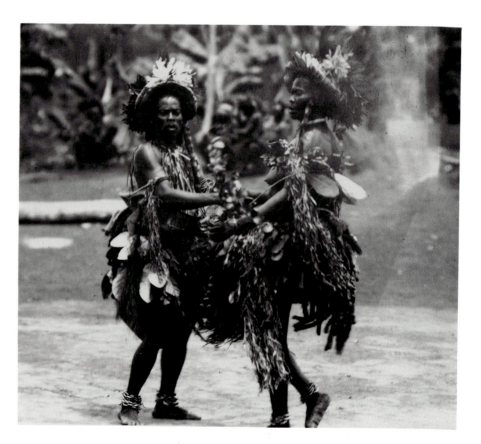

9.4

Double pot, Mangbetu(?). *Ceramic, plant fiber. L: 7.3 in. (18.6 cm); H: 6.2 in. (16 cm). Lang, coll. Niangara, 1909–15. AMNH, 90.1/4699.*

Used in the *naando* ritual, double pots like this one were filled with hallucinogenic liquid made from a macerated root, also called *naando*. Participants drank through a long tube, first from one side and then the other, before beginning their strenuous and lengthy dancing.

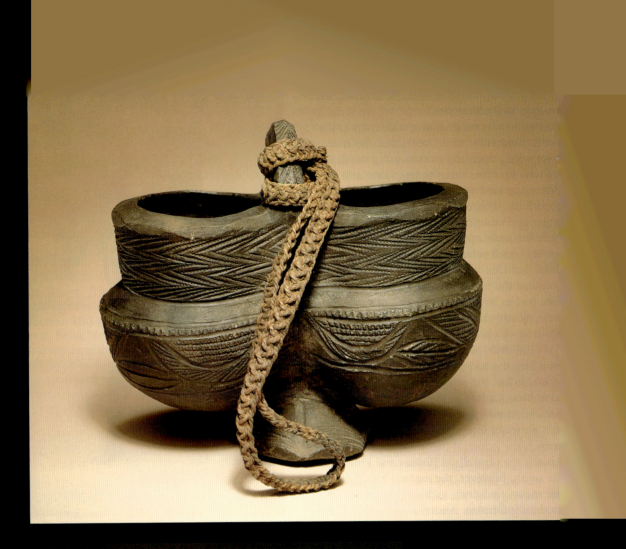

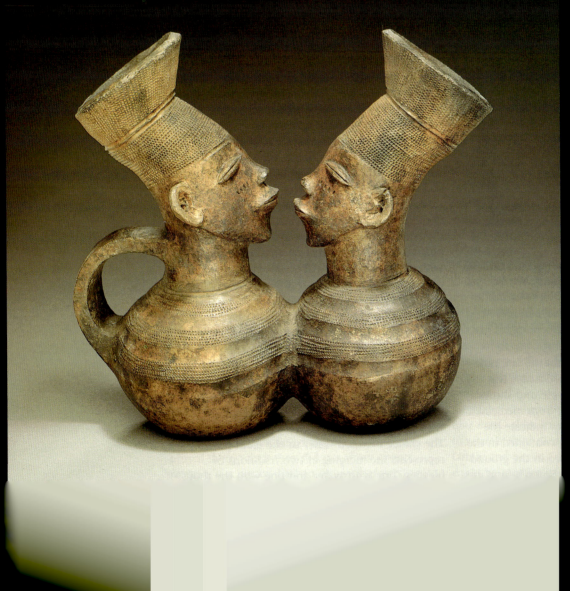

9.5

Double pot, Mangbetu. *Ceram L: 10.5 in. (27 cm); H: 9.2 in. (23.5 cm). Lang, coll. Niangara, 1913. AMNH, 90.1/4693.*

Anthropomorphic ceramic pots were sometimes produced with double images as seen here. Th use for such pots is uncertain, but the double-bowl form is derived from *naando* pots.

transitory misfortunes (like a cold or the flu) or universal ones (like insect attacks on gardens) were not considered due to witchcraft. Witchcraft was believed to be so widespread that it would have been impractical to discover all its sources. Consulting the *mapingo* involved time and wealth, and there were many effective medicines against witchcraft that were less costly and incurred less social risk. When a person died, however, the *mapingo* oracle was consulted (see below, Oracles). The oracle would often counsel vengeance magic rather than confrontation.

When the oracle looked for the cause of a misfortune, it searched among the enemies of the family. It assumed that witchcraft was directed by thoughts of envy or revenge and that victims were not chosen at random. Suspicions and accusations of witchcraft did not generally threaten the social hierarchy: a subject would not have accused a chief, because a chief had no reason to envy his subjects. Similarly, a woman would not have accused a man, because men had no reason to envy women. Chiefs feared their subjects since commoners could bewitch chiefs, but the chiefs did not generally accuse subjects of witchcraft, because powerful oracles and medicines enabled the chiefs to foresee problems and guard against harm. An accusation would have been an admission of weakness. Likewise, it would have been self-defeating for a man to accuse his father or brother, since witchcraft was always passed from father to son. The most frequent accusations were made by men against their wives.

Neada

Besides *notu*, envious or vengeful people could also be accused of using magic[6] or poisons to harm others. Such "bad medicine," *neo amada* or *neada*, was widely available because many medicines had both good and bad uses. Unlike witchcraft, *neada* could be used day or night and against men of one's own sublineage. Evans-Pritchard's term *sorcerer*, when applied to Mangbetu who used bad medicines, is somewhat misleading. In some cases such medicines were sanctioned, as when a Big Man used them against enemies of his House, or when a family used them on the advice of an oracle for secret revenge against someone who was held responsible for the death of one of their members. Some people made a practice of using bad medicines and might therefore be termed sorcerers by Mangbetu, but almost everyone knew how to use potentially harmful medicines or could easily learn. However, use of such medicines out of personal greed, jealousy, or vengeance

was not condoned, and both sorcerers and occasional users were punished. The most powerful sorcerers were either killed or chased away or, if it was feasible, put to work by a chief or king against his enemies. Occasional users were expected to heal their victims and refrain from their misdeeds.

Society and Nature

The Mangbetu-related peoples were deeply aware of nature's patterns and made their living almost exclusively from activities that depended on nature. They calculated time by the sun, moon, and stars, and patterned their yearly work after the rhythm of the rainy and dry seasons. They knew intimately the plant, animal, and mineral resources of their land and extracted its raw materials for both their material and symbolic culture. Mangbetu speakers who can also speak French use the word for forest, *negbondo*, when translating the French word for "nature" into Mangbetu. The forest is the largest and most general symbol of nature in the region. Rivers and streams, marshes, rocky outcroppings, and patches of savanna are regular features of the land, but the forest dominates the concept of nature.

There is not a great deal of information on Mangbetu beliefs about the origin of nature. Today informants in the northern Mangbetu area say that the forest has always been there, even before Azapane, and also before the creator god called Angele, introduced by Muslims and Christians. Southern Meje informants say that the first ancestor, Azapane, was himself created by a person they called Nouboofobu ("it grew by itself"), a term also used for a volunteer plant in a garden. Whatever nature's origin, it existed independently of any concept of a divine being and was believed to be essentially fixed and ordered. It was susceptible to minor influence through magic, but drastic actions were usually unnecessary, and probably futile. People could normally count on a good growing season and a good hunt every year.

We do know something about Mangbetu beliefs concerning the control of rain, for they are expressed in a number of objects made for this purpose. Both Hutereau and Lang collected staffs and charms for bringing rain and for stopping it. The magic was aimed at controlling the rain on a particular occasion, for an impending journey or a hunt, for example. It was not aimed at changing the weather for a whole season. The Mangbetu assumed that rain would come seasonally and that it could only be stopped for a short while (as for a feast or to dry a crop) or in a small place (such as the garden of an enemy). They also believed that

9.9
Child's belt, Meje. *Okapi hide with hair, animal tails, turtle vertebrae, seedpods, fish jawbone, tooth, fiber cordage, shell, brass wire. W: 8.8 in. (22.5 cm); L: 17.6 in. (45 cm). Lang, coll. Medje, 1910. AMNH, 90.1/1527.*
A child wore this belt, with its numerous hanging charms, as protection against witches.

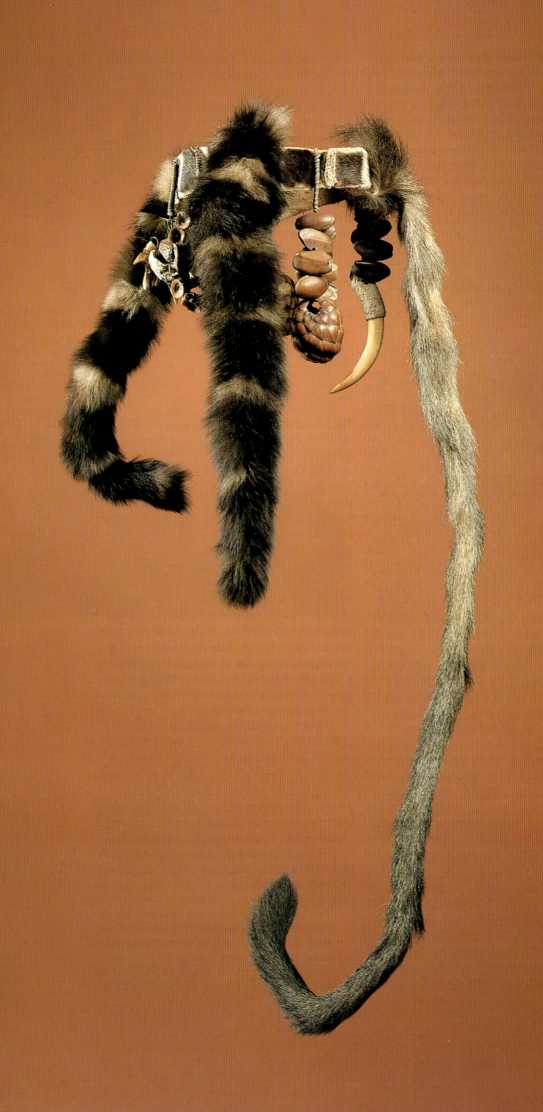

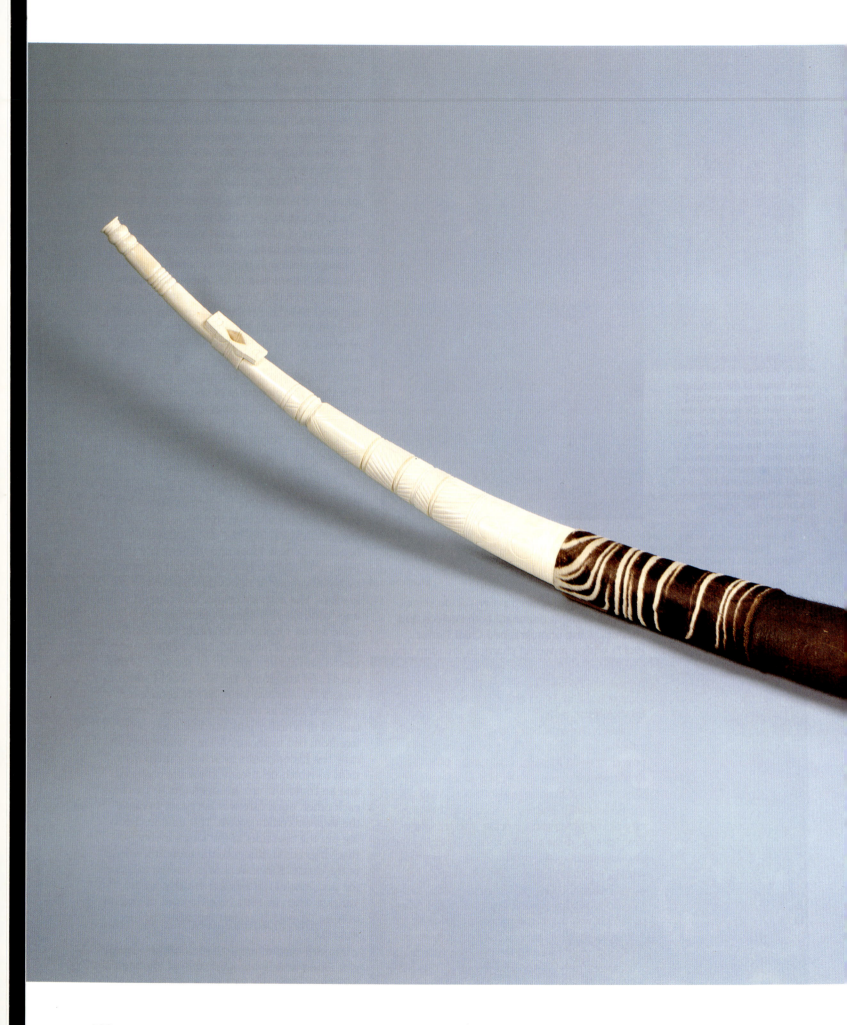

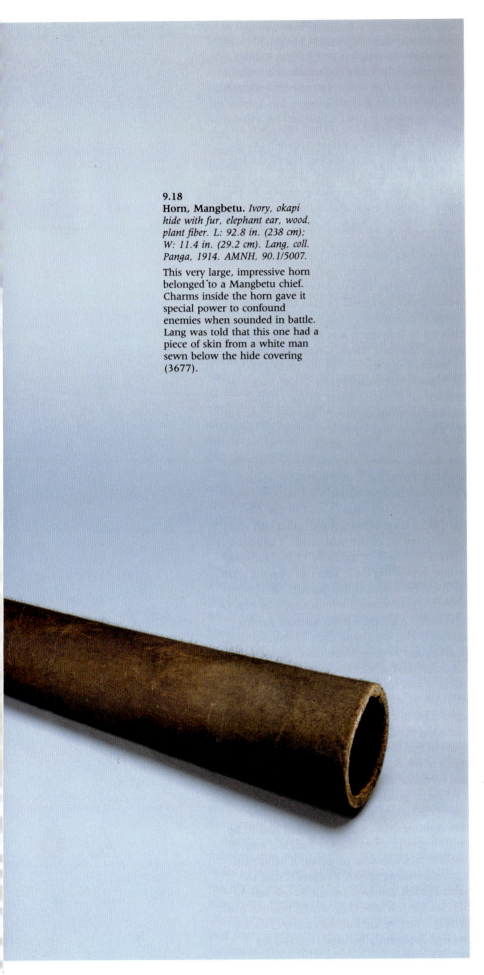

9.18
Horn, Mangbetu. *Ivory, okapi hide with fur, elephant ear, wood, plant fiber. L: 92.8 in. (238 cm); W: 11.4 in. (29.2 cm). Lang, coll. Panga, 1914. AMNH, 90.1/5007.*

This very large, impressive horn belonged to a Mangbetu chief. Charms inside the horn gave it special power to confound enemies when sounded in battle. Lang was told that this one had a piece of skin from a white man sewn below the hide covering (3677).

and on, Mangbetu subjects. There the sticks used in a chief's *mapingo* were sometimes replaced with little statues representing the chief. The answers given by this *mapingo* were then said to be answers given by the chief, thus identifying the immense prestige of the *mapingo* with the person of the chief.

The evolution of kingship ritual is also evident in *natolo*. The ruling Mangbetu-Mabiti lineage came to declare that it ruled the other lineages because of the *mbali* that was a gift from the first ancestor, Azapane. The Mangbetu-Mabiti lineage evidently called on more distant ancestors than did ordinary lineages, thereby enlarging the ruling lineage and legitimizing it with the blessings of many illustrious ancestors. South of the Bomokandi River, dead kings were buried in special houses and guarded by valiant soldiers (*adimbo*) whose occupation became hereditary. Here, King Azanga (Mbunza's brother) and his son Danga became important ancestors. When Danga died in exile in 1927, his head wife brought back his beard and a part of a finger, which were buried in his last residence in order to do *natolo*. She also returned with water that the chief had spit into a bottle so that his family could receive his *naando* blessing.

Like that of *natolo*, the role of *naando* evolved with the Mangbetu kingdoms. Nzamaye indicates, for example, that when the Mangbetu established the first kingdom south of the Bomokandi River in about 1865, Azanga did not know about *naando*. Azanga used other medicines such as *neiga* and *nogbogbo*. Once Azanga had established himself in power, *andoi* from each subject lineage gathered to transfer their *naando* to him. This practice of gathering *andoi* from all lineages to bless a new ruler continued into the middle colonial period.[18]

Such ritualization of kingship cannot be interpreted as a one-sided capture of ritual force by the king, however. Subject lineages gave their own interpretations to ritual relationships as well. For example, the Mangbetu rulers were sometimes half-jokingly and half-seriously accused of being witches who attained power by *notu* and not *mbali*.[19] The *naando* blessing given to the Mangbetu kings by subjects actually tended to make the kings ritually dependent on their subjects. Likewise, the fact that *mapingo* operators came from subject lineages made it possible for those subjects to influence the king's decisions at critical points. Such ritual accommodation of a new king and new subjects is common in African history and indicates that both the king and his subjects were beginning to recognize their interdependence. The struggle for ritual power between the kings and their

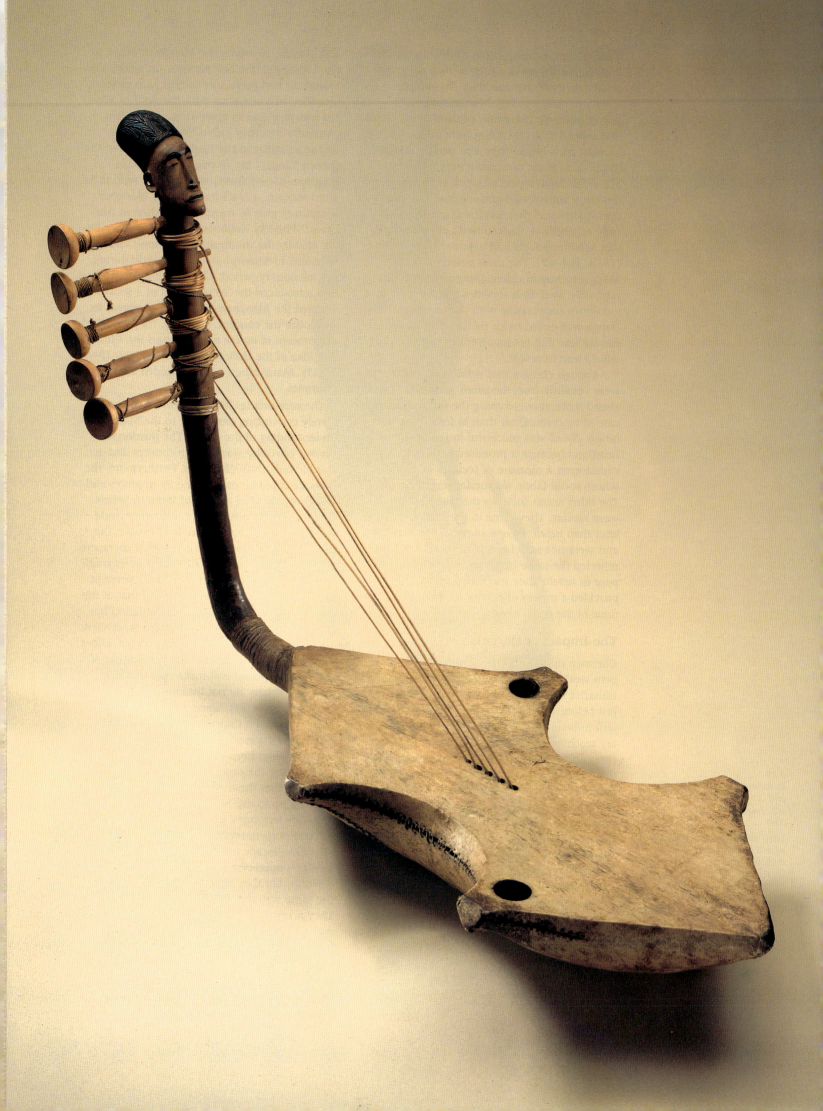

10

Music and Dance in Northeastern Zaire

Part 1

The Social Organization of Mangbetu Music

by Didier Demolin

The social organization of music has common features among all the societies of northeastern Zaire. Ritual or ceremonial music associated with initiations, mourning, and feasts is played by ensembles. This music is nearly always accompanied by dance. The music played by individuals, on the other hand, is seldom related to such formal occasions; its primary function is entertainment. This repertoire consists of songs accompanied by small instruments: harps, *sanza*s (**10.2**),[1] and zithers.

The music of the peoples of northeastern Zaire is characterized by polyphony (a texture produced by independent, contrapuntal melodic lines being played or sung simultaneously), hocketing (a technique whereby single notes are produced in alternation by different singers or players so that the combination creates a single melodic pattern), and polyrhythms (simultaneously performed rhythms composed of differing numbers of beats, played or sung within the framework of a single meter or cycle to obtain a "cross-effect"). The major rhythmic principle governing music throughout northeastern Zaire has been described as an ostinato —"the regular, uninterrupted repetition of a rhythmic pattern or melodic-rhythmic pattern with invariable periodicity" (Arom 1985, 93)— with variations. The modes used are traditionally pentatonic, most often without semitones. In the music of this region the voice carries the main melodic line. Musical instruments, whether melodic or rhythmic, accompany the voice.

Behind the unity in the structure and social organization of music in the area, there are many cultural variations. Each ethnic group has its own musical idiom, with distinctive songs, modes, instruments, and ensembles. Music has been exchanged among cultural groups for centuries, and the study of changes in musical idioms sheds light on the historical interactions among peoples.

The population of northeast Zaire can be seen as members of four interacting linguistic/cultural groups. The Pygmies—Asua, Efe, Mbuti—live in the rain forest. When Schweinfurth arrived at the court of Mbunza in 1870, he confirmed at nearly the same time as did du Chaillu (1868) in Gabon that Pygmies actually existed. Many Westerners subsequently observed them in the entourages of kings and chiefs. They were often invited by the kings for big celebrations, though such invitations depended upon whether relations between the two groups were good at the time. On these occasions, the Mangbetu greatly appreciated the singing and dancing of the Pygmies. Pygmy music consists mainly of vocal polyphony; they also perform in horn bands. Their influence on Mangbetu vocal music is apparent in some polyphonic dance songs.

The Bantu-speaking Bua, Bali, Ndaka, Budu, Nyali, and Bira also live in the forest and have polyphonic songs that incorporate Pygmy influences. These songs are connected to rites of passage (especially circumcision) and are characterized by hocket polyphony. Throughout the entire region, hocket polyphony is played on

10.1
Harp, Azande. *Wood, hide, plant fiber cord. L: 35.1 in. (90 cm). Lang, coll. Niangara, 1913. AMNH, 90.1/3965.*

Europeans admired harps with carved elongated heads. Although the heads depict the Mangbetu style, such harps were commonly made by the Azande.

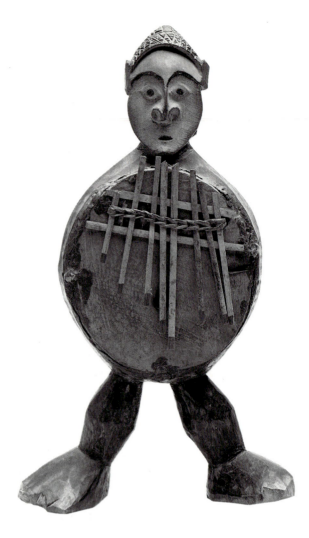

wind instruments. The Bantu-speaking peoples perform this music on whistles.

A third group of people, who speak Sudanic languages—the Mangbetu, Lese, Mamvu, Mvuba, Ndo, Logo, Bari, and others—live in both grasslands and forests. Their music includes hocket polyphony played by elaborate orchestras of wooden horns centered around chiefs, with an emphasis on mourning music. The musical ensembles of the Mangbetu chiefs play complex polyrhythms. The Mangbele were originally Bantu speakers but have been assimilated to the Mangbetu. They brought with them Bantu traditions that they have contributed to the Mangbetu.

In the north of the region, a fourth group is composed of Ubangian speakers, including the Azande and the Barambo. They play melodic instruments including xylophones, lyres, and *sanza*s in a polyphonic style.

Cultural exchanges were common throughout the region. Although the history of culture reconstructed through the study of present-day musical forms is often highly conjectural, musical instruments clearly spread from one group to another as a result of migrations, cultural assimilation, borrowing, and exchange. We can be quite certain that harps were introduced into the area where the Mangbetu live by two differ-

←
10.2
Sanza, Azande. *Wood. H: 11.6 in. (29.5 cm). Collection of Dr. and Mrs. Robert Kuhn.*

The *sanza* is played by holding the instrument in the hands and plucking the ends of the keys with the thumbs or fingers. The carving on this instrument bears a strong stylistic resemblance to other Zande figures that were made in the region of Yambio (see chap. 11).

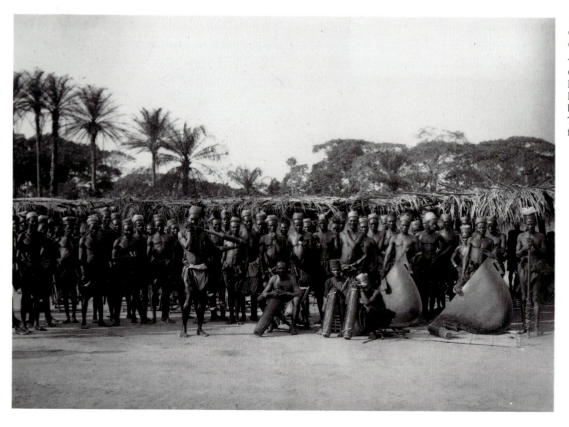

10.3
Chief Okondo's orchestra, Okondo's village, 1910. *AMNH Archives, 111896.*

Okondo's orchestra included large slit drums, conical double-headed skin drums, small iron bells, and a transverse horn. These instruments were played for court dances.

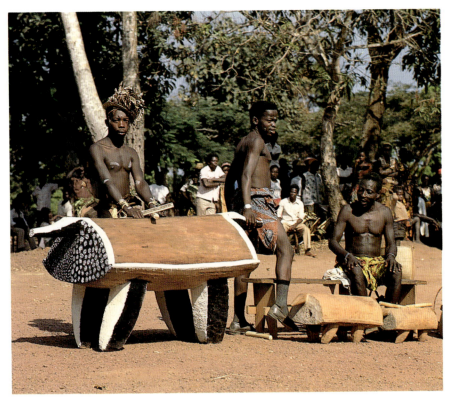

**10.4
Court orchestra, Nangazizi, 1989.**

The Mangbetu continue the tradition of the court orchestra with the same kinds of instruments played early in the century. Here the musicians are playing slit drums in three sizes, each making a different set of tones.

**10.5
Court orchestra, Nangazizi, 1989.**

The spectators wear Western clothes, but the court musicians wear barkcloth, monkey fur, basketry hats with feathers, and body-painting.

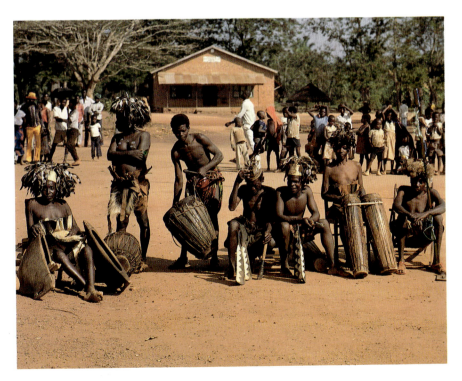

ent groups: the Bantu speakers, who came from the west during this millennium, and the Ubangian speakers, who came from the northwest in the last two centuries (Wachsmann 1964). Some instruments arrived relatively recently. Two examples are the stick zither, brought in by Arab traders, and the *sanza*.[2] In the extreme northeast, among some Zande groups and also among the Logo, the presence of the lyre indicates contacts with the peoples of the Nile basin.

The diffusion of instrumental ensembles, mainly horn bands, can be partly explained by a custom common to Sudanic groups: the practice of bringing musicians from one chiefdom to another. A chief who wanted his musicians to learn the music of another group would invite the other group to his court. He would send his eldest son to the other chief as a guarantee that the musicians would return once their mission was accomplished. The same process was used to exchange songs.

The Mangbetu comprise a number of peoples who have shared musical knowledge for several centuries. These peoples include the Meje, Makere, Malele, Mapopoi, Abelu, Lombi, Mangbele, Mayogo, Bangba, Matchaga, and some of the Budu. The assimilation of these groups with the Mangbetu in the nineteenth century during the reigns of Nabiembali, Tuba, and Mbunza brought about the integration of many cultural patterns. Musical instruments, including the harp, and certain musical customs spread in this way. Out of this fusion of cultures emerged new patterns in music as well as in other forms of artistic expression. Some originally non-Mangbetu groups, including the Mangbele and the Matchaga, are now so well integrated that only their names indicate their foreign origins.

Within Mangbetu culture we can distinguish two musical styles, which in some respects reflect the political and social structures of the groups practicing them. In the region between the Uele and Bomokandi rivers, within the Mangbetu kingdoms of the nineteenth century, the most distinctive feature was court music (10.3–10.5). After the fall of Mbunza and the last large Mangbetu kingdom in 1873, smaller chiefs perpetuated this tradition, although they themselves were not always Mangbetu. This was true of the Matchaga and the Mangbele, who were linguistically, culturally, and politically assimilated. South of the Bomokandi River, however, musical styles were not associated with court life. The most important music of this area was ritual and ceremonial, especially the music performed around circumcision and mourning. This style most probably remains very close to the music of the Mangbetu

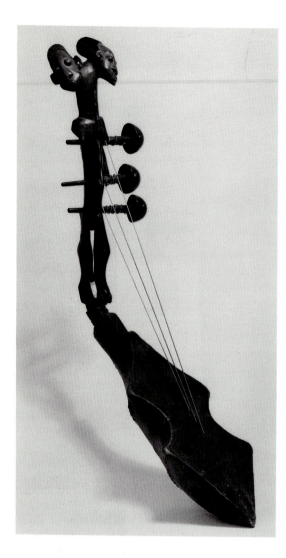

peoples as it was played before the development of kingdoms.

Harps: The Question of Origins

As the fame of the Mangbetu spread rapidly among Europeans in the early colonial period, their ivory horns and harps attracted special attention. The ivory horns, reserved for kings, were insignia of royal power. Beautiful harps decorated with carved heads at the ends of their bows were made in the area at that time. The carved elongated heads distinguished these harps from others made in the region. The custom of carving human heads on harps was widespread among the Azande (10.1) and Barambo in the north, but Schweinfurth asserted that the Mangbetu had no stringed instruments of any kind (1874, 2:117). After the turn of the century, however, many of these instruments were made with carved heads representing the elongated Mangbetu style. These harps may have been introduced into the region of the Mangbetu kingdoms after the time of Schweinfurth's visit. Hutereau and Lang both claimed that the Meje and the Mangbetu adopted the

harp from the Azande (Hutereau 1912; Lang fieldnote 2105). Many of these instruments were collected by Lang and others between 1910 and 1915.

Despite the claims of Hutereau and Lang, linguistic evidence suggests that the harp may have been introduced to the Mangbetu from the south. The Mangbetu use the Bantu name *domu* for the harp. Harps may have been first introduced and used south of the Uele by the Mangbele (now assimilated to the Mangbetu but originally a Bantu group) and the Matchaga. Quite probably some Mangbetu groups, most likely the Mangbele, and other Bantu groups such as the Budu had at first a simple version of the instrument and then modified it in the style of the Ubangian speakers to the north. The carving of elongated heads on the harps is most probably an extension of a northern tradition.

Some of the older Mangbetu today claim that the heads on the harps represented Queen Nenzima and King Yangala, and that after their deaths the custom of carving them gradually declined. Many harps produced in the first quarter of this century had full figures—male or female—carved into their bows. Some had variations, such as the two-headed harp in the collection of the Museum Rietberg (10.6). Lang photographed and collected a harp with a saluting soldier carved on the bow (10.8). He also noted the stylistic difference in carving between the elongated Mangbetu heads and the "normal" Zande heads with typical Zande hairstyle (10.9). None of the harps collected among the Mangbetu have carved legs at the base of the resonator, as do the harps of the Ngbaka to the northwest.

Harps may well have been less important to the Mangbetu as musical instruments than as art objects. Although Lang photographed a few Mangbetu people with harps, in these photographs the instruments rarely appear to be in use. Many types of material were incorporated into the carved forms. The bows, of various lengths, were made of wood or ivory. A variety of animal skins was used to cover the resonators, including pangolin scales (10.10), okapi and leopard pelts, and the skins of monitors and several kinds of snake. Combinations of the above materials, along with the anthropomorphic bows, created visually striking instruments.

Court Music

When Europeans first arrived in the region in the nineteenth century, they were struck by the power and the splendor of the Mangbetu courts (see chaps. 2 and 6). Schweinfurth, in particu-

←
10.6
Harp, Uele region. *Wood, hide. H: 21.6 in (55 cm). Museum Rietberg.*

Although figures were commonly carved on instruments, this two-headed harp is an unusual example that shows the extent to which the carvers elaborated the basic idea of the anthropomorphic form.

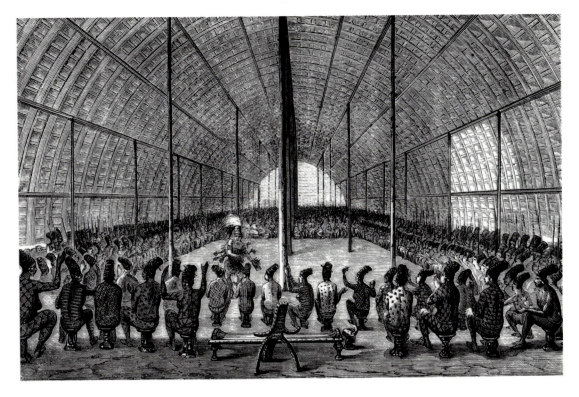

10.7
Illustration by Georg
Schweinfurth of King Mbunza
dancing, *The Heart of Africa*
(1874), vol. 2, facing p. 74.

Schweinfurth witnessed the
mabolo dance at Mbunza's court
and made this drawing of the
performance. In the king's Great
Hall, Mbunza dances before his
numerous wives. The women sit
on their stools, with their bodies
painted in a variety of designs,
waving their arms as the king
dances.

lar, enthusiastically described the music and
dance he heard and saw at Mbunza's court. The
horn players, with their large ivory horns, seem
to have impressed him:

> [They] proceeded to execute solos upon their
> instruments. These men were advanced profi-
> cients in their art, and brought forth sounds of
> such power, compass, and flexibility that they
> could be modulated from sounds like the roar
> of a hungry lion, or the trumpeting of an infu-
> riated elephant, down to tones which might be
> compared to the sighing of the breeze or to a
> lover's whisper. One of them, whose ivory
> horn was so huge that he could scarcely hold
> it in a horizontal position, executed rapid pas-
> sages and shakes with as much neatness and
> decision as though he were performing on a
> flute. (1874, 2:49–50)

What seems to have struck him most about
court music, however, were the dances, espe-
cially the dance of King Mbunza (**10.7**):

> But the wonder of the king's dress was as
> nothing compared to his action. His dancing
> was furious. His arms flung themselves fu-
> riously in every direction, though always
> marking the time of the music; whilst his legs
> exhibited all the contortions of an acrobat's,
> being at one moment stretched out horizon-
> tally to the ground, and at the next pointed
> upwards and elevated in the air. The music ran
> on in a wild and monotonous strain, and the
> women raised their hands and clapped to-

> gether their open palms to mark the time. For
> what length of time this dance had been going
> on I did not quite understand; I only know
> that Munza was raving in the hall with all the
> mad excitement which would have been wor-
> thy of the most infatuated dervish that had
> ever been seen in Cairo. Moment after mo-
> ment, it looked as if the enthusiast must stag-
> ger, and, foaming at the mouth, fall down in a
> fit of epilepsy; but nervous energy seems
> greater in Central Africa than among the *hash-
> ishit* of the north: a slight pause at the end of
> half an hour, and all the strength revived; once
> again would commence the dance, and con-
> tinue unslackened and unwearied. (1874,
> 2:75–76)

Schweinfurth's account shows that in the 1870s
there was an organized court repertoire with
numerous musicians. He mentioned all the in-
struments played in present-day Mangbetu
court music.

The music of the Mangbetu was first heard in
the West on wax-roll recordings made by Hu-
tereau between 1911 and 1913. Two wax rolls
were recorded at the court of Chief Senze in
1912 (wax rolls 47–48). Soon after Hutereau's
recording was made, Lang photographed Chief
Senze's orchestra (**10.11**) with the same instru-
ments as those described in Hutereau's notes,
giving a complete picture of the Mangbetu or-
chestra at that date. Very few recordings have
been published since then.[3]

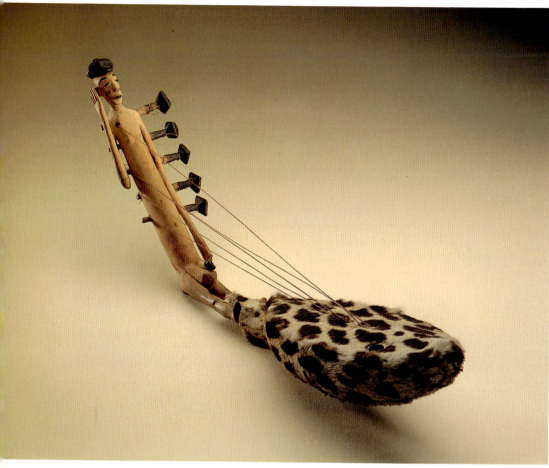

10.8
Harp, Mangbetu. *Leopard hide with fur, wood, vine, fiber cord. L: 24.6 in. (63 cm). Lang, coll. Niangara, 1910. AMNH, 90.1/3964.*

Harps were carved not only with the classic Mangbetu elongated head but also with depictions of contemporaries such as this saluting soldier. The Mangbetu chief Okondo presented this harp to Lang.

10.9
Harp, Azande. *Wood, cane, hide, plant fiber. L: 24.2 in. (62 cm). Lang, coll. Niangara, 1913. AMNH, 90.1/3966.*

The Azande produced harps earlier than their southern neighbors, the Mangbetu and the Meje. This harp depicts a Zande style of hairdress. It also has pegs on the left, a feature that distinguishes it from Mangbetu harps, which have pegs on the right.

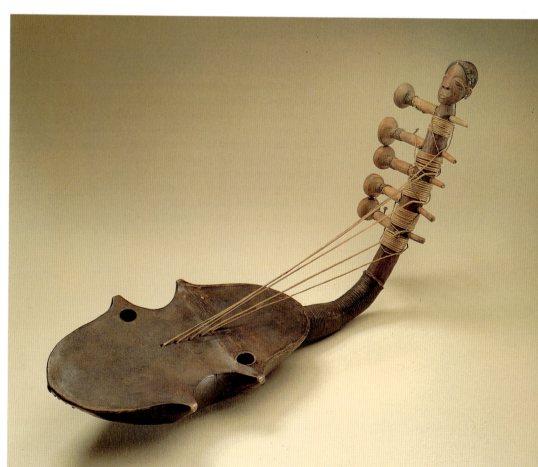

10.10
Harp, Mangbetu(?). *Wood,*
pangolin scales, plant fiber, pitch.
L: 22.2 in. (57 cm). Lang, coll.
Niangara, 1910. AMNH, 90.1/
3969.

Pangolin scales cover this harp's
resonator. The carved human
figure with body-painting on the
harp's neck combines with the
unusual-looking resonator to
stress the visual qualities of this
instrument.

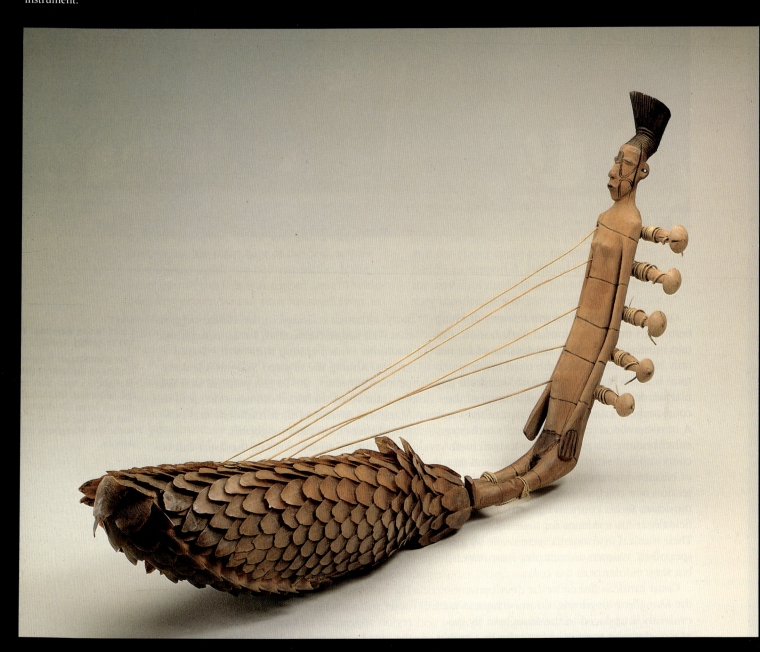

10.16
Slit drum, Mangbetu. *Wood, copper alloy, plant fiber. L: 26.2 in. (67.1 cm); W: 11.9 in. (30.6 cm). Lang, coll. Rungu, 1910. AMNH, 90.1/2737.*

Flat, bell-shaped drums were played in the chief's orchestra for dances, to announce when a chief was drinking palm wine or beer, and during visits from one chief to another. Lang described this drum as "an especially fine specimen much esteemed on account of the far-reaching sound. The wood is blackened in mud and extremely hard" (837).

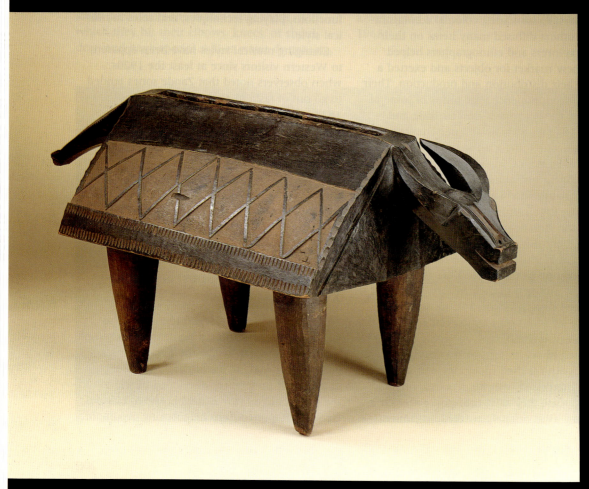

10.17
Slit drum, Barambo. *Wood. L: 45.6 in. (117 cm); W: 17.9 in. (46 cm); H: 17.6 in. (45 cm). Lang, coll. Poko, 1913. AMNH, 90.1/ 3670.*

Large wooden drums (*nekpokpo*) were played in the chief's orchestra but they served mainly to transmit messages from one village to another. Usually resting on four legs, the drums often depict animal forms; Lang noted that this one represents a buffalo (2491).

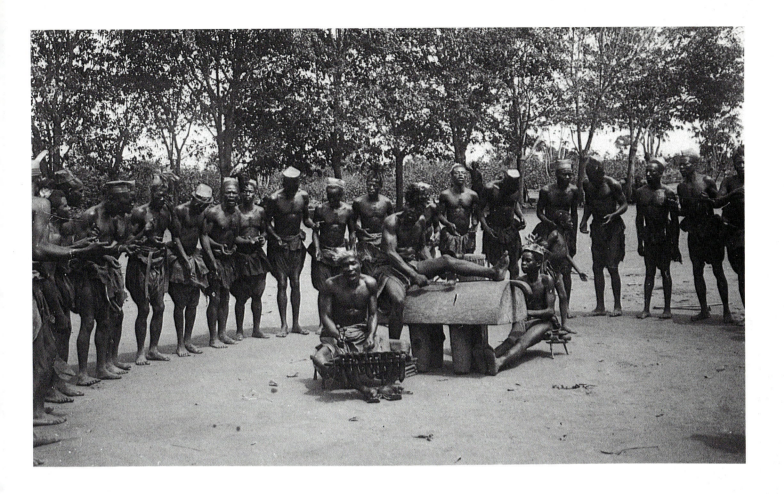

Zande musicians, Manziga's village, near Niangara, 1913.
AMNH Archives, 846(s).

The xylophone (*manza*) player here uses four mallets. Sitting on a stool, he braces the instrument with his legs to support it. The large slit drum is played by two musicians, one of whom sits atop the instrument and covers the slit with his leg to mute the sound.

areas. Idiophonic wooden slit drums hewn from large trees are emphasized in forested areas, whereas drums with membranes made of hide play a greater role in the music of the grasslands. The relationship between music and nature extends beyond the materials used for instruments to hunting songs, plants associated with song magic, imitations of animal sounds, and zoomorphic instruments.

There are two basic forms of slit drum in the region: the bell-shaped type with handle (10.16) and a hollowed-out log on four legs or two pads (10.17).[10] Among the Azande, the latter type may be played by two musicians at once. A player often sits on top of the instrument and uses one leg as a damper, covering the slit to mute the sound (10.18). Carrying handles protrude from the front and back of many larger instruments, sometimes also serving as a seat for the player. The handles of the large slit drum may be carved to represent the head, horns, and tail of a buffalo, combining with the body and legs of the drum to give the entire instrument a zoomorphic appearance (10.17). The slit drum can take on animal form in sound as well as in shape: Evans-Pritchard

observed, "When the wind blows into its hollowed body it lows like a buffalo" (1928, 447).

Many slit drums have their sides hollowed out unevenly to produce two pitches, corresponding to the high and low sounds of tonal languages.[11] Through combinations of high and low tones in short and long patterns, the drums can transmit complex verbal messages. Lang transcribed the drum syllables of the *negwogwo*, a flat slit drum played with one end on the ground to announce beer drinking, dancing, or the arrival of important persons, as follows:

> The sound is gū-gŭ-gū-gŭ-gū-gŭ etc. for the large ones and about gadu-gadu-gadu-gadu for the small ones, the latter sounds alternating high and low. (2038)

He also described the sound and playing technique of another type of flat slit drum (*abi-amgama*) used for dancing:

> Several beats are given near the edge and from time to time further towards the center. The sound is given by a Mangbetu about as dĕri-dĕri-dentūlў (3 times) dili-dulў-dentūly (2 times) deri-deri-dentūly (3 times, etc.). (2036)

One large slit drum, a chief's signal drum made by the Mabudu, was particularly admired by Lang and Chapin but they could not persuade its owner to part with it. Chapin later wrote that it was obtained for them by Ario Guyon, an Italian noncommissioned officer and self-styled "King of the Mabudu." Sixteen men were needed to carry the drum, which was too big to fit into any of the boats available at some river crossings and took months to reach Stanleyville (Chapin 1942, 67–68).

Slit drums had many important public functions. Besides their musical uses in dance and royal orchestras and their "speaking" roles of announcing and signaling, large slit drums served as symbols of chieftaincy. The construction of the largest slit drums, being the most labor intensive, demanded the patronage of the most important chiefs. The larger and louder the drum, the farther its signal could carry and the greater its symbolic value. The instrument was considered so potent a symbol that a "punitive expedition" led by Major Boulnois in 1905 abducted the largest slit drum in the village of the Avongara chief Yambio. A member of the expedition commented, "That we carried away the drum was of great effect in assuring the people that Yambio was really done for" (Seligmann 1911, 17).

Skin drums, as noted above, are less emphasized in heavily wooded areas than are slit drums. Although Czekanowski (1924, 146) stated that most drums of the Mangbele—who live on the edge of the forest—were skin drums, they also have wooden slit drums, indicating a mixing of various traditions.[12] Among the Budu, a Bantu group living deep in the forest where cattle or antelope skins for membranes were at a premium, wooden slit drums were prevalent and many conical drums were covered with elephant ears (Tracey 1955, TR-126, B2). Skin drums are beaten with hands and sticks. Double-headed skin drums are played on the ground or slung over the shoulder. Lang's informants gave the sound of the cylindrical *negudu* as "bu-bu-bu-bu" and that of the conical *nabita* as "di-di-di-di etc." (2041, 2043).

Schweinfurth (1874, 2:126) and Czekanowski (1924, 147) both observed that xylophones were not played by the Mangbetu and were rare among the Azande. Xylophones are found around Niangara, but the Mangbetu have not adopted them into their musical life.[13] The Zande chief Manziga gave Lang a xylophone with gourd resonators (*manza*) that was generally reserved for chiefs. This instrument was played either by a single musician with four rubber mallets (**10.18**) or by two musicians at once (Hutereau 1912). The *manza* had a curved wooden handle, which the musician placed around his body, with the end under his seat. By exerting pressure outward against the handle with his legs, the player kept the gourd resonators suspended above the ground. The keys on the *manza*s in the American Museum collection are slabs of redwood flaring out at the ends (beyond the nodes where the keys are attached). The instruments are tuned to various pentatonic scales, some with intervals smaller than whole tones. Most of the keys are laid out so that octave equivalents are placed next to one another, although some instruments break up this pattern. Lang described the *manza* player as striking two bars at once with each hand, suggesting a performance style in parallel octaves (fieldnote 1915).[14] The large Zande xylophone without resonators (*kpaningba*) described by Lang had "nine sticks laid upon two trunks of plantains" (fieldnote 1916). This instrument was played by four men at once, each using two small sticks.

Horns

Okondo commissioned ornate ivory horns for Lang, who considered them primarily as art objects rather than representative musical instruments. Some of these horns were deliberately left unplayable, their mouthpieces unfinished. One artist spent two months carving a large ivory horn that Lang said was "the finest work I have seen. . . . It has not been pierced, as I did not think it worth while that the artist should spend 10 days on this slow process. His time could be used more advantageously" (2770).

The materials used to make horns have changed in response to the changing economy and ecology of northeastern Zaire. Instruments of wood, animal horn, and gourd have long been played throughout the region for hunting, signaling, and music. Far more labor and, consequently, patronage were required to catch an elephant and carve a horn out of a solid ivory tusk than to make an instrument of hollow antelope or buffalo horn. When international trade made ivory more valuable, it became associated with foreigners and chiefs' relationships to them. Ivory horns, as a symbol of chieftaincy, became part of the Mangbetu court orchestra. Court dancers often held these ivory horns aloft as royal emblems; their symbolic value may have taken precedence over their musical function on these occasions. When tusks later became relatively scarce and hence more costly, chiefs had fewer ivory horns made, retaining older instruments for a longer time (1237) and replacing them with instruments of antelope horn (Demolin 1985, 10, 21).

10.19
Sanza, **Azande.** *Wood, barkcloth, tail, brass. L: 23.9 in. (61.2 cm); W: 11.5 in. (29.5 cm). Lang, coll. Panga, 1914. AMNH, 90.1/3317.*

People throughout Africa play the *sanza.* This Zande instrument is constructed in the form of a woman, complete with a *negbe* and a barkcloth that covers a detailed depiction of her genitalia.

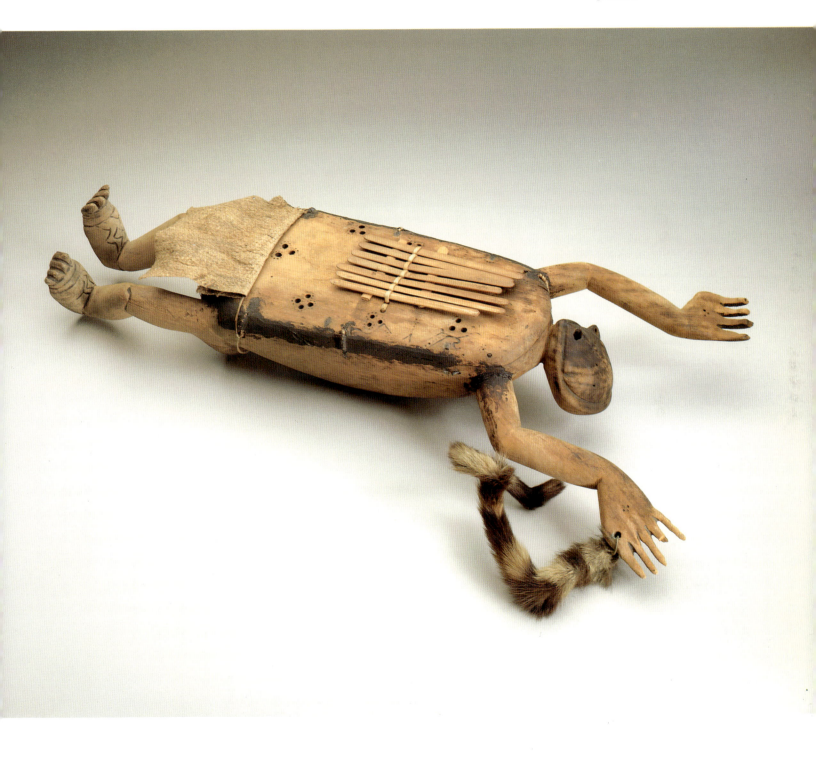

213

Most wooden and gourd horns, such as the savanna type played in Logo horn bands, are blown from one end, whereas many instruments of ivory and animal horn are held in the transverse position, with a lateral mouthpiece carved near the tip. Some have a hole in the tip that the player opens and closes with a finger or thumb to produce additional tones. The hand is sometimes used as a mute on the wide end of smaller horns. While playing his instrument the musician moves around, pointing the wide end of the horn in different directions. The sound is amplified by pointing the horn at the ground, creating a resonator of earth. To Lang, the resulting sound was raucous:

> Often the chief stops, one of the principal women indicates the direction the horn should point which causes a very considerable change. The din is greatest when they are pointed towards the ground and as they slowly turn them upward, to the right or the left the sounds become more agreeable. (2041)

There is considerable variation in horn music throughout the region. One form of horn band plays in a hocketed polyphonic style influenced by Pygmy music, each man playing a single note of the resultant melody. Horns may imitate the voices of animals. Lang described "the frantic endeavors of a trio refreshed with drafts of millet beer" imitating elephants, lions, leopards, boar, and buffaloes (1918a, 548).[15]

*Sanza*s, Harps, and Other Instruments

The Mangbetu and their neighbors have played a variety of quieter instruments, including the stick zither (*nenzenze*), for "personal" music; today the *sanza* (**10.19**) is the most common. The fact that Lang collected relatively few *sanza*s supports statements that at that time the harp was more popular for this type of music. Lang collected several *sanza*s of a type that was then typical of the Uele region, with a wooden soundboard laced over a sewn bark box resonator (see Laurenty 1962).[16] The instruments collected by Lang have varying numbers of keys, some of them arrayed on either side of the soundboard. The modes employed in the *sanza* music of northeastern Zaire are not always pentatonic. In the mid-1950s, Hugh Tracey recorded *sanza*s in the region being played in many different tunings. Ebogoma Gabriel, a Meje player, tuned the same instrument differently for different songs (Tracey 1955, TR-120, B).

Mangbetu harps have been considered in depth as art objects, but little is known of their musical uses. They evidently appeared among the Mangbetu sometime after the mid-1870s and reached a peak of popularity during the early colonial period. Though still popular among the Azande, harps are no longer found among the Mangbetu. Today they are silent symbols of a bygone era. The Mangbetu type of harp (*domu*) can be heard playing a basic ostinato accompaniment on Tracey's 1952 recordings of Ndongo, Balengba, and Mamvu songs (1955, TR-119).

The Mangbetu harp had five strings, reflecting the traditional pentatonic tuning system. Most other harps from the Uele-Bomokandi region also have five strings, commonly of plant fiber.[17] The tuning pegs of the Mangbetu harp were on the player's right (if the instrument was held with the carved figure facing the player), whereas the Zande type (*kundi*) has its pegs on the opposite side. Resonators are usually of an oval or hourglass shape. There is considerable variation in the angle of neck attachment and in the curvature of the bow. The carved figure forms the entire neck of some of the more elaborately decorated instruments. Often the conjunction between the neck and body is wrapped with cord. On many anthropomorphic harps with full figures, the figure's feet form an arch on either side of this joint. On Ngbaka harps the figure's legs are carved below the resonator, so that the body of the harp is also the body of the figure. Nearly all those harps cataloged as Mangbetu in the American Museum collection have anthropomorphic carving. Lang collected two headless Mangbetu harps in Medje from Zebuandra's people, but said that he had never seen them being played (125, 126).[18]

Other instruments from northeastern Zaire in the American Museum include double iron bells; wooden bells (with and without clappers) used for dancing and magic or worn by dogs for hunting; basket rattles, of similar construction among different groups; various stampers, clappers, and rattles, including several archaic and rarely used forms; a few flutes, one of which Lang had heard imitating an army bugle call; and numerous charms and whistles. Lang collected many other instruments from the Logo and a few types that were not played by the Mangbetu—mainly lyres, stick zithers, and raft rattles—from the Makere, Budu, and Azande. Some of these instruments are no longer found among those groups.

Culture, Contact, and Change

In northeastern Zaire, the years from the establishment of the Belgian Congo to the start of World War I constituted a unique stylistic pe-

riod. The musical instruments collected by the American Museum Congo Expedition of 1909–15 embody this cultural moment. Some, such as the instruments of the Mangbetu royal orchestra, have remained in the repertoire over the years. Others appeared and disappeared in response to social and musical change. Many other musical phenomena in this region of cross-cultural currents were relatively short-lived. The disruption of traditional patterns by colonialism and the opportunities created by new markets contributed to a particularly vibrant period of new forms and instruments, some of which gradually died out when social realities and popular tastes changed again. By 1939, one visitor passing through Mangbetu country expressed disappointment at finding few obvious "evidences of an artistic bent" (Birnbaum 1939, 82).

The demand of ethnographic collectors was only one factor among many cultural forces shaping these objects. During the early colonial period, local traditions were interwoven in the fabric of musical life with practices adapted to the collectors' market. Some of the fanciest specimens collected by Lang and Chapin were in fact made-to-order as museum pieces, but other aspects of musical culture expressed the new realities of colonialism for local consumption, not foreign collections. That Westerners helped to define and disseminate Mangbetu art forms did not render them inauthentic; on the contrary, such arts were integral to an environment of social and cultural change.

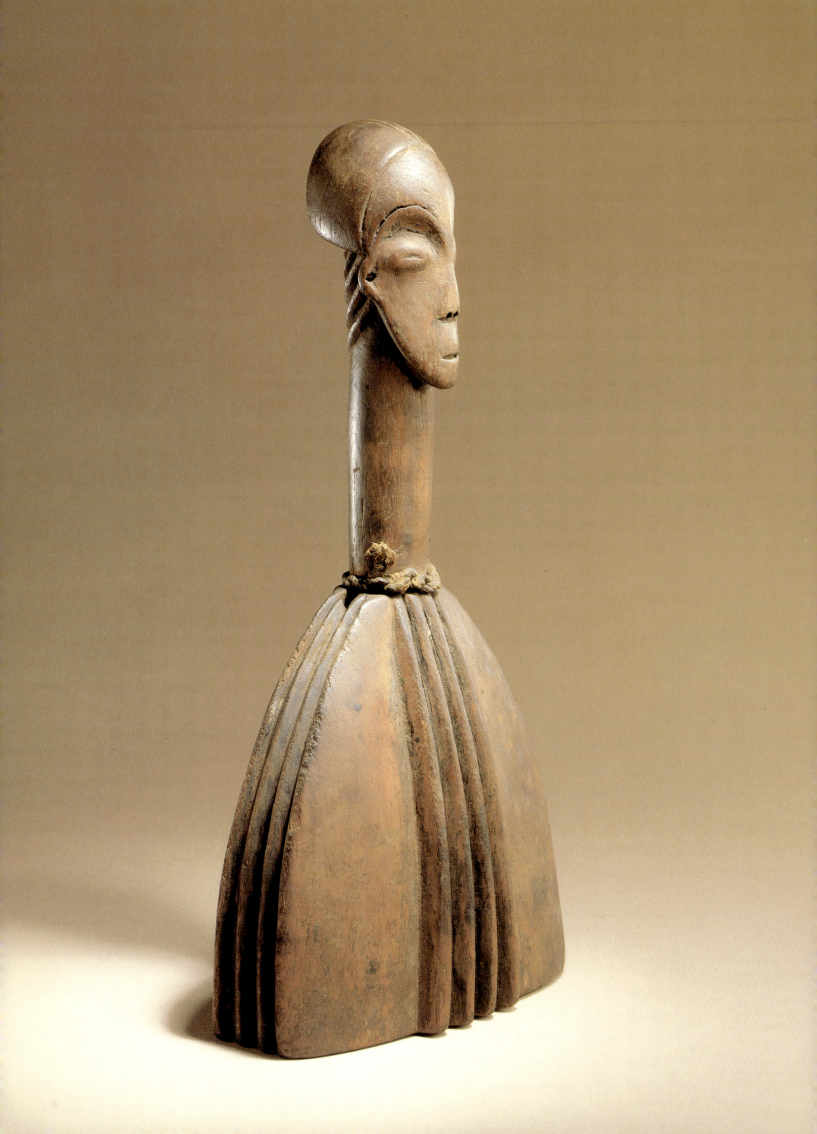

11

Art, Culture, and Tribute among the Azande

by John Mack

Left: A Zande warrior with shield and throwing knife. Drawn on an ivory horn by Saza. *Right*: A Zande with a bow and arrow and an iron clapper. Lang wrote that the clapper was sounded after words of praise for the chief, wine, and women (2762).

←
11.1
Bell, Azande. *Wood, fiber cord. H: 12.9 in. (33 cm). Lang, coll. Poko, 1913. AMNH, 90.1/3667.*

This bell, with its gracefully carved head that repeats the curved motif on the bell, has no clapper. It was meant to be struck when the chief was drinking wine.

The Azande have been a major historical force in the area lying beyond the Uele River since at least the late eighteenth century.[1] As northern neighbors of the Mangbetu they have at various times threatened to overrun adjacent areas of the Mangbetu kingdoms, and after the death of the celebrated King Mbunza in 1873, the Azande began once again to push southward into his former territories.

At the point when colonial administrations sought to control indigenous affairs, the Azande were still in the course of expansion. Warfare for the Azande is not only a process of aggression but also a process of assimilation. Zande art and culture are deeply interlocked with those of peoples throughout a large area of northeastern Zaire, southwestern Sudan, and the southeastern corner of the Central African Republic. Azande live in all three countries.[2]

With rare exceptions the Azande have received relatively scant attention in reviews of the arts of central Africa. Indeed, what has been written on them proves rather discouraging to those who concentrate on figurative imagery. Major P. M. Larken, resident among the Azande for over twenty years, reported in 1927 that "with the exception of heads carved above the pegs of lutes, spontaneous modelling of the human form or part of it, in any material, is rare" (Larkin 1927, 96). Most comment since has reverted to repetition of a few original attempts at assigning provenance and meaning (notably those of Baumann 1927 and Burssens 1960). The relative paucity of figurative art,

however, does not mean that the Azande lack rich and complex artistic traditions of other kinds.

One of the few discussions of Zande material culture written against a background of extensive field experience in Zande country is that by E. E. Evans-Pritchard.[3] His fieldwork, conducted between the years 1926 and 1930, was very largely limited to the district of Yambio within the Sudan in the northeastern region of Zande influence, and thus the most remote from the areas of Zaire considered in the other chapters of this volume. He also included very little discussion of figurative arts, and he made no reference at all to a significant tradition of sculpture that at least one authority (Fagg 1970, 47–48) assigns to the turn of the century and identifies with the very area in which Evans-Pritchard came to reside. Whether or not this dating is correct, a tradition of wood sculpture was certainly developing immediately after his departure. Even so, Evans-Pritchard broadly concluded that Zande arts developed from an amalgam of traditions in which those of the Mangbetu to the south were prominent. If so, the Azande might be considered, at least from an art historical point of view, as an extension of the Mangbetu sphere of influence. Whether this is so or in fact the reverse is the case and the Mangbetu in important respects have been more influenced by the Azande, their two cultures are deeply interwoven.

Significantly, the Azande themselves appear to assign an exotic origin to many of their cul-

tural and artifactual styles. They recognize borrowing and imitation as a viable means of creating a "tradition." This presents us with a somewhat unexpected scenario. The whole history of the Azande is one of conquest, of the annexation of neighboring peoples and the imposition of their own political will (and their own language). Their story is that of a gently rolling but unstoppable steamroller. As territories were annexed, subject peoples were incorporated as commoners or slaves into the expanding network of Zande political and military influence. In such circumstances being a "true" Azande, and being able to demonstrate it, had particular importance. Even so, the ruling Zande clan, the Avongara, seem to emerge as erratic and careless of some aspects of their own cultural heritage. The descriptions given in the nineteenth-century sources already needed substantial revision by the turn of the century, even in such central details as whether the Azande wear skins or barkcloth or whether they practice male circumcision. The Azande seem to have been as much collectors of foreign styles and practices as they were perpetuators of their own distinctive traditions. The purpose here, in part, will be to try to explain this apparent paradox.

Nineteenth-Century Accounts of the Azande

Nineteenth-century reports of the Azande give an uneven picture of their society, courtly life in particular. In most accounts, the Azande are known by the name Niam-niam. This is the term used by the Dinka, Nilotic pastoralists who live in the Bahr-el-Ghazal Province of the Sudan. The extensive use of this term in the literature indicates the main direction from which most travelers arrived in the area and suggests the character of their contacts. They came mostly from the north, following the routes opened into the region by Arab traders in ivory and slaves. Some were actually attached to Arab trading caravans.[4] By about 1866 or 1867, this connection already extended through Zande country to the territory of the Mangbetu. Zande material was included in the Paris Exhibition of 1867 (in the Egyptian section, reflecting the wider balance of European interests in the region at the time). The nearest Arab station (*zeriba*) to the Azande for much of the period was located among their northern neighbors, the Bongo, though the developing town of Wau still farther to the north became the administrative center of the area.[5]

As a result, many of those writers who discussed the Azande—and some who even col-

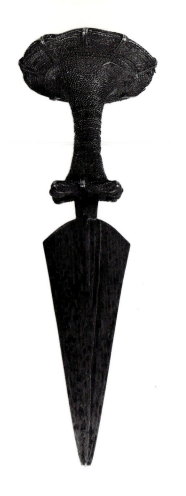

11.2
Knife, Adio Azande. *Iron, wood. H: 14.9 in. (38 cm). Coll. 1882. British Museum, +8331.*
This elegant knife with a metal wrapped handle is typical of show knives worn throughout the region in the nineteenth century.

lected Zande art and material culture—never in fact reached Zande country proper (**11.2**). James Petherick, whose account was the first by a European, only visited the Makaraka (also known as the Adio Azande), whose territory lay on the very eastern fringes of Zandeland. Similarly, the luckless Alexandrine Tinne, who lost both her mother and her aunt in the Sudan (and who was herself later killed in the Sahara), collected Zande material that was subsequently placed in what was then the Liverpool Free Public Museum, England. Her base was not in Zandeland, however, but at Wau (Hunt 1972). Frank Lupton (Lupton Bey), who took over the administration of Bahr-el-Ghazal in 1881, also made extensive collections among the Adio group of the Azande.[6] Even Emin Pasha, who traveled widely in the southern Sudan and Uganda (and who visited the Mangbetu in 1883), never passed through Zande country. The person in the best position to give a full and authoritative picture of the Azande was the Italian Carlo Piaggia, who lived among them during the period from 1863 to 1865. His account is limited, however (see chap. 2), and the fullest report of his impressions was written by his friend Orazio Antinori. In recent years Italian scholars have begun to collate these and other accounts of the period preserved in Italian sources (Antinori 1984; Piaggia 1978).

Among the more thorough and detailed reports are those by Georg Schweinfurth and Dr.

Wilhelm Junker. Schweinfurth visited the Azande—though not Zandeland proper—in 1870 before moving south to see and report in glowing terms on the Mangbetu kingdom of Mbunza. However, let us compare that account of Mangbetu opulence and the finery of their arts and dress (quoted in chap. 8, First Impressions: Schweinfurth's Visit to the Mangbetu Court) with what he had to say of the Azande. The courts of Zande princes were, certainly, immediately identifiable, but not because of any exceptional architectural features like the ones he described for Mangbetu country. "Very modest in its pretensions," he noted among the Azande, "was the court of this negro prince, and it had little to distinguish it from the huts of the ordinary mortals who had their homes around" (he was talking of the residence of King Ngangi of the eastern Azande). Rather, this court was notable for "the numerous shields that are hung upon the trees and posts in the vicinity, and by the troop of picked men, fully equipped who act as sentinels, and are at hand night and day to perform any requisite service" (1874, 1:441).

As to the appearance of members of the royal court, we learn that at his first meeting with Schweinfurth, Ngangi was "perfectly naked except for a little apron that he wore. He was sitting on a Monbutto [Mangbetu] stool, quite unarmed, and with no insignia whatever of his rank. There were, indeed, some twenty or thirty natives who were armed and kept guard in the outer court, but apart from this any pretension of state was entirely wanting" (1874, 1:441–42). Later Schweinfurth presented Ngangi with a large number of garnet-beaded necklaces of a type unknown to the Azande. He recalls: "Out of compliment to me, Nganye [i.e., Ngangi] always wore my gifts as long as we remained in his locality, but, in the same way as other chieftains, he at other times systematically abstained from adorning himself with any foreign trinkets" (1874, 1:443).

Junker, by contrast, gave a somewhat more favorable impression of the Azande than the singularly lackluster description left by Schweinfurth. Furthermore, his account is based on the experience of ten years' travel in the area. He tells us that although the courts of some Zande princes were little more than temporary structures, the Zande king Bakangai's court was certainly more significant: "All that here met my eye was evidently on a scale and

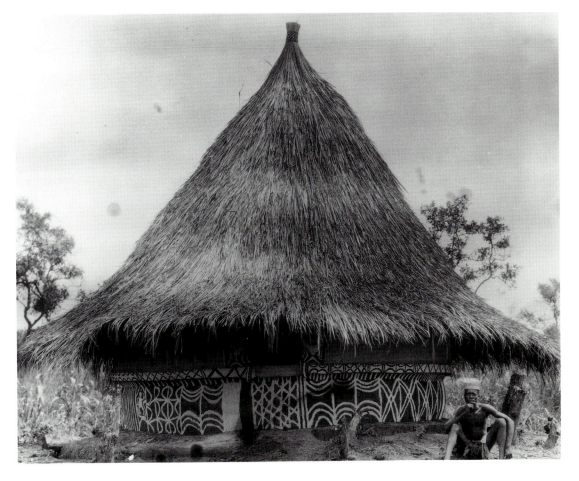

11.3
Zande mural painting, Faradje, 1911. *AMNH Archives, 223993.*

When Lang visited the region, he photographed painted houses, many of which were decorated by Zande artists. The designs here, although primarily geometric, also feature a cleverly abstracted human figure on the left.

in a style that proclaimed the power and greatness of a really formidable African ruler" (1892, 4).[7] Junker was impressed by the vastness and number of the architectural structures he saw and by the painted interiors of the assembly rooms (**11.3**).

Bakangai was one of the Zande rulers most likely to be influenced by Mangbetu or neighboring Barambo styles. His territory lay in southern Zande country in the forests not far from the Mangbetu.[8] Furthermore, his father, Tikima (Kipa), had fought against the Mangbetu and had taken his sons with him on his warring expeditions.[9] Even so, for Junker the Azande still remained the poor relations compared with the Mangbetu. Bakangai's assembly hall "was effective only from its great size, for in the manner of its construction it could bear no comparison with the fine artistic structure of the Mangbattu people." Junker went on to observe, "The Zandehs [sic] in fact lack the sense of proportion, and the patience for time-consuming details. The mud floor in the vast hall had not even been levelled, so that the two ends stood considerably lower than the central part, while the roof-ridge described a curved instead of a straight line" (Junker 1892, 7). Of Bakangai himself, Junker wrote:

> The oval face was adorned by a short, bushy black beard, and he wore his hair, Mangbattu fashion, raised high above the crown and gathered behind, while his royal blood was indicated by a leopard-skin cap in form not unlike a bishop's mitre. But the effect was somewhat spoilt by a rag of blue cloth fastened round his forehead. Dispensing with all ornaments, he limited his costume to the rokko of fig-bark girdled round the waist. (Junker 1892, 2)

Distinctions in the literature between Azande and Mangbetu may very well be overdrawn. Evans-Pritchard pointed out (1971, 175ff.) that accounts of the Zande court only relate to the outer, more public areas of the royal enclosures. A much smaller inner court, a "court of whispers," always lay nearby, with access restricted to certain categories of senior Zande men. The building itself was perhaps no more opulent than those public halls seen by Schweinfurth and Junker, but certainly the complex structuring of space, the intricacies of social and political relationships, and the nature of aristocratic Avongara power were far more complicated than the restricted Western descriptions of courts and courtiers imply. Schweinfurth's enthusiastic report of the Mangbetu was certainly overromanticized, and his estimate of the Azande correspondingly understated. Keim (1983, 3) points out that Schweinfurth remained at Mbunza's court for only twenty-five days and lost most of the notes he had made. Appearances can deceive, and Schweinfurth, obliged to travel as part of a large Arab trading

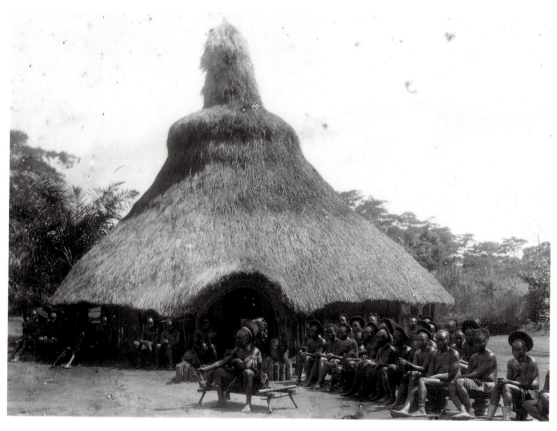

11.4
Chief Akenge, Akenge's village, 1913. *AMNH Archives, 111631.*

Zande chiefs, although very powerful, did not have elaborate, conspicuous courts. Chief Akenge is seen here surrounded by some of his many wives, but the only symbols of his position are a fly whisk for a scepter and magic whistles worn around his arm (**9.13**).

caravan consisting of more than a thousand people, might be forgiven for not seeing beyond the apparent magnificence of Mangbetu courtly life to the fragility of the royal power on which it was founded.

In a few respects, however, all these accounts are accurate, at least regarding the Azande. All speak of "courts," not of "palaces." Zande royal enclosures are places of assembly, where cases are heard and discussed; they are not arenas for the performance of major public rituals under the auspices of the ruler. All these observers were also uncertain whether they should be talking of kings, princes, or chiefs when discussing Zande rulers (though no such difficulty is apparent when the subject is "King" Mbunza and the Mangbetu). Finally, all noted a general paucity of ornament or other visual marks of distinction and rank (11.4). Junker mentioned only the wearing of leopard-skin headwear to indicate aristocratic descent. On the same subject, Evans-Pritchard was surprisingly dismissive of the symbolic significance of ivory among the Azande, even though horns, whistles, hairpins, and knife handles were all made from ivory for courtly use. Elsewhere in Africa, ivory is a leading metaphor of royal power, and its use is frequently restricted to royalty. Yet Evans-Pritchard reported that Azande sought elephants more for their flesh than their tusks. In due course, as its commercial value increased, ivory proved a ready item of trade with Arabs (1971, 311).

Certainly no Zande ruler would have had the resources or the standing to appear on ceremonial occasions, like the Kuba king, elsewhere in Zaire, bedecked in regalia whose very materials refer to symbolic and sacred qualities embodied in the king and in kingship itself. Such reference and such royal costume quite simply did not exist for the Azande. Indeed, in the whole of the substantial literature about them, reference to any kind of inherited property, to treasures and heirlooms, is rare. Among the few exceptions are certain magical items, particularly magical whistles once used before battles to ensure success,[10] and large slit drums used for signaling and for summoning subjects.

Similarly, the Zande have none of the elaborate and public ancestral shrines associated with aristocratic clans in other hierarchical African societies. Some forest Azande retained parts of the corpses of important rulers as magical substances. Thus skin from the forehead of the Zande king Kipa, together with parts of the bones from his knees and feet, were kept in a bark box with other medicines at a family shrine.[11] Otherwise, however, all that is found today are dead branches planted in the ground from which, in Schweinfurth's day, war trophies in the form of skulls or bones were hung, or the more familiar *tuka*, a term that Evans-Pritchard translates as "ghost shrine" (1937, pl. XXIII). *Tuka* are simple constructions of forked sticks placed outside a family hut at which personal offerings are made to the spirit of an occupant's deceased father. There is no basic distinction in form between those set up by Avongara and by commoners, and such sites appear to always be essentially family-based. The Azande have no specifically distinctive royal shrines or any form of material object in which ancestral powers are deemed to reside. The basis of Zande power was the person of the ruler himself, not sacred and magical qualities seen as inherent either in his person or the office he occupied.

Thus the categories of "regalia" and of "ritual object," so much beloved by Westerners as a convenient euphemism for items that are not overtly practical, are of little relevance to the Azande. Almost all their arts are functional or are direct adaptations of functional objects. Museum collections and textual illustrations of Zande artifacts concentrate on items such as shields, weapons, pottery, wooden stools, basketry hats, barkcloth, harps (11.5), and slit drums. One variation on the theme of the functional is the presence of ceremonial knives (11.7), given by princes and kings to leading courtiers and to occasional privileged commoners. With ownership of such knives came access

11.5
Harp, Azande. *Wood, hide. H: 34.2 in. (87.2 cm). Access. 1949. British Museum, 1949Af46.524.*

Zande harps often feature beautifully carved heads with typical ridged hairstyles. They predate the appearance of harps among the Mangbetu and probably inspired carving of harps farther south.

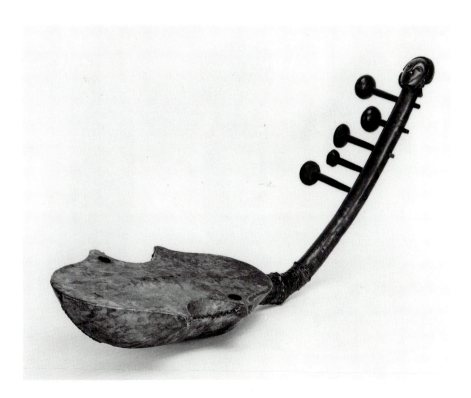

to the inner sanctum of the court. The most important magical items were naturally occurring substances such as those used in oracles, notably the *benge* plant collected from distant areas for use as a poison oracle (given not to humans but to chickens). Alternatives like the *iwa* board were also used for purposes of divination; these were Zande versions of the rubbing oracle familiar elsewhere in the Zaire region.[12]

Figurative sculpture was of three kinds. One kind consisted of small, often highly abstract figures carved in wood or sometimes modeled in clay and often with various other substances added to create a caked surface. This group of images is the one to which the general term *yanda* is applied; they are discussed in detail in Burssens 1962. They were used in the rituals of *mani*, a secret society that spread among the Azande around the turn of the century. Twisted roots functioned as alternatives to these manufactured objects.

Mani included both men and women members. It did not specifically exclude Avongara from its membership, and many aristocratic Azande must have numbered among its adherents. *Mani* was an alternative to the magic of poison oracles and other devices administered by the court, and as such found its membership most readily among commoners and subject peoples. Its general aim was to seek advantage for its members by magical means. *Mani* might assist, for example, in ensuring a rich catch on hunting or fishing expeditions, promote fecundity, render initiates immune to evil magic, or produce harmony within the family.

Mani probably originated among the Azande of the Central African Republic, from there spreading eastward to groups living north of the Uele in what is now Zaire and into Sudan. The magical items used in the ritual of the association included medicines of various kinds, magic whistles, mica, and blue beads. Figures, when used, were regularly doused in magical powder, and their owners procured food and gifts for them (11.6). They were also honored in an annual festival. Although a number of different styles of *yanda* figure were produced, all served essentially the same purpose, with no distinction of function between the various kinds. Certain individual figures, however, might come to be regarded as more efficacious and more powerful than others, and thus to be used more frequently.

A second type of figurative art, especially associated with the Sudanese Azande, appears in the full figures in wood, which probably served a variety of purposes (5.1). One of the first Westerners to mention such figures was the for-

mer district commissioner for the area, Major P. M. Larken, initially appointed as early as 1911 (within six years of the creation of the Anglo-Egyptian Sudan). He recalled seeing two wooden figures that had been carved for Chief Tambura by a Mberidi or Mbegumba carver—that is, by a man belonging not to the Azande but to the neighboring Belanda, a people who are known to have carved figurative sculpture for placement on tombs (see, for instance, Kronenberg and Kronenberg 1960 and 1981). The figures, Larken says, "represented a married couple whom Tambura disliked. During a drought, they were placed in the Yubo river, in order to bring rain, where they probably lie to this day, there being a popular prejudice against taking them out" (1926, 45).

Paired male and female figures were certainly produced—and possibly since before the turn of the century as Fagg has surmised (though there is no independent evidence to support the suggestion)—at Yambio, one-time capital of the kingdom of Gbudwe, lying just east of Tambura's territory. One set of these figures in the collections of the British Museum (11.8, 11.9) so impressed the British sculptor Henry Moore

11.6
Left to right:
Yanda figure, Azande. *Wood, metal. H: 7.1 in. (18.1 cm). Collection of Marc and Denyse Ginzberg, New York.*

Yanda figure, Azande. *Wood. H: 8.0 in. (20.4 cm). Collection of Marc and Denyse Ginzberg, New York.*

Yanda figure, Azande. *Wood. H: 10.4 in. (26.5 cm). Collection of Marc and Denyse Ginzberg, New York.*

Small, abstract figures were used in the *mani* secret society, which spread among the Azande after the turn of the century.

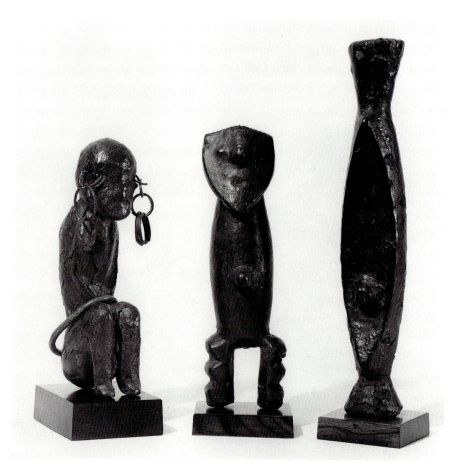

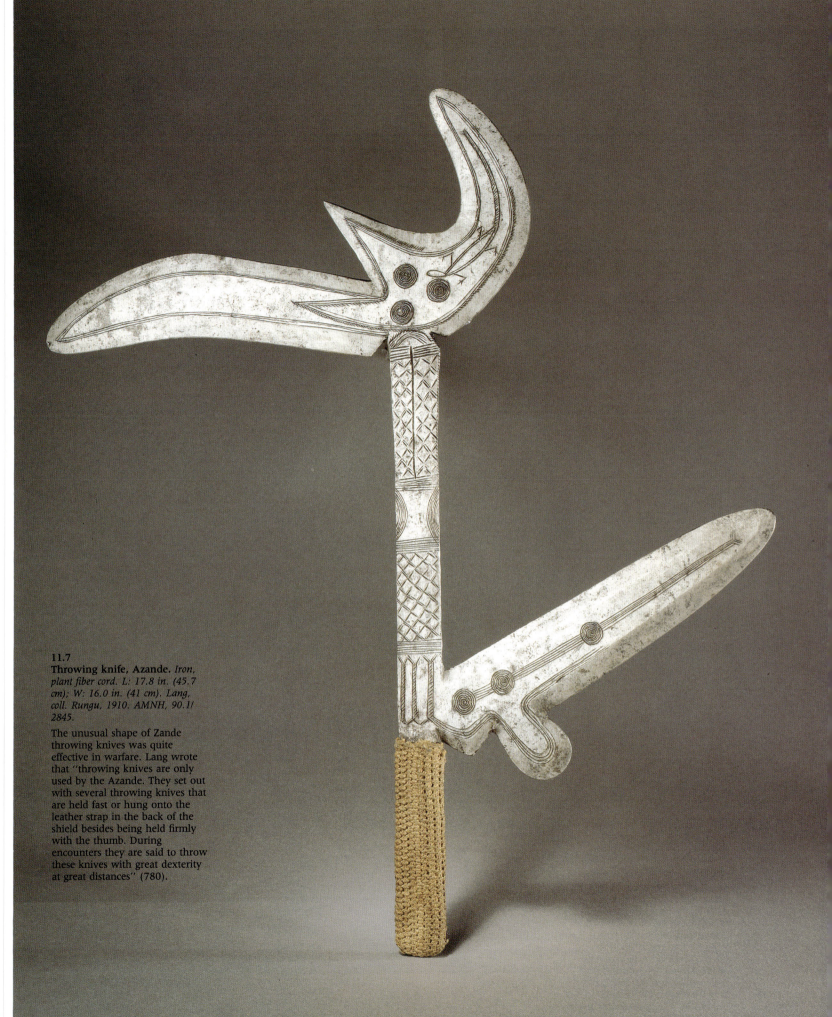

11.7
Throwing knife, Azande. *Iron, plant fiber cord. L: 17.8 in. (45.7 cm); W: 16.0 in. (41 cm). Lang, coll. Rungu, 1910. AMNH, 90.1/ 2845.*

The unusual shape of Zande throwing knives was quite effective in warfare. Lang wrote that "throwing knives are only used by the Azande. They set out with several throwing knives that are held fast or hung onto the leather strap in the back of the shield besides being held firmly with the thumb. During encounters they are said to throw these knives with great dexterity at great distances" (780).

carrying goods of all descriptions—not for trade but as tribute to kingly or provincial courts. Why did royalty not make more use of the quantities of exotic goods passing through their hands for their own personal ends? Evans-Pritchard reported a notable incident dating back at least to the turn of the century. It concerns Gbudwe, often portrayed as the most conservative or "traditionalist" of Zande rulers:

> He generally carried a curved ceremonial knife in his hand and would lay it across his knees as he sat in court, and he used it to assist himself in rising from his stool by pressing it on the ground. He once possessed a knife of this kind with a very fine handle of Mangbetu workmanship, but his courtiers so often and so pointedly admired it, saying, "Gbudwe, what a fine knife, what a fine piece of craftsmanship!" that in despair he gave it away to one of them, and ever afterwards he used one with an ordinary wooden handle. (1971, 373)

Royal power was ambiguous. Kings and princes had the authority to order the mutilation or death of any subject who caused them displeasure. Yet their subjects expected to be fed when at court and, in turn, to receive a portion of the goods flowing into the court from near and far. Generosity in such matters was incumbent on rulers. Subjects turned up at court to demand goods, especially the spears that could be used to acquire wives. Many of the Zande texts quoted by Evans-Pritchard emphasize this point (e.g., 1971, 217–23). Tribute was not given by subjects for the personal edification of kings or princes; it was ultimately intended for the court as a whole. It was not for accumulation but for distribution. The prestige of the ruler, therefore, was not (or not only) enhanced by the goods he received; what he gave away was equally important. In the story quoted above, collected more than twenty years after Gbudwe's death, he is remembered not for having an ivory-handled knife (11.13) but for having given it away.

Goods redistributed by the king or prince thus became agents in the creation of a set of relationships. Ceremonial knives, presented by the ruler to his courtiers as a mark of their right of access to the inner sanctum of the kingdom or province, were merely the most obvious examples of this understanding. In practice, all who attended court had the right to expect, indeed to demand, the generosity of royalty. The system went far beyond artifacts to include not only foodstuffs but wives and slaves (see, for instance, Krapf-Askari 1972). Nonetheless, to the extent that objects were involved, the Zande emphasis on non-esoteric, functional items is consistent with these ends. Similarly,

the items redistributed frequently came from the distant spheres of Zande influence. By sharing exotic goods and ensuring their rapid circulation rather than possessing them personally and exclusively, Avongara rulers contributed to the shifts in material styles observed in nineteenth- and early twentieth-century sources.

The Azande and Colonial Contacts

Throughout this period there were, of course, other and powerful forces with whom the Azande had to come to terms. They did not occupy some isolated niche, exploring and exploiting the resources of their immediate environment, without reference to external circumstances. The Arab traders, the occasional Europeans who followed them, and, in due course, Belgian, French, and British colonizing missions, all sought for different reasons to establish various kinds of relationships with Avongara rulers. Many oral accounts recorded among the Azande in the 1920s chart the progress of these relationships in terms of the prestations going back and forth between rulers and foreigners. Crises in relationships were signaled by a failure to observe the protocol of the gift-giving process. For instance, one account of an Arab trader who, deserted by his homesick Zande wife, demanded the return of marriage spears summarizes neatly—in Zande terms—the breakdown of the Zande-Arab connection. Such moments were bound to arise because the two parties held different views about what was involved: the Arab traders sought an essentially commercial engagement with the Azande, whereas the Avongara manipulated the niceties of tribute and gifts to assess and structure relative status.

Inevitably, a number of significant items did find their way northward to Khartoum and beyond. The collections of the British Museum, for instance, include a large wooden slit drum acquired from the Mahdists at the Battle of Omdurman in 1898 (see Bravmann 1983, 51–52). Its style is not necessarily associated with the Azande. It shows an animal head, possibly that of a goat, but the Azande may not have kept domesticated stock at the time (although they do now). Zande slit drums typically lack this feature (as is evident from Schweinfurth's illustration of one [1875, pl. XI, 8]). The style is more common among southern neighbors of the Azande such as the Barambo, who may have constituted a significant proportion of the Zande conquered subjects. Gbudwe's slit drum, though its body is differently styled, also had an animal head carved at one end (Seligmann 1911). The Mahdist drum could certainly have

11.13
Knife, Mangbetu. *Ivory, brass. L: 15.2 in. (39 cm). Lang, coll. Niangara, 1913. AMNH, 90.1/ 4143.*

Mangbetu knives were highly prized among the Azande for their workmanship and form. These knives were items of luxury trade among peoples in the region.

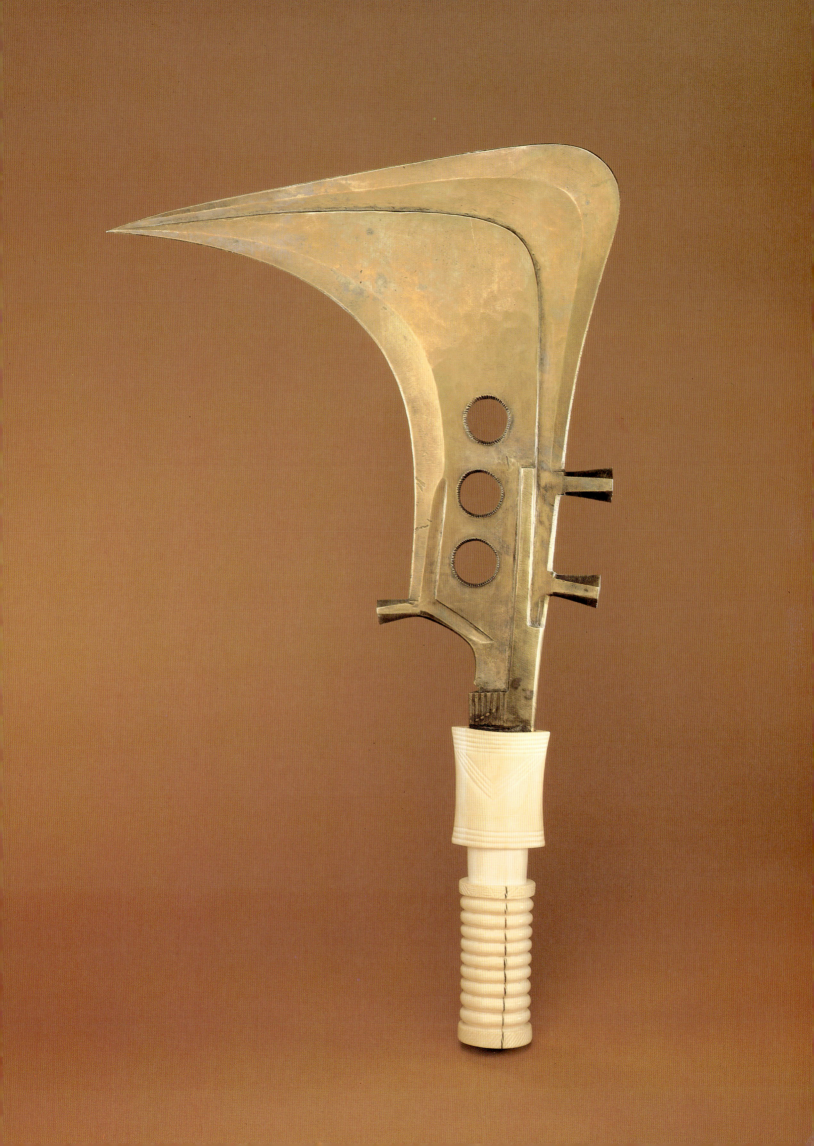

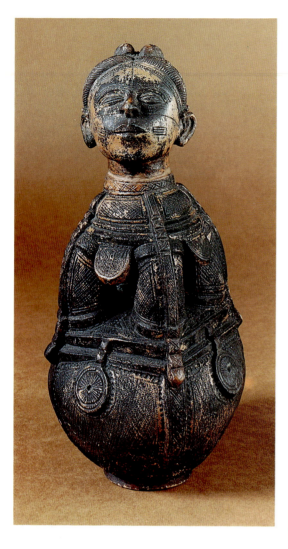

remarkable ceramic pieces with modeled figures, the work of a Zande potter called Mbitim (Powell-Cotton 1934) (**11.14, 11.16–11.18**). An older tradition associated with the Adio Azande just beyond Yambio District was the production of large water pots with human heads at the neck (Seligmann and Seligmann 1932, 498). By the time the Powell-Cottons visited Lirangu, Mbitim was producing such varied objects as ceramic bowls with figures seated on the rims and bookends with figurative elements (**11.16–11.18**).

Lirangu, however, was also a center for wood carving. Staff members of the medical center were themselves sometimes honored in figurative carvings, as happened at Source Yuba, another sleeping sickness station (Wyndham 1936, 195–96 and pls. 36–38). The director at the time of the Powell-Cottons' visit was a Syrian doctor. A number of wood carvings (of which two came to the British Museum in 1938) show figures with tall coiffures that display a crescent-shaped motif (**11.15**). This could reflect an older tradition in which this emblem was used to connote Arabs, or it could be intended to specifically refer to the nationality of the director at the time the figures were made.[16]

←
11.14
Pot, Azande. *Ceramic. H: 13 in. (33.2 cm). Major and Mrs. Powell-Cotton, coll. c. 1930s. British Museum, 1934.3.8.27.*

This figurative ceramic pot was made by the Zande potter Mbitim in the 1930s. The open space in the center formed by the use of clay supports was a form commonly found in nonanthropomorphic pottery.

been acquired through the Azande, if not directly from some of their southern neighbors. The drum has Islamic designs on its flanks, as appropriate to its Mahdist owners.

The Mangbetu prepared objects specifically for presentation to Lang and Chapin. There is certainly sufficient evidence to suggest that the Azande saw similar prestations as a method of structuring a relationship. These gifts were all the more necessary in uncertain times, as in the period of Arab and European contact. The era of colonial rule (in all three countries in which the Azande lived) threatened the continued operation of the court system. However, the idea that objects might be fashioned specifically for presentation was to an extent sustained as part of an essentially noncommercial relationship. Thus at Lirangu, a village near Yambio in the southern Sudan, figurative work in both ceramics and wood was produced into the 1930s. Lirangu was a center for the treatment of sleeping sickness, with a medical staff composed of foreigners. It was visited in 1933 by Major and Mrs. Powell-Cotton, who collected a number of

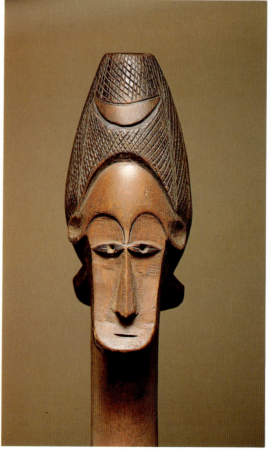

11.15
Club (detail), Azande. *Wood, leather. L: 26.1 in. (67 cm). Access. 1924. AMNH, 90.1/5764.*

This club was collected in the Sudan and cataloged as coming from the Dinka, northern neighbors of the Azande, among whom it was probably collected. Stylistically similar to Zande figures, it may have been made by a Zande carver.

At Source Yuba members of the staff were portrayed on large pole sculptures placed in the village (sometimes misinterpreted as funerary carvings). In a photograph taken by one of the staff, one such sculpture had a placard attached. Considering the use Azande have made of objects to create and sustain relationships, the motto it bears is particularly appropriate in the context of a medical establishment staffed by foreign healers. It reads "Entente Cordiale Square."

11.16
Bowl, Azande. *Ceramic. H: 8.1 in. (20.7 cm). Major and Mrs. Powell-Cotton, coll. c. 1930s. Powell-Cotton Museum, 63.*

Working in the 1930s, the Zande potter Mbitim produced a series of bowls, jars, and dishes with carefully sculpted human figures placed around the sides. The Powell-Cottons visited the atelier where Mbitim worked and collected many pieces from the artist.

11.17, 11.18
Bookends, Azande. *Ceramic. H: 6 in. (15.3 cm). Major and Mrs. Powell-Cotton, coll. c. 1930s. British Museum, 1934.3.8.25, 1934.3.8.26.*

Clearly a work made for the European market, the potter Mbitim created these fanciful bookends with full figures seated on the ceramic bases.

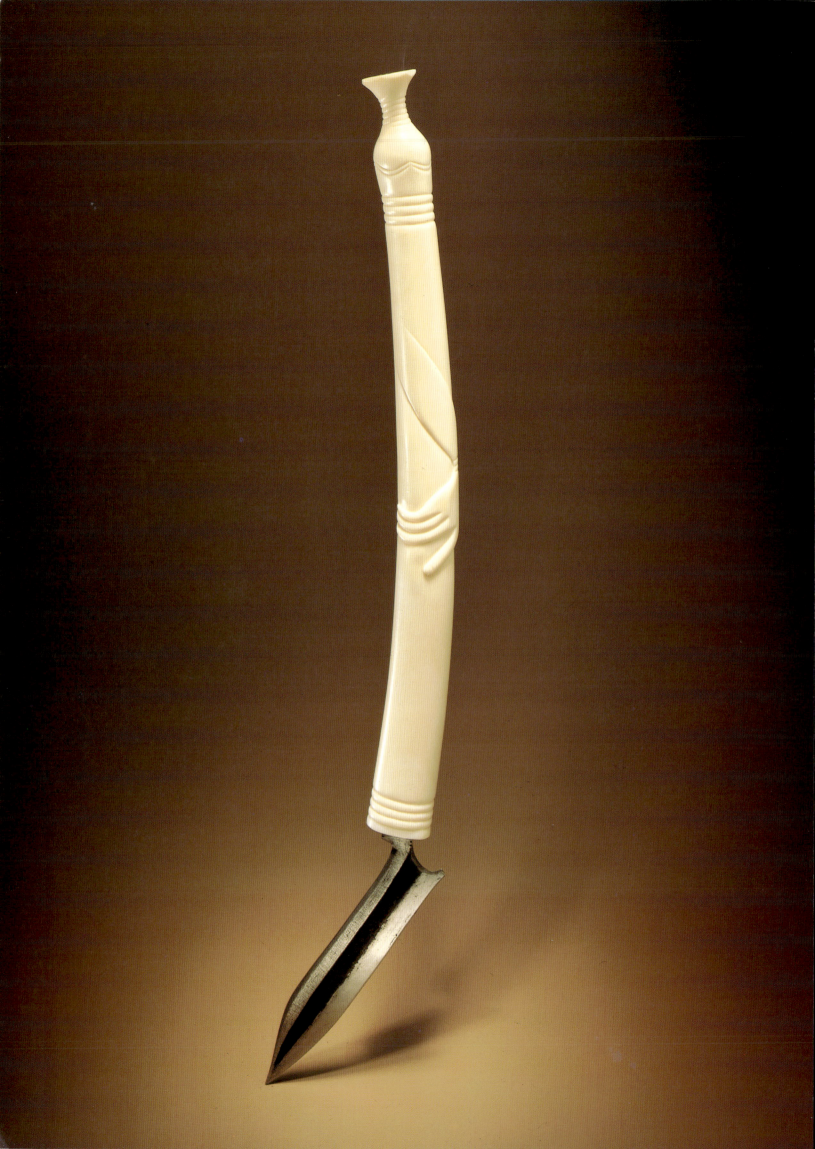

12

Reflections on Mangbetu Art

12.1
Knife, Mangbetu. *Ivory, iron. L: 16.6 in. (42.5 cm). Lang, coll. Poko(?), 1914. AMNH, 90.1/4777.* Knives of this type were used for carving wood and ivory. The blade is sharpened on only one side, allowing the forefinger to rest on the blunt, outer blade. This positioning gives the carver greater control and precision. The hand carved on this ivory handle was said by the artist to represent his own hand (3377).

Elongated heads sculpted on knives, harps, pots, and boxes may have once typified the art of the Mangbetu, but their prominence has eclipsed both more fundamental creative expressions of the Mangbetu and the art of neighboring peoples. We have followed two main arguments in this book. The first is that the basic esthetic principles of the peoples of northeastern Zaire are expressed in the wide variety of useful objects they make that embody a vibrant sense of design. The second is that the anthropomorphic sculpture associated with the Mangbetu developed around 1900 out of pre-existing artistic traditions found among the surrounding peoples. Furthermore, the abundance of anthropomorphic objects produced in the first quarter of the twentieth century—and their subsequent disappearance from the artistic repertoire—can be explained only in the historical context of the colonial encounter. The anthropomorphic genre, as it developed among the Mangbetu, reflected the interaction of various African cultures in the region with one another and with the newly intruding Europeans. To both the Westerners who admired it and the artists who made it, "Mangbetu art" embodied ethnicity: to the former, it was a stereotyped image of traditional African beauty, and to the latter, an expression of a new sense of ethnic identity.

There are at least two ways to approach the question of why anthropomorphic art became so important in northeastern Zaire in the colonial period, and by extension why so few ex-

amples of the genre were discovered among the Mangbetu in the preceding century. One approach is to argue from historical data, which for northeastern Zaire consist of written accounts by European observers beginning in the 1860s. Despite the myths and stereotypes that so often cloud Westerners' descriptions of Africa, these accounts can be used judiciously to trace threads of evidence through space and time. What they describe is a matter of chance: the evidence follows the haphazard trail of traders, explorers, colonial administrators, and tourists. However, in the absence of archeological data or solid oral histories, such descriptions are all we have for the precolonial period. Taken together, as we will show in the following pages, these accounts suggest that Mangbetu anthropomorphic art did not develop significantly until the dawn of the colonial era.

Assuming that this interpretation of the historical evidence is correct, what accounts for the burgeoning of anthropomorphic art among the Mangbetu in the colonial period, and why was it not important earlier? This is properly a question of ethnography and ethnohistory. This approach addresses the role played by particular artifacts in the repertoire of material culture (of particular peoples at particular times). What were the intentions of the makers of artifacts and what were the meanings, in terms of symbolism and function, of the objects themselves? To answer these questions, several kinds of evidence are available, such as the field records of observers in the colonial period, including col-

lectors like Lang and Hutereau, as well as accounts based on modern field research among present-day Mangbetu, in which the most important data are the transcribed statements of the people themselves. We can also study collections of artifacts directly to compare variations in techniques, styles, and provenances. In this chapter we pursue both the historical and the ethnographic lines of inquiry, returning finally to the question posed in the opening chapter: who created Mangbetu art—and why?

Materials and Their Meaning

All the materials used in artifacts made in the precolonial period were derived from the plants, animals, and minerals found in the immediate environment or from a very few processed materials acquired through trade: copper, brass, and glass beads. Less obviously, these materials often had meanings beyond the utilitarian.[1] Some of these meanings were symbolic in the sense that something in nature stood for some cultural concept. For example, a leopard's tooth stood for the power of the chief to "devour" his subjects (the leopard was the region's only natural predator of humans), and a hornbill's beak stood for a man's protectiveness for his family (and, when worn, supposedly helped the wearer to acquire wives). Sometimes, of course, materials were used simply as signs of status or wealth, as in the case of copper or ivory hatpins, which were available only to members of the ruling class. The Mangbetu used plants as medicines in a direct pharmacological way, but certain plant and animal materials, used as medicines or as symbols, also had generative power—power to transform or change the lives of their owners. Materials classified as "minerals" on the other hand (including metals, glass, and also ivory, which, like a mineral, does not rot) were not used as medicine and represented pure wealth. They were what they were, and their value increased only by the owner accumulating more of them.

Plants also had a place in each of the major ritual transfers of power in *naando, natolo,* and *neo*. In some instances the *naando* blessing was given with a narcotic root product. In *natolo* communication with ancestors depended on fast-growing domestic plants (manioc and fig) (9.7). Plants were especially important to *neo* because the great majority of medicines were plant substances. A clear connection exists between the life found in plants and the desire for vitality demonstrated by their use in ritual practice. Some plants also evoked emblematic meanings. For instance, the head of a family or a young man could be called a *negbola*, a kind

of tree used for house posts because it was very strong and not eaten by white ants. The tree symbolized these men because "they support the society."[2]

Animal substances were used as emblems, as simple decoration, or to generate power. There was often a perceived relationship between the characteristics of an animal and its ability as medicine to produce some effect. Lang and others have given many examples, some of which have been cited in this book. The tree hyrax, to cite just one example, was the source of important antiwitchcraft medicines. Every evening the tree hyrax gives out calls from the forest that sound like a woman's scream. Lang wrote that the animal "howls intermittently for hours and hours during the night, and his voice may be heard at a great distance" (502). The Mangbetu use the bones and fur of the tree hyrax to detect witches. If, for example, the animal parts are hidden in a pot of water, any witch who tries to drink out of the pot will say that the water has a bad odor and taste. The medicines derive their efficacy from the fact that the night crying of the hyrax deters action by witches and from the animal's ability to avoid capture. Lang also collected two charms of tree hyrax teeth that could "protect bearer from headache [including trance, possession, witchcraft] and give great mental capabilities" (503).

Although Mangbetu decorated the human body, they also regarded it as the source of many "raw" materials to be used independently (detached from the person—literally disembodied) as sources of power.[3] As with plants, the body was involved in the major ritual complexes through which the Mangbetu conferred power: *naando, natolo,* and *neo* (see chap. 9). In *naando,* saliva or water from the mouth of an elder was used for blessing. In *natolo,* the dead body in the grave is an essential part of the relationship between the living family and the ancestor. For example, King Danga died in exile, but his finger and beard were brought back to his family so that they could receive his blessing. In *neo,* human substances taken from someone's body were used to prepare medicines that magically could harm that person. Body substances also were used ritually to transfer power to objects, as in the use of blood to transfer power to the king's double bell or the use of menstrual blood or semen to prepare the medicines of *nebeli* secret societies.

Human substances served exclusively to impart power or as a medicine with one exception: the use of human hair in constructing the famous hairpieces worn by Mangbetu women. But even hair could be used magically, as when Danga's beard was returned from exile for *na-*

tolo. In another case, when the Italian explorer Miani died at Mbunza's court in 1871, Mbunza cut off Miani's large beard and had it braided into a belt, perhaps thereby assuming or neutralizing some of the power of the foreigner.

As already noted, the Mangbetu classify ivory in the same category as metal. Before the 1860s and the advent of long-distance trade, ivory was evidently relatively unimportant as a raw material. One informant in the 1970s even stated that ivory was formerly discarded when an elephant was killed. By the time of Schweinfurth, however, a brisk trade of ivory for copper and iron had been established with Arabs from the Nile Valley. Schweinfurth believed that the ivory trade was a monopoly of King Mbunza, but his description of the many Mangbetu trading at the Nangazizi market makes this idea unlikely. Casati indicated that the best tusk of each elephant went to the king, and the hunter himself owned the other one. Neither Schweinfurth nor the visitors of the 1880s noted any extensive use of ivory in Mangbetu material culture except as trumpets, barkcloth beaters, and a very occasional ornament. The role of ivory in material culture began to change dramatically in the period of the Congo Free State, and soon after its establishment Lang noted that "not until 1910 did Greeks and Hindus flock into the northeastern Uele offering so high a price for tusks that ivory soon became scarce" (1918a, 531).[4]

Minerals, like ivory, were usually processed, but they also had value simply as raw materials, much as Westerners value gold. They represented stored wealth even when worn as ornaments and were never used as medicines although they could be fashioned into representations of animal parts, most commonly claws. Shaped into ornaments, they took on added symbolic resonance even though they did not have the power associated with the actual animal material. Mineral substances could serve as vehicles for medicines, however. For instance, the Mangbetu sometimes soaked porous rocks in solutions made with medicinal plants and then used the rocks for healing. Likewise, applying blood to the king's iron double bell endowed it with power.

Iron, the most ancient of the metals used by the Mangbetu, is considered dangerous to the operators of the furnace and the forge, who must observe ritual precautions while it is being processed. For the final consumer, however, iron connotes production and reproduction (it is the quintessential material used for bridewealth payments) and also wealth and political power. There is an obvious connection between iron and the tools of agriculture and weapons of war. Copper and bronze were introduced as a result of long-distance trade at the end of the nineteenth century and were quickly equated with iron. Mbunza displayed rows of copper weapons that symbolized both his wealth and his role as a conqueror king.

These examples demonstrate that for the Mangbetu, *unworked material* had meaning and power in itself. The nature of the materials used to make objects was as important as the work done to them. The Mangbetu wore imported glass beads in massive strings, in exactly the form they had been obtained, whereas among the Kuba, the Maasai, and the Bamum, for example, glass beads became part of an elaborate symbolic iconography. One of Okondo's wives, Matubani, owned a necklace made from four brass-wrapped cylinders of wood (9.13). It was not the cylindrical shape of the wood or the brass embellishment that made these objects particular treasures but rather the particular species of wood from which they were made. A bracelet collected by Lang had tiny links made of identically shaped squares of wood; the bracelet was a powerful charm because each link had been cut from a different kind of wood, each with its special medicinal property. The accumulated appendages on bracelets, belts, and necklaces were selected for the meanings given to the various materials, and most of them were incorporated as they were found, often without embellishment or decoration. Iron, used as bridewealth, could take the form of well-crafted blades or simply raw lumps from the smelter; it had the same value either way.

Natural materials also served as emblems of political power. In the precolonial period the very possession of leopard's teeth or the red tail feathers of the gray parrot was restricted to royalty. Mbunza, according to Schweinfurth, had an entire room filled with hats and feathers of every variety (1874, 2:98). Besides the leopard, other powerful predators like the eagle symbolized the power of kings. In areas beyond the habitat of the okapi, such as in the Mangbetu heartland between the Uele and Bomokandi rivers, okapi skins were a symbol of royalty because of their beauty and rarity. These animal parts were not used as medicine, although they could be transformed into ornaments.

These attitudes toward the ingredients of material culture suggest an explanation for the lack of art, as Westerners conventionally define it, among the precolonial Mangbetu and Azande. In many African societies, art—particularly sculpture—is used as a medium of communication with ancestors and with powers of nature. The precolonial Mangbetu and related peoples of northeastern Zaire achieved this kind of com-

tices in this region. They suggest that although ancestral shrines were not necessarily or even generally associated with sculpture, carved figures could be incorporated into them. As with knives, harps, and pots, our best information suggests that the sculpture was not essential to the functioning of the grave but rather was an embellishment.

Although harps with sculpted heads were found among the Azande in the nineteenth century, they were clearly always a secular art form, as they later would become, briefly, for the Mangbetu. Harps, whistles, knives, and all the other implements sometimes adorned with heads were also made without them. All of these objects functioned perfectly well as harps, knives, whistles, or pots with or without anthropomorphic carving. This situation would be inconceivable to many African peoples for whom sculpture itself has ritual significance. The heads on harps, knives, and even full figures sometimes portrayed actual people and were often caricatures of ethnic types. Perhaps because these sculptures were made as art, it was easy for their creators to treat them with humor, something that would have been improbable had they been made for a more serious purpose.

Historical Perspectives on Mangbetu Portraits

We now return to the problem posed at the beginning of this volume: the origin of anthropomorphic art among the Mangbetu. Addressing this question means sorting out the patterns of communication that crisscrossed the region in the precolonial and colonial periods and it means assessing, in particular, the influence of the Azande, the Barambo, and the Bua on Mangbetu art.

Schweinfurth was the first observer to associate an anthropomorphic object with the Mangbetu, but significantly, he never described anthropomorphic art done by the Mangbetu themselves. Writing of the Zande whistle illustrated in *Artes Africanae* (1875, pl. XIV), Schweinfurth stated that "the head attached to the wooden whistle represents a Monbuttoo, with high chignon of hair and perforated ears." On the same page he illustrated a Zande anthropomorphic harp that he described as having "a careful imitation of the tattooing in chequered squares on forehead, cheeks and temples characteristic of the Niam-niam [Azande], the well-parted braids, etc." (1875, pl. XIV). *Artes Africanae* was published five years after Schweinfurth's African journey. In the original drawing of the same harp (**12.5**) there is an

inscription, omitted from the 1875 publication, that notes that "der Kopf soll den Sultan Munsa (Monbuttu) vorstellen" ("the head is said to represent King Munsa of the Mangbetu").

This reference is highly significant. Although Schweinfurth described no anthropomorphic art among the Mangbetu and little among the Azande, the only two anthropomorphic objects from the Azande were both said to represent Mangbetu. Earlier collectors (including Piaggia, Antinori, Petherick, and Junker) had found anthropomorphic objects among the Azande and Bongo in the Sudan, including ivory trumpets, harps, and pipes. Certainly not all of these were portraits of Mangbetu, but Schweinfurth nonetheless made this association while clearly indicating that the Mangbetu had no anthropomorphic sculpture of their own.[9] Several interpretations can be made, but the most plausible is that Zande informants or more probably Schweinfurth's Arab interpreters, or

12.5
Drawing by Georg Schweinfurth of a Zande harp, 1870–71. *Frobenius-Institut, 2284.*

Schweinfurth made numerous drawings during his travels in central Africa, including this previously unpublished illustration of a Zande harp. From Schweinfurth's inscription underneath the head, one finds that it was said to represent the Mangbetu king Mbunza.

Schweinfurth himself, suggested this explanation of the objects. However, with regard to the harp, Schweinfurth changed his interpretation of who was portrayed in the five-year period between his visit and his publication. In the published version, only the whistle, the one object that had an elongated head, was said to be a representation of a Mangbetu.[10]

Although we will never know whether the idea that the harp represented King Mbunza came from Schweinfurth himself or from Zande informants, it is clear that as early as the 1880s the elongated harp became such an obvious marker of Mangbetu identity that it was assumed to represent Mangbetu whether or not a Mangbetu artist carved it. Early observers from Casati to Lang noted that the head portrayed, or caricatured, the Mangbetu. Czekanowski wrote that some harp bows in the southern Azande area ended in finely carved human heads in which "one can recognize a caricature [*Karikatur*] of a deformed Mangbetu head" (Czekanowski 1924, 39; quoted in Evans-Pritchard 1963, 189). Evans-Pritchard, who had little first-hand acquaintance with the Mangbetu, was one of the few who took issue with this interpretation. He assumed that all the anthropomorphic carvings found among the Azande were actually Mangbetu work, except for the one statue that he saw a Zande carve. That one, he supposed, was a "copy of Mangbetu work" (1963, 189).

These various historical references indicate that most of the earliest Western observers of the Mangbetu and Azande recognized that carvings portraying the Mangbetu as people typified by an elongated head were not necessarily the work of Mangbetu artists. Individuals among the Budu, Mayogo, Azande, Barambo, Makere, Lese, Mamvu, Meje, and other groups (some of whom were incorporated into the Mangbetu kingdoms) adopted the practice of elongating the head, and some of these people were carvers who portrayed the fashion in their work.

Secret Societies and the Transmission of Art

By the 1880s the crosscurrents of artistic influence had become so complex that art in northeastern Zaire was already a trade commodity, as well as a form of tribute (see chap. 11). The trade in art, like the trade in many other aspects of culture, including foods, technologies, medicines, and rituals, long predated European contact. "It was a common practice," wrote Evans-Pritchard, "for those who journeyed to the south to collect oracle-poison to bring back with them, also Mangbetu artifacts, carefully bound in leaves, to present to their princes" (1963, 189).

Secret societies were important in the diffusion of art styles and art objects. The continual search for new medicines was one reason for this movement, but even more importantly, organizations like the *nebeli* society, first described in the 1880s, cut across cultural, linguistic, and political boundaries. Czekanowski (1924, 164) wrote that *nebeli* among the Mangbetu expressed a need for solidarity "among different native peoples in the face of European conquest" (Evans-Pritchard 1965, 1).[11] Evans-Pritchard, having first ascribed these societies to a reaction against colonialism, later emphasized the chaos caused three decades earlier by the Arab slavers. In speaking of the Avongara kingdom of Gbudwe, he wrote that

> it was an unsettled period and the magical associations which emerged . . . can indeed be considered to be a response to a situation in which social life was seriously disturbed and the ruling classes were losing their control. They may even be regarded as subversive, having their own organization of cells not subject to the supervision of the traditional rulers, kept secret from them and opposed to them. That this was the view of the Avongara rulers of the Azande is demonstrated by the efforts they made to suppress them. The European administrations also regarded them as subversive and treated membership of [*sic*] them as a criminal offence. (1965, 2; see **2.13**)

Among the Azande, Evans-Pritchard noted the "foreign origins" of many secret societies, rituals, and medicines, including *naando*, *nebeli*, *siba* (from people south of the Uele, including the Mangbetu), *biri* (from the Mangbetu or the Bangba), *mani* (from any one of several southern peoples), *kpira* (from the Bongo to the north), and *wanga* (also from the north) (1965, 1–2).

In addition to medicines, whistles (like the whistle on the *nebeli* bracelet collected by Lang and those mentioned in chap. 9), and possibly funerary figures, two other classes of objects were specifically linked to secret societies: figures and masks. The *mani* society figures, known as *yanda* and associated with the western Azande, are sometimes interpreted as sculptural transformations of the Zande rubbing oracle (Burssens 1962). The idea of using figures in the *mani* society could just as easily have come to the Azande from neighbors. One small figure, now in the Museum of Mankind, was collected in the 1870s somewhere in "East Central Africa" (**12.6**). It has what appears to be a typical Zande ridged hairstyle similar to the treatment on the heads of early anthropo-

that have stylistic and possibly functional affinities to masks collected by Hutereau from the Bua (**12.8**). More recently collected masks from the western Azande are probably also of Bua derivation (Burssens 1960, 108).[14] Although simpler in form than the Bua masks, the masks Burrows collected have the same alternating dark and light patterns. The symbolic significance of this patterning is not entirely clear, but Hutereau's notes about a flecked hat (**6.20**) collected from the Bua indicate that the alternation of light and dark was said to represent the spots of "certain cats," almost certainly leopards. This suggests an association with the *naando*, wherein the *amamboliombie* covers himself with white spots to represent a leopard (**9.6**). Also, as described in chapter 9 (*Notu*), Mangbetu el-

←
12.6
Figure, East Central Africa.
Wood, copper wire. H: 6.6 in. (16.8 cm). Khedive of Egypt, coll. c. 1878. British Museum, +991.

This figure was given to the British Museum by the Khedive of Egypt in 1878 and displayed earlier that year at the Paris Exhibition. The ridged hairstyle is similar to the treatment on Zande harps of the same period.

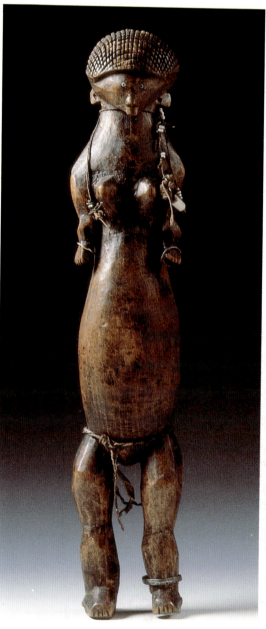

12.7
Figure, White Nile region, Azande(?). *Wood, beads. H: 19.6 in. (50 cm). Gessi, coll. 1883. Museo preistorico ed etnografico "Luigi Pigorini," Rome, 29606.*

This figure, collected in 1883 by Gessi Pasha (Romolo Gessi) in the southern Sudan west of the Nile River, is an early example of figurative carving in the region.

morphic harps and on the large standing figure collected by Gessi in 1883 (**12.7**). It also has saucerlike eyes of the type sometimes associated with the Ngbaka, who lived to the northwest of the Mangbetu and the Azande.[12]

Masks also owe their distribution in northeastern Zaire to secret associations, most of which cross ethnic boundaries. Several masks have been collected from the Mangbetu, but many early reports state explicitly that the Mangbetu have no tradition of masks. Casati, however, saw a monkey skin "covering" on the head of a person he described as a jester at a dance at the court of Yangala, a Bangba chief (Casati 1891, 1:148–49). This person was probably connected to *nebeli*, for *nebeli* was important to Yangala, and Czekanowski reported that a basketlike head covering was a feature of the cult (Czekanowski 1924, 166).[13] Burrows collected a skin mask around 1900 that he claimed was a Mangbetu hunting mask, and we know that the southern Bantu-speaking neighbors of the Mangbetu used skin masks for hunting rituals.

Burrows collected two wooden war masks (**3.6**, **3.7**) that he labeled "Mang-bettou" but

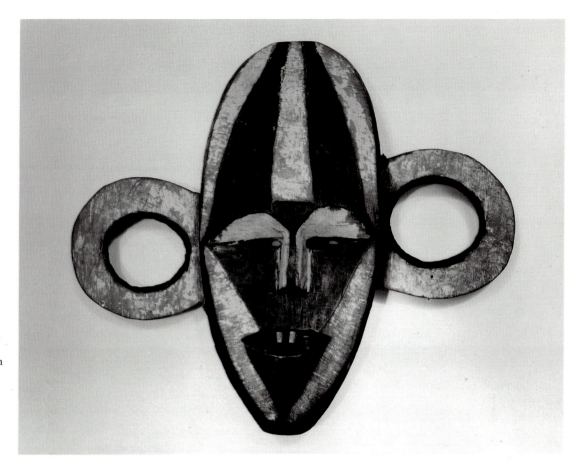

12.8
Mask, Bua. *Wood. H: 11.9 in. (30.4 cm). Hutereau, coll. c. 1911–13. Musée royal de l'Afrique centrale, 11697.*

This mask, said to give power over the enemy, was from a Bua war dance called by Hutereau *pongdudu*. During a Bua rebellion against the Belgians, a colonial officer, Commandant Christians, was wounded by a Bua sorcerer who was wearing this mask. Christians managed to seize the mask, however, and then fled to Magombo Island taking it with him.

ders who performed circumcision operations and autopsies painted their faces in a half-white, half-black pattern and their bodies with spots.

This dark/light patterning is clearly the most basic design element in the region, and it can still be found today on many common implements. Lang collected many knives, axes, bark-cloth beaters, and hoes with this patterning applied to the wooden handles (**4.13**). It also appears on barkcloth, on bamboo beds, where patterns are applied with a hot iron or where some of the elements are blackened over a fire (**2.8**), and on many other objects.

Patterns of Influence

In studying the history of northeastern Zaire, the question of the mutual influence of the Zande and Mangbetu on each other's art forms frequently arises (see chap. 11). The militarily stronger Azande had occupied territory on three sides of the Mangbetu by the late nineteenth century and displaced a number of Mangbetu rulers. Evans-Pritchard, who did his fieldwork among the Azande in the 1920s, made a considerable point of his belief that the Azande had learned many of the finer points of wood carv-

ing, architecture, potting, and smithing from the Mangbetu (1960; 1963; 1965; 1971, 89–105). He erroneously assumed that by the time of Schweinfurth's visit, the Azande "had already . . . been strongly influenced by Mangbetu styles of carving bowls and stools, and this is particularly noticeable in the carving of human heads on harps and whistles, the latter now no longer to be seen in the Sudan" (1963, 189).

The Mangbetu certainly contributed to Zande culture, but it appears that Evans-Pritchard may have misunderstood their influence. Based on his own detailed knowledge of the Azande and some mistaken assumptions about the Mangbetu, Evans-Pritchard misread some of the earliest sources. Thus he rejected Emin Pasha's comment that "real artists, who carve heads and figures, etc., are more numerous amongst the A-Zande" (Emin Pasha 1888, 213, cited in Evans-Pritchard 1963, 186) because Emin Pasha knew little about the Azande or the Mangbetu. Evans-Pritchard accepted Casati's judgment that the Mangbetu were superior carvers, even though Casati had little contact with the Azande. This assessment tended to obscure important points. A more accurate interpretation of Emin Pasha's account would be that on his visit to the Matchaga rulers of the

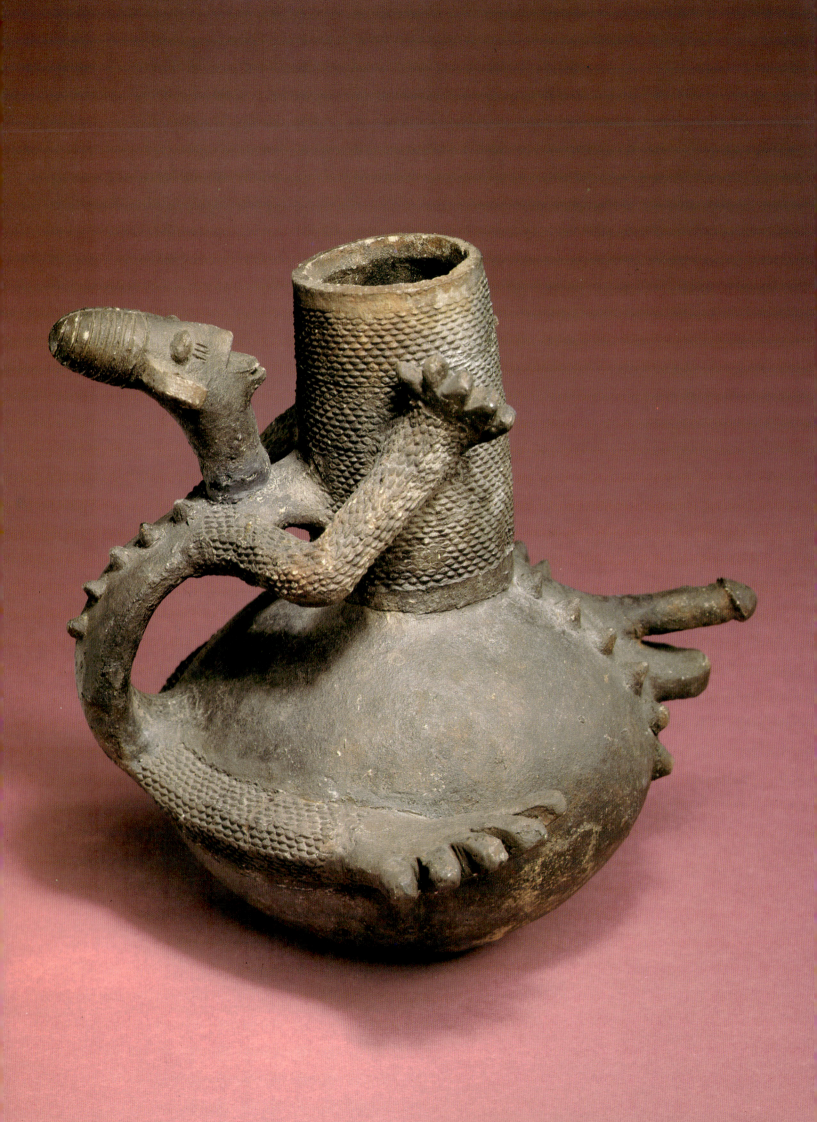

Mangbetu in 1883, he observed that the Match-aga and their subject peoples (the Bangba, in particular) in the eastern Mangbetu region had limited knowledge of carving figures, but that one people in the area—the Adio Azande—knew the art form well. Furthermore, Casati's statement about the skill of Mangbetu carvers indicated nothing about the direction of cultural influence or the types of items being produced, whether anthropomorphic or not. In fact, when Casati illustrated an anthropomorphic harp, he shows it held by a Zande, not a Mangbetu.

Evans-Pritchard concurred with the anthropologist Robert Lowie[15] that culture (in general) "may indeed be aptly described as a thing of shreds and patches (a garment of bits and pieces, but a garment all the same)" (1963, 183). Evans-Pritchard understood that Zande culture incorporated art styles from neighboring peoples, but he did not realize that exactly the same could be said of the Mangbetu. Sorting out the direction of influence between these groups (and between both groups and their neighbors to the east and west) will probably remain difficult. As we have already indicated, there is evidence that anthropomorphic styles moved from north to south, though not exclusively. Certainly the earliest harps from the region, as well as anthropomorphic pipes, were collected among the Azande and the Bongo at a time when they were not yet in use among the Mangbetu.

A pattern of northern influence can also be discerned in the forms and fashions of Mangbetu pottery (Schildkrout, Hellman, and Keim 1989). Although Mangbetu pottery was generally made by women, when anthropomorphic pottery came into vogue in the early colonial period, it was made by men, possibly Zande men (as discussed in chap. 6). It may well have been Zande potters who encouraged Mangbetu men to make pots. Most Mangbetu anthropomorphic pots come from the Niangara area on the border between Mangbetu and Zande territory. Zande artists were certainly active there before and during the colonial period.

The question of northern influences on Mangbetu art leads sooner or later to the Barambo, a people who speak a language related to that of the Azande. Prior to the nineteenth century groups of Barambo lived all over the grasslands for several hundred miles north of the Uele River, in the forest just south of the Uele, and just west of what became the Mangbetu heartlands. During the nineteenth-century period of conquest many Barambo became Zande or Mangbetu subjects while others remained independent but in close contact. Very little research has been done on the Barambo,

making it difficult to study their influence on the art of the region, but Casati, who visited the Barambo west of the Mangbetu in the early 1880s, wrote an intriguing passage:

> A special industry gives an idea of their talent—the art of making pretty little statues by wood-carving is theirs, and in this they excel all the other tribes. Handles of their barkboxes, the girdles which they use for dress, are all ornamented with carvings of human heads and small figures, in which a certain regularity of design is united to clever and intelligent workmanship. (Casati 1891, 2:194)

Referring to an area near Poko, Casati remarked that the Barambo were the best carvers of ivory in the region (1891, 2:97). Significantly, this was the same area where Lang, Czekanowski, and Hutereau all collected anthropomorphic statues, as well as many other beautifully worked objects, a quarter of a century later. By the time these collectors reached the area, the statues were mostly attributed to Zande and Mangbetu carvers, but quite possibly these pieces were influenced by the Barambo, or even the statues themselves may have been made by Barambo artists.

The connection between the Barambo and the Matchaga, a northern grasslands clan that conquered some of the Mangbetu kingdoms in 1873, is relevant here. The Matchaga rulers originally belonged to a Barambo clan known as the Duga, who adopted Mangbetu institutions of kingship and thus are often referred to as Mangbetu kings. Okondo and Ekibondo, the "Mangbetu" rulers most often visited by Europeans in the colonial period, were both Matchaga.

One of the most obvious examples of the influence of northern grasslands traditions on the Mangbetu is mural painting. Many early examples of human and animal figures and geometric designs painted on houses were described in the savanna region just north of the forest, but few from villages in the forest itself. One observer, for example, said specifically that the Bangba and not the Mangbetu decorated the outsides of their houses. He noted that it was the sons of Yangala, the conquering Bangba chief who died in 1895, who decorated their villages in this way (Van Overbergh and De Jonghe 1909, 87).

Bantu-speaking peoples from the south and west also intermingled with and influenced the art of the Mangbetu. The Bua, who were living in the middle Bomokandi valley when the Mangbetu arrived, provide the clearest example.[16] We have already mentioned the affinities between Bua masks and the two putative Mangbetu masks collected by Burrows. These

12.9
Pot, Mangbetu. *Ceramic. H: 7.6 in. (19.5 cm); D: 8.0 in. (20.4 cm). Lang, coll. Niangara, 1910. AMNH, 90.1/4703.*

The exaggeration of sexual parts appears on Mangbetu pottery, boxes, and figures. According to Lang, these works were meant to amuse by mocking the behavior of outsiders, both African and European.

masks, and many other objects, reflect the dominant regional design motif of alternating light and dark patterns. We also referred earlier to the sculpted heads on *mapingo* sticks used by the Mangbele, a group living just south of the Uele who are descended from proto-Bua. There is evidence that the origin of Mangbetu kingship lies with the proto-Bantu. The double iron bell, the most important symbol of the power of Mangbetu rulers, has clear Bantu origins (see chap. 10, pt. 1), and evidence suggests that the Mangbetu called upon Bantu smiths to oversee their production.

Anthropomorphic Art in the Early Colonial Period

In the colonial period, the European presence greatly expanded the market for certain types of regional art. The number of Europeans in northeastern Zaire was never great (about 100 had been in the area up to 1900), but this new patronage did have consequences for art. One was that it encouraged the development and spread of certain types of art already present in the immediate Mangbetu region. Anthropomorphic harp necks, box lids, and knife handles (already present in different parts of the region) were produced in greater numbers, and their use and manufacture spread to new places. Some types of geometric art, like mural painting and decoration on women's aprons (or *egbe*), probably also increased in the colonial period because of the new audience. Furthermore, the new patrons encouraged the adoption of anthropomorphic shapes on newly introduced objects such as the European-style pipe. European influence even transformed certain kinds of traditional objects: for the first time they became vehicles for anthropomorphic sculpture. Pottery is the prime example; sculpted heads and bodies were added to the rich inventory of existing shapes (6.12). Finally, the European presence lent new prestige to the Mangbetu head style. Art depicting a Mangbetu-style head was called "Mangbetu" no matter who produced it.

Most colonial officials and Europeans on collecting expeditions (such as Hutereau) worked through chiefs to obtain artifacts. Chiefs collected and commissioned objects for these visitors. Lang and Chapin also collected in this way, but because they were primarily interested in animals, they spent much of their time away from the major centers and acquired a great many objects in places away from important chiefs. At the end of their stay, Lang was communicating directly with artists and he commissioned a number of works, mainly in ivory.

Interestingly, Lang acquired his first collection of anthropomorphic art as a gift from a Belgian government official in Rungu in 1910. Although he previously cataloged more than 800 artifacts, only one depicted a human figure, a well-used and beautifully forged dagger with an anthropomorphic handle (cover photograph).[17] Lang noted that this knife was carved by someone in the court of Zebuandra, a Mangbetu chief, although he did not note the head on its handle. But after he received the Rungu collection he regularly commented on sculpted heads. Several of the anthropomorphic objects in the Rungu collection show no signs of wear, and those statues like the one of a soldier (4.19) may have been made for Europeans. Such works caused amusement among Africans, partly because of their explicit and sometimes exaggerated sexuality (12.9). These works represent a genre that emerged around 1911 when a number of carvers began producing objects for new patrons or for chiefs who presented the art to colonial officials as a way of currying favor in the new power structure.

Lang (and others) collected a number of carved figures of Mangbetu women that clearly depict Mangbetu fashion of the turn of the century, including body-painting and tiny *egbe*. Such carvings, Lang noted, were called *andro*, "persons." Hutereau collected a male figure that exactly depicts the style of dress of men at that time, including the hat, barkcloth, and belt with charms (7.22). When Lang collected a female figure, dressed in barkcloth and *negbe* (7.15), he wrote:

> Carved human figures, not used as idols, but produce always great hilarity among a crowd, that may roar of laughter [sic]. Simply produced in a spirit of imitating a human figure. Are females. Show the typical hair dress of the women and also simple designs, as used by the Mangbetu women to decorate their bodies in bast with the juice of the fruit of gardenia. (1391)

In regard to a similar piece, he wrote:

> A figure of a woman carved in wood 49 cm. high made simply for ornamentation and the pleasure to look at. Said to have been made in former times for chiefs who put them in their hut. No fetich or any superstitious power is ascribed to these skillful accomplishments of their artists. (1970)

Elsewhere Lang wrote that the figures were made "for sport" (2497). Of the carved figure of a messenger (3.16), he noted that "these figures are considered simply funny. The Mangbetu have no idols, though they firmly believe in bad spirits on the road, in the forest, in case

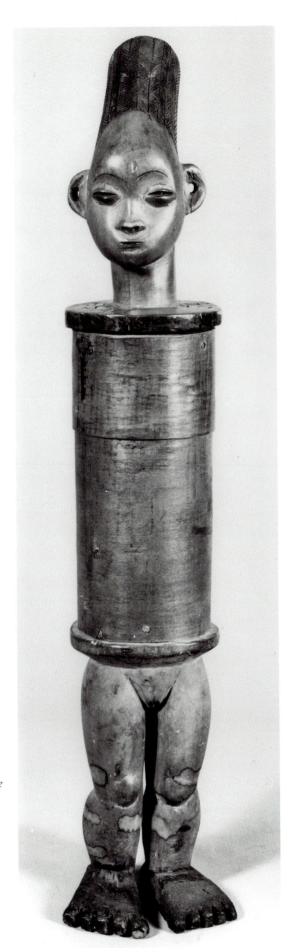

12.10
Bark box, Mangbetu. *Wood, bark. H: 22.6 in. (57.5 cm). Fraipont, c. 1903–7. Musée royal de l'Afrique centrale, 2618.*

Collected in the first decade of the twentieth century, this bark box is signed by its carver, Gataye.

of death of any of their chiefs they change the site of their villages'' (693).

Many of these figures, in the American Museum collection and others, clearly seem to have been made by the same hand. None of the collectors at the time documented any specific use for them, although recently a Mangbetu informant remarked that they were made for the *nebasa* (meeting house) of the *nebeli* society and ''burned'' because of pressure from missionaries.[18] This is improbable. Few missionaries were active in this area at the time these figures were collected. Moreover, such figures were given to Europeans, and perhaps even made for them, in the first decade of this century. There is no evidence that they were ever hidden; it is more likely that they were made to be collected and admired as art.

A number of named artists can be identified in this period, including several that signed their work (**12.10**). Songo was an Avongara chief from Rungu who was also a carver of wood and ivory (**12.14**, **12.13**). He signed a number of his pieces, all of which can be identified as being made by him by the distinctive features of the face. He made statues, bark and wooden boxes, ivory objects, and incised drawings on gourds. Several of the artists who made objects for Lang could write and usually signed their work with their name, ethnic identity, or clan name (e.g., ''Avongara'') and place of residence. These artists probably had more contact with Europeans than did many other people because Europeans, like Lang, sought them out to give them commissions.

Some artists who cannot be identified by name can be identified by style. A harp (**10.1**) collected by Lang and a pipe in the Cambridge University Museum (**12.17**) have similar faces and resemble harps and pipes in other collections. Many of the anthropomorphic pots seem to be made by the same person, and Lang stated that there were only a few men (among the Mangbetu) doing this work. One reason that this art disappeared may be that there were only a few artists making it and that when they died, with no continuing market to encourage it, the art died with them.

Anthropomorphic pottery developed after the turn of the century[19] in and around Niangara, a cosmopolitan town that attracted Zande and Mangbetu artists. Only a few men made the blackened anthropomorphic pots, but the style began to spread throughout the region in this period. In Medje, for example, Lang collected no anthropomorphic pottery in 1910, but when he returned there in 1914 there was one potter making this type of pot (**12.11**). The Medje anthropomorphic pot is clearly an adaptation of

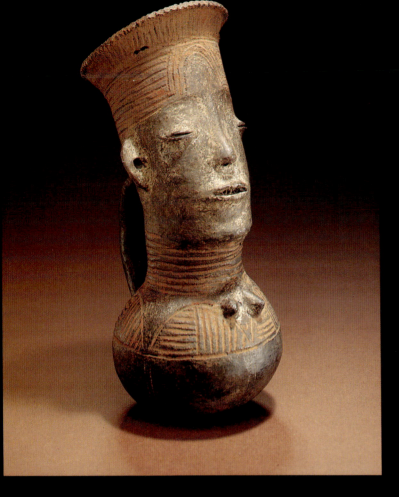

12.11
Pot, Meje. *Ceramic. H: 10.9 in. (28 cm); D: 6.7 in. (17.1 cm). Lang, Medje, 1914. AMNH, 90.1/ 2239.*

Although Lang collected Meje pottery from the beginning of the expedition in 1910, this anthropomorphic style was not acquired, and probably not produced, until 1914. The incised pattern, particularly the half-circles composed of horizontal and vertical lines, closely resembles that found on nonanthropomorphic Meje water jars.

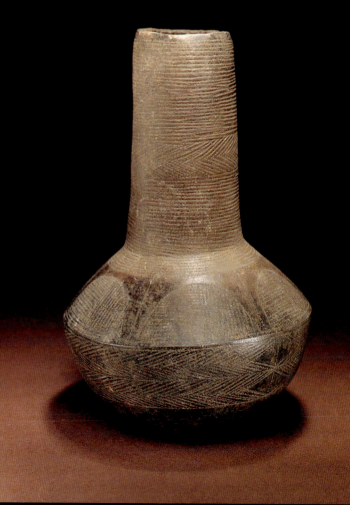

12.12
Water jar, Meje. *Ceramic. H: 10.1 in. (26 cm); D: 6.2 in. (16 cm). Lang, coll. Medje, 1910. AMNH, 90.1/2337.*

This graceful Meje water jar is decorated with incised patterns and rubbed with camwood powder to produce a subtle alteration of shiny and matte surfaces.

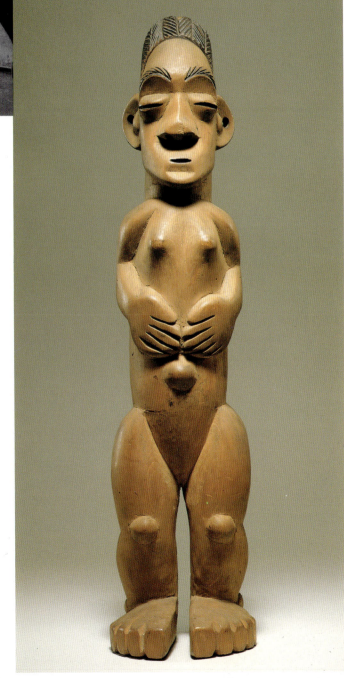

the design of traditional water pots from the
area (**12.12**). Like the Niangara pots, the an-
thropomorphic examples have the same surface
designs as the preexisting simpler forms that
were made without heads. As already noted,
the pots with stylized Mangbetu heads were
made by men. Among the Mangbetu, these
men were carvers and smiths who extended
their work into a new medium in the early
colonial period. Probably, too, some of the
Mangbetu-style pots were made by male Zande
potters.

Harps provide another example of the spread
of the anthropomorphic genre in this period.
Harps have evidently never been integral to the
Mangbetu musical repertoire although they
were popular for a few years early in this cen-
tury. Schweinfurth explicitly claimed that the
Mangbetu did not have any stringed instru-
ments (1874, 2:25, 117), and Czekanowski
(1924, 146), Lang's contemporary (even though
he published later), observed that the Zande
type of "mandolin" occurred among the Mang-
betu only where Zande influence was strong
(Evans-Pritchard 1963, 191). Lang photo-
graphed a few people with harps in Okondo's
court and he also noted that they came to the
Mangbetu from the Azande and were played for
pleasure (see chap. 10). Many harps were made
in this period and decorated with an extraordi-
narily wide range of materials, including snake-
skin, okapi skin, and pangolin scales. Okondo

12.15
Left:
Box, Mangbetu/Azande. *Wood, ivory. H: 21 in. (53.8 cm). Lang, coll. Medje, 1914. AMNH, 90.1/1764.*

Right:
Box, Mangbetu/Azande. *Wood, ivory. H: 21.5 in. (54. 6 cm). Lang, coll. Medje, 1914. AMNH, 90.1/1766.*

This pair of carved boxes represents a Mangbetu king and a queen, who wears the typical female hairdress (*tumburu*). The boxes illustrate the limits of applying ethnic labels to art from this region: the carving of the wood and ivory was done by a Mangbetu artist, Karibu, but the engraving on the ivory is the work of the Zande artist Saza.

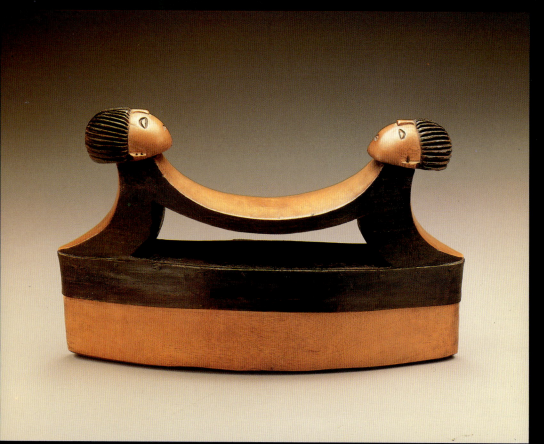

12.16
Headrest box, Azande. *Wood. H: 9.3 in. (23.7 cm); L: 14.7 in. (37.5 cm). Renkin, coll. Buta, 1909. Musée royal de l'Afrique centrale, 24905.*

Headrests of this type were also used as boxes to store personal articles. This Zande box has the additional feature of carved heads placed on the basic box/headrest form.

commissioned an ivory harp covered with okapi skin (8.14) that was given ultimately to Lang.

Wood and bark boxes and knives were found among the Mangbetu and their neighbors before the turn of the century. Some were beautifully sculpted prestige objects coveted for their fine workmanship (12.16). Knives, boxes, and stools were decorated with brass studs and with copper and brass wire. Metal decoration probably preceded the addition of anthropomorphic carving in most of the region (4.16). In the early colonial period, Europeans admired and collected the boxes and knives with carved heads, and this probably encouraged their production. Some boxes had sculpted depictions of soldiers or stereotypical portrayals of people from different ethnic groups; some, like the ivory boxes with incised drawings described below, served as a medium on which to narrate descriptions of daily life.

Three camwood and ivory boxes are the epitomy of boxes made for Europeans (12.15).[20] The carving, in ivory and wood, was done by a Mangbetu from Niangara and the engravings were made by a Zande "of the neighborhood of Poko." One of the carved lids represents a Mangbetu king; the others represent two of his wives, one with a Mangbetu coiffure and the other with a Zande hairstyle. The incising on the ivory boxes includes scenes of daily life. Lang's description of the images shows how the artist, Saza, pictured scenes that reflected the collector's interest in hunting. Lang described the scenes on one of the boxes:

> Mangbetu nekarabu. A carved human head (female) with a box formed by a section of engraved ivory tusk. The hairdress of the figure represents the typical tumburu of the Mangbetu. The engraving . . . represents: 1) In front fishermen at work in a canoe. 2) A hunter going out with the net hung over his shoulder and spear in hands. The net is not for fishing but is stretched out and hung on trees to take mammals—chiefly small antelopes and pigs. 3) Two men carrying a Red River hog. They make two crosscuts close together, one pair in front near the shoulder, one pair on the pelvic region, lift up the skin and pass through a pole. 4) Shows an Azande in full dress and installed on his chair (after hunting) scolding at his right one of his wives who offers him leaves to clean himself and a cup of wine. At his left is one of his other wives who holds his spears and his shield. (2902)

Another box was carved to represent the

famous hairdress of the Azande called bagbedi. The figures represent: An Azande standing before the elephant holding in his left hand the medicine that in the native belief made the elephant walk up and look at him without charging. They even pretend that they go thus in the middle of a herd and throw pieces of manioc around that the elephants are speedily devouring. The native thus is able to choose the best tusker which he kills by cutting his trunk with his broad spear. They simply throw their spear in his vital spot and if their medicine has been good they surely will kill the elephant. The front scene shows the Azande installed in his best dress playing [a] harp, his servant sitting guard by his spear and shield he has hung up on the three crossed sticks. His women running up speedily—one offering wine, the other something to eat. (2904)

Reflections on Ivory

The three boxes belonged to a large collection of ivory objects that Lang brought back to the American Museum. Objects in ivory provide perhaps the clearest example of the transformation occurring in the art of the region during the early colonial period. For Lang, ivory carving was the epitome of Mangbetu art, and his analysis of these works, published three years after his return, shows how much he still adhered to the "Mangbetu myth" (see chap. 2).

Before the turn of the century, ivory had been reserved for the use of important persons and to make prestige objects (usually horns), but otherwise it was rarely used as a material for carving. Schweinfurth, in Artes Africanae, described only one ivory belt ornament among the Mangbetu and Azande and no ivory knives. The only utilitarian objects made of ivory, even by Lang's time, were the heads of barkcloth beaters. The graceful ivory hatpins that became so popular in Lang's time do not appear in collections made before 1910, although copper, bone, and wooden ones were in use earlier.

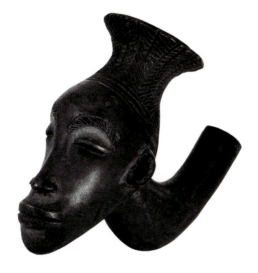

12.17
Pipe, Azande. *Wood. H: 3.5 in. (9 cm). University Museum for Archaeology and Anthropology, Cambridge, 40.93.*

The similarity of the facial features on this pipe to those on a harp collected by Lang (10.1) suggests that they were carved by the same artist.

Lang believed—and the Mangbetu may have deliberately led him to this conclusion—that the paucity of old ivory objects resulted from the "fact" that upon a king's death all of his property was buried with him or destroyed:

> One might hope to find within the court large stores of ivory treasures accumulated for hundreds of years, as ivory by right belonged to the king. But at the death of a ruler barbarian custom demanded immediate destruction of his residence and all his property. So it happens that only recent objects are found at the royal headquarters, and the Museum party was fortunate that, because of some superstition, the famous Okondo, last of these kings, was willing to part with the best he had, ordering other objects to be made by his most skilled artists. (1918a, 532)

In the course of Lang's five-year stay in the region the production of ivory objects increased greatly (12.18). By the end of his stay, a few Mangbetu carvers were producing objects for him. They made traditional kinds of objects such as horns commissioned by him directly or by Okondo—including two very large ivory horns (12.19)—as well as ivory imitations of European implements. The idea of making an object in several different materials was an old one, as seen earlier in the manufacture of copper and iron animal-claw pendants. When carved in ivory, "utilitarian objects" became nonfunctional works of art or curios (depending on some kind of judgment about their quality), like the ivory bow, ivory spatulas (4.18 and 12.20), and the spoons, knives, and forks carved for Lang to replace his plain pewter tableware (12.21). There are also napkin rings, letter openers, rings, and bracelets, as well as small carvings portraying the Mangbetu elongated head, which Lang claimed depicted Queen Nenzima.[21] They made small model slit drums, model boats, and tiny boxes as well as whip handles, staffs, a pipe, and anthropomorphic hatpins (7.1). One carver portrayed his own hand on the handle of an ivory carving knife (12.1) and told Lang that he was "entitled to a special gratification" since it was his own hand (3377).

The ivory carvers clearly delighted in producing a tremendous variety of objects, and their work suggests that they relished the artistic freedom provided by their new patron. One carver took a piece of diseased ivory and carved many heads in it. He explained to Lang that it was the story of a lineage, each head representing a different relative. Although most carving was done by a few Mangbetu artists, the Zande artist Saza began to incise pictures on ivory. Some pieces, such as the boxes described above,

represent the joint efforts of Saza and the Mangbetu carver Karibu. Saza generally signed his work as "Saza Avungara na Poko" (Saza, of the Avongara clan, living in Poko).

Songo and most likely the other artists who drew on gourds and calabashes had collections of European magazines. Several artists at this time incorporated images of Europeans in murals (see chap. 6), on carved ivory horns and boxes, and on gourds (12.22). In addition to the hunting scenes mentioned above, these works depicted encounters between the Mangbetu, Barambo, and the Azande. Lang's notes record artists' descriptions of these pictures, and they reveal a good deal about male/female relations, the division of labor, technology, politics and dispute settlement, relations with Europeans, styles of adornment, animal mythology, and other matters.

Lang paid a great deal of attention to the ivory carvers whom Okondo had gathered around him. But his explanation of their high status, as he perceived it, was based on an exaggerated evaluation of the intertwined power of the chiefs and the artists they employed. Whereas Lang's fieldnotes are fairly straightforward descriptions of what he saw and heard, his one publication specifically on the Mangbetu (1918a) is an absurdly sensationalist account of the past. He claims that the earlier Mangbetu kings were fearsome tyrants, who regularly slaughtered dozens of prisoners as food for their courts. He admitted to having

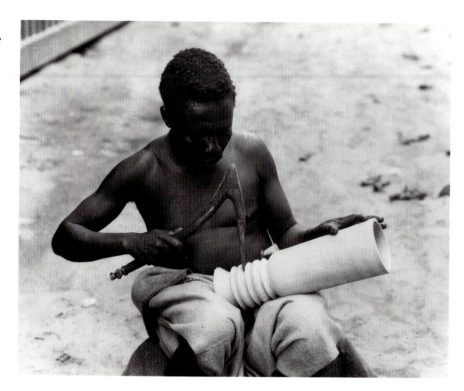

12.18
Mangbetu artist, Okondo's village, c. 1909–15. *AMNH Archives, 224470.*

Mangbetu artists carved ivory into numerous objects. Initial shaping was done with an axe and further carving with an adze, as seen here. For finer detail, a knife with a long handle and single-edged, small blade was used (12.1). The ivory surface was then smoothed with a moistened leaf containing silica crystals.

12.19
Horn, Mangbetu. *Ivory. L: 53.8 in. (138 cm); W: 4.9 in. (12.6 cm). Lang, coll. Niangara, 1913. AMNH, 90.1/4618.*

Court artists made instruments for use in the chief's orchestra. This large ivory horn, carved with a woman's figure, was made by an artist of Chief Okondo. Lang commissioned it for the American Museum of Natural History; the mouthpiece was never finished.

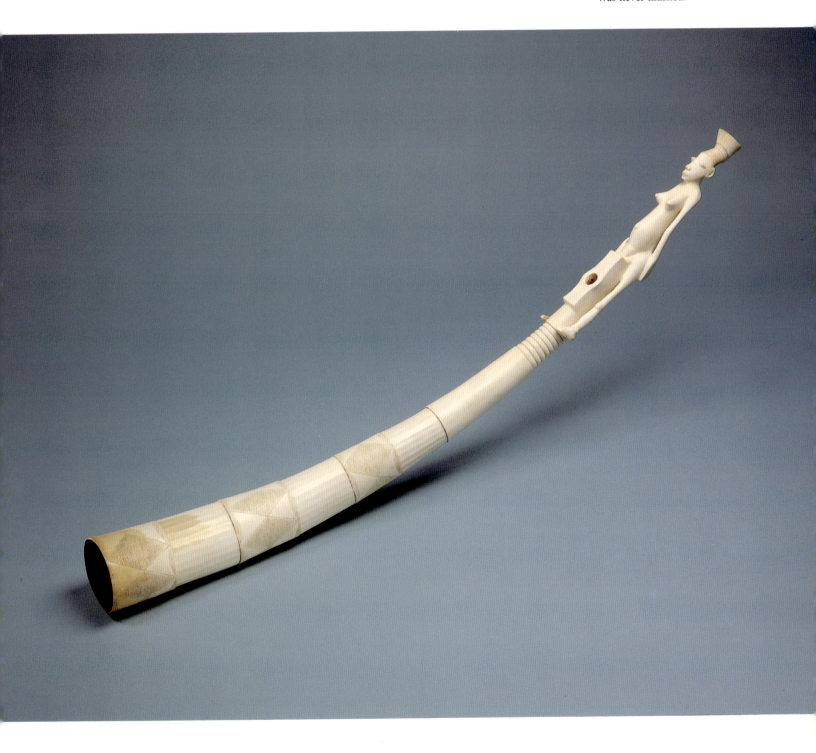

12.21

Left to right:

Spoon, Mangbetu. *Ivory. L: 8.0 in. (20.5 cm). Lang, coll. Avakubi, 1914. AMNH, 90.1/3891.*

Fork, Mangbetu. *Ivory. L: 8.2 in. (21.1). Lang, coll. Panga, 1914. AMNH, 90.1/4888*

Spoon, Mangbetu. *Ivory. L: 8.2 in. (21 cm). Lang, coll. Panga, 1914. AMNH, 90.1/4885.*

Fork, Mangbetu. *Ivory. L: 8.8 in. (22.5 cm). Lang, coll. Medje, 1914. AMNH, 90.1/2295.*

Spoon, Mangbetu. *Ivory. L: 8.4 in. (21.5 cm). Lang, coll. Panga, 1914. AMNH, 90.1/4887.*

Fork, Mangbetu. *Ivory. L: 8.3 in. (21.3 cm). Lang, coll. Panga, 1914. AMNH, 90.1/4886.*

Spoon, Mangbetu. *Ivory. L: 7.8 in. (20 cm). Lang, coll. Panga, 1914. AMNH, 90.1/3415.*

The Mangbetu held definite ideas regarding design, for themselves and for the Europeans as well. Lang wrote that these expressed "the Mangbetu idea of what a spoon and fork that a big white man would use, should look [like]. They never had seen but perfectly plain models without the slightest attempt of decoration as generally used by white men in the Congo" (3202).

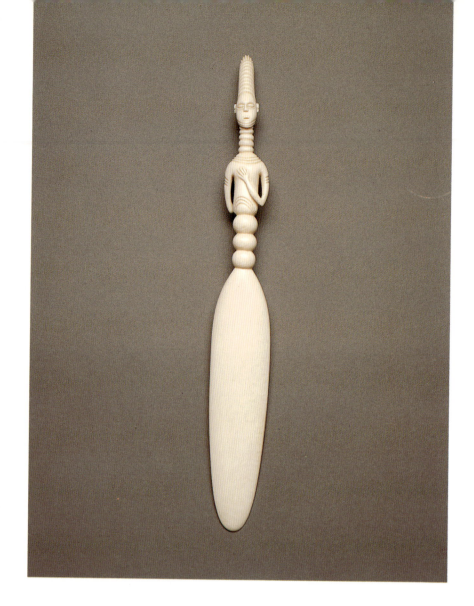

12.20

Spatula, Mangbetu. *Ivory. L: 14.4 in. (37 cm). Lang, coll. Panga, 1914. AMNH, 90.1/4634.*

Lang collected 380 carved ivory pieces, some of which were novelty items such as this spatula. The position of the hands, with one in front and one behind, is a typical Mangbetu pose (see cover photograph) and expresses the Mangbetu conception of symmetry.

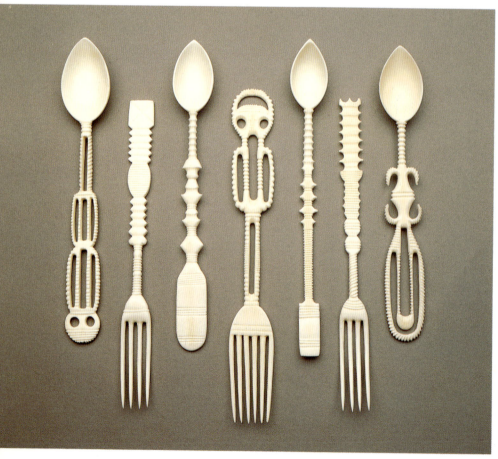

never seen cannibalism or even "piles of skulls" of victims, but he maintains (probably correctly) that this reputation was itself a buttress to chiefs' power, inspiring fear in ordinary subjects and the artists who sought the protection of the court. The artists were, in Lang's view, among the few African "superior men" and also the basis for royal power, since the multitudes flocked to court to see their work:

> Perhaps it was the fact that these rulers surrounded themselves with the few men of talent and ability they could bring together that raised Mangbetu domination to such heights.

After Okondo

Many of the arts that flourished in the very early colonial period gradually died out in the years after the death of Okondo in 1915. Once the system of colonial rule became firmly established, chiefs were less inclined to use art to win favor with colonial officials. As the interests of the Europeans shifted, resident officials turned their attention to the production of cash crops. One after another of the various art forms that had flourished in the first decade of the century disappeared. Carvers found obtain-

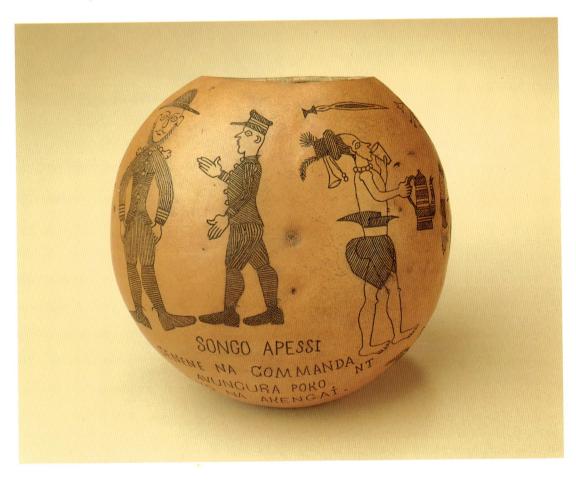

12.22
Cup, Azande. *Gourd. H: 4.5 in. (11.5 cm). Lang, coll. Poko, 1913. AMNH, 90.1/4313.*
This engraved gourd signed by the Zande artist Chief Songo depicts colonial life, with soldiers, knives, and an African man drinking coffee. Lang wrote of this artist, "He is said to be able to copy pictures from humoristic magazines" (1937).

No wonder thousands of subjects flocked to the court to see the spectacular exhibitions. Thus we can understand why tyrants, who daily slaughtered a dozen prisoners bound to the stake, to furnish meat for their household of hundreds of queens, would grant generous protection to artists. These, in turn, surrounded by a bewildering chaos of rapidly rising and falling destinies, had grave reasons to please their master, and naturally strove to outdo one another in eager competition. Credited by popular belief with supernatural acquisition of talent, they formed a small caste to which access could be gained only through initiation, and any one attempting to compete with them invited severe misfortune or forfeited his life. (1918a, 530)

ing tusks difficult because of high prices and gave up carving ivory. The Mangbetu did not retain the harp, and harps were no longer being made with their image. Mangbetu men never became potters in any serious way, and few women ever made anthropomorphic pots.[22] Show knives fell out of use, probably because carrying weapons came under state control. The Mangbetu no longer bind the heads of infants, and the elongated head is no longer a prestigious fashion.[23]

Although occasional tourists have visited the region, northeastern Zaire never became a tourist center on a large scale. Nevertheless villages like Ekibondo continued some of these art tra-

ditions until World War II. By the 1930s most of the art created specifically for sale to passing tourists was generally not of very good quality. A photograph taken south of Niangara by C. Zagourski in the 1930s illustrates the tourist art of the time. The picture shows a number of crudely carved wooden objects—including figures wearing barkcloth—and several full-figure ceramic pots displayed in a typically symmetrical array on what appears to be the porch of a store (12.23).

Several accounts of the art of the region in the 1930s and 1940s give some clue to what happened to the art. Lelong, a Dominican priest, showed that until at least the 1940s elaborately sculpted posts were made to support the large *egbamu* (sing., *negbamu*), roofed shelters without walls.[24] However, it appears that by this time the traditional geometric posts had become trivialized with carvings representing African life in a kind of folkloric style. According to Lelong, some of the posts he saw in the 1940s, probably in the Bangba area north of the Bomokandi River, were

> overloaded with sculptures: at the bottom, the inevitable geometric designs; at midway, a small indentation has been arranged in master columns in order to contain the figurines. These can often appear to be obscene: they would surely be in another place. Here they shock no one. . . . One finds above all the representation of familiar objects: a canoe, a drum, a vase. The sculptor has copied living beings with a minutia that reveals a real gift of observation. Sometimes one envisions scenes of family life that the rock carvers of the Middle Ages left on the gates of cathedrals showing the signs of the zodiac. (Lelong 1946, 1:217)

Although no real market for tourist art developed in northeastern Zaire, other centers thrived and produced Mangbetu-style art. A lively trade to Europeans developed in Buta, 250 kilometers west of Niangara in Bua country. The Buta mission was one of the earliest in the region, and evidence exists that Catholic missionaries there supported the production of art for tourists. The continuing patronage of Europeans that Buta provided allowed Mangbetu-style art to continue, although divorced from its original context. Lelong (1946, 1:220–21) called Buta "the Mecca of statuary in northern Congo." These statues, some of them with Mangbetu heads, could also be bought in Stanleyville, the largest town in northern Congo.

Some Mangbetu artists did turn to producing work for Europeans on commission. Lelong wrote that Europeans used to provide models for local sculptors to copy. Some even gave

12.23
Shop selling anthropomorphic art, south of Niangara, c. 1930s.

By the 1930s anthropomorphic art was being made for sale in shops to Europeans. As this photograph illustrates, crudely sculpted and carved pots and wooden figures had by then replaced the elegant art produced in the early colonial period.

"commandes indiscrètes," that is, orders for statues in styles from other parts of Africa. Lelong considered these models not much better than the local "créations spontanées." In another case Europeans asked local sculptors to reproduce statues brought from the Nile Valley. Lelong saw this idea as a similar disservice to local art, but a lesser one since Egyptian standards were considered to be somewhat higher than those of black Africa (Lelong 1946, 1:218–20).

The practice of asking local artists to reproduce art from other parts of Africa and the world was exemplified by Patrick Putnam, an American who lived at Epulu in the nearby Ituri forest from 1927 to 1953. Putnam started a dispensary and a leper colony that were visited by many Africans. He also ran a small guest house for Europeans. This is the vicinity where Colin Turnbull did his work with the Mbuti and the Bira. Turnbull wrote that

> by the time I got there, in 1950 for the first time, it was plain that all the Ituri population had to some extent been affected by Patrick Putnam's interest in carving, and by the many books of African art that he had with him at Camp Putnam where he had a large entourage of workers, including craftsmen, from all over the Ituri. His last wife, Anne Putnam, was herself an artist and again encouraged their workers to carve, using photographs as models, to the extent that you can now occasionally find what look like Ibo or Dan or other masks being carved and used in the *nkumbi* circumcision rite in place of the more traditional skin masks. And since they imitated so freely from photographs, and since Epulu, during the time

of the Putnams, was such a gathering place for members of just about all the Ituri peoples, the resultant confusion of styles is enormous and I would not begin to try and sift it out.

Certainly Bira craftsmen (and Ndaka, who seemed more given to this kind of activity) imitated Mangbetu and Budo [Budu] styles, including the elongated head, and were in turn imitated by the Mbuti who were also encouraged to carve so that the Putnams were able to offer tourists keepsakes, genuine enough in their way, to take home with them. [This provided] individuals with some access to cash which was a scarce commodity and increasingly necessary for tax payments and desirable for the purchase of luxury items such as Western clothing, cigarettes and beer.[25]

Another major force in the region in this century was the mission art school opened by a European sculptor, Brother Rescigno. He arrived among the Dominicans in 1927 to set up a school of sculpture in Rungu, a village forty kilometers south of Niangara on the border between the Bangba-Matchaga and Mangbetu territories. During the 1930s a painter and sculptor named Brother Marcolin taught at the school.[26] Martin Birnbaum, an American visitor in the 1930s, reported that the students made "objets d'art," including chairs such as the ones he saw at the Mayogo capital with little Mangbetu heads carved on their arms (Birnbaum 1939, 82; 1941). A similar chair is in the collection at the Musée royal de l'Afrique centrale (**12.24**).

The styles of art taught at the Rungu mission school were certainly those of Europeans. Lelong devoted several pages to a discussion of whether Europeans ought to influence African sculpture and, more specifically, change the proportions of the bodies depicted in African sculptures. His opinion was that "correcting" the proportions is helpful and is welcomed by Africans, who have not yet discovered "true artistic principles" (1946, 1:336).

Since independence from Belgium the production of sculpture in the region has dwindled even further. It is still possible to find smiths who can make and repair iron bells, knives, hoes, and axes, for these are things that are still important in daily life. Some Mangbetu still make hats, baskets, mats, barkcloth, wooden stools and dishes, pots, and other items, but the work is generally neither so varied nor so elaborate as formerly. The kinds of objects that were produced in abundance in the early colonial period in response to the new European audience, and in response to the political pressures of that time, have virtually disappeared. Today statues, figurines, bookends, and vases carved of ebony and ivory are occasionally hawked in Isiro, the administrative and commercial center for much of northeastern Zaire. But most foreign businesses have left the area, and there are few customers. The finest of these modern tourist pieces have been carved far away in Kisangani or Buta.

Conclusion

In this chapter we have tried to show why anthropomorphic art was not intrinsic to the material culture of the Mangbetu and Azande in the precolonial period. We have also discussed the rise and fall of anthropomorphic art in the Mangbetu region in this century. In conclusion, we review some of the argument and address the issue of why this art arose in the colonial period in the first place.

In the early nineteenth century a small lineage, the Mangbetu-Mabiti, began to consolidate some of the peoples living on the northern

12.24
Chair, Mangbetu. *Wood. H: 38.8 in. (98.8 cm); L: 40.2 in. (102.5 cm). Acquired 1986. Musée royal de l'Afrique centrale, 86.17.1.*

The form of this chair is based on that of the European steamer chair, whereas the numerous carved heads are typical of the Mangbetu style that developed in the colonial period.

edge of the Zaire rain forest. They were a practical people who gained and held power by force, by kinship ties, and by the prestige of their achievement. Their art focused less on conveying religious and political power than on geometric decoration of practical objects such as pots, baskets, houses, and weapons. Objects that did carry symbolic or ritual significance had little relationship to what Europeans, at least at that time, defined as art; for the Mangbetu and other peoples in the region, sculpture and carving were decorative embellishments, not intrinsic sources of meaning.

Although art traditions had local variations, many of which have yet to be explored, interchange and communication took place among local groups. Regional style zones, if they existed at all, varied only gradually from one locality to the next because the inhabitants of the region—conquerors, conquered, and neighbors—had lived in contact with one another for hundreds of years. Representational art, including anthropomorphic art, was scattered throughout the region, gained a widespread audience through local trade, and was sometimes given as tribute, but it was not a dominant form in any one artistic tradition.

After the middle of the nineteenth century, the Mangbetu tried to establish their kingdoms more permanently by elaborating the institutions of control. At the same time, militarily strong grassland societies such as the Azande and the Matchaga brought increasing pressure on the Mangbetu. In terms of art, the character of this period seems to be reflected in large and orderly royal villages like the one visited by Schweinfurth in 1870 and in the physical appearance of members of the noble lineage. Well-appointed courts, elongated heads, and fine vestments were symbolic of the right to rule. But no evidence suggests the widespread occurrence of anthropomorphic art at this time.

During the latter half of the nineteenth century, neighbors and subjects began to see the Mangbetu, their courts, and their styles as prestigious. In fact, it was most probably neighbors and subjects who first began to carve art representing the Mangbetu head, the most distinctive and portrayable feature of the new kingdoms. The new head style was depicted here and there in art, but the market remained quite limited because of few patrons and a lack of important political or ritual functions for such art. Grassland arts such as mural painting became more widespread during this time.

In the colonial period, the European presence greatly expanded the market for certain types of art. With the powerful precolonial kingdoms in disarray, many local chiefs sought favor with

12.25
Artist with sculpture, Niapu, 1986.

The depiction of Europeans in Mangbetu art, often in a mocking manner, is found in rare instances today. This artist was given clothes belonging to a missionary in the area, and with them he created the life-sized portrait of the missionary seen here beside him.

the colonial regime. The chiefs mediated between new patrons and local artists and encouraged artists to produce the kinds of works that Europeans admired. These included the anthropomorphic harp necks, box lids, and knife handles as well as some types of geometric art such as mural painting and the women's *egbe*. Europeans encouraged the production of anthropomorphic pottery, an innovative adaptation within an already-varied array of forms. The European presence, and the importation of graphic images that went with this, also encouraged new forms of art, such as the pictographs on gourds and ivory. Anthropomorphic art lent new prestige to the Mangbetu head style; finally, art depicting an elongated head was called "Mangbetu" no matter who produced it.

Talented artists responded to the challenge and soon created a phenomenal body of work in which they expressed their interpretation of the events going on around them: they portrayed Europeans and Africans and began to caricature African ethnicity. Schweinfurth first documented an example of this kind of caricature in 1870, but an awareness of ethnicity increasingly appeared in representational art as the market for it expanded. The artists seized on visible expressions of cultural identity and put them into their works. Neither sculpture nor painting had any particular symbolic meaning for local artists, and they could therefore use these forms to portray, mock, and criticize the world around them. This type of social commentary is most obvious in graphic art, but it is also characteristic of sculpture.

After Okondo and other rulers of the early colonial period died or lost power, the new leaders no longer used anthropomorphic art as a currency in their relationships with Europeans (see chap. 8). Direct commerce between African artists and Europeans was limited, and without African patrons the market for high-quality anthropomorphic art disappeared. After 1915, with only a few exceptions, most of the Europeans who came to the region had little curiosity about Africa and Africans; by the 1930s poor imitations of earlier work were all that could be found in the very small tourist market that had developed. European bureaucrats, businessmen, and laborers may have collected curios made in Buta and other centers, but few were interested in the local culture or even genuinely interested in art. From time to time, Europeans tapped the skills of potters or carvers for reproductions of artwork from other places, for commissions of Mangbetu-style anthropomorphic pieces, and for the work of the Rungu art school, but they did not demand, or get, work as fine as that produced in the early part of the century. Very occasionally, and for their own amusement, carvers still depict human figures in art, such as in the unusual life-size carving of a missionary made a few years ago by one Mangbetu-Makere carver (**12.25**). Although anthropomorphic art has virtually disappeared in the region, many of the basic elements of design described in this catalog have persisted and can still be seen on everyday objects (especially pots, furniture, tools, mats, hats, and baskets), on objects made for court dances (such as women's *egbe*), and on musical instruments. Despite the active work of missionaries and the political and economic pressures of recent years, ritual life, at least for older people, goes on much as it did in earlier days, independent of the anthropomorphic art that made the region so well known to outsiders.

Notes

Chapter 1

1. The American Museum of Natural History has in its collections about 800 objects from the Uele region, a gift in 1907 from the Congo Free State, and about 4,000 objects collected by Lang and Chapin. The Musée royal de l'Afrique centrale has many more from the region collected by the Congo Free State government and an estimated 10,000 to 12,000 collected on the Belgian Ethnographic Mission by Armand Hutereau. Adding miscellaneous, other early colonial collections, the number of objects totals well over 20,000.

2. By *class* we refer to more or less enduring inequalities in society based on prestige, wealth, and ability to exercise power. Qualifications for membership in upper classes are discussed more fully in chapter 5.

3. Mangbetu population statistics for 1955 were about 200,000 for all Mangbetu speakers and about 100,000 for those living in chiefdoms. Population figures for the 1970s and 1980s suggest that today's population has declined by about 15 percent since the 1950s. This might be due to miscounting—then or now—but since many modern chiefdoms show the same trend, it is probably better explained by outmigration and general population decline (Gourou 1955).

4. In the colonial period the region was divided among the Belgians, French, and British. In the Belgian colony, the region had changing administrative boundaries and incorporated the Haut-Uele, the Bas-Uele, and the Ituri districts. In the widest sense, the cultural affinities of peoples discussed in this book could be said to extend today into parts of the Sudan, the People's Republic of the Congo, and the Republic of Zaire.

5. Armand Hutereau, Jan Czekanowski, Hermann Schubotz, Guy Burrows, and others collected throughout the region. See chap. 2.

6. During the colonial period, African rulers were called chiefs by Europeans. We use the term *king* to refer to Mangbetu rulers in the precolonial period, and *chiefs* when they were incorporated into the administrative system in the colonial and independence periods.

Chapter 2

1. With apologies to Marvin Harris (1977) this subtext could be entitled "Tales of Cannibals and Kings."

2. See, for example, Geary (1988) on similar myths about the Cameroon kingdom of Bamum of the same period.

3. The Mangbetu have heard of these stereotypes and join freely in their elaboration. Even today they recount tales of cannibalism among Africans; in precolonial times, former enemies often described each other as cannibals, and today many people claim that Europeans manifest the same tastes in the Eucharist and even practice it covertly.

4. The expeditions under the command of Selim Qapunan numbered 600 men, among whom were the German Werne and the Frenchmen D'Archaud and Thibaut.

5. Most of the objects that Piaggia collected are today located in Perugia in the Museo archaeologico nazionale and in Florence in the Museo nazionale di antropologia e di etnologia. A few artifacts are in the Berlin Museum für Völkerkunde.

6. The eastern route, used by Miani in 1871–72, left the White Nile at Gondokoro, crossed the lands of the Adio Azande, and turned southwest toward Mangbetu territory. The central route left from Meshra-el-Rek and passed through the lands of the Zande chiefs Tombo, Mbio, and Ndoruma before reaching the Uele. The western itinerary connected the copper mines of Hofrat-el-Nahas on the southern boundary of Darfur with the Banda and Nzakara territories, turning south toward the southeastern Azande, the Bua, and the Mangbetu.

7. Giovanni Miani traveled to the Mangbetu in 1872, shortly after Schweinfurth. He was able to visit the forest Azande west of the Mangbetu but died at Mbunza's on the way home, leaving only a few notes of his trip. Some of the objects he collected in the Upper Nile region are in the Venice Civico museo di storia naturale, the Paris Musée d'histoire naturelle, the Vienna Museum für Völkerkunde. After his death, the objects belonging to him were sent by Schweinfurth to the Societá geografica in Rome and later deposited in the Museo preistorico ed etnografico "Luigi Pigorini" (Bassani 1979, 398–99).

8. Lang recorded statements on this subject, and more recent statements are shown on the film *Spirits of Defiance: The Mangbetu People of Zaire*, co-produced (1989) by the American Museum of Natural History, Harcourt Films, British Broadcasting Corporation, and Arts and Entertainment.

9. A profusion of terms was used in the early literature for the peoples and territories of this region. "Monbutto," "Mambattu," "Mangbuttu," and so on, were common designations for the whole Egyptian district south of the Uele and Kibali rivers from c. 27° east latitude to c. 29°30′ west. Moreover, confusion often occurs in the written sources between the people and the wider region. Here, "Monbuttu" refers to the whole region under nominal Egyptian rule but not specifically to the Mangbetu peoples.

10. There are a few small collections of objects made by the explorers and administrators who reached the Mangbetu in the period before the Belgian conquest. Schweinfurth's collection was partially destroyed on his return trip when a fire burned the wooden portions of the tools and weapons. The few artifacts remaining are housed in the Berlin Museum für Völkerkunde. A number of Schweinfurth's drawings, some of which have not been published, are in the Frobenius-Institut in Frankfurt. Junker's objects are in Leningrad's Ethnographic Museum and the Berlin Museum für Völkerkunde. Emin Pasha's collection is in the Vienna Museum für Völkerkunde.

11. At the Berlin Conference (1884–85) the European powers agreed to abide by two rules in their conquest of Africa: first, they could begin their conquest only from the "spheres of influence" that they had already established on the continent, and second, they could not claim land that they did not effectively occupy. By these two rules, European states avoided armed conflict among themselves.

12. Yangala was accustomed to dealing with foreigners because he had been an ally first of the traders and then of the Egyptian government. Léon Lotar, chronicler of this period, shows that Yangala was under attack but not on the verge of defeat (1946, 100–101).

13. These men are identified in Van Overbergh and De Jonghe by military titles and not by first names.

14. The Burrows collection is mainly in the British Museum (Museum of Mankind) as part of the Christy collection of 1898.

15. In 1900 Sir Harry Johnston obtained from the Congo Free State some okapi skin that was identified at the London Zoological Society as a species of zebra and named *Equus johnstoni*. In 1901 a Swedish officer of the Congo Free State sent a complete skin and skull to Johnston in Uganda. The cloven hoof-bones indicated it was not a zebra but a relative of the giraffe. By 1907 it was placed in a new genus, *Okapia* (Alexander 1907, 2:267).

16. This is in fact the first reference to Congo Free State administrators in Niangara taking guests to visit Okondo, a practice that seems to have become regular until Okondo's death in 1915.

17. Objects collected by Czekanowski are in the Berlin Museum für Völkerkunde, the Vienna Museum für Völkerkunde, and possibly (although we have not been able to ascertain this) in museums in the German Democratic Republic and the Soviet Union. Schubotz's small collection and several pieces belonging to von Mecklenburg are in the Frankfurt Museum für Völkerkunde.

18. *Arts et métiers congolais: Douze gravures originales en couleurs*.

19. We are grateful to Elisabeth Sunday, William Scheele, and Louis de Stryker for bringing these works to our attention.

Chapter 3

1. King Leopold II had several representatives in the United States, including General Henry Sandford, one of the two American representatives at the Berlin Conference.

2. Bumpus actually purchased the Philippine house that was brought to the 1904 St. Louis Exposition. He moved it and made it his summer residence.

3. Ota Benga's story is being written by Verner's grandson Phillips Bradford Verner. Several others have done research on Verner, including Dr. Gordon Gibson, curator emeritus at the Smithsonian Institution.

4. Verner was associated with Frederick Starr. Starr stayed with Verner in Africa while he was gathering the ethnographic collection that he sold to the American Museum in 1910.

5. J. P. Morgan had been involved with King Leopold before this in a railway venture in China (personal communication, Jean-Luc Vellut, 14 June 1988).

6. "Rumor had it," James Chapin related in 1960, "that this [the Congo gift] resulted from a friendship between Leopold and Mr. J. Pierpont Morgan, one of our trustees."

7. The collection was cataloged by the anthropologist Robert H. Lowie, who was also slated to publish the ethnographic material collected by Lang. He never did.

8. In the early years of the Free State administration, personnel were recruited from many countries of Europe and even the United States. King Leopold sent a special commissioner to the United States, for example, "for the purpose of strengthening the commercial-cum-military personnel of [his] Administration by the admixture of a number of young and adventurous Americans. In all, sixteen citizens of the Republic [*sic*] were engaged. Of these, two handed in their resignations soon after arrival in Africa, nine were killed or fell victims to the climate, and two only—one of whom perished during his second term—returned to the Congo after expiration of their contracts" (John Geo. Leigh, Introduction to Burrows 1903, xiii). The survivor was Edgar Canisius, author of "A Campaign amongst the Cannibals" (1903).

9. In 1903 the British House of Commons unanimously approved a motion requesting the government to confer with other signatories of the Berlin Act about reforms.

10. "The Congo News Letter," Apr. 1907, issued by the Congo Reform Association, Boston, Mass., file 592, AMNH Archives. See also Slade 1962; Shaloff 1969; and Stengers and Vansina 1985, 326.

11. 27 Sept. 1907, file 592, AMNH Archives.

12. One of the staunchest defenders of the Independent State of the Congo was Professor Frederick Starr, who was briefly a curator of ethnology at the American Museum in the 1890s. By the time Starr went to the Congo, he had moved to the University of Chicago, but nevertheless in 1910 he sold the museum its second large Congo collection. In 1907 Starr published a series of articles in the *Chicago Daily Tribune*, later reprinted as the book *The Truth about the Congo* (1907).

13. In fact, Bumpus had personal connections with the advocates of reform. The president of the Congo Reform Association and the chairman of its national committee were both friends from his student days at Brown University. Also see Bumpus to Whiteley, 27 Sept. 1907, file 592, AMNH Archives.

14. Letter from Sherwood to Romeike, 20 May 1908, file 592, AMNH Archives.

15. For a time in 1907 Bumpus tried to assist Bridgman in traveling to the Congo to ferret out the truth of the "Congo question." However, Bumpus's initiative in this regard was terminated when he learned that Bridgman was strongly opposed by the Congo Reform Association.

16. The Jesup Fund was a large bequest left to the American Museum by Morris K. Jesup, president of the museum from 1881 to 1908.

17. Lang was born in 1879 in the village of Oeringen, Wurttemberg, Germany, one of eleven children, four of whom eventually came to America. He became interested in collecting and preserving wildlife very early in life, and he left school to take a job as a taxidermist in Zurich. He then worked in Paris and later in London.

18. Chapin was born about a mile from the American Museum in 1888 and moved to Staten Island when he was three. He too became a naturalist at a very early age. After high school he spent a year at the museum preparing specimens before entering Columbia University.

19. In a letter written after Lang's death, Chapin acknowledged that Lang was "like a father" to him.

20. After the expedition to British Guiana, Lang went on a trip to Angola with a museum patron and game hunter named Arthur Vernay. After he left Vernay in Angola, over a year elapsed before the museum had any communication from Lang. This led the administration to declare that he had voluntarily left his position. Lang eventually married in South Africa and came to be associated with the Transvaal Museum.

21. Chapin continued his career as a curator in the Department of Ornithology until his death in 1964. He made many more research trips to Africa after the Congo Expedition. He is also known for his research on birds in Panama, the United States, the Galapagos, and the Pacific.

22. This is true of the ethnographic photographs although not of the "anthropological" ones—those meant to provide data for physical anthropology. These frontal, side, and three-quarter shots of both head and full body record individuals as specimens to be measured and compared at a later time. See Geary (1988, 31) for an important discussion of this genre of photography.

23. "To the northeast of Stanleyville . . . there were virtually no stores other than those of the Congo government. A few Greek ivory merchants operated near the Sudan border" (Chapin 1960, 15).

24. Chapin noted elsewhere that Weeks had supplied some information to Morel for the latter's account of Congo atrocities. See also Stengers and Vansina 1985, 326.

25. Lang to Bridgman, letter, 9 Jan. 1910, file 771, AMNH Archives.

26. Chapin also said, "That there was sometimes a little oppression in the matter of rubber-gathering I shall not deny. Chiefs might be browbeaten to get more of their men out into the forest. All the rubber came from wild vines in the heavy, humid forest, where the workers must camp under most primitive conditions, and they did not like it. In the course of our search for okapi Lang and I visited some of the rubber-camps, where we were with our canvas tents and folding cots anything but comfortable. Forty hours work per month was then the legal maximum . . . that could be demanded of a grown man; women and children were not taxed" (1960).

27. Report of 29 Nov. 1909, file 771, section E, AMNH Archives.

28. Jan Vansina has suggested that the expedition was "perhaps the major economic enterprise in the area at that time—this after rubber's peak" (personal communication). However, given the size of other expeditions, like the Hutereau and the Von Mecklenburg expeditions, porterage for all government officials, expeditions, and outposts was a major source of employment, of which the American Museum expedition was only a part, albeit a major part.

29. Letter from Medje, 8 Oct. 1910, file 771, AMNH Archives.

30. The complete itinerary appears in Osborn 1919, xxiv–xxv.

31. Twelfth report, 8 Feb. 1913, Faradje, p. 17, file 771, AMNH Archives.

32. "Especially the regions west to northeast of Irumu, those in the District of the Uele southeast, east, and north of Niangara, and between Gombari and Vankerckhovenville" (ibid., p. 16).

33. Lang to Bridgman, letter, 9 Jan. 1910, file 771, AMNH Archives.

34. Twelfth report, 8 Feb. 1913, Faradje, file 771, AMNH Archives.

35. The titles of these articles are revealing in themselves: "Nomad Dwarfs and Civilization" (1919); "Famous Ivory Treasures of a Negro King" (1918a).

36. Bumpus to Lang, letter, 10 Aug. 1911, file 771, AMNH Archives.

37. Lang to Bumpus, letter, 27 July 1912, file 771, AMNH Archives.

38. Report, 29 Nov. 1909, p. 29, file 771, AMNH Archives.

39. Report, 14 Jan. 1911, p. 1, file 771, AMNH Archives.

40. Lang to AMNH, 30 June 1910, Medje, Anthropology Section, p. 2, file 771, AMNH Archives.

41. This was hardly unique to the Congo or to Africa. All over the world, European missionaries, administrators, and traders were presented with gifts from local leaders. While they often procured well-worn treasures, many of the chiefs also patronized local artists, who produced more or less traditional objects for gifts.

42. In his account of his 1913 visit to Okondo, Schubotz described the Great Hall in terms reminiscent of Schweinfurth. Schubotz thought it was the same hall described by Schweinfurth and was unaware that it had been reconstructed for Lang two years earlier (1913, 46). Chapin's 1960 "Reminiscences" indicate, however, that he and Lang knew Schubotz in 1911.

Chapter 4

1. Apart from Neolithic tools the only other find is the accidental discovery of a carved stone head, found without associated material to indicate its origin, by the Uele River (Leuzinger 1960, 40, pl. 2).

2. This work has been done for the Bantu languages of the area by Mary McMaster (1988); the main subdivisions of other groups in the area are also known.

3. The term *Buan* stems from McMaster (1988), who studied the history of members of this group. Buan is derived from Bua, a major language of the group.

4. Linguistic dating is derived from lexicostatistics, a dating technique that gives only approximations.

5. This branching happened much earlier than the date given by Ehret, as has become evident from Mamvu-Buan interaction in the middle Bomokandi area.

6. Fowls came to Africa from Asia through the Middle East. They were known in central Africa by the eighth century A.D., in Rwanda and in Shaba (Vansina 1989, n. 4).

7. Scientific names for the animals mentioned in this section are, for the savanna: kob, *Kobus kob*; topi, *Damaliscus niro*; eland, *Taurotragus derbyi*; buffalo, *Syncerus caffer*; duiker, *Cephalophus silvicultor*; giraffe, *Giraffa camelopardalis*; lion, *Panthera leo*; African wildcat, *Felis libyca*; serval, *Felis serval*; civet, *Civettictus civetta*; genet, *Genetta* spp.; hyena, *Hyaena brunnea* and *Crocuta crocuta*; jackal, *Canis mesomelas*; baboon, *Papio papio*; aardvark, *Orycteropus afer*; elephant, *Loxodonta africana*; hippopotamus, *Hippopotamus amphibius*; bush pig, *Potamochoerus porcus*; warthog, *Phacochoerus aethiopicus*. In the forest, the large antelopes are the lechwe, *Kobus lechee*; bongo, *Boocerus eurycerus*; and bushbuck, *Tragelaphus scriptus*. The small antelope is the sitatunga, *Tragelaphus spekei*. Other animals of the forest are the dik-dik, *Madoqua guinie*; dwarf antelopes, *Neotragus batesi* and *Cephalophus coerula*; okapi, *Okapia johnstoni*; water chevrotain, *Hyemoschus aquaticus*; leopard, *Panthera pardus*; golden cat, *Felis aurata*; monkeys (mangabeys, guenons, dianas, vervets, and colobus), *Cercocebus* spp., *Cercopithecus* spp., and *Colobus* spp.; baboon (mandrill), *Mandrillus* spp.; chimpanzee, *Pan troglodytes*; potto, *Perodictus potto*; galago (bushbaby), *Galago senegalensis*; pangolin, *Manis tricuspis*; giant forest hog, *Hylochoerus meinertzhagenii*; forest elephant, *Loxodonta cyclotis*. Hippopotamus, chimpanzee, vervet, galago, leopard, bush pig, buffalo, and elephant are actually found in both environments (Walker 1964).

8. Especially *Corythaeola cristata* V. or *bulikoko*.

9. The Mangbetu borrowed the Bantu term for *shield* (McMaster 1988, fig. 7.7). They kept older Central Sudanic terms for *spear*, probably originally referring to a throwing spear rather than a stabbing weapon.

10. By 1900 the institution of *mambela* chains of villages was still spreading and had not yet reached the villages farthest away from the Budu. See Bouccin 1935, 695.

11. The exact location remains uncertain. See also Keim 1979, 38–40. Curtis Keim's dissertation is the major recent study dealing with Mangbetu history. This chapter has benefited greatly from his comments.

12. Seven of the former House-chiefdoms are usually mentioned.

13. [There is no widely accepted model for translating African terms for rulers into Western terms. In the case of the Azande, Vansina calls subordinate rulers "princes" because the Zande political system was one in which sons of rulers founded new, semi-independent provinces on the periphery of their father's (the chief's) territory in an ever-widening circle. Evans-Pritchard called the father a king because he retained some influence over the princes (sons and royal kinsmen) and over "commoner governors," whom he installed to govern some of his provinces (Evans-Pritchard 1971, 168–69). In chapter 11 John Mack adopts Evans-Pritchard's model except that the term *governor* includes sons and other members of the royal lineage as well as commoners. In the case of the Mangbetu, we have adopted the terms *king* and *subchief* for the precolonial political hierarchy (see chap. 8).]

14. There are conflicting traditions about Dakpala's status. In some he remained a slave until he escaped

from Nabiembali; in others he became Nabiembali's client before breaking with the Mangbetu.

15. [Vansina's assertion that after the fall of Mbunza in 1873, the Mangbetu kingdom was replaced by a number of House-chiefdoms equates prekingdom and postkingdom political organizations. This is true in the sense that after the fall of Mbunza, the Mangbetu-Mabiti no longer controlled the heartlands or looked to a single king as head of the lineage. On the other hand, the Mangbetu polities outside the heartlands were already largely independent of the heartlands before the death of Mbunza. After 1873, moreover, they continued to employ most of the same methods of rule used by Mbunza (see chap. 8). Thus in the rest of this catalog we use the term *king* for Mangbetu and Matchaga rulers up until the colonial period, when they were officially subordinated and termed *chiefs*. These were admittedly weak kings, but the Mangbetu themselves—from Nabiembali to the present—have used the phrase *nekinyi kpokpo* ("great rulers") to designate all those rulers we term *king* and to distinguish them from *nekinyi sasangwe* ("small rulers"), the subchiefs whom kings installed in their provinces.]

16. This was also the case in the largest territorial empire central Africa has known, the Lunda empire. There, officials were given titles that corresponded to names of relatives of the king (e.g., king's first wife, king's uncle). When an official died or was replaced, his successor was assigned the same title and fictive kin relationship to the ruler. These practices, termed positional succession and perpetual kinship, tied the kingdom together and ensured that new officials understood their proper relationships to the king. See Vansina 1966, 80–83.

17. This system differed from the *palanga* system of the Azande (Keim 1979, 93–97). Their bodyguards were young pages who were the sons of tributary chiefs and headmen. The pages were sent to the court to be educated and to start a career in government service. See Evans Pritchard 1971, 183–85.

Chapter 5

1. Mangbetu kinship terms illustrate how lineage members feel themselves to be part of a larger "family" than is common in our own society. A Mangbetu man uses the term *father* for his father and also for all of his father's brothers. He calls the children of these men *brothers* and *sisters*.

2. Slaves were formally emancipated in 1910.

3. See the discussions of *nataate* and *nakire* in chaps. 8 and 9.

4. There is some evidence to indicate that before the Mangbetu conquest, the dominant section of a lineage often came to be considered its eldest section, thus putting reality and the lineage ideology into harmony.

5. For a discussion of the difference in Vansina's terminology from that used here see chap. 4, nn. 13 and 15, and chap. 8, The Mangbetu Style of Leadership.

6. Interview with C. Keim, 19 Oct. 1977.

7. G. Vossen, "Compte rendu," 18 Sept. 1939, Isiro archives.

8. According to Hutereau, the Mangbetu peoples were also permitted to marry the women of their son-in-law's lineage, a practice sometimes associated with pre-House organizations (1909, 68). Today informants among the northern Meje agree that this tie and also the marriage of women from a brother-in-law's lineage were possible, but they add that the practice was not widespread, because it caused a great deal of confusion in cases of divorce. More recently, Mangbetu men have not married women of in-law lineages for fear of being accused of sister exchange, a practice outlawed by the Belgians.

9. In Mangbetu kinship terminology *sisters* include father's brothers' daughters.

Chapter 6

1. The Mamvu were sometimes brought in as slaves of the Mangbetu.

2. The Mangbetu and Zande terms in parentheses are those given by Lang in his fieldnotes.

3. The designs might originally have had symbolic meanings, but if so, they are no longer remembered. The students of the great masters today say that there was no such meaning to the designs.

4. The term *Meje* is generally used to refer to the people; *Medje* was a colonial spelling for a town that served as a government post among the southern Meje.

5. Made from the herb *Tephrosia vogelii*.

6. Including 90.1/4708, 90.1/4719, 90.1/4680, 90.1/4679. The fifth pot is badly broken.

7. We are grateful to Judith Levinson and Marian Kaminitz for providing guidance in the technical descriptions of these objects.

8. Unfortunately, we do not know whether men of the neighboring peoples made mats.

9. Musée royal de l'Afrique centrale, dossier no. 298, p. 152. *Belebele*, according to Didier Demolin, means "negative" in Mangbetu, suggesting again the light/dark dichotomy.

10. This box is in the Ethnographic Museum in Leningrad.

11. A box with a head almost identical to that of 3.4 but whose container is made of ivory rather than bark has recently been seen in the collection of Phillipe and Hélène Leloup.

12. A stool-making workshop existed in Ekibondo in the 1940s. Photographs of this workshop are in the archives of the Musée royal de l'Afrique centrale in Tervuren.

13. As shown in the film *Spirits of Defiance: The Mangbetu People of Zaire*, produced by the American Museum of Natural History, Harcourt Films, British Broadcasting Corporation, and Arts and Entertainment.

Chapter 7

1. These were the same leaves and bark that were used to blacken pots and barkcloth (4581).

2. Soap was available after the 1860s, when its manufacture was introduced by Arab traders. Schweinfurth says that they preferred to bathe twice a day. Lang wrote that "the males generally take a nearly complete ablution every morning. Before going to bed they only wash their mouth, their hands, and their feet. The poorer classes are of course more neglectful in taking care of their bodies" (238).

3. Lang wrote often of wealthy and poor women and distinguished their dress accordingly.

4. We are grateful to Judith Levinson and Marian Kaminitz, who worked on the conservation of these hats, for details of this description.

5. According to Lang (1058) the Mangbetu got cowrie shells first from the Azande and then, by 1910, from the government.

Chapter 8

1. It is important to note that the differences between Vansina and ourselves are not crucial to understanding the Mangbetu in the period leading up to the European conquest. We all agree that this was an era in which a formerly centralized Mangbetu power was devolving and expanding and that new institutions were developing that were not typical during the founders' reigns. Our differences are rather over terms—whether the rulers of the period might be called smaller kings or bigger chiefs—which stem

from the models we are using to explain the situation. In fact, neither *king* nor *chief* captures the reality of the situation since both have such a variety of meanings in our language and experience. Even the Mangbetu term *nekinyi kpokpo* is inadequate since it also has a variety of meanings depending on the time and place it is used.

2. Lang noted that among the Meje whether a person carried spears or a bow was not so much a question of being Mangbetu or non-Mangbetu as it was one of class. Wealthy men, a category that included most Mangbetu, could afford to carry spears and shields whereas poorer men used bows and arrows (338).

3. Interview with Mayombe by C. Keim, 24 Mar. 1977.

4. Interview conducted by C. Keim, 27 Sept. 1976.

5. As noted earlier, Yangala was a Matchaga who had conquered the Mangbetu heartlands in 1873 and adopted Mangbetu culture. The original Mangbetu nobility, the Mangbetu-Mabiti, wanted to recapture their lands.

6. The Africans were Nyamwezi, from the area that is now Tanzania. The traders belonged to seventeen different firms, hired 3,220 porters from outside the Congo, and exported fifty tons of ivory (Czekanowski 1924, 19).

7. One missionary wrote in 1905: "It is certain that these nomad merchants that one sees roaming from Bambili [west of Mangbetu] or Bomokandi up to here [east of Mangbetu] do not help in diffusing our holy faith. They are of every nationality: Italians, Greeks, Arabs, Ugandans, Protestants en masse. The quantity of ivory that they exchange for merchandise is considerable; and nonetheless these envious ones are trying to take our poor Congo in their nets and charge that the Independent State hinders freedom of Commerce! In my opinion, trade is nowhere freer than here" (Derickx 1905, 254–55).

8. Catholic mission work had begun just after 1900, but it only became significant after 1911 when it was taken over by Belgian Dominicans. Two Protestant missionaries of the Heart of Africa Mission (HAM), a newly founded British society, arrived in Niangara in 1913. Five more HAM missionaries arrived in 1915, and the mission headquarters was moved to Nala the next year. In the following decade nearly one hundred HAM missionaries, half of them women, came to the area.

9. The Simba rebellion lasted in Kisangani for a few months during the third quarter of 1964. A "People's Republic" was declared in sympathy with the political movement led by Patrice Lumumba, although by that time Lumumba was dead. The rebellion was put down by the central Congo government with the help of the United States and mercenary soldiers. More than three thousand people died in Isiro.

Chapter 9

1. This chapter could not have been written without the help of numerous Mangbetu informants who were interviewed by Curtis Keim in 1976, 1977, and 1988. The most helpful of these informants were Iode Mbunza and Nzamaye Bondo. Iode, who died in 1980 at about the age of ninety, was a member of the royal family who had devoted himself to history. A gentle man, Iode decided as a youth to listen to elders around the fire instead of going to war or following the hunt. He could recount for hours the stories of the great Mangbetu heroes. In 1988 Nzamaye was a man of about sixty-five years old. He is a man of exceptional character, memory, and intelligence. Nzamaye's father was a Mayogo who was enslaved as a young boy by the Mangbetu king Azanga. Azanga chose the father to tend his fire and then put him in charge of court construction. When Nzamaye was young, he began to work as a carrier of the sedan chair of Azanga's grandson, Chief Niapu, and was eventually charged with organizing tradi-

tional aspects of the chief's court, a job of great responsibility. Today, Nzamaye is certainly the best single informant on Mangbetu traditional life. An enthusiastic proponent of Mangbetu culture, he works as a headman in the village of Nangazizi (not the Nangazizi of King Mbunza's day).

2. Although this chapter is written in the past tense, in conformity with the collection dates of the objects in the exhibition, to which it provides a context, many of the beliefs described here are still current among Mangbetu people in northeastern Zaire.

3. Interview with Andreza Andranyi by C. Keim, 15 Sept. 1976.

4. The blessing could also be given only with words. The use of kola among the Mangbetu is sometimes compared to the *naando* blessing. The kola is separated into lobes, which are passed among people along with a handshake. This small ritual, common throughout Africa where kola is found or imported, is supposed to indicate good will and communicate a mild blessing.

5. Past grievances could also intensify the beating. If the husband had generally mistreated his wife, her brothers would be especially severe.

6. Among the Mangbetu we take magic to mean the manipulation of unseen forces; witchcraft is not magic because it is considered to come from a body organ. The Azande have a similar understanding (see Evans-Pritchard 1937).

7. It seems probable that many of the concepts of *ope* predate the institution of *natolo* and that the imprecise relationship between *atolo* and *ope* is a result of Mangbetu attempts to integrate the two ideas. Jan Vansina suggests in a private communication that *ope* were the main spirits of the Mamvu (who, like the Mangbetu, are Eastern Central Sudanic speakers) and that the *ope* are the equivalent of the Bantu *molimo* and *elima*.

8. There is some recent oral evidence to indicate that a very long time ago people believed that children came from such *ope* villages.

9. Evans-Pritchard (1937) used this phrase for a similar concept, *ngua*, among the Azande.

10. The reasons behind this might be found either in the closer contact of southerners with Bantu ideas or in the greater centralization of northern Mangbetu.

11. Lang noted that *netumo* is also the word for a kind of eagle—like the lion, an animal with prominent claws.

12. Some modern informants say that the mixing of blood signified a mixing of families and was not medicine. Most agree with the interpretation given here.

13. The term *mapingo* is used here because it is common in literature on the Mangbetu. The proper term is *namapingo*.

14. In some areas all sticks were placed on one banana trunk; in other areas two trunks were used, one was positive and one negative. Sometimes there were two positive groups of three sticks each and two negative.

15. Informants among the southern Meje, who were heavily influenced by the forest Azande in the last part of the nineteenth century, say that they trusted the *noele*, an equivalent of the Zande *benge*, more than *mapingo*. In the *noele* oracle a plant poison was fed to a chicken; if the chicken died, the answer to the question posed was affirmative.

16. Interview with Abongobo by C. Keim, 5 Jan. 1977.

17. Now in the Musée royal de l'Afrique centrale, Tervuren, catalog number 11634.

18. When a new chief was installed in 1952, only *andoi* from the Makpao came. The Makpao, uncles of Azanga's son Chief Danga, are now known as the lineage of most *andoi* specialists.

19. The half-joking Mangbetu response to this was that subjects should ask the Mando lineage whether

the royal lineage possessed *notu*. This is because in the late nineteenth century the Mando soldiers of Mbunza's son Mbala were supposed to have eaten some of King Mbunza's children. If the royal lineage had been witches, the *notu* organ would have been found in the male children.

20. We are grateful to Didier Demolin for the suggestion that the kings used the *amamboliombie* against the *andoi*. If the *andoi* were closely connected to the lineages, as Nzamaye suggests, the kings were also using the *amamboliombie* against the lineages.

21. *Makango* is a generic term for fishermen in the region, who come from a number of different ethnic groups. The connection with fishermen probably indicates that *nebeli* came from the west, since many ideas and objects were exchanged along the Uele River. Also related to river people throughout the region is Kilima, a water spirit associated with whirlpools, rainbows, and dangerous fish and eels.

22. In the Matchaga version of the rise of Dakpala he escapes from Nabiembali. In the Mangbetu version Nabiembali confers power on Dakpala because Nabiembali's own sons have rebelled (see chap. 4).

23. Interview with Chief Tagba by C. Keim, 1988.

24. One informant said with anger that Father Bonhomme Jourdain, the best-known Dominican missionary in the region, had collected many whistles and sent them to Europe so they could be used as medicine there.

25. The strongest evidence for the Mangbetu not having had a creator god comes from northern Meje informants (see also Lelong 1946, 1:244–45). Many southern informants recall that their forefathers prayed to ancestors, but they do not recall as clearly as their northern counterparts that there was no creator god.

Chapter 10

1. [The *sanza*, in some places called *likembe* or *mbira*, is a type of idiophone with keys (lamellae) made of metal, bamboo, or wooden strips. The keys pass under a lateral bar and over a bridge set on top of a soundboard, which may be mounted on a box or placed inside a bowl or gourd resonator for amplification. The keys are plucked with the thumbs or the fingers; thus the instrument is sometimes called a thumb piano. This type of instrument is widespread throughout sub-Saharan Africa. Beads, bottlecaps, bits of metal or wire, shells, or other small, hard objects are often loosely attached to create a buzzing texture through sympathetic vibrations.]

2. The *sanza*, the instrument most commonly played for entertainment, was most likely imported from the south by Bantu speakers. It probably existed in the area before the nineteenth century but spread more widely through the region at the end of the nineteenth century with the arrival of many soldiers and police recruited from the southern Congo.

3. There is one Mangbetu song in a small anthology of Congo music recorded in 1935–36 by the Denis-Roosevelt African Expedition. Another set of recordings was made in 1952 by Hugh Tracey in the northeast Congo, mainly of assimilated groups including the Meje, the Mayogo, the Bangba, and the Mangbele. Tracey's recordings were made during a survey of traditional African music organized by the Library of African Music in Johannesburg. The *Mangbetu-Zaire* LP (ECPC03), recorded by the author in 1984–85, contains court and popular music of the Mangbetu (see Demolin 1985).

4. This was emphasized by several Mangbetu blacksmiths during interviews conducted by the author at Nangazizi in 1984, 1985, and 1988.

5. There is a repertoire of court songs called *Amangbetu olya*. These songs of the elders are performed in court for conversing with the king or to recall important traditions. Two examples of the genre can be heard on the *Mangbetu-Zaire* LP (see Demolin 1985).

6. Excerpts from the circumcision and *mabolo* dances can be heard on the *Mangbetu-Zaire* LP (see Demolin 1985).

7. Very few recordings of Mangbetu playing these types of instrument exist. In 1952 Hugh Tracey recorded *sanza* and *nenzenze* music, but there are no recordings of Mangbetu harp music. The wax-roll recordings made by Hutereau in 1912 include only music of chiefs' orchestras and songs.

8. Among my various sources I am particularly indebted to Didier Demolin for his research on Mangbetu music and instruments and especially for his field recordings made among the Mangbetu in 1984–85.

9. Throughout part 2 of this chapter the term *musical instruments* is used to refer to all objects made for producing sound, including those used for signals, announcements, messages, magical charms, and other purposes.

10. The slit drum, an idiophone carved from a single log hollowed out through a narrow slit, is sometimes referred to in the literature as a gong.

11. Several of the slit drums in the American Museum are tuned to an interval of approximately a major third.

12. Curt Keim, personal communication.

13. Curt Keim, personal communication.

14. Burssens (1958, 166) described a Ngbandi harp on which "each string corresponds to two keys on the xylophone." This observation further suggests that octave equivalency is a feature of the xylophone music of the region.

15. Human voices also imitate animals. Giorgetti (1952, 216–18) published transcriptions of Zande songs imitating the *gangaringana* and *turumoni* birds. Hutereau recorded animal imitations among the Efe in a Mamvu village in 1912 (wax roll 67). I am indebted to Didier Demolin for providing the wax-roll material.

16. Larken (1927, 104) wrote that an oval form of wooden *sanza* died out among the northern Azande in the Sudan and was replaced by a shallow box-shaped type around 1917.

17. Schweinfurth, describing a Niam-niam "harp-guitar" ("kundee"), wrote that the "two base-strings [sic] are taken from the strong hair of the tail of the giraffe, while the rem...ining three are twisted of sinews" (1875, pl. XIV). On some harps in the American Museum, one of the holes punched in the body for string attachment (the one closest to the neck) is of a smaller diameter than the rest of the holes. Some of the instruments have what appear to be six string holes in the body, but only five holes in the neck for the attached tuning pegs; others apparently have six peg holes but only five string holes. This would seem to suggest that harp tunings may have been varied enough to require changing the string placement, but the extra holes could also have been added after collection in order to hang the harps in a display.

18. One of these instruments (AMNH, 90.1/1768) has a thin bark top sewn onto a wooden trough resonator, open at the base, with strips of fiber wrapped around the body.

Chapter 11

1. The opportunity to undertake this work was afforded by the president and Council of the British Institute in Eastern Africa and the then director of its Southern Sudan research project, Professor Nicholas David. Thanks are also due to the trustees of the British Museum for granting the leave to participate in this research and to the Sudan Antiquities Service and Regional Ministry of Culture, under whose auspices it was carried out. I would like to thank in particular Dr. Curtis Keim for his helpful remarks on an earlier draft of this chapter. A number of his suggestions are incorporated here. I am also grateful to Malcolm McLeod, Enid Schildkrout, and Jeremy

Coote for reading and commenting on the text. Help with various aspects of the research was given by Leslie Forbes (Sudan Archive, University of Durham), Elizabeth Edwards (Pitt Rivers Museum, Oxford), and Yvonne Schumann (Merseyside County Museums, Liverpool).

2. This circumstance makes estimating the contemporary population of the Azande difficult. Collating statistics taken at different census points across three countries is problematic, but the total number is likely to be more than one million.

3. His three separate essays (1960, 1963, 1965) have been grouped together with other articles about the Azande in Evans-Pritchard 1971. Braithwaite 1982 considers aspects of Zande pottery. My own field experience in Zande country was limited to a brief visit to the Sudanese groups of Azande in 1979, when it was also possible to gain an impression of the Belanda, who, arguably, have made a significant contribution to northern Zande culture. I made more extensive observations among the Moru, who have had sustained contact with the Azande though they never actually succumbed to Zande rule.

4. Of British collectors Captain Guy Burrows was perhaps the leading exception of the period. Burrows spent six years in what is now northeastern Zaire, first as commandant of the Zones of Makua and of Rubi-Uele and later as district commissioner of the Aruwimi centered at Basoko. Parts of the collection he formed, now housed in the British Museum, are included in the exhibition with which this publication is associated.

5. In the nineteenth century that part of Zande country lying within the Sudan (though the final determination of borders was delayed until 1907) was administered as part of the Province of Bahr-el-Ghazal, and we refer to it here as such. Subsequently, however, it became part of a new province, Equatoria, with its administrative center at Juba, the capital city of the southern Sudan.

6. Most of the objects collected by Petherick appear to have been consigned to the United Services Institution and subsequently scattered. Many were ultimately placed in the British Museum and came from a variety of sources. Lupton Bey's collection came into the British Museum as one donation in 1882. (For an accessible account of the travels of the Pethericks and the Tinnes, see Hall 1980.)

7. [John Mack uses the title *prince* as Vansina and Evans-Pritchard do, to indicate that there were many competing Zande rulers. He uses *king* here to show that Bakangai had a significantly larger court than the other Zande princes.]

8. [This seems to be the same place that Lang refers to as Akenge.]

9. I am grateful to Curtis Keim for pointing out these further associations between Bakangai and the Mangbetu.

10. One such whistle is reported by Evans-Pritchard. This was originally owned by King Gbudwe's father and subsequently passed to him after his father's death. It was then handed on to Gbudwe's son, who had it at the time Evans-Pritchard was in Zandeland (1971, 303).

11. Curtis Keim, personal communication.

12. The most directly comparable system of divination is that of the Kuba, whose rubbing oracle is known as *itombwa*, a word probably related to the Zande term *iwa*.

13. The same form of animal is also represented on a copper ring (**2.5**) acquired from the same source

and at the same time. Both it and the harp are in the British Museum (BM 4416 and 4452) and are also included in the American Museum of Natural History exhibition.

14. None of the larger figures found in British collections were collected on what, in colonial times, was the Belgian side of the border. These figures are virtually, if not entirely, absent from public collections in Belgium or Zaire.

15. The character of Avongara rule has been well described (for a general review of the literature see Baxter and Butt 1953).

16. This was suggested to me by a doctor formerly employed there.

Chapter 12

1. No systematic study has been done of how the peoples of this region classify the natural world. We have drawn on Lang's fieldnotes, our own study of museum collections, interviews conducted in the 1970s and 1980s by Keim among the Mangbetu, and published materials to construct the argument presented here.

2. Interview with Meumeu, by C. Keim, 31 Mar. 1977.

3. We can speculate that this attitude toward the body is perhaps a necessary but not sufficient condition for cannibalism.

4. The greatest change in the availability of ivory to carvers followed the two decrees opening the region to general trade: in the area north of the Uele River in July 1910 and in the area to the south of the river in July 1912.

5. This is shown in the film *Spirits of Defiance: The Mangbetu People of Zaire,* produced by the American Museum of Natural History, Harcourt Films, British Broadcasting Corporation, and Arts and Entertainment.

6. Lang collected the entire outfit of a *mu* (also called *liandu* or *naando*) dancer among the Barambo in Poko. This material included objects described in fieldnotes 2372–91 as follows: bunches of pig bristles and leaves that ornament the head of the dancers; strings that are fastened in front of the leaves to keep them upright, made of corn straw; strings of pig bristles and fifty tails of genets, wildcats, and monkeys that were fastened about the waist; another string of twenty skins (mostly genets and civets) and fifteen bunches of feathers, all mounted on wooden pins, which are used to fasten the bunches of pig bristles to the hair of the dancer; four armlets to which the dancers attach some kind of dried grass or also a genet's tail ("often the skin of a genet is pushed between the armlet and the skin"); two twisted cords to which or underneath which the dancers fasten the tails, skins, and green vegetation about the waist; the tail of a pangolin to be fastened to the waist; a bunch of red parrot feathers worn usually on top of the hats of chiefs; two armlets having the magic power of giving good health.

7. Mary McMaster's research among the Bua indicates that they sometimes used figures in funerary contexts, but that the figures were incidental and used just for decoration (personal communication; see also McMaster 1988). The figure discovered by Czekanowski is published in von Sydow 1954, 124.

8. We are grateful to Margot Dembo for translating this passage.

9. Schweinfurth's drawings (1875, 74) do not show the flared hairstyle so typical of Mangbetu anthropomorphic art. Perhaps this style also came later and provides a clue to dating some pieces.

10. Schweinfurth described the practice of head binding in *The Heart of Africa*, 2:107.

11. There is some evidence, from Casati and from informants' statements, that the Bantu-speaking Makongo, fishermen on the Uele River, were responsible for the introduction of *nebeli* to the Matchaga in the nineteenth century.

12. A much larger figure (88 cm) with similar eyes was collected by Miani in 1878 (Bassani 1977, 102). It is in the Museo preistorico ed etnografico (L. Pigorini) in Rome.

13. See also chap. 9 for a discussion of the wearing of a fish net by elders who performed surgical operations on dead people to discover whether they had been witches.

14. There is a similar example in the Museum für Völkerkunde in Frankfurt and another, collected by Captain E. Piola in 1907, in the Universita degli Studi istituto di zoologia, Parma (Bassani 1977, 26).

15. Lowie was slated to write up Lang's ethnographic work from the Congo, but he never did.

16. The Mangbetu lexicon for forest technology includes many Bua loanwords (McMaster 1988).

17. A very similar knife is in the collection at the Musée royal de l'Afrique centrale in Tervuren, collected about 1903.

18. This remark was made by Nzamaye in an interview conducted on film. We showed him a photograph of **7.15** and filmed his comments. The interview is not included in the edited version of the film *Spirits of Defiance: The Mangbetu People of Zaire* or in the film accompanying the exhibition. There is evidence that missionaries and chiefs who became part of the colonial administration collected and burned whistles.

19. We have found no documented example of anthropomorphic pottery collected before Lang.

20. One of the three boxes is missing from the American Museum collection.

21. It is interesting that many of the carved figures hold their arms in the same position seen on some of the older wooden knife handles—one in front and one behind.

22. One woman was seen in 1988 making an anthropomorphic pot, but this probably represented something of an experimental revival.

23. The Belgian Congo government outlawed the practice. Moreover, today, far from northeastern Zaire in Kinshasa, the capital of the country, head binding is not admired. The Lingala term *mutumanbetu* means "ugly person."

24. In 1909 Wacquez remarked on an unusual *negbamu* that he had seen at the court of one of Yangala's sons. Each of the more than sixty pillars of the structure was sculpted in a different fashion (Van Overbergh and De Jonghe 1909, 227).

25. Colin Turnbull to Curtis A. Keim, letter, dated 25 Sept. 1985.

26. Interview with Thomas Tsembete, catechist, Rungu, 9 Oct. 1976; and Rev. P. G. M. Radoux, "Histoire de la mission de Rungu" (Musée royal de l'Afrique centrale, Tervuren, 1934, manuscript), 12.

Bibliography

Alexander, Boyd. 1907. *From the Niger to the Nile.* 2 vols. New York: Longmans, Green and Co.

Anstey, Roger. 1966. *King Leopold's Legacy: The Congo under Belgian Rule, 1908–1960.* London: Oxford University Press.

Antinori, Orazio. 1984. *Orazio Antinori in Africa centrale, 1859–1861.* Ed. E. Castelli. Perugia: Ministero beni culturali e ambientali.

Armstrong, Jack P. 1910. "Report on the Condition of the Natives in the Uele District." Archives. Public Record Office, London. FO367, 259.

Arom, Simha. 1985. *Polyphonies et polyrythmies instrumentales d'Afrique centrale.* 2 vols. Paris: SELAF.

Arts et métiers congolais: Douze gravures originales en couleurs. 1937. Brussels: Les Editions de Belgique.

Bakonzi, Agayo. 1982. "The Gold Mines of Kilo-Moto in Northeastern Zaire: 1905–1960." Ph.D. diss., University of Wisconsin, Madison.

Bassani, Ezio. 1977. *Scultura africana nei musei italiani.* Bologna: Edizoni Calderini.

———. 1979. *Carlo Piaggia e l'Africa.* Istituto storico lucchese sede centrale. Lucca: Maria Pacini Fazzi Editore.

Bastin, Yvonne, et al. 1983. "Classification lexicostatistique des langues bantoues (214 relevés)." *Bulletin des séances de l'Académie royale des sciences outre-mer* 27(2):173–99.

Baumann, Hermann. 1927. "Die materielle Kultur der Azande und Mangbetu." *Baessler Archiv* 11:3–129.

Baxter, Paul T. M., and Audrey Butt. 1953. *The Azande and Related Peoples of the Anglo-Egyptian Sudan and Belgian Congo.* Ethnographic Survey of Africa, 9. London: International African Institute.

Belgian Congo. 1931. *Commission de la main-d'oeuvre indigène, Rapport.* Brussels: Imprimerie A. Lesigne.

Bertrand, R. 1930. "Note sur les Mabudu-Madimbisa (dits Wasumbi), Ibambi." Dossiers AIMO. District Kibali-Ituri Archives. Musée royal de l'Afrique centrale, Tervuren.

———. 1932. "Notes sur les Mangbetu, Niangara." African Archives. Ministère des affaires étrangères, Brussels.

Birnbaum, Martin. 1939. "The Long-Headed Mangbetus." *Natural History* 43:73–83.

———. 1942. *Vanishing Eden: Wanderings in the Tropics.* New York: William E. Rudge's Sons.

Boone, Olga. 1951. *Les tambours du Congo belge et du Ruanda-Urundi.* Annuaire du Musée Congo belge. Tervuren.

Bouccin. 1935. "Les Babali." *Congo* 2(5):685–712.

———. 1936. "Les Babali." *Congo* 3(1):26–41.

Braithwaite, Mary. 1982. "Decoration as Ritual Symbol: A Theoretical Proposal and an Ethnographic Study." In I. Hodder, ed., *Symbolic and Structural Archaeology*, pp. 80–88. London: Cambridge University Press.

Bravmann, René. 1983. *African Islam.* Washington, D.C.: Smithsonian Institution Press and Ethnographica.

Browne, W. G. 1798. *Travels in Africa, Egypt and Syria from the Year 1792 to 1799.* London: T. Tadel, Junior, and W. Davies.

Bruggen. 1914. "Renseignements sur la constitution de la chefferie Kiravungu, secteur Kembira, Poko." Dossiers AIMO. Territoire Poko. Archives. Musée royal de l'Afrique centrale, Tervuren.

Bryan, M. A. 1959. *The Bantu Languages of Africa.* London: Oxford University Press.

Burrows, Guy. 1898. *The Land of the Pigmies.* New York: Thomas Y. Crowell and Co.

———. 1903. *The Curse of Central Africa.* London: R. A. Everett.

Burssens, Hermann. 1958. *Les peuplades de l'Entre Congo-Ubangi (Ngbandi, Ngbaka, Mbandja, Ngombe et Gens d'Eau).* Ethnographic Survey of Africa, Central Africa, Belgian Congo, pt. 4. London: International African Institute.

———. 1960. "Enkele Zande-maskers uit Uele." *Congo-Tervuren* 6(4).

———. 1962. *Yanda-beelden en Mani-sekte bij de Zande.* Annales du Musée royal de l'Afrique centrale, n.s., no. 4. Tervuren.

Buxton, Alfred B. 1920. *The First Seven Years of the Heart of Africa Mission, 1913–1919.* Belfast: Graham and Heslip.

Canisius, Edgar. 1903. "A Campaign amongst the Cannibals." In Guy Burrows, *The Curse of Central Africa.* London: R. A. Everett.

Carrington, John F. 1949. *Talking Drums of Africa.* London: Carey Kingsgate Press.

Casati, Gaetano. 1891. *Ten Years in Equatoria and the Return with Emin Pasha.* 2 vols. Trans. Mrs. Randolph Clay. London: Federick Warne and Co.

Castelli, Enrico. 1987. "Bari Statuary: The Influence Exerted by European Traders on the Traditional Production of Figured Objects." *Res* 14:85–106.

Ceulemans, P. 1959. *La question arabe et le Congo (1883–1892).* Brussels: Académie royale des sciences coloniales.

Chaillu, P. du. 1868. *L'Afrique sauvage.* Paris: Levy.

Chalux [pseud.]. 1925. *Un an au Congo belge.* Brussels: Albert Dewit.

Chapin, James P. 1932–54. *Birds of the Belgian Congo.* 4 vols. New York: American Museum of Natural History.

———. 1937. "In Pursuit of the Congo Peacock." *Natural History*, December, 725–78.

———. 1942. "The Travels of a Talking Drum." *Natural History* 50:62–68.

———. 1960. "Reminiscences," tape transcript. Archives. Department of Ornithology, American Museum of Natural History, New York.

Choprix, Guy. 1961. *La naissance d'une ville: Etude géographique de Paulis (1934–1957).* Brussels: CEMUBAC.

Christiaens. 1896. "Le pays des Mangbettus." *Causerie du cercle africain*, 23 November, 1–31.

Cleire, R. 1966. "Les bases socio-culturelles du mariage traditionnel au Congo." Report to Permanent Committee of the "Ordinarii" of Congo. Archives, CEPAS. Kinshasa.

Cordell, Dennis. 1983. "The Savanna Belt of North-Central Africa." In David Birmingham and Phyllis Martin, eds., *History of Central Africa*, vol. 1, pp. 30–74. New York: Longman.

Costermans, B. J. 1947. "Muziek-instrumenten van Watsa-Gombari en omstreken." *Zaire* 5:516–42; 6:629–63.

———: 1953. *Mosaïque Bangba: Notes pour servir*

à l'étude des peuplades de l'Uele. Brussels: Institut royal colonial belge.

Czekanowski, Jan. 1924. *Forschungen im Nil-Kongo-Zwischengebiet.* Vol. 6, pt. 2, *Ethnographie Uele, Ituri, Nilländer.* Leipzig: Klinkhardt and Biermann.

Dalby, David. 1977. *Language Map of Africa and the Adjacent Islands.* Limited provisional edition. London: International African Institute.

Daye, Pierre. 1923. *L'empire colonial belge.* Paris: Berger-Levrault.

De Calonne-Beaufaict, A. 1921. *Azande: Introduction à une ethnographie générale des bassins de l'Ubangui-Uele et de l'Aruwimi.* Brussels: Maurice Lamertin.

De Deken, Constant. 1902. *Deux ans au Congo.* Antwerp: Clément Thibaut.

De Hen, F. 1960. *Beitrag zur Kenntnis der Muzikinstrumente aus Belgisch-Kongo und Ruanda-Urundi.* Tervuren: Musée royal de l'Afrique centrale.

De Jonghe, E. 1949. *Les formes d'asservissement dans les sociétés indigènes du Congo belge.* Brussels: de Rudeval.

Delhaise-Arnould, Charles. 1919. "Les associations sécrètes du Congo: Le Nebili ou Negbo." *Bulletin de la Société des études congolaises* 21:283–90.

Demolin, Didier. 1985. *Mangbetu-Zaire.* Liner notes to *Mangbetu-Zaire* LP. Tervuren: Paul Collaer, Centre ethnomusicologique, Musée royal de l'Afrique centrale, ECPC03.

Denis, Paul. 1961. *Histoire des Mangbetu et des Matshaga jusqu'à l'arrivée des Belges.* Tervuren: Musée royal de l'Afrique centrale.

Derickx, M. 1905. "A travers l'Uele, d'après différentes lettres du Rev. M. Derickx, préfet apostolique." *Le mouvement des missions catholiques au Congo* 17(9):197–202, 231–36, 253–58.

De Wildeman, E. 1920. "'Le niando' succedané du chanvre au Congo belge." *Congo* 1(5):534–38.

du Bourg de Bozas, Robert. 1906. *Mission scientifique du Bourg de Bozas de la mer Rouge à l'Atlantique à travers l'Afrique tropicale (octobre 1900–mai 1903), Carnets de route.* Paris: De Rudeval.

Dubreucq, René. 1909. *A travers le Congo belge: Récit de voyage de Banana au Katanga.* Brussels: L'Expansion Belge.

Ehret, Christopher, et al. 1975. "Some Thoughts on the Early History of the Nile-Congo Watershed." *Ufahamu* 5(2):85–112.

Emin Pasha. 1888. *Emin Pasha in Central Africa.* London: G. Philip & Son.

Evans-Pritchard, E. E. 1928. "The Dance." *Africa* 1(4):446–62.

———. 1931. "Mani, A Zande Secret Society." *Sudan Notes and Records* 14(2):105–48.

———. 1937. *Witchcraft, Oracles and Magic among the Azande.* Oxford: Clarendon Press.

———. 1960. "A Contribution to the Study of Zande Culture." *Africa* 30:309–24.

———. 1963. "A Further Contribution to the Study of Zande Culture." *Africa* 33:183–97.

———. 1964. "The Zande State" (The Huxley Memorial Lecture 1963). *Journal of the Royal Anthropological Society* 93. Reprinted in E. E. Evans-Pritchard. 1965. *The Position of Women in Primitive Societies and Other Essays in Social Anthropology,* pp. 102–32. London: Faber and Faber.

———. 1965. "A Final Contribution to the Study of Zande Culture." *Africa* 35:21–29.

———. 1971. *The Azande: History and Political Institutions.* London: Oxford University Press.

Fagg, William B. 1962. *The Art of Central Africa.* London: Collins.

———. 1970. *The Tribal Image.* London: British Museum Publications.

Flandrau, Grace. 1929. *Then I Saw the Congo.* New York: Harcourt, Brace and Co.

Foury, P. 1937. "Indications données par l'état actuel de la végétation sur la répartition ancienne des groupements humains." *Bulletin de la Société d'études camerounaises* 2:7–13.

Frechkop, S. [1953?]. "Les mammifères du Congo belge." In *Encyclopédie du Congo belge,* vol. 2. Brussels.

Friedrich, Adolf. 1913. *From the Congo to the Niger and the Nile: An Account of the German Central African Expedition of 1910–1911.* London: Duckworth and Co.

Geary, Christraud. 1988. *Images from Bamum: Colonial Photography at the Court of King Njoya.* Washington, D.C.: Smithsonian Institution Press.

Geerincks, J. 1922. *Guide commercial du Congo belge.* 2d ed. Brussels: A. Lesigne.

Giorgetti, Rev. Father Filiberto F.S.G. 1952. "African Music (With Special Reference to the Zande Tribe)." Trans. H. B. Bullen. *Sudan Notes and Records* 33:216–23.

Goffart, F. 1908. *Le Congo géographique, physique, politique, et économique.* 2d ed. Brussels: Misch et Thron.

Goffinet, J. 1913. "Aperçu sur l'agriculture de l'Uele." *Bulletin agricole du Congo belge* 4(3):587–609.

Gourou, Pierre. 1955. *La densité de la population rurale du Congo belge.* Brussels: Académie royale des sciences d'outre-mer.

Gray, R. 1962. *A History of the Southern Sudan, 1839–1889.* London: Oxford University Press.

Greenberg, Joseph H. 1963. "The Languages of Africa." *International Journal of American Linguistics* 29, no. 1, pt. 2.

Grubb, Norman Percy. 1945. *Christ in Congo Forests: The Story of the Heart of Africa Mission.* London: Lutterworth Press.

Gustin, A. 1895. "Les abeilles." *Le Congo illustré* 4:16, 32, 39–40, 55–56.

Hackars, H. M. 1919. "Inspection du territoire d'Avakubi: Politique indigène Kisangani." Dossiers AIMO. Bafwasende. Archives. Musée royal de l'Afrique centrale, Tervuren.

Hall, Richard. 1980. *Lovers on the Nile.* London: Quartet Books.

Harris, Marvin. 1977. *Cannibals and Kings.* New York: Random House.

Hart, T. B. 1985. "The Ecology of a Single-Species Dominant Forest and of a Mixed Forest in Zaire, Africa." Ph.D. diss., Michigan State University, East Lansing.

Herodotus. 1952. *The History of Herodotus.* Trans. George Rawlinson. Chicago: Encyclopaedia Britannica.

Hubbard, Mary Inez. 1973. "In Search of the Mangbetu." Paper presented to the seminar of C. Ehret. University of California, Los Angeles.

Hunt, Charles. 1972. "Africa and the Liverpool Museum." *African Arts* 5:46–51.

Hutereau, Armand. 1909. *Notes sur la vie familiale et juridique de quelques populations du Congo belge.* Tervuren: Musée du Congo belge.

———. 1912. "Note sur les instruments congolais." Unpublished letter to M. Vermandele, professor at the Brussels Conservatory of Music.

———. [1922]. *Histoire des peuplades de l'Uele et de l'Ubangi.* Brussels: Goemaere.

Iacovleff, Alexandre. 1928. "Dessins et peintures d'Afrique, exécutés au cours de l'expédition Citroën Centre Afrique. Deuxième mission Haardt, Audouin-Dubreuil."

Julien, Paul. 1935. "Tusschen Nijl en Congo, onwettenschappelijke ervaringen tijdens een pygmeeen onderzoek in N.O. Congo." *Congo* 2(2):218–21.

Junker, Wilhelm. 1890. *Travels in Africa during the Years 1875–1878.* Trans. A. H. Keane. London: Chapman and Hall.

————. 1891. *Travels in Africa during the Years 1879–1883*. Trans. A. H. Keane. London: Chapman and Hall.

————. 1892. *Travels in Africa during the Years 1882–1885*. Trans. A. H. Keane. London: Chapman and Hall.

Keim, Curtis A. 1979. "Precolonial Mangbetu Rule: Political and Economic Factors in Nineteenth-Century Mangbetu History (Northeast Zaire)." Ph.D. diss., Indiana University, Bloomington.

————. 1983. "Long-Distance Trade and the Mangbetu." *Journal of African History* 24:1–22.

Knost, Gaston. 1968. *Enquête sur la vie musicale au Congo belge, 1934–1935*. Tervuren: Musée royal de l'Afrique centrale.

Krapf-Askari, Eva. 1972. "Women, Spears and Scarce Goods: A Comparison of the Sociological Function of Warfare in Two Central African Societies." In André Singer and B. V. Street, eds., *Zande Themes*, pp. 19–40. London: Blackwell.

Kronenberg, Waltraud, and Andreas Kronenberg. 1960. "Wood Carvings in the South Western Sudan." *Kush* 8:274–81.

————. 1981. *Die Bongo: Bauern und Jäger im Südsudan*. Wiesbaden: Franz Steiner Verlag.

Kubik, Gerhard. 1964. "Harp Music of the Azande and Related People in the Central African Republic." *African Music* 3(3):37–76.

Lacomblez, M. 1918. "L'agriculture chez les Mangbetu de l'Ituri." *Bulletin agricole du Congo belge* 9(6):95–110.

Lagae, C. R. 1926. *Les Azande ou Niam-Niam*. Brussels: Vromant and Co.

Lang, Herbert. 1909–14. Fieldnotes. Archives. Department of Anthropology, American Museum of Natural History, New York.

————. 1911. "Report from the Congo Expedition." *American Museum Journal* 11(2):44–48.

————. 1915. "An Explorer's View of the Congo." *American Museum Journal* 15(8):379–88.

————. 1918a. "Famous Ivory Treasures of a Negro King." *American Museum Journal* 18(7):527–52.

————. 1918b. "In Quest of the Rare Okapi." *Zoological Society Bulletin* 21(3):1601–13.

————. 1919. "Nomad Dwarfs and Civilization." *Natural History* 19(6):696–713.

————. 1920. "The White Rhinoceros of the Belgian Congo." *Zoological Society Bulletin* 23(4):66–92.

————. 1922. "Notes on Ant-Eating Mammals in the Belgian Congo." *Bulletin of the American Museum of Natural History* 45:320–29.

————. 1923. "A New Genus of African Monkey, *Allenopithecus*." *American Museum Novitates*, no. 87.

————. 1924. "The Vanishing Wild Life of Africa." *Natural History* 24(3):312–27.

Lang, Herbert, and James P. Chapin. 1918. "Nesting Habits of the African Hornbill." *American Museum Journal* 18(4):271–77.

Larken, P. M. 1926. "An Account of the Azande." *Sudan Notes and Records* 9(1):1–55.

————. 1927. "Impressions of the Azande." *Sudan Notes and Records* 10:85–135.

————. 1930. "Impressions of the Azande." *Sudan Notes and Records* 13(1):99–115.

Larochette, J. 1958. *Grammaire des dialectes Mangbetu et Medje suivie d'un manuel de conversation et d'un lexique*. Tervuren: Musée royal du Congo belge.

Laurenty, J. S. 1960. *Les cordophones du Congo belge et du Ruanda-Urundi*. Annuaire du Musée royal du Congo belge. Tervuren.

————. 1962. *Les sanza du Congo*. Annuaire du Musée royal de l'Afrique centrale. Tervuren.

————. 1968. *Les tambours à fente de l'Afrique centrale*. Annuaire du Musée royal de l'Afrique centrale. Tervuren.

————. 1972. *Les aerophones de l'Afrique centrale*. Annuaire du Musée royal de l'Afrique centrale. Tervuren.

Lebrun, J. 1934. "Rapport sur un voyage d'études botaniques dans le district de l'Uele-Nepoko." *Bulletin agricole du Congo belge* 25(2):192–204.

Lelong, Maurice-Hyacinthe. 1946. *Mes frères du Congo*. 2 vols. Algiers: Editions Baconnier.

Lemaire, Alban. 1898. "Les Mangbetu." *La Belgique coloniale* 4:42–43.

Letouzey, René. 1968. *Etude phytogéographique du Cameroun*. Paris: Lechevalier.

Leuzinger, Elsy. 1960. *Africa: The Art of the Negro Peoples*. New York: Methuen.

Lloyd, David. 1978. "The Precolonial Economic History of the Avongara-Azande, c. 1750–1916." Ph.D. diss., University of California, Los Angeles.

Lotar, Léon. 1946. *La grande chronique de l'Uele*. Institut royal colonial belge, Sciences morales et politiques, Mémoires, vol. 14. Brussels.

McMaster, M. 1988. "Patterns of Interaction: A Comparative Ethnolinguistic Perspective on the Uele Region of Zaire, c. 500 B.C. to 1900 A.D." Ph.D. diss., University of California, Los Angeles.

Moeller, A. 1936. *Les grandes lignes des migrations des Bantous de la province orientale du Congo Belge*. Brussels: Institut royal colonial belge.

Mohun, R. D. 1893. "Consular Dispatch from Basoko Camp June 21 1893." U.S. Consulate Boma 1882–1893. U.S. Department of State. Microfilm.

Moore, Henry. 1981. *Henry Moore at the British Museum*. London: British Museum Publications.

Morel, Edmund D. 1904. *King Leopold's Rule in Africa*. London: Heineman.

Nketia, J. H. Kwabena. 1975. *The Music of Africa*. London: Victor Gollancz.

Osborn, Henry Fairfield. 1919. "The Congo Expedition." *American Museum of Natural History Bulletin* 39:xv–xxviii.

Peeters, Leo. 1965. *Les limites forêt-savane dans le nord du Congo en relation avec le milieu géographique*. Brussels: CEMUBAC.

Petherick, John. 1861. *Egypt, the Soudan, and Central Africa, With Explorations from Khartoum on the White Nile to the Regions of the Equator, Being Sketches from Sixteen Years' Travel*. London: William Blackwood and Sons.

Petherick, Mr. and Mrs. 1869. *Travels in Central Africa, and Explorations of the Western Nile Tributaries*. 2 vols. London: Tinsley Bros.

Philippe, R. 1962. "La secte 'Nebele' chez les Mangbetu." *Africa-Tervuren* 8(4):98.

Philipps, J. E. T. 1926. "Observations on Some Aspects of Religion amongst the Azande (Niam-Niam) of Equatorial Africa." *Journal of the Royal Anthropological Institute* 56:171–87.

Piaggia, C. 1978. *Nella terra dei Niam-Niam (1863–1865)*. Ed. E. Bassani. Lucca: Maria Pacini Fazzi.

Powell-Cotton, Mrs. 1934. "Village Handicrafts in the Sudan." *Man* 34(112):90–91.

Reeves Sound Studios. 1937. Introductory note to *The Belgian Congo Records, Primitive African Music*. Reeves Sound Studios, New York.

Salmon, Pierre. 1963. *La reconnaissance Graziani chez les sultans du nord de L'Uele (1908)*. Brussels: CEMUBAC.

————. 1969. *La dernière insurrection de Mopoie Bangezegino (1916)*. Brussels: CEMUBAC.

————. 1970. "Les carnets de campagne de

Louis Leclercq." *Revue de l'Université de Bruxelles* 22:1–70.

———. 1972. "Sectes secretes Zande (République du Zaire)." In *Etudes de géographie tropicale offertes à Pierre Gourou*. Paris: Mouton.

Schaeffner, André. 1968. *Origine des instruments de musique*. Paris: Mouton.

Schildkrout, Enid, Jill Hellman, and Curtis A. Keim. 1989. "Mangbetu Pottery: Tradition and Innovation in Northeast Zaire." *African Arts* 22(2):38–47.

Schubotz, Hermann. 1913. "The Mangbetu Country." In Adolf Friedrich, *From the Congo to the Niger and the Nile*, vol. 2. London: Duckworth and Co.

Schweinfurth, Georg A. 1874. *The Heart of Africa: Three Years' Travels and Adventures in the Unexplored Regions of Central Africa from 1868 to 1871*. 2 vols. Trans. Ellen E. Frewer. New York: Harper and Bros.

———. 1875. *Artes Africanae: Illustrations and Descriptions of Productions of the Industrial Arts of Central African Tribes*. Leipzig: F. A. Brockhaus.

Schweinfurth, Georg, Friedrich Ratzel, Gustav Hartlaub, and Robert William Felkin, eds. 1889. *Emin Pasha in Central Africa, Being a Collection of His Letters and Journals*. Trans. R. W. Felkin. New York: Dodd, Mead.

Seidel, H. 1889. "Das Uelle-Gebiet." *Globus* 56(11):161–65, 185–88.

Seligmann, Charles G. 1911. "An Avungura Drum." *Man* 7:17.

Seligmann, Charles G., and Brenda Z. Seligmann. 1932. *Pagan Tribes of the Nilotic Sudan*. London: George Routledge and Sons.

Shaloff, Stanley. 1969. *Reform in Leopold's Congo*. Richmond, Va.: John Knox Press.

Siffer. 1916. "Note générale sur les Mabodu." Dossiers AIMO. Territoire de Wamba. Archives. Musée royal de l'Afrique centrale, Tervuren.

Simon, Arthur, ed. 1983. *Musik in Africa*. Berlin: Museum für Völkerkunde.

Singer, André, and B. V. Street, eds. 1972. *Zande Themes: Essays Presented to Sir Edward Evans-Pritchard*. Oxford: Blackwell.

Slade, Ruth. 1962. *King Leopold's Congo*. London: Oxford University Press.

Starr, Frederick. 1907. *The Truth about the Congo: The Chicago Tribune Articles*. Chicago: Forbes and Co.

Stengers, Jean, and Jan Vansina. 1985. "King Leopold's Congo, 1886–1908." In J. D. Fage and R. Oliver, eds., *The Cambridge History of Africa*, vol. 6, pp. 315–59. Cambridge: Cambridge University Press.

Tercafs, Mlle. n.d. "Dossier ethnographique." Archives. Musée royal de l'Afrique centrale, Tervuren.

Thompson, Robert Farris. 1983. *Painting from a Single Heart: Preliminary Remarks on Bark-Cloth Designs of the Mbuti Women of Haut-Zaire*. Munich: Fred und Jens Jahn Galerie für afrikanische Kunst.

Thuriaux-Hennebert, A. 1964. *Les Azande dans l'histoire du Bahr-el-Ghazal et de l'Equatoria*. Brussels: Institut de sociologie de l'Université libre de Bruxelles.

Tracey, Hugh. 1955. *Catalogue of the Recordings: The Sound of Africa Series*. 2 vols. Johannesburg: International Library of African Music.

Tucker, Archibald N., and Peter E. Hackett. 1959. *Le groupe linguistique Zande*. Tervuren: Musée royal du Congo belge.

Turnbull, Colin. 1965. "The Mbuti Pygmies: An Ethnographic Survey." *Anthropological Papers of the American Museum of Natural History* 50(3):139–282.

Twain, Mark. 1905. *King Leopold's Soliloquy*. Boston: P. B. Warren Co.

Van den Plas, V. H. 1921. "Introduction." In C. R. Lagae, *La langue des Azande*, vol. 1, pp. 9–65. Ghent: Veritas.

Van der Kerken, George. 1932. *Notes sur les Mangbetu*. Supplement to *Trait d'Union*. Antwerp: Veritas.

Van Geluwe, Huguette. 1960. *Les Bali et les peuplades apparentées (Ndaka, Mbo, Beke, Lika, Budu, Ngari)*. Tervuren: Musée royal du Congo belge.

van Kerckhoven, Guillaume-François. 1896. "L'expédition Vankerckhoven." *Belgique coloniale* 2:26–49.

Van Noten, Francis. 1968. *The Uelian: A Culture with a Neolithic Aspect, Uele Basin N.E. Congo Republic*. Tervuren: Musée royal de l'Afrique centrale.

Van Noten, Francis, and Elaine Van Noten. 1974. "Het ijzersmelten bij de Madi." *Africa-Tervuren* 20(3/4):57–66.

Van Noten, Francis. 1982. *The Archaeology of Central Africa*. Graz, Austria: Akademische Druck.

Van Overbergh, Cyrille, and Eduard De Jonghe. 1909. *Les Mangbetu*. Brussels: Institut international de bibliographie, Albert de Wit.

Vansina, Jan. 1966. *Kingdoms of the Savanna*. Madison: University of Wisconsin Press.

———. 1969. "The Bells of Kings." *Journal of African History* 10(2):187–97.

———. 1982. "Towards a History of the Lost Corners in the World." *Economic History Review*, 2d ser. 35(2):165–78.

———. 1984. "Western Bantu Expansion." *Journal of African History* 25:129–45.

———. 1989. "Western Bantu and the Notion of Tradition." *Paiduma* 35:289–300.

Vedy, Dr. 1906. "Les riverains de l'Uele." *Bulletin de la Société royale belge de géographie* 30:185–209, 299–324.

Vekens, A. 1928. *La langue des Makere, des Medje et des Mangbetu*. Ghent: Veritas.

Vincart, L. 1899. "Notes pour servir à l'histoire des peuplades environnant le poste de Masidjadet." *Belgique coloniale* 5:521–23, 529–33, 544–46.

Vogel, Susan, ed. 1981. *For Spirits and Kings*. New York: Metropolitan Museum of Art and Abrams Press.

Vogel, Susan, and Francine N'Diaye. 1985. *African Masterpieces from the Musée de l'Homme*. New York: Center for African Art.

Von Mecklenburg, Adolf Friedrich. 1913. *From the Congo to the Niger and the Nile*. 2 vols. London: Duckworth and Co.

von Sydow, Eckart. 1954. *Afrikanische Plastik: Aus dem Nachlass herausgegeben von Gerdt Kutscher*. Berlin: Gebr. Mann.

Vorbichler, A. 1969. "Linguistische Bemerkungen zur Herkunft der Mamvu Balese." *Zeitschrift der Deutschen morgenländische Gesellschaft*, suppl. 1, pt. l, 3:1145–54.

Wachsmann, Klaus Peter. 1964. "Human Migration and African Harps." *Journal of the International Folk Music Council* 16:84–88.

Walker, Ernest P. 1964. *Mammals of the World*. 1st ed. Baltimore: Johns Hopkins University Press.

Wauters, Alphonse Jules. 1885. *La rivière d'Oubangi: Le problème de l'Oeullé, hypothèse nouvelle*. Brussels.

Weeks, J. H. 1913. *Among Congo Cannibals*. Philadelphia: J. B. Lippincott.

Wegner, Ulrich. 1984. *Afrikanische saiteninstrumente*. Berlin: Staatliche Museen preussischer Kulturbesitz, Museum für Völkerkunde.

Winckelmans, A. 1931. "Rapport d'enquête, Niangara." African Archives. Ministère des affaires étrangères, Brussels.

Wyndham, Richard. 1936. *The Gentle Savage: A Sudanese Journey in the Province of Bahr-el-Ghazal, Commonly Called "The Bog."* London: Cassell.

Index

Photo Credits

Photographs of AMNH objects are by Lynton
Gardiner. Archival photographs from the American
Museum Congo Expedition were taken by Herbert
Lang; an (s) following a negative number indicates
that the image is from a stereoscopic negative. All
photographs are courtesy of the AMNH Photographic
Archives with the exception of the following list.
Photographs are cited by figure number.

AMNH Department of Ornithology, New York, 3.11;
Roger Asselberghs, 12.16; British Museum, London,
2.5, 2.14, 2.15, 3.6, 3.7, 5.10, 6.24, 8.8, 11.2, 11.5,
11.8, 11.9, 11.12, 11.14, 11.17, 11.18, 12.2, 12.6;
Didier Demolin, 4.7, 6.9, 7.2, 8.22, 8.23, 9.2, 9.6,
10.4, 10.5, 10.15, 12.25; Frobenius-Institut, Frank-
furt, 8.2, 12.5; Jeremy Marre, 4.3, 9.16; Musée royal
de l'Afrique centrale, Tervuren, 3.5, 4.10, 4.11, 4.16,
6.2, 6.20, 7.22, 7.23, 8.17, 12.8, 12.10, 12.16, 12.24;
Museo archaeologico nazionale di Perugia, 2.6, 2.7;
Museo preistorico ed etnografico ''Luigi Pigorini,''
Rome, 2.9, 12.7; Museum of Cultural History,
University of California, Los Angeles, 4.17, 8.9, 10.2;
Museum Rietberg, Zurich, 10.6; Museum für Völker-
kunde, Berlin, 2.10; Museum für Völkerkunde,
Frankfurt, 11.10; Museum für Völkerkunde, Vienna,
2.4, 12.3; Luigi Pellettieri, 11.6; Powell-Cotton
Museum, Kent, 11.16; University Museum for
Archaeology and Anthropology, Cambridge, 12.17;
C. Zagourski, 12.23.

Pictographs: Drawings taken from pictographs incised
on ivory horns and boxes collected by Herbert Lang
in 1913–14. Page 15, AMNH, 90.1/1805; page 29,
AMNH, 90.1/5010, AMNH, 90.1/2726; page 47,
AMNH, 90.1/4802; page 69, AMNH, 90.1/1765
[missing from the AMNH collection]; page 89, *left to
right*, AMNH 90.1/3919, 90.1/2728, 90.1/3919; page
101, AMNH, 90.1/4764; page 123, AMNH, 90.1/
1805; page 143, AMNH, 90.1/1765; page 169,
AMNH, 90.1/2726; page 195, AMNH, 90.1/4764;
page 209, AMNH, 90.1/2728; page 217, AMNH 90.1/
3919, 90.1/1805; page 232, AMNH, 90.1/1766a.